Journal of a Living Experiment

A Documentary History of the First Ten Years of Teachers and Writers Collaborative

Edited, With Commentary, by Phillip Lopate

Teachers&Writers

84 Fifth Avenue, New York, New York 10011

This book is made possible by a grant from the National Endowment for the Arts in Washington, D.C., a federal agency.

Library of Congress Cataloging in Publication Data
Main entry under title:

Journal of a living experiment.

1. Arts—Study and teaching (Elementary)—New York (City)
2. Teachers & Writers Collaborative.

I. Lopate, Phillip, 1943-

NX311.N4J68 372.5 79-19199
ISBN 0-915924-09-9

Table of Contents

Introduction

When the director of Teachers & Writers Collaborative, Steve Schrader, asked me to put together a special issue of our magazine celebrating the organization's tenth anniversary, we had in mind a light, graceful walk down Memory Lane of approximately fifty-two pages in length. Obviously it did not turn out that way. As I began collecting the material, I became fascinated with the complexity of the group's history, and the serious larger issues it touched. What attracted me first of all was the sheer amount of literary history that Teachers & Writers Collaborative had a hand in. An organization which has engaged the dedicated energies of so many important writers of the last decade —Herbert Kohl, Muriel Rukeyser, Anne Sexton, Kenneth Koch, Grace Paley, David Henderson, Benjamin DeMott, June Jordan, Nat Hentoff, Victor Hernandez Cruz, Joel Oppenheimer, Ron Padgett, Florence Howe, Mark Mirsky, John Holt, Jay Wright, Rosellen Brown, Sonia Sanchez, Louise Gluck, Felipe Luciano, Pedro Pietri, David Shapiro, A. B. Spellman, Tom Weatherly, Wesley Brown, Maria Irene Fornes, Robert Silvers, Jonathan Baumbach, Bill Berkson, Armand Schwerner, Sidney Goldfarb, Calvin Trillin, Richard Elman, Leonard Jenkin, Dick Gallup, Meredith Sue Willis, Lennox Raphael, Karen Hubert, Richard Perry, and Bill Zavatsky, to name only the most widely-published—must have a story worth telling. The cast of characters was rich, as was the verbal record they left behind of their struggles and satisfactions in attempting a reformation of language arts teaching in the schools.

But it could not be allowed to turn into a syrupy *Festschrift*. The decision of an organization to write its own history must be based on something other than self-aggrandizement for it to be of general value.

There is a tradition at Teachers & Writers, grounded in the act of diary-keeping, of self-reflection, and painful honesty about mistakes and tensions. This volume will in no way depart from that tradition. The value for some readers, I hope, is that an airing of the history of one group's struggles over an extended period will be useful to others attempting similar enterprises; the value to us as an organization may be that the excavation of the historical record will put us in touch with some of the old zeals which were present at birth (and since routinized or blunted), while also enabling us to go forward on a new footing.

Teachers & Writers Collaborative is, first of all, the original organization to have sent poets, novelists, and other artists into the schools on a regular basis. It came out of a series of meetings in 1966-67 among writers whose awakened social conscience about the plight of the schools—particularly ghetto schools—compelled them to become involved and to take action in some way. Because they were writers they addressed themselves initially to what they saw as disastrous shortcomings in the English curriculum; but their concern for language and the ways that schools traditionally choked off students' creative, alive, use of language was only a metaphorical starting-point for larger concerns about educational tracking and racial and social injustices that seemed to be taking place in the schools. The writers' (and later, the other artists') idea was that by going into the schools, they could both lend support to the students' ''authentic'' voices and cultures, while taking students further through

professional guidance in art-making activities—at the same time helping to bring about a more enjoyable, unrepressed school environment.

The twistings and turnings of that idea through every conceivable barrier and self-doubt, is one way of looking at the history of Teachers & Writers. This book is also very much a document of the past decade, from the 1960's into the 1970's, and the lives of a select and special group of people, some famous, some not. This is—for me—a book about "activists," not Mark Rudd type activists, nor Ralph Nader types, but people who wanted to *do* something and—though not without discomfit—did it. Are still doing it.

It has not been an easy road. Many of the founders of T&W, who were present at the 1966 Huntting Writers' and Teachers' Conference, have expressed surprise bordering on incredulity that the group has lasted ten years. It was slated for an early death. There is even a hint of disappointment, an understandable *après moi le deluge* sentiment on the part of some pioneers, that it did not go under or turn bad after they left. It continues to stumble on one year at a time, renewing its shaky annual contracts on life. At some distant turning-point in its past, Teachers & Writers, born in an all-or-nothing spirit, began to cling to life, chose to survive. Not that that decision means that it will survive. But what it does imply is that the organization has lived past its wailing infancy and suicidal adolescence. It is even approaching a distinguished middle age, when the highs are not so high, the lows not so low. Such is the destiny, perhaps, of any idealistic agency which reaches a certain maturity.

In a sense, Teachers & Writers Collaborative is typical of thousands of small, non-profit agencies for social change, many of which sprouted up in the late '60s as an alternative response to the status quo in every field of delivery of social services. There are very few satisfactory accounts of these cliff-hanging agencies' careers, but we know that many did not make it into the 1970s. No matter what energy and ideals informed their birth, all were soon up against the dilemma of year-to-year grant funding. Foundations which had given out original "seed money" expressed unwillingness to continue to carry the programs. The result was that agencies had to divert energy from crucial program operations into grantsmanship and public relations; though often that did little good.

In addition to funding worries, the frustration of being helpless to change in any visible way the larger social service system, such as Welfare or the Board of Education or the Bureau of Health, whose wrongs they had originally formed to redress, marked a crisis of purpose in the lives of many of these small activist agencies. Should they continue to try to survive, knowing that their efforts would be as slow to alter the problems as the proverbial rain beating on the mountain, or should they, taking the path always remarkably open to radicals and reformers—self-destruct? Choose an issue for a last confrontation, and go down in a martyr's blaze? Or should they simply disperse, quietly, as many did, on the last day that the grant ran out, and pick up their lives at some other point, working either for another alternative organization, or finding securer positions in government or corporate life, or gravitating toward less security, going "free-lance," making pottery for street fairs, joining a communal farm?

All of these alternatives were part of the daily drama for people struggling to make a go of such agencies. Above and beyond the question of whe-

8

ther the organization's program was effective, or actually doing anything, rose the doubt in every worker's mind: would the organization even be there tomorrow? As Zelda Wirtshafter, the second director of Teachers & Writers (during one of its most beleaguered periods) put it eloquently:

> At present all the programs can be much better than they have been, and much more effective, and yet we cannot even think of our future existence without anxiety. This seems a foolish way to function. The writers and teachers most involved in our program just begin to see ways in which the material and personnel of the Teachers & Writers Collaborative can be used more effectively, yet can't act upon this insight because the specter of non-existence continually hangs in the air.

After ten years of this grim game of staring into financial non-existence, Teachers & Writers has developed an *ad hoc* personality, flexible in responding to emergencies, while reluctant to engage in long-range planning. So it became hard to put into words the pedagogic program of the organization in terms of a set of clearly definable educational goals and objectives. The one Teachers & Writers Collaborative goal that has remained consistent has been to help release the creative capacities of children, adolescents and adults. The Teachers & Writers operative, who is luxuriously free from the burdens placed on the classroom teacher to bring each student up to a community-accepted norm in math, reading and science, has another obligation placed on him or her. It is the responsibility to detect the pre-artistic promise in a person and bring that to full expression.

The record of pedagogic adventures in this book will, I hope, prove a rich storehouse of ideas for teachers, parents, and volunteers eager to work in creative directions. More than just a set of teaching ideas, what is being presented here is a special mode of work, and a patient, experimental *attitude toward* work, which, when successful, can be deeply freeing and educational. It is this ideal of good, freely-chosen work (however vague that sounds for the moment) which lies at the heart of the Collaborative's search, and which unifies its members in a consistent belief-structure.

The idea behind the Collaborative has always been to place writers and other artists in situations without telling them what to do, but letting them find their own way, in the same manner that they would proceed into their own art. The assumption has been that artists are more at home with initial open-ended uncertainty, and with setting up problems and tasks for themselves, out of the freedom to do almost anything. The assurance that each artist can make his or her own program in the school (even abandoning one's special skill and pursuing a different medium) has been a constant of Teachers & Writers policy—which has had a bracing, giddy and sometimes anxious effect on its members.

Another emphasis that runs throughout the Collaborative's history has been on continuing relationships between student and artist, with the understanding that the relationship itself—rather than a detachable set of lessons or skills—will form the ground of the teaching. June Jordan worked with a group of children on Saturdays, first in a community center, then at a church, and at their schools, and finally helped set up a summer camp for them. Bill Zavatsky stayed in contact with his ex-poetry students after they graduated from elementary school, and eventually gave a free workshop for them on Saturdays in his apartment. The search on the part of the artist for other ways of relating to children, more naturally, casually, equally, playfully, or more

9

driven when it comes to completing a crucial task, continues to be an important undercurrent of the work. Many Teachers & Writers artists have reported that their nicest moments have come about when the kids hung around after a lesson, or while shooting a film on location, outside of school, and sharing a pizza afterwards. Sue Willis's article about her "crush" on a little boy, Luis, provides a good description of the sweetness and pain of these intimate connections, which remain a major benefit of the work.

In working with the materials for this publication, I began to sense a number of unifying themes and questions. There was, as I have mentioned, the issue of activism and reforming the schools; of students' authentic language versus school-language; of the organization itself and its various stages of development; of the economics of art politics and non-profit organizations; of the patient practice of opening people to their own courageous self-expression; and the importance of continuing relationships for the teaching experience to take hold. I also became aware of a series of larger questions: What is the relationship of democracy to aesthetics? What is, or should be the role of the artist in society? What is the role of the artist-outsider, the so-called "change agent," in regard to an institution and its permanent staff, and what are the potential pitfalls in that situation?

So often, as I read through the artists' diaries while assembling this record, I came across a *fragility* which reminded me what shy, peculiar, difficult, special people artists can sometimes be. Having elected a life which implies a certain retreat, a certain detachment and aloneness, they would rush into the schools, needy for the "world," for an external set of problems. Their own thirst for contact—with children, with other adults and colleagues—would make them vulnerable to a point where their first disappointment released waves of over-criticism and analysis. Some artists tended to project all their ambivalence onto the external situation, the schools themselves, with their physical ugliness and social crimes, while seeing themselves and the students as somehow innocents. Other writers, like Anne Sexton, were fully and honestly aware of the struggle it took to put themselves in the middle of this world, and to make something besides their art real to them. How to balance the two work-lives, one so introverted, the other so extroverted? How to translate the insights which the artist has learned by private means, alone, into terms that will benefit whole classrooms? To what extent might the artist need an external work-place, and to what extent might he or she resent that need?

The stresses and attractions of a double career-commitment thus form a kind of extra frame around the artists' perceptions of school life. What we have here, in certain of the documents, is the moment of surprise for someone who thought he or she already had a "calling" (art), at being drawn toward another calling (teaching)—and the embrace or refusal of that other vocation. Some of the documents are very rich in this way. I should explain how they came to be assembled.

When I was given the job of putting together a tenth anniversary commemorative issue on Teachers & Writers Collaborative, the logical first step seemed to me to go through the "archives." There were organizational files, memos, progress reports, and piles of artists' diaries and Teachers & Writers publications to read. It was an interesting experience to get lost in these mounds of old papers, filled with hopes and promises, dated rhetoric and stir-

ring predictions (often wrong) of what was to come. Some of the documents buried in the files were jewels. Others were anything but jewels—more like dirty coal that left me smudged and blackened from head to foot. But I shall never forget coming across Anne Sexton's lost diaries, or June Jordan's unpublished journals, and reading them with the mounting excitement and realization that all I needed to do was type them over: they were already finished literary statements. Other writers' diaries, on the other hand, had to be edited extensively. And many key figures—directors and assistant directors of Teachers & Writers, for instance—never kept diaries. I needed to supplement the artists' documents with other source material, to fill in the missing pieces of the story. With Zelda Wirtshafter, an ex-director, I was lucky enough to find a folder of letters and memos that made a coherent narrative statement, much like a diary. But in other cases, I needed to interview these people, thus gaining their thoughtful backward glance at ten-year-old history. The interviewees included Herbert Kohl, Robert Silvers, Kenneth Koch, Karen Kennerly, Zelda Wirtshafter, Tinka Topping, Ron Padgett and Leonard Randolph. I have transcribed these interviews and, wherever it was practical to do so, inserted them in the text. When it came to collecting material on the more recent history of Teachers & Writers, I asked those involved to write articles which would reflect on some of the long-range aspects of their experience. Many obliged with beautiful pieces: including Marv Hoffman's humorous account of his former directorship, Karen Hubert's analysis of the experience of colleagueship, Miguel Ortiz's memoirs of a storefront school, and the moving and illuminating pieces on working with children, by Sue Willis, Teri Mack, Bob Sievert, Ron Padgett, and Alan Ziegler.

By the time I had collected all this material, the ten-year anniversary of Teachers & Writers had passed. I was still going through the archives and editing manuscripts when the eleventh anniversary had passed...It was clear by now that the contents of this research would not be issued as a magazine. The manuscript had grown to unwieldy proportions: it included articles, diaries, letters, manifestos, graphics, memoirs, etc., and the problem was how to embed these different mosaic surfaces in an overall context. Much as I was anxious to let the source materials speak for themselves, I realized that it would be necessary to put the material in historical and thematic framework—and to give it a point of view. Hence, the commentaries which I have scattered throughout the text. As editor, I have elected to decentralize my commentary into periodically appearing essays, in the hope that I will be able to pinpoint the themes and issues as they come up in the documents. Of course it is impossible to be at all places at once and to comment immediately when each question arises; the reader will have to be patient and charitable at times in wading through a dense, but, I feel, ultimately rewarding, method of organization.

The texts were not chosen to make an anthology of the "best of Teachers & Writers Collaborative"—that would have been another book, and in any case, the group's most successful curricula are already available in other Collaborative publications—but because they represented, to my mind, what was characteristic and historical. The resulting text is part-documentary history, part-source book, and part-one man's commentary.

—Phillip Lopate

11

THE
HUNTTING
INN

ESTABLISHED 1751

EAST HAMPTON

Part One:
The First Year

A Friendly Inn in the Heart of East Hampton

Roots and Origins
by Phillip Lopate

For writers are needed by students, just as dogs are needed by city people.
—Muriel Rukeyser

There is an argument to be made that no era is harder to see or understand than the one through which one has just passed. The period from 1965 to 1970 may have been more peculiar and ungraspable and idiosyncratic than most. Why, for instance, everyone should have felt so keenly at this particular moment that there was a crisis in American public education, is not altogether easy to re-imagine. Ten years earlier, perhaps, the voices of optimism and patriotic conformity would have predominated. Ten years later the crisis in the schools has begun to seem permanent—eternal, therefore less alarming.

The forces which converged to create Teachers & Writers Collaborative (among many other similar groups) in the late sixties were various and sometimes so contradictory in outlook that perhaps we should wonder more that they meshed at all. It so happened that certain educational and aesthetic and political ideas that were in the air managed to coalesce into organizational form at a particularly ripe moment, when anger at the power structure, heightened social consciousness on the part of artists and writers and some extra government money floating around fortuitously came together.

It was a time when intellectuals would turn down invitations to the LBJ White House, in protest of the Vietnam War, and then end up in Washington attending government conferences on upgrading the academic professions. Consider the Tufts Seminars, which many people seem to think is where the story of Teachers & Writers properly begins, and so here is where I shall begin it as well.

In the beginning was Tufts.

For two weeks, August 30th through September 11th, 1965, approximately forty-five respected names in a variety of professional fields, "from science and mathematics to literature and writing, history, and the social and behavioral sciences," were brought together for a Seminar to Initiate New Experiments in Undergraduate Instruction, at Tufts University, Medford, Massachusetts. The seminar was co-chaired by the physicist Jerrold Zacharias of M.I.T. and Jack Tessman of Tufts, and funded by the U.S. Office of Education and the National Science Foundation. Herbert Kohl is of the opinion that the impetus for the Tufts Seminar was the panic caused by Sputnik and other Soviet space advances (see his Interview, p. 21); but whether this was the only inspiration is doubtful, since the Sputnik shot occurred eight years earlier, in 1957. There can be no doubt, however, that the Federal Government was directly and vitally interested in these seminars, as evidenced not only by its funding of them but by the presence of a top-level advisor to the president, Joseph Turner, of the Office of Science and Technology. It was Turner, in fact, who wrote the Tufts seminar report.

The delegates were subdivided according to their disciplines. The work of other sections, particularly mathematics and the natural sciences, seems to have been substantial, and to have led to the adoption of influential new curricula; but we cannot be concerned with their achievements here, but only

14

with the Committee of English, Literature and the Arts (consisting of William Alfred, Benjamin DeMott, Joseph Farrell, Jack Gelber, Sister Jacqueline Mattfield, Charles Muscatine, Benjamin Nichols, Esther Raushenbush, Seymour Simckes, and Father Walter Ong, chairperson). Their main focus at Tufts was how to upgrade undergraduate and graduate instruction. There was much pillorying of "Freshman English," and criticism of standard English teaching in college which divorced literature from real life and the experience of the students. This argument was "crystallized with great passion through the effort of Benjamin DeMott and his opponents and defenders (the two were not always distinguishable)," the recorder notes. DeMott argued that professional English teachers are not able to make books connect with experience because they are too engrossed in "introducing students to arcane literary hierarchies —the mystique of 'good books'...to the structure and design of the poem or book...the particular modes of persuasion...or the lives of the great writers." DeMott appealed for movies and popular magazines and "junk" books to be brought into the classroom so that students could learn to discriminate for themselves between what "lies" and what "tells the truth."

Among the committee members, there seemed to be a shared conviction that the teaching of English was "a disaster area," though the participants were by no means agreed as to solutions. One approach temporarily embraced by the group was novelist John Hawkes' Voice Project. Hawkes wanted to set up a model pilot course for a hundred Stanford freshmen which would try to put each in touch with his or her personal voice—for instance, by going from taped speech to transcriptions of oral reports, which would then be edited to make a better piece of writing—so that all student writing, whether scientific, "creative" or journalistic, would eventually reflect an authentic, personal style. The Voice Project, which was eventually carried out, raised important questions about the disjunction between expressive speech and written Standard English, especially among minority groups—issues that were later to be taken up by Teachers & Writers Collaborative.

A second proposal at Tufts that had near-unanimous backing was to set up Institutes for Literary Studies, perhaps first at Stanford University and Sarah Lawrence, which would serve as training laboratories for doctoral candidates. Prof. Charles Muscatine of Berkeley put forth what was regarded as:

> the most novel and, to many, promising of proposals here...that both members of graduate faculties and graduate students, perhaps at experimental centers or laboratories, should be involved in doing teaching at levels below college as part of their education. As Muscatine put it, they—or some of them, at least—should become acquainted with high school teaching in order to know what they will be getting from the high schools, and with elementary school teaching in order to rediscover their subject matter itself in a fresh light by trying to convey some of it to young children.... "College teachers can learn from young, fresh minds something about their own projects. It would not be too much to predict that even for research in the nature of literature—a graduate school subject—the responses of children would provide first-rate material. There is little doubt that concrete experience in the fourth grade and creative thinking about it would teach a future college teacher a lot about literature and about learning that would help in college teaching."

It is interesting to note that teaching young children is here proposed mainly for its salutary effect on scholars, like a stay at a hot springs. This is another way of saying that the Tufts group was mostly composed of college teachers, scholars, administrators and writers preoccupied with the experience

of academia (as befits a seminar devoted to undergraduate instruction). If one can trace the genesis of Teachers & Writers Collaborative back to Tufts, it is less because of theoretical affinities, as because Tufts provided the financial umbrella for a series of conferences, of which it was the first—the next two were at Sarah Lawrence and Columbia University—and that eventually led to the Huntting Inn Conference, at which the Collaborative was established. It seems odd that anything actually comes from conferences; and doubly odd that an organization with the vibrant, troubled history of Teachers & Writers Collaborative should have been inseminated and birthed from this dehydrated milieu.

At Sarah Lawrence five months later (February 11-12, 1966), the continuing committee held a second seminar, "to talk about the teaching of writing and reading, and about the place of writers in teaching." Note that the emphasis has already shifted to professional writers—novelists and poets—and away from college administrators and teachers at this gathering. It was here, at Sarah Lawrence, that Joseph Turner dropped the catnip-scented hint that let all the cats out of the bag. Turner

> made clear that if concrete ideas that could lead to better teaching came from writers—
> "pilot projects" which could be tried out in a limited situation but which might be
> adopted later on a larger scale—the U.S. Office of Education or the Office of Economic
> Opportunity might be interested in giving financial support.

Forthwith came a multitude of proposals. R. V. Cassill proposed "a 'central casting agency'—a pool to which key teachers of writing throughout the country would recommend their most creative graduates and to which sympathetic administrators willing to hire non-Ph.D's could apply." Harvey Swados envisioned a sort of Peace Corps for young writers, who, "at an age when they are most idealistic (21, 22) and also least able to support themselves by anything related to writing, would be given grants to live for a year or two in underprivileged communities," and write and teach in neighborhood storefronts. William Alfred felt "that the real answer to the Freshman English crisis lies in getting government funds for more teachers, so that classes can be limited to eight"—an idea which, according to the recorder, Jane Cooper, "won the only heartfelt applause of the two days." Mitchell Goodman thought that a writers' lobby should be started to pressure the Office of Education. As many writers as were present, there seemed to be that many schemes, that many hustles, pipedreams—some nakedly self-serving, others wildly idealistic; some practical (and since implemented), others just pie in the sky. Turner had let the genie out of the bottle.

But no sooner had the writers begun flirtatiously to present their plans, when the opposite reaction set it: they became suspicious. Tension developed around the question, "What exactly is a pilot project?" The excitement of all that money dangled in front of the participants was dimmed somewhat by the fact that the Government was only interested in projects which could be replicated on a national scale. Jerrold Zacharias of M.I.T. shared Turner's faith in the replicability of successful projects, and tried to convince the writers. "Mr. Zacharias felt that whatever can be done on a small scale in teaching can in time be done on a larger one...Mr. Zacharias had recommended that projects be kept manageable, but Donald Barthelme objected that the problems writers deal with may precisely not be 'manageable' in Mr. Zacharias' sense;

therefore the analogy between teaching writing and teaching physics may break down." Grace Paley thought the problem of the Sarah Lawrence conference for her was that people were being asked to think "in a national way," when she as a writer could only come up with local solutions. As Jane Cooper, the recorder, noted:

> Obviously, there was a deep divergence of opinion here, which perhaps had to do with the nature of those present as writers: on the one hand, some felt that given the magnitude of the educational crisis, only large-scale solutions could have any relevance, while others felt that the value of the writer's voice—here as elsewhere—is that it is individual, and that they could only suggest limited, local projects with integrity.

The same battles are being fought today; and there continues to be some difficulty with the notion of "replicability," especially as regards projects where art is made. Structures may be copied, job titles or curriculum guides reproduced, but that is no guarantee that the quality will follow. Donald Barthelme may do something exciting in Texas or New York, but how can he be sure that the program will work in Omaha when he is not there to see it through: he knows there is only one Donald Barthelme. Beyond the problem of finding analogously strong personnel, there is the deeper philosophical, Heraclitean question of: how can we even speak of repeating an experience when every moment is different? This may sound ingenuous to funding agents, but it is the approach that poets and novelists have been trained all their lives to use: to see each moment as perishable and worthy.

It is poignant, in reading over these dry single-spaced conference minutes from years ago, to detect still the stifled anger and frustration among people whose whole sense of self rested on being unique—at having to be replicable, like a clone.

Joseph Turner patiently explained "that in the sciences, especially physics, the success of experimental projects led to their general acceptance in many areas of the country." Further: "To be paid for by the Office of Education an experimental project must leave a trail behind it, and Mr. Turner thought that in this case the appropriate trail would be a book about the subject—perhaps a diary kept by the young writers themselves." This government official certainly seems to have been reasonable and understanding with the writers, and to have phrased the obligation in terms that would not be inimical to their craft. Perhaps the problem was one of vocabulary: the science metaphors which Turner and Zacharias used simply unnerved the writers, who feared that their profession was about to be "rationalized" and made to answer to Pentagon-style cost benefit analyses. One thing was certain: if the writers wanted their dreams and plans funded by the government, they were learning, they would have to accept some form of monitoring and accountability.

One of the attendants at the Sarah Lawrence conference was Tinka Topping. Mrs. Topping was not a writer; at the time she was pouring her energies into making the Hampton Day School a model of alternative education, and her broader concern was "how are we to educate vast numbers of elementary school youngsters?" She kept inserting into the conference her thoughts about "how writers could make elementary school curricula more exciting." Two proposals addressed to this question were generated, one by Seymour Simckes, who had been present at Tufts, and one by George P. Elliott. The Sim-

ckes proposal is interesting for our purposes because it constitutes the first full statement of what would become the Teachers & Writers Collaborative concept:

> Mr. Simckes wondered how many other writers besides himself would be interested in actually going into elementary school classrooms. He stressed what many recognized: children's language is naturally "ambitious," but something happens to the child when he enters the school system. In order for college not to seem an "attack" on all the student has learned previously, we need to get at the point where false learning, covering up, flattening out begin. Why should writing come as a shock to college freshmen? Mr. Simckes described an experiment he would like to try with a group of very young children: having them write their own text. That is, each child would contribute his own language and experience, the children might act out or even paint scenes before they were written down, but in any case they would become used at an early age to seeing their lives achieve a written form. Texts from one group of children would be handed down to succeeding groups, so that classes would have an inherited literature as well as the intoxicating sense of themselves as authors. Mr. Hawkes felt that some such method would be very helpful in teaching disadvantaged children—those whose speech is furthest from Standard English. Miss Levertov commented that at the City and Country School in New York children's stories and songs are recorded and handed down. Mr. Simckes felt that by going into the schools in this way writers themselves might reach a greater understanding of "the basic educational esperience."

The Simckes idea was opposed by George P. Elliott, who took what he argued was a more realistic position that "school teaching is going to continue to be dominated by school boards and that few teachers are truly gifted. Given this situation, there will never be enough writers to revolutionize existing school standards by actually going into the classrooms. But writers can help by writing textbooks, making lists of selections, setting up criteria for good writing and reading which regular teachers can then follow. He would like to see high school students given literary texts that are beyond them, written not for them but by writers for themselves, according to their own painstaking standards." Concurring, Susan Sontag suggested new "kits for high school teaching, the use of films, Saturday afternoon instruction of high school students at colleges, new curricula as well as textbooks, designed by writers." William Melvin Kelley wanted to make sure that the texts would be realistic, and based on contemporary experience.

This division, now buried in history, between those who thought writers should affect elementary school education by going into the classrooms, and those who thought that they should stay outside but write textbooks and new curricula to help reshape language arts education, persisted as a question of priorities throughout the early years of Teachers & Writers Collaborative. Eventually it came to seem a false dichotomy: why not do both? Mediating at Sarah Lawrence, Tinka Topping called for a "combined program to bring writers into the elementary schools, both as teachers and by having them write for children." What has in fact resulted is a joint teaching-and-curriculum-generating approach, but the materials are not exactly what Elliott or Sontag or Kelley had in mind. They consist rather on the students' own texts (more what Simckes had suggested) and pedagogical explanations for teachers on how the students' writing was generated, based on the writers' teaching experiences—instead of a set of textbooks written by authors directly for young people. It is important to keep in mind that no all the threads of ideas from these conferences were pursued; decisions were made, fertile options cast over-

board or forgotten; and this was only one example of a "road not taken."

As the stormy Sarah Lawrence conference came to a close, a proposal was made for a subsequent meeting to continue the dialogue. Davidson Taylor, director of Columbia University's, then new, School of the Arts, stepped forward and offered his facilities for a conference the following month, March 11-12, 1966.

At the Columbia meeting, ideas which had been vaguely put forward in previous conferences began to be tacked into shape. To the minutes-keeper, Carter Wilson,

> Anyone who went to both meetings must have gotten a funny sense of accomplishment at some time during the second stanza. At Sarah Lawrence there was a great deal of talk about the State of Reading and Writing and though a general agreement was reached, who could tell if it would hold up after a month? At Columbia we stood on the foundation of the Sarah Lawrence consensus and found it firm enough.

What was this consensus which made for such headiness? Essentially, it was a shared diagnosis of how bad things were. The diagnosis, as Wilson set it down, is fascinating not only because of what it says but the way it is said. It smells unparaphraseably of the diction of the times: at once passionate and painfully abstract in its urgent desire to connect with "life," apocalyptic, earnest, slangy yet academic, and always reaching for the generational, globally shared experience of "our," "you" or "we":

> Things are rotten from top to bottom. At the bottom children do not learn to write as a means of telling the world about themselves or as a way of telling themselves about themselves. They learn that writing is limiting, that they must take on a "standard language" for writing, and standard language bears little relation to the language they are speaking or using to communicate. And if writing is separated from the self, reading is divorced from life. Often school books contain neither any picture of life the children can recognize, nor any reasonable facsimile of the imaginative world he inhabits, and certainly books contain none of the intricate problems a child deals with. So reading becomes from the beginning a meaningless chore, and writing becomes a heavy harness you must put on to get accepted in the world. Later you find out there are two kinds of harnesses—expressive harnesses and literal harnesses, and unless you are especially talented you have to wear the second one till the day you die. Most people then avoid both harnesses, give up writing as a means of communicating and reading as a means of finding out about the world. What people do read is badly written, and yet becomes the standard. Our public language is a language of evasion, for cheating and lying, so we inadvertently learn to cheat and lie and evade. Even at Columbia, Jacques Barzun said, there is a defeatist attitude about the use of English: many people think that since no one seemed to be practicing it, the use of good language and the teaching of it must be impossible.

Who will come to the rescue of our beleaguered language? The answer is not far off:

> Writers worry about language. They worry because someone is breaking or dulling their tools, they worry because their audience turns away and yawns, or simply because they have some stake in language. If the state of things is as rotten as it seems, then writers must burrow into the educational structure from the top or the bottom and see what they can do. Writers have maintained various cells in the structure before: some have taught school to earn a living; others have taught prestigious writing courses to tiny college elites. But in the present situation many writers want to know how they can do more, how they can work more directly to change the nature of education in language all through the structure.

That *writers* should have seen themselves as the answer to this enor-

mous crisis constitutes a rare, nay, miraculous instance of collective confidence in a profession so often plagued by self-doubt. The notion of writers burrowing into every inch of the educational cheese is arresting. The "go to the students" idea, as it was now called, picked up considerable momentum at the Columbia conference; and now the emphasis was definitely on elementary and secondary schools, rather than college. Tinka Topping and Zelda Wirtshafter were present, as was, for the first time, Herbert Kohl, and they all talked about the concrete problems and possibilities surrounding the lower schools.

Mrs. Topping explained some of the serious failures in the way language is now introduced to children. In reading, children are limited by the "phonic" method of learning. Grouped almost at once by their reading abilities, many children learn quickly to be ashamed and embarrassed about their reading. In writing, spelling and punctuation matter more than content, and so real, individual expression is cut off by teachers. Zelda Wirtshafter noted that children are taught what "figurative language" is, but that teachers hardly listen to the metaphors children invent themelves.

The writers followed this testimony, entranced, getting a crash course from educators whose expertise they were now compelled to solicit, being total novices in the field. Or, as the minutes wryly put it: "The writers were made aware...that they themselves know little about these innovations and have not yet worked with children themselves." So the Tufts seminar series, which had begun with university professionals and had been taken over by writers, was now being hijacked again by open-education types!

Of course, not all of the Columbia meeting was taken up by elementary and high school matters: R.V. Cassill reintroduced his idea to link writers with jobs in colleges; and Mitchell Goodman and Grace Paley argued for a Greenwich Village community arts center for dropouts and adolescents; and Robert Creeley reported on university plans to hire writers to teach Freshman English. But the discussion kept returning to the lower grades. Mark Mirsky and William Melvin Kelley wanted to develop a set of "throwaway texts" of contemporary writers to dump in high schools like comic books. Elizabeth Kray talked about her Academy of American Poets' project to send younger poets into the classrooms to give readings. Muriel Rukeyser said she was having her advanced poetry students at Sarah Lawrence teach in public schools.

In short: "The 'go to the students' idea became a part of most plans presented at the meeting, especially because it seemed successful and practicable in New York. But who would manage the logistics of such a huge migration?"

Yes, who indeed? Tinka Topping proposed that a special conference of writers and schoolteachers be held specifically to set up an administrative center for these activities.* She was able to raise some money for a week-long conference, which would be held under the auspices of the Hampton Day School, at the Huntting Inn in Easthampton, Long Island. At this point, Tinka Topping and her friend, Robert Silvers, turned to Herbert Kohl, as the person to chair the conference and to help manage the "migration."

*This center became known as The Teachers and Writers Collaborative. The name of the group was provided by Mrs. Topping's mother, "who was good at naming things."

Interview with Herbert Kohl

This interview took place in the basement study of Herb Kohl's house in the Berkeley Hills, California, September 1976.

1. The Background

LOPATE: What I'd like you to do is to give a brief account of how you got involved in the group that eventually started Teachers & Writers Collaborative—or else your sense of the beginning of the process.

KOHL: Okay. I wasn't involved in the earliest stages. One of the things that came out of Kennedy's election and the Sputnik shot into space was: American kids are scientifically behind. Before any of the writing about schools, the thing that really put the money into education was that, "The Russkies are doing better than us." And out of that came a series of conferences called the Tufts Conferences. They were to be held in all the different subject areas: there was one in the sciences, one in math—the New Math, the Madison math in particular, Bob Davis and those people. The Science Curriculum Improvement Study came out of that, and the Secondary School Mathematics Program.

In each particular group, they called together the superstar liberal academic intellectuals. So far as I know, very very few practicing teachers were ever involved; and on the other hand, people who had probably never taught secondary and elementary school were involved in the setting up and designing of these programs. Hence one of the reasons for the failure of the New Math: there were no teachers and no people who had thought about children involved in it. Jerome Bruner, I think, was part of the group. He'd studied children but had not worked much with kids as a teacher. And I think the EDC, the Educational Development Corporation, came out of those conferences too, and the Study of Man curriculum, and the attempt to use sophisticated, essentially structuralist notions of learning, and a lot of Piagetan notions of learning, as applied to the latest state of the art in any particular intellectual area, then turning it into a curriculum for kids. I could go on further about that; but anyway, there were these series of meetings.

LOPATE: Who were the moving forces behind this?

KOHL: There was Jerry Zacharias, Joe Turner and John Mays. It was Mays who eventually really nurtured the Teachers & Writers into existence. They were all working at the time in the Office of Science and Technology. They were scientific advisors to the President, and part of the executive offices of the White House. So they were directly responsible to the President, L.B.J. It's very important to realize that they were *opposite* the Office of Education bureaucracy—with the exception of a few people, like Fritz Ianni. In other words, the Kennedy people were involved in the conferences, but the old psychological-behaviorist-oriented school people, and the old bureaucratic school administrators, were not part of the process.

LOPATE: When you say "opposite," do you mean opposed?

KOHL: Yes. In fact, they're the people, Zacharias and so on, who created the National Institute of Education, NIE, in order to destroy the Office of Educa-

tion. Absolutely. Most of these same people had also been involved in the creation of the National Science Foundation, and so the National Institute of Education was created on the model of National Science Foundation. It was a Federal, liberal academic, intellectual, very often East Coast-based group, with a few people from elsewhere. They had the romantic idea of—well, you know Bruner's statement, that: Put in adequate and appropriate form and structure, children of any age can learn any subject matter. And therefore, if the greatest minds in any field got together, they could simplify the structures and be able to teach anything. That was the idea, anyway.

LOPATE: Now what happened when this came to English?

KOHL: Well, what happened was: the people who were most involved were Benjamin DeMott, and Father Ong, and John Hawkes and Albert Guerard... and who else? Bob Silvers. There was a meeting at Tufts, then there was a meeting at Sarah Lawrence, and it was through Sarah Lawrence that Grace Paley and Muriel Rukeyser and a lot of other writers got involved because they were all teaching at Sarah Lawrence. Denise Levertov was involved, and Anne Sexton...What you've got to realize was that to a large degree, there were whole poetic traditions ignored. The only Black writer who was involved was William Melvin Kelley. And he told me at one point that he just thought it was a bunch of horseshit. There were practically no West Coast poets, you didn't find people like Creeley, Ginsberg, Corso, Robert Bly, Gary Snyder—very significant figures were absent. There was an incredible dominance of the northeastern white establishment.

LOPATE: And university-based poets.

KOHL: That's absolutely right, university-based. And Koch wasn't even involved at that time: he was much too far-out. The whole New York School, Ron Padgett and those people who later got into it, were not included here—much less Victor Cruz and David Henderson and June Jordan and all the other people who eventually got involved. Then there was a meeting at Columbia.

I have to backtrack and tell you what I was doing at that time. Because the desire to bring writers and teachers together was the last thing I had in mind. Quite frankly, it was just simply not one of my ideas. I was pretty much functionally unemployable in the school system, after having been involved in a lot of political struggles, and having worked with parents to try to take over schools, and having confronted Principals and all kinds of things. I had just come back from a year in Spain, where Judy [Kohl's wife] and I had gone to rest after all that stuff. And I had written a not-very-good autobiographical Jewish novel about the Bronx which I'll only show now to my closest friends and maybe someday to my children. I hadn't yet been able to start *36 Children*.

So when I came back from Spain, I immediately hooked up with my former students in Harlem. I didn't have any job and I couldn't find one, and New York City schools—I was in such despair over them that if I had gone into a school I would have hit somebody. So I set up a school in my living room with some of the kids whom I had formerly taught. No; I wasn't working with them so much as with older kids, the friends of the kids in *36 Children* and their older brothers and sisters. These were people who had dropped out, or who in one way or another were having trouble with school, and whom I'd

known from before. It was an interesting situation because I didn't have to re-establish myself in the community. I just walked in and filled a need. Essentially it was started because some of the kids called me and said, they want to learn how to read but they ain't goin' to school.

I was working, as I say, in my apartment; but other than that, nothing. And what do you do if you've got nothing else to do in America? You go to graduate school. So I applied to graduate school. I tried to become a clinical psychologist, very briefly. But absolutely not one training institution in clinical psychology would accept me. You know why? Because I'd been in analysis. I'd gone through a successful, full dream analysis that was legitimately terminated, and that was the reason I wasn't considered proper material.

LOPATE: You weren't a virgin.

KOHL: I wasn't a virgin; that's right! And I think they kind of scared me a little bit. And I scared them a great deal, and it was a standoff. I'm glad, I wouldn't have lasted a month anyway, because clinical psychology is just not my mode. But I still had this myth that the Ph.D. would give me another weapon, with which to attack the system. And all I was looking for was another way to get in there again and get my shot at the public schools of New York and do something for the kids.

So I didn't get into clinical psychology, but I went to Columbia's Teachers College instead, where I was both a pet and a problem. I was a real troublemaker, but they liked me in some peculiar way; they thought they needed a troublemaker around. I had been there before to get my M.A., and they were willing to readmit me into a doctoral program on the education of the severely disturbed. One reason I chose that was that Judy was working at the time—and that was pretty much our sole source of financial support—at the Manhattan School for the Severely Disturbed, teaching schizophrenic kids, which she loved and did extraordinarily well. But I didn't stay just in Teachers College, because that's such an intellectually deadening place. I managed to study anthropology in the university, and advanced abnormal psychology up in the New York Psychiatric Institute; I managed to take a couple of math courses and I just *managed*, you know, to fit together my whole insane kind of synthesis that is constantly evolving in my mind.

Meanwhile I was also working with a group of people around a magazine called *What's Happening?*, a kids' magazine written by teenagers, that was run by Elaine Avedon. She happened to be teaching at Cooper Junior High School across the street from P.S. 103 where I had taught. We used to have lunch together. Through Elaine and through Jeremy Larner, who was doing an article at the time for *Dissent* on the public schools, and through my own contacts I was connected with a network of pretty hip, certainly very serious teachers.

And I was also walking around like a madman with the kids' writing. I was carrying it around. I'd saved every scrap of paper. I would grab people in the street and read it to them! In fact that's exactly how I got a contract for *36 Children:* I once grabbed ahold of Phyllis Seidel, who had gone to college with me, and who was now an editor at New American Library. I was reading it to her and to Nelson Aldrich (now editor of *Harpers*) and all of these people who I went to Harvard with. I would just read the stuff compulsively and show it to people. I involved Whitney Ellsworth, from *The New York*

23

Review of Books, and Sally Bingham in the tutoring program I had set up at that time for adults, in teaching simple competency to pass civil service exams.

I had this enormous energy and Judy had the same amount of energy, and between the two of us it was just a thousand little things looking for a focus.

So Nelson Aldrich came over to me one day, and this is specifically how it was. And he said, "Herb, I'd like you to come to this series of meetings that are going on at Columbia. And bring the kids' writing." Nelson and Bob Silvers [editor of *New York Review of Books*] had set it up for me to go in there, I think. They had been watching me in a way that I wasn't aware of being watched: in my work, in my relation to the kids, in everything. So I went to the meeting. And the scientists had already been working away on their programs; and the mathematicians already had the first edition of the New Math...And the writers were still bullshitting, right? [both laugh]

LOPATE: Still talking about a writer's lobby.

KOHL: That's right. They couldn't *focus.* I remember Reed Whittemore was talking about his little shtik and Ben DeMott was carrying on all over the place. John Holt was someone that they all respected and knew and liked, and were trying to get involved, but John wasn't really *there,* he was not interested. So I walked into that first meeting, which was in a room in Columbia, and I felt really good in the sense that I saw a bunch of raggedy, crazy-looking people, all these writers; and after being at Teachers College, Columbia for long enough, you know, it's a welcome sight. It's like you're out of the desert and into a wilderness that is just extraordinary. Muriel Rukeyser was being stately and beautiful. And Anne Sexton was being very *concerned,* and Denise Levertov very serious-looking. William Melvin Kelley behind dark glasses: I must have spent an hour trying to figure out what *he* was thinking from the expression on his face, just taking the whole thing in.

And then they started talking, and I don't remember about what— there must be transcriptions of this somewhere, though I haven't seen any. All I remember is jumping up at one point and telling them that it was all a lot of horseshit. That they didn't know what they were talking about, they didn't know anything about children. And someone challenged me, which I think had been set up. See, I keep on suspecting that this was a setup. So I started reading some of the kids' stuff. At that point people really started listening, and became very interested. I wasn't talking any ideology or anything, I was just bringing forth a lot of ideas. And I remember John Mays, who at that point was an observer from the Office of Science and Technology to the whole Tufts Conferences, got very interested.

I also said that if writers have anything to offer, they should work directly with kids in the classroom and they should work with teachers who are doing something. And listen to the teachers. And that it should be a "collaborative operation." I guess the point that I kept hitting over and over again is that there should be some equity between the writers and the teachers, and the kids. And that you couldn't have the writer as the expert come in and tell us what to do.

Someone said: "Well, what would you do?" I said I could do a confer-

ence; that's one of the things I threw out. I said I would be willing to set up a conference with whatever writers *you* want to invite (because the writers who were there and the writers who were my friends were different people. I had never met most of those writers before.) Anyway, I said I would do it under the following condition: that I would be able to invite a dozen teachers whose work I respected. I had wanted very much to give some legitimacy and some strength to those teachers whom I knew, myself included, who were struggling and very isolated and very much a minority within the schools; and who also believed in the kids in a way that was very different from anything that was being said at that meeting.

I told them there would be another condition: that they would let me write some statement about the kind of thing I was talking about (because I didn't know what the writers were talking about). It would say this is the kind of thing that we're talking about, and if you don't agree, please don't come. In that way we would get an essentially congenial group of people who were accepting an initial statement, an initial challenge.

LOPATE: Were you doing this because your adrenalin was flowing at the moment?

KOHL: Mhm hm, yep.

LOPATE: Or because you actually were willing to back up this position, by taking on the job?

KOHL: Well, let's put it this way: first of all, my adrenalin was flowing; second of all, I've got a big mouth; third of all, I had nothing to lose since I hated where I was anyway. When this challenge came, let me just tell you, I had walked out of Teachers College. I didn't quit or anything; I just stopped studying, stopped going to classes. I had already taken all the courses that were interesting, and they were requiring me to take some Mickey Mouse bullshit: Statistics 1, after I had taken some very serious mathematics in my life, and also *The Education of the Gifted Left-Handed Child With Dyslexic Orientation Toward the South Magnetic Pole.* I had already come up with a proposal for a thesis, which I'll show to you some day, Phillip; and I had passed my comprehensives, and I was hating myself for the horseshit I had been tolerating. I simply walked out. I had nothing to lose; that's why I jumped in. It was that stage of my life.

LOPATE: Under this sign of despair, Teachers & Writers was born.

KOHL: That's right, exactly. I had felt like a real crazy and very isolated and lonely because...I would read the stuff the kids had written, and other than a few people I knew, most teachers didn't believe it was of any value, the instructors at Teachers College didn't believe it, some of the parents questioned it. And here were these *writers,* a large number of whom were extremely interested, and saw in the kids' writing and language what I saw in it. And what a lot of other people didn't. They had genuine interest in the work.

LOPATE: You finally found your audience.

KOHL: Yeah. Muriel was really listening, Denise and all these other people were weighing the language, and that's—that's kind of wonderful.

Then I left. Nelson said Bob Silvers would like to have lunch with me. I

really didn't know very much who Bob Silvers was: I may have known that he was the main force behind *The New York Review of Books,* but that's about all. So I went and had lunch with him. He had gone out and bought my first book, *The Age of Complexity*—to see if I was adequately intelligent for what he had in mind, I imagine. We had a very serious academic discussion, not about very much else than the ideas in the book. Then I got another call, either from Nelson or from Bob himself this time, that he would like to have lunch with me again, and he would like me to meet a friend, Tinka Topping. She was involved in the Hampton Day School on Long Island, he said, and she also had something to do with setting up these conferences, like the one at Columbia. So we got together for lunch. The lunches that we had were always at the Russian Tea Room.

II. The Huntting Conference

KOHL: By this time what you have to realize is that they had a certain amount of money left over in the Tufts fund. It was $35,000, and they had to spend it on a conference. When I first found out that information at lunch, I told them it would really be nice if they could give it to me, and that I could run this school for all these kids for three years on $35,000. They said they'd love to, but they couldn't because of the government. It was totally insane. They agreed to the irony and insanity of this money mandated only for a conference. There was nobody involved, except for the Feds, who didn't see the craziness of it.

LOPATE: I can only say that this craziness has increased more and more each year. You can get money for "communication," but not to do anything.

KOHL: Well they don't want you to do anything. That's what you learn after awhile. If you did anything we'd have some real trouble here.

So Tinka and Bob told me that there was money for this conference, and the Hampton Day School would be the fiscally responsible agent. And that's why it was in East Hampton, Long Island. I should have a conference in East Hampton?

LOPATE: (laughter) I always wondered about that.

KOHL: I had never been to East Hampton. Tinka lives in East Hampton. She handled the mechanics of the conference and she set up the place, and they called it the Huntting Conference, because it was at the Huntting Inn in East Hampton. I would have had it in Harlem, you know? Or in my apartment. But they had to do it that way. They had this $35,000 budget. And they wanted to know if I would be willing to run the meeting, and would I really write this thing I said I was going to write? And, could I write a proposal as to what I would do, and a little bit about who the other teachers I was inviting were? I said yeah. I went ahead and did all of those things. I was intrigued; and also it was very refreshing to talk to adults of some intelligence and sensitivity.

Meanwhile, you got to realize, I was right in the middle of all the kids and *their* activity. And this seemed like a vehicle. I have a little craziness in me, in the sense that I figured: I'm gonna *use* this to *have* that school for the kids, *somehow.* Teachers & Writers was always in my mind the second most

26

important thing, in terms of my conviction. My conviction was, this was gonna be the way to sneak in and get back at those bastards in the school system, and to really organize in a community, and let grow and flower what happens with kids. That was the first consideration. And the bringing in of writers and the cultivating of the writers was always second in my mind... which is why I was willing to do a lot of other things: because there was this other vision behind it. I am not a hustler, and I'm not an empirebuilder and all, but I really do have some passion for the work.

So Teachers & Writers was also born into a dual life because the teachers-and-writers aspect of it was never, for me, very central.

LOPATE: You were from the first interested in diverting funds into a kind of *Other Ways?* [The alternative school Kohl started in California years later.]

KOHL: That's right. I was also very interested in the writers, but the writers whom I was talking about, like Victor Cruz, because I knew that they were already teaching the kids on the streets, and that they had come from those streets. Or if they hadn't, they at least had some real sensitivity to it, and could do it. They were just like the best teachers I knew.

All of these possibilities were jumbling in my mind. So I put together a little booklet called, *An Exploration of Children's Writing*. I used a lot of the work of some of my students, and other people's students, and I wrote it very quickly. The thing just flew off my pen. We took it down to the press, and had it printed in one of those little photo offset shops; Judy drew the cover. And we mailed it out to the list of writers that had been given to me.

Later, Bob Silvers took me aside and told me that he was very impressed with the piece; and eventually, the *New York Review of Books* published it, with a few changes, as a booklet under the new title, *Teaching the Unteachable*.

LOPATE: And which has been anthologized I don't know how many times.

KOHL: Right. So we sent it out, and we got an enormously positive response. We just got a lot of people to come. All the teachers I invited, by the way, were very skeptical and cynical. They just thought, another bunch of bullshit academics. Remember, there were some teachers coming from Youth House, from Cooper Junior High, and a couple from the 600 schools [for "behavior problem" adolescents]. The teachers were much more skeptical about it being of any value. But the writers were intrigued. Most of the bullshit people didn't come—it's interesting. The people who wanted a way to get something out of it for their careers or their own empires, didn't sense that there was anything there for them.

LOPATE: You're lucky.

KOHL: We were lucky. And the environment was bristling, primarily because we had these teachers, all of whom wanted to read the writings of their kids. All of them wanted to make known what they were doing, and to communicate their work, and were also, really, crying for help. So that much was set up, even before we began. Anne Sexton brought a friend of hers, Bob Clawson. Anne had never met Muriel Rukeyser before, so they met there for the first time. And Anne Sexton and Muriel Rukeyser and Denise Levertov

being together there was like a monumental meeting of women poets. Because of the teachers' presence, because of the presence of great women poets, and many other excellent writers, and because of me, the dominance of not only the academics but of the literary-ambitious types was subdued in a proper way.

LOPATE: Like *******

KOHL: That's exactly who I mean. So anyway, we got there, and Anne and I fell in love right away. There was something just so beautiful and moving about her. And I was very lucky: the energy that was there was also because Judy was there. So I was in a social, family context, not merely in a conference context. I felt in Anne something so intense and serious. By the way, at that point I had not read any of her poetry. I didn't know anything about who she was supposed to be; I'd heard the name. The name sounds like what a poet's name should be, so I assumed that she was a famous poet, but I really didn't know. But there was an enormous gentleness in her. It was almost like she was crying out not to be bitter. You could see it on her face: a whole part of her was this bitter thing, and yet under it was this enormous warmth and love and crying out for strength, and I just somehow resonated to that. Both Judy and I. With Muriel, I'd been reading quite a lot of Jung several years before, and I saw in Muriel Rukeyser the archetypal androgyne —The man-woman, the synthesis.

LOPATE: Tiresias.

KOHL: Yeah. And I just about, in some sense, followed her around there. And eventually—I don't know if you know—she's Tonya's godmother. [Tonya is Kohl's first child.] It came out of that. Muriel and I would spend hours together, and it became a twenty-four hour thing. We'd talk about Jung and symbols of transformation and all kinds of stuff, and *she* really knows about that. I had to learn how to listen to her, which was very challenging to me, because her language is so unique and idiosyncratic that you have to kind of move your head.

I had set it up so that the teachers presented their students' materials, talked about their work. And then the writers and the teachers socialized. And since I'm both a teacher and a writer, I became this crazy bridge-person. I was totally caught up in what I was learning from the writers, talking to them and helping my own work, all throughout the evening. And in the day I could keep it going so that the teachers' input was there: I mean I could get the teachers to *talk*, and to understand that there was an audience that was receptive and serious, that it wasn't just another one of them things where they were going to be laughed at or forgotten.

This went on for a week. Bob Clawson, Anne Sexton, Judy and myself would stay up until about two in the morning. Or it would be us and Muriel. Or Anne and Muriel would go off, and Clawson and I would talk. The people that I was closest to there, personally, were Anne and Muriel. Every once in a while Bob Silvers would pop up, and I got to like him and respect him, but we were never that close. Nelson Aldrich was around a lot. And Mirsky. Simkes interested me very much, so I listened to him a lot. And I would kind of sneak a listen to Denise Levertov, but we never hit it off very well, personally. Not negatively, but not positively either. Then Mitch Goodman,

28

who was Denise's husband, recommended that three people be included in the conference, and they were Sam Moon, who was a wonderful creative writing teacher, and Florence Howe, and Paul Lauter. They were teaching writing, and trying to work out a lot of ideas, and since then have done more and more. Also, in effect what had happened, which later on must have caused a little bit of anxiety to people in Washington, was that we must have had three-quarters of the National Committee of Resistance on the board of Teachers & Writers and in that particular meeting.

LOPATE: That was Mitch Goodman, Denise Levertov, Florence Howe, Grace Paley?

KOHL: Grace Paley was there, right! That's another person who was marvelous and whom I spent a lot of time with. Grace was on the National Resist Board too.

LOPATE: Not to interrupt you, but—

KOHL: You just did interrupt me! (laughs) Go ahead.

LOPATE: What did it look like visually? What do you retain as far as what the place was like?

KOHL: All I remember is that I had never been to East Hampton in my life. We were staying in an old white building with grass that looked like it was handcut with a scissors, with flowers lining the thing. Tinka had this ranch nearby which was *beautiful*. The most wonderful half-rustic and half upper-class, posh style. I felt like a kid from the Bronx, tiptoeing in East Hampton.

There was another important person there, let me just mention, and that was Betty Kray. And her husband, who's totally wild, the composer Vladimir Ussachevsky. He runs the electronic music laboratory at Columbia. It was very clear from the way Betty Kray was treated that she was an important part of the more established group. That there was some power there. I later learned that she was the head of the Academy of American Poets; everyone treated her with some reverence and respect. She was nice, but I didn't get a chance to talk to her too much because there were so many people to talk to, and such passion about the kids' works. People came to deal with serious matters rather than to hustle.

In fact, one of the most beautiful things, Phillip, was at the end, in Tinka's farmhouse—I'll never forget, a beautiful house, semi-modern but tastefully done, with this enormous living room. The writers came up to me, I think it was either Mitch or Denise, and said that the writers felt that the teachers had given so much, that they wanted to have a reading in order to share their work with the teachers. And they gave a reading in her living room. Everyone, all of the writers read. I mean it was extraordinary—Anne and Muriel—the reading went on for three hours. Mirsky brilliantly performed a part of his novel, and the whole reading was orchestrated. The writer that impressed me as being the most intelligent, I mean intelligence in a really fine sense, I don't just mean smart, but intelligence on a broader level, was Denise. And somehow I got the feeling that she orchestrated the reading: *that* kind of intelligence, so that the Mirsky didn't crash with the Anne Sexton. There was this enormous balance, and weight.

Oh, and Jonathan Baumbach was there too. Jonathan was very serious,

slightly dour. His role is to be the cynical uncle. But when it came right down to it, this "cynical uncle" was just incredibly strong when convinced. And later he did really supportive things, and pushed the Collaborative.

Believe it or not, there were practically none of the people I've mentioned who we didn't see on a regular basis until we left New York. But Anne—and you can tell it from her diaries—became like my sister. That was even more insanely fulfilled when I got hit by a car on my hip, the same day she broke her hip. The same hip!

LOPATE: Younger or older sister?

KOHL: Older. No, the same age. Twin sisters, almost. She was exactly my age, a few years older perhaps, but she didn't seem "wise" old, you know?

LOPATE: How old were you at this time?

KOHL: That was eleven years ago, so I was twenty-eight.

LOPATE: How was it that someone who was twenty-eight years old was able to take over this conference of people who were generally older, and even be a father-figure to them?

KOHL: I dunno. First of all, I think I grew up fast when I was teaching. And I went to Harvard, right? So I knew how to deal with that tone, and don't get easily intimidated by people like that, and even when I do get intimidated I learned at Harvard how to hide it. The other thing was that I'd seen the kids jiving and bluffing their way through all kinds of situations, and I learned how to do that from them. Along with that, there's another part of me. I'm a mathematician; a systems studier. You know, I really love systems, and organizing, and constructing wholes. So I could see beyond: my mind functions simultaneously, almost always, in three or four different ways, focusing on three or four different subjects. So while all this was happening, I would have these meetings with Mays, and Betty Kray and Bob Silvers, on the business of what to do next. I wasn't bound to let that good experience become just one good shot—again, because I was driven. I still am. The kids were the focus beyond the conference. The Huntting Conference wasn't a culmination for me. It was not a peak experience, even. It was wonderful, you know, but it wouldn't have meant anything unless something good could come out of it. And the last day I said, "We really ought to put something together." After seeing this, the people from Washington, John Mays especially, became convinced. See, I could talk to him: he would throw questions at me about Piaget; well I could throw Piaget back at anybody. So I was able to convince those people that intellectually I could handle the professional educator types, and the psychologists, and the proposal writers, and people who wanted an evaluation, and all that nonsense. At the same time the writers became convinced that it was possible to do something. Even when I wasn't sure. I mean, I just bluffed a lot of that.

So they said, "Go ahead and do something." And I felt that a statement had to come out of the conference. As for the mandate, it was clear to me that no one else was gonna be a leader. I just learned from my grandfather that the way you do things is doing them. You don't just sit around waiting for someone to give you permission or ask people, you know, whether it's feasible. You just do it. And that's how I jumped into Other Ways

and jumped into all kinds of things. So I knew that in some way, I had to be the one to lead it. The writers were too much involved in their writing. The other teachers had too much of a teacher mentality: they were the best of teachers, but they were used to working in a system where there were simple limits and constraints on what they could do. They were used to doing the best conceivable within those constraints, but not going wild, not moving out.

So this is how the Huntting statement came about. Everyone agreed, but now how are we going to phrase this? We had a whole bunch of people sitting down to try to do it. The ideas became clear. Some of the ideas were borrowed from the thing I wrote. Some principles were borrowed from people who were wise in teaching writing. I think Grace really had thought a lot about teaching writing. And Muriel...they all knew how real writing grows. And Silvers had thought about it; I don't know whether Silvers hasn't really written all of History, and is just letting everybody play it out.

There was a question of who would write it. And at that point, it was very simply resolved. There were some people who said, I can't get involved, and some people who made very important decisions *to* get involved. Anne was one of them. But at that point, the writer's writer, the unappreciated writer's writer, was unanimously Grace Paley. Everyone in that room agreed that, as a craftsperson, Grace would be the one. So Grace was given some notes which had been formulated by Mitch and Denise and myself; and then essentially it was written by Grace.*

Manifesto of the Huntting Writers and Teachers Conference

To teachers and writers throughout the country, the English classroom is a disaster area. Why?

The curriculum and textbooks as they now exist do not present life as the children know it. The books are full of bland creatures without personalities who don't know conflict, confusion, pain or love. These flat beings don't speak the language. They do not have the range of emotions which children themselves have. Where is—Hate? Anger? Bad smells? Yet these things are experiences in the lives of children and are some of the things that good writing and teaching are all about. Milky texts and toneless curriculum are worse than boring. They present a vision of life which does not correspond with what is real to the child, and does not help him make sense of his experience. What is worse, they indict the teacher, through his association with these false representations of life, as a fraudulent person.

A number of frustrated teachers have had to throw out the curriculum

* Grace Paley's own account is different. In a recent letter she writes: "I don't remember that I wrote the Huntting Statement. I remember that I had something to do with it. I remember pressing some points though I don't remember exactly what they were—though they probably came from my innocence about proposals and so forth. Also I think you better ask some of the other people who may not have Herb's recollection....I don't mind Herb saying that in an interview but really—Phillip check it out, I'm not being modest—if I had that much to do with it, I'm happy and proud too but why isn't it tight in my head?"

Tinka Topping remembers Mark Mirsky as being the chief writer-scribe-consolidator of the statement.

to get to the students. They have found that by giving the children a chance to speak and write about themselves, the children have become alive in the classroom. Moreover, they have found that before the children could write, there had to be talk between teacher and child: that is, trust. Where does this trust come from? The admission of real feelings, of love, hate, fear, power. The child has to begin to make sense of his own life before he can make sense of the world.

It is from the children's writing that the teachers have been able to discover what it was that was most important for their pupils to learn at that moment in their classes. Prefabricated curriculum was irrelevant. Teachers had few precedents in education for such creative personalized curriculum and to look to their own knowledge of literature to present images of life which were real and coherent. Teachers found that many of the arbitrary limits placed on children's receptivity and performance disappeared; what was supposedly appropriate at a certain grade level became a mockery of the needs of the children. New criteria and necessities became apparent. It was not grammatical structure, number of words, but human content which determined the lesson.

New principles emerged:

1. The grading of written work should be eliminated. A child's writing should be considered as an intimate revelation of his feelings and impressions, one to be respected.

2. Teachers must learn to accept the language of children without imposing arbitrary standards of usage that frustrate the free flow of expression. Early emphasis on "correct" usage can make the act of writing no more than an anxious, crippling exercise for many children.

3. Children should be allowed to invent the language by which they manage their own world. When children are encouraged to make uninhibited and imaginative use of their own verbal experience, their sensibilities will be more open to the power and sweep of language in the stories, myths, legends and poems of the literary tradition.

4. No arbitrary limits should be placed on the range of experience and language used in the classroom. If children or teachers feel that words or references or ideas that are important to them must be censored—or are "out of bounds"—then the classroom itself can become a sterile and irrelevant place.

5. Writing must not be estranged from the other arts. Acting, drawing, and dancing can all be used in telling a story, and should be.

These methods and attitudes can reach back to the earliest years. It seemed therefore natural, in pursuing them, to find out about the living experience of language. At this point the need to talk not only to other teachers, but to writers, became apparent. Writers on the other hand had begun to enter the schools and develop teaching concerns.

In contacts with writers themselves, teachers saw their pupils discover the existence of live people who wrote down words. The children's response was unexpected. It was as if they were saying, "That grown-up says what he wants to say. I can say what I want to say..." The children saw that one could be brave and bold with words. He learned that power resides in language

and that writing is a way of preserving and experimenting with power. And the children wrote.

The writer in the classroom is reminded of the potential in life, of how easily children can forget what they were supposed to feel and discover new possibilities of feeling. The writers have been stimulated by the students' questions and their immediate response to the work. There is feedback. The writer offers his work to the students and is changed himself by that audience.

The necessity of a dialogue between teachers and writers therefore becomes apparent.

There are many ways in which writers and teachers can work together. The Huntting Conference of Writers and Teachers has been a joint exploration of these possibilities. It has become clear that writers and teachers can profitably meet to develop new strategies of curriculum development, that writers can enrich the teachers' work through their participation in classes, that children benefit from extra-curricular help in writing, that teacher training in English teaching is richer and more relevant when writers participate. Because of these discoveries the Huntting Conference has decided to develop a program in which teachers and writers collaborate to revitalize the entire teaching of language and literature throughout the school life of the child.

Therefore we propose to establish a *Teachers and Writers Center* to develop and co-ordinate all the explorations and experiments that have emerged from our initial meetings.

The Center will:

1) Develop a central co-ordinating committee which will attempt to tie together the work of teachers and writers, recruit writers and teachers interested in such work, and disseminate their findings.

2) Establish Saturday classes in writing for short term repair work.

3) Develop an experimental approach to curriculum in English and create materials from which teachers could personalize their teaching and develop individual means of self-evaluation.

4) Enable writers to observe children's language.

5) Involve college students by having them teach to young children what they're studying (e.g. poetry, writing).

6) Develop a living textbook to accompany writers into schools.

7) Develop an action program for the creating of writing and literary centers within the community, outside the school system.

These programs have been developed and are ready for action.

Other ideas, still in the formulative stage, have come out of the meetings. The central coordinating committee would like to develop these into specific proposals:

1) Teacher training programs involving writers.

2) Writers visiting teachers colleges.

3) Writers collaborating with teachers in classrooms.

4) Writers actually teaching a class for an extended period of time and keeping a journal of their classroom experiences. They could be teachers or teacher assistants. They would observe the development of individual chil-

dren and attempt to discover the means of evaluating progress in English as newly defined here.

We are now creating the kind of educational program which demands a new kind of evaluation, which we will develop. It will draw on the methods of biography and journal writing the cultural anthropologists use. We envision teachers and writers as participant-observers in this research.

Now we are impatient.

Our statements of impatience is in terms of the urgency of the situation and the need to honor the short life of the child. Right now the teachers and writers are sitting down together, but if the association is to hold and grow, the proposals made must now be implemented. Large corporations may have the staff and money to pursue these matters over long periods of time, but this conference consists of working teachers and writers. They are concerned with children and the life of society. It would be a sad comment if the capital of this concern were wasted.

III. Funding and Community Work

LOPATE: I've seen several versions of the Huntting statement. And the ending keeps changing. The first version is, I assume, the shorter one; then the second version starts saying, "It would be a pity if this weren't funded." The statement starts moving toward a more direct address to funding agents.

KOHL: That's interesting. I'd forgotten about that. Well the short one was written as a Manifesto. And the longer one was added to by me, with other people agreeing to it, as almost a teaser to get money. Absolutely right. It was done consciously.

Then people said to me, "You go ahead and do it." Now, still, remember, I had no money, there was nothing tangible, there were these promises. John Mays and Fritz Ianni and those people said, "Why don't you write a proposal? Think of—ah, a million, a million-and-a-half dollars. Don't worry about money." So the first proposal was for a million-and-a-half dollars! I took them seriously, I said fuckit, why not a million-and-a-half dollars? I sent in the proposal, and there was nothing. And I wasn't going back to Columbia, I wasn't going back to those classes. By the way, the other thing that I knew, was that I was already doin' a lot of the stuff that was in that proposal.

LOPATE: And so what you had to do was legitimize—

KOHL: What was done, that's right. I waited for a couple of weeks, and I finally went to Ianni, who kept on calling me, and encouraging me, and I said, "It's marvelous of you to encourage me, but where the hell are we going to be and how am I going to live?" All of a sudden Ianni comes up and says, "I am now Director of Horace Mann-Lincoln Institute*, and we're going to have some room. I'll give you an office." And I figured, I'll take it. I'll take it because... the kids from *What's Happening* magazine needed a place to meet, and I needed a place for a classroom.

*A part of Teachers College at Columbia University.

LOPATE: You sent your proposal into the Office of Education?

KOHL: To the Office of Education. John Mays and Ianni essentially were the ones who were seeing it through; they were shepherding it through, except that it got whittled down and down, till finally it was $78,000, if I remember correctly, from the original million!

And there's this other thing in-between that I wanted to tell you about, and this is really part of why I left Teachers & Writers. Ianni said, "Go ahead, do it, you're gonna get money." And then he said, "I'm gonna make you a research associate," and he juggled his budget somehow and he came up with a little bit of money for me to work at Columbia. Then he got to know a little bit more about me. Then he began to realize that I had friends in Harlem. And his job really—behind the scenes was—he was working with his old buddy Mario Fantini, who was at the Ford Foundation. He introduced me to Mario. He did it by taking me down to an old Italian restaurant on Mulberry Street, and they talked about themselves, the two of them, as being the Educational Mafia. And they were telling me these jokes and... I really came away feeling really bad, I felt... something's going on here. I liked Fantini, but I felt, something's going on here. Eventually, what came out was that they weren't really that interested in Teachers & Writers. What they were interested in is what they called the Benjamin Franklin High School Project. All of these strands keep on coming together, until it really gets crazy.

They were interested in the Benjamin Franklin High School Project, setting up a community center in East Harlem, and then *using* East Harlem as a pilot project for Bobby Kennedy's Save the Ghetto program, to get him elected. And there was eventually five million dollars of Ford Foundation money from Fantini behind it, that was given to Columbia University and the community in Harlem, and the prestige of Teachers College was behind it, and they involved this guy Paul Rosenbloom in the math program. So, Ianni had me doing a lot of field work in places where I was already known. And I was a little bit naive those days.

LOPATE: This is described in your book, *Half The House*.

KOHL: Yeah. But what's really interesting in terms of Teachers & Writers, is that we didn't get the grant until eight months after I applied. I spent eight months of anxiety waiting for the grant, hustling around, setting up the program, having people coming in and threatening to beat me up because I didn't have any money to pay them. Ianni would then assure everyone that everyone would be paid; but it would be my responsibility to do it, right? And Columbia was dribbling out little bits of money that they would take out of the grant in the future. But it didn't come in for eight months. During the middle of this whole problem, I began to realize I was being used. My job was to assure people in the community that Ianni didn't have any hidden agendas, that they could plan their own way of using the Ford Foundation money; whereas in fact he had the whole thing planned, and he had the whole agenda, and he already recruited other people. So I ended up a liar. But I wouldn't be a liar, because I actually stood with the parents, and told him to go—you know? That's how I met David Spencer [then the head of the I.S. 201 Community Board]. I was supposed to be the emissary to a bunch of people, in-

cluding Berlin and Dave Spencer and Babette Edwards. As I got in there and I found out this stuff, I went straight to them and told them what I knew. I squealed on Ianni. I went to him and *told* him I'd told them. Then I went with them and I told him in their presence that I'd told them. We managed to stop some of the more pernicious things.

But still the money hadn't come in. And Teachers and Writers was just beginning. In the middle of that was when I broke my hip. I spent time in the hospital. Then I came out of the hospital. Then finally the money came in, and the program was ready to go.

So when Teachers and Writers started, I was recovering from the accident. I was totally fed up with Horace Mann-Lincoln Institute and Ianni and Columbia. The only value was that I was able to convince them to buy me a Gestetner, and it was on that Gestetner machine that the "What's Happening" kids could produce its materials. I also turned the office of Teachers & Writers Collaborative over to the curriculum center for the I.S. 201 complex during the strike. And between the mimeograph and the Gestetner, all the materials that were used in the school by the parents when they were keeping school open despite the teachers, were turned out in the Teachers & Writers Collaborative office. So you see, I was using the Collaborative for the struggle I had been involved in for four or five years already.

In the interim Ishmael Reed came to me, because Betty Kray had sent him to me, and Ishmael checked me out because he wanted to introduce me to a friend of his, a young man he wanted taken care of well. He brought Victor Hernandez Cruz over to my house and introduced me to Victor. Then Victor joined this writing class that I was running and that Felipe Luciano was in, from the Young Lords, and a bunch of others—all the brilliant dropouts from Benjamin Franklin High.

I got Victor teaching for the Collaborative, and working in Queens and all over. I got David Henderson into working with Edythe Gaines, who's now the Superintendent in Hartford, who then was the Principal of Joan of Arc Junior High, and who really welcomed us. So what I was able to do was, in fact, deliver what the writers wanted, in terms of setting up situations, and support some of those teachers and administrators who were good; and really work and support the community, and turn the office over to the kids. All the people who worked at Teachers & Writers, except for Karen Kennerly [then administrative assistant], were either brothers and sisters or people related to my students. David Spencer's daughter Marsha worked there, Leroy Akhmer's sister Dolores worked there, Alvin was there, Robert was there. [The last two were Kohl's ex-pupils, written about in *36 Children*.]

LOPATE: There's something that confuses me a little. When I look through the early publications, I see names like Donald Barthelme and Bill Berkson. These are people who seem to have had very brief careers with the Collaborative.

KOHL: First of all, I really didn't want to be in a position of saying, I'm going to take only this writer or that writer.

LOPATE: Right. How were they chosen?

KOHL: They were chosen through a network of contacts with people in the

organization. Karen Kennerly was a good friend of Barthelme's and Louise Gluck and Bill Berkson. I don't think I've ever met Bill Berkson. Bob Silvers would give a couple of names; Betty Kray every once in a while would send over somebody's name. And if there was money available, and there was a teacher interested, and if I'd read the person's writing and liked it and talked to him over the phone, or they'd come into the office, and if they were interested, I would hustle to try to do something to let them do it. The person I had the hardest time convincing, but who later went in with us, was June Jordan. June and I became very close. She was working for MEND; and Arthur Tobier at the Urban Review had hired her as a reporter to do an article on Benjamin Franklin High School. She wanted two students who dropped out and two students who graduated, to do a portrait of four students at Benjamin Franklin. I happened to know a lot of kids from Franklin, so I introduced her to two dropouts, Victor Cruz, and Paul Luciano. Then the Principal introduced her to two kids who graduated. And she wrote this thing called "You Can't See the River for the Trees," one of the most beautiful things on education. It's a poetic essay just about these four kids. What she finds out of course is that these two dropouts—one is a poet of no mean accomplishment, Victor, right? And the other is this extremely sensitive, socially aware guy, one of the founders of the Young Lords, Paul Luciano. Felipe Luciano is his brother. And *their* ambition was to teach. And save the kids. And the ambition of the two who were graduating was money, greed, and screw the people. And June managed to tie this together.

When I saw what she did with that, I just became convinced that she should work with the Collaborative. We were in a center in East Harlem, and she said, "Get me some students." You know how she got her students? I told Alvin Curry's sister Linda, "Linda, you've been bugging me for awhile to help you do some writing. But you don't want to get in Alvin's shadow. So why don't you come and bring a bunch of friends?" And she did, and some of the kids brought their teacher at the time, who was Terri Bush. That's how that thing got started, with June Jordan and Terri Bush working together; that's how *The Voice Of The Children* developed.

LOPATE: So The Voice of The Children project was originally sponsored by Teachers and Writers?

KOHL: M hm. We supported June, we supported Terri, we nurtured that whole thing. But the nice thing, the reason I could do so much of this, Phillip, is that if you choose well, if you choose someone like June Jordan, she'll take care of her own business.

IV. The Teacher and Writers Seminar

KOHL: Meanwhile, I found myself "administrating." When the money finally came, six months of it was retroactive, to pay off everybody for the first eight months, so we only had six months left on a one-year grant; and they told me that I had to start all over again. Looking for money. I think that's when I began to get ideas about leaving the Collaborative. The I.S. 201 struggle—my role in the 201 struggle, which had really been consuming a lot of my time, was about over. I had done what I was supposed to do, what

the community people had asked me to do. It was getting time for me to leave, because it was time for the community to take control. I had been a technician to their struggle, and now it was theirs to build a new community and new schools. It didn't happen. But it could have. It will. Anyway, so the organization asked me to write this dumb proposal again. I had to give up teaching: I got to the point where there was no time to teach. I had to talk to these people who I would rather throw out the window. When I think about it, I feel again that anger and frustration that I felt then. The only teaching I was doing then, right before I left, was a once-a-week Friday seminar for writers and teachers, which I enjoyed.

LOPATE: Which I understand was very good.

KOHL: It was really good. It was the first time I had ever done something like that. I was thinking on my feet, and I also had brought in writers who were very serious, and they met good teachers.

LOPATE: Do you want to explain the function of that seminar? It's always seemed to me to have been the concrete way of putting into practice the idea of teachers & writers collaborating.

KOHL: The function of the seminar was to take the writers, as many as we could, and the teachers they were working with, and myself—I essentially kind of ran the thing—and learn something out of all the work that was going on between them in the classroom. In terms of the substance of the curriculum, my feeling was that out of this could come a whole way of approaching the business of language with kids. In order to do this we couldn't deal with one-shot things, and we couldn't deal with individual, particular instances, but we had to get down and talk about what happened, what didn't happen, what works and doesn't work; and we also had to talk about how that related to everything else* that goes on in the classroom. And how that could be worked up into a program.

See, very few of the writers were working at that time like *you* work: that is, assuming full responsibility for a particular teaching program over a long period of time. My idea was how to get these new insights to become translated into fundamental change in a classroom with kids. So what I was doing was trying to draw out from the writers what it is that they saw and perceived and felt and could add. From the teachers I was really trying to get some greater commitment, not just to the writer or to Teachers & Writers Collaborative, but to teaching writing themselves, and to *writing* themselves. And actually it went beyond that: it was a commitment to a different view of the kids.

V. The Problem of Evaluation

LOPATE: You mentioned drawing perceptions out of the writers. In the first proposal there's a very important statement, that: Evaluation will be in the anthropological, record-keeping, diaristic form, rather than statistical. What led you to that strategy? Had you anticipated trouble?

KOHL: I told them I wouldn't do it any other way. I gotta tell you something funny about that. This is one of the funniest stories. The people in the

Office of Education wanted a statistics design. And so they sent down one of their specialists, a little projects officer who was assigned to us. I mean he was a little boy, even though he had a Ph.D.; he was a person without human experience and depth, and no perception, who knew nothing of literature and read nothing of it. He came down to talk to us about our evaluation. We met on neutral turf, at the Center for Urban Education. We met in this big conference room. The Committee on Evaluation for Teachers & Writers Collaborative consisted of: Muriel Rukeyser, Bob Silvers, Tinka Topping, myself, and David Henderson. We met with this guy; the guy didn't look at us. He really made a mistake. He said, "This is the kind of evaluation I want." He drew a square on the blackboard. With Cell A, Cell B... He assumed that he was in the presence of a bunch of intellectual idiots. And I knew that was going to happen. I had set the guy up to be wiped out. I do some wicked things sometimes. So he draws these four cells, and he says, "You have to have a control group, and an experiment group. The experiment group consists of, let's call it your S's. And the control group consists of your C's. Now in order to have a statistically significant sampling, you will need this many C's, and this many S's." Immediately Muriel starts talking to him. I don't remember what she starts talking to him about. It could have been Jung. It could have been the Tower of London, or *The Traces of Thomas Hariot*—but she starts talking, and he kind of drops his chalk and starts looking at her. She starts saying, "An evaluation is very interesting, like: How do you evaluate the soul?" In a very quiet way. And she's saying these beautiful things about: "An evaluation means what's of *value*. Now, what do you value? How do you find it?" She talks about value. Then she comes, in her own way, to the value of writing. At which point Bob Silvers comes in with something about the inadequacy of experimental designs... I come in with the fact that we have a very difficult problem with control groups. And he smiled because he thought I was the psychologist; I was the behaviorist of the group, right? I said the problem with the control groups is that nobody teaches writing. So we have nothing to control it against. You know, there was no writing in the schools. We're not talking about penmanship; we're not talking about handwriting; and we're not talking about copying. And the guy gives me a look and he says, "I have to go back to Washington." And he walked out of the room. (Laughter)

LOPATE: What happened to Muriel Rukeyser? I get the impression she didn't do too much teaching for the Collaborative.

KOHL: No, she didn't. She was very busy at Sarah Lawrence. She did a little. You've probably seen her diaries. But she was very much with us in spirit. This reminds me of an amazing story about Muriel. It was during the riots in Harlem, and things were just exploding. Muriel came down and said, "Herb, we have to do something. Teachers & Writers has to do something." I think the thing about Muriel that was so important for the Collaborative was that she believed in it. When she talked about it, even though she was never around, it was an *entity*. She already had made it *something;* she'd given it life in her mind. And for me that gave it life. It was both Silvers' kind of dry, "it's possible to do and this is how we do it," and it was

Muriel's metaphysical, "It *is*!" You know? It's already one of the platonic forms.

Every once in a while she would come by or call, and this time she said: "Herb, I want you to take me up to Harlem. I want to sit on 125th Street." She was going to sit somewhere in the middle of the worst part of the riots, and she was going to open her book and read poetry. And she was going to calm it down. And she was going to do it! You understand, she would do it. It was like that time in her life when she got arrested for protesting the Scottsboro boys' trial. I stopped her. I had just been there, and it was not— one shouldn't. I was on a block where I knew all the kids, and people were going crazy. We just got out five minutes before we'd have been killed.

LOPATE: You weren't going to open a book and start reading poetry?

KOHL: I was runnin'! But who knows, it may have gone all right. Every once in a while I have this recurrent dream of the whole world in riotous flames, and Muriel sitting, reading poetry with it all going around her, and slowly the whole thing recedes. The words come out, the *presence* just comes out, with that conviction, and the flames draw back.

LOPATE: Getting back to the evaluation—

KOHL: John Mays really pulled that out. He listened to me.

I took the position that the only way to enter a new field is to see what you can learn and what you can try again. Evaluation is even totally premature in that context. You can call it evaluation if you want, but it's ridiculous. What we're doing is basic research. What I mean by basic research is simply that it hasn't been done before. We're trying to do it, and if it works in one context, we'll see what value it might be to other people. And *then* we'll sit down and look back at it and decide how much of this can be taught to other people, how much of it is unique and how much of it is lousy. We're honest enough to be able to say that we failed, something nobody ever trusts you to do because they expect you to want to build an empire.

I showed them Oscar Lewis, and I showed them a lot of anthropological material, where an anthropologist goes into an unknown situation, and tries to make sense out of the unknown, while being a participant in it. I had all these rationales, and I could talk easily about it. But there was no fundamental conviction on the part of the Office of Education that Teachers & Writers was of any value. That's why they only gave us $78,000; they essentially felt it was a way of pleasing Ianni till they could get his spirit out of the place. John Mays also told them, in terms of evaluation, to get off our backs. I think they didn't demand evaluation, because they really thought it would be a one-year thing and then it would go away.

LOPATE: And surprisingly enough, that initial strategy of evaluation has been one of the most productive parts of Teachers & Writers, in that it generated the materials, the diaries that led to curriculum units and publications.

KOHL: My idea was simply that if you get writers writing about teaching, you'll learn something new. Out of those diaries I was hoping *I* would learn an enormous amount, because knowing the way writers are, if they have to

40

put something down, they're going to think about it. They're not going to put themselves on the page in a stupid way, unless they really don't care, but those who are committed are going to be passionate about it. The passion of June's work, for instance. And that's what the Newsletter came out of. We would take these things, and take the materials produced by the kids, and compile them. Then distribute it to a wider audience. Also, let people see the identity of the Collaborative through something real, that is, through the Newsletter.

LOPATE: Originally, it was announced as a bi-monthly. That's always seemed excessively ambitious to me.

KOHL: Well, Karen Kennerly and I were doing all of that, with the help of a few other people, and we were excessively ambitious.

LOPATE: Could I say something about that?

KOHL: Sure.

LOPATE: In looking through the documents, it often seems to me that what you tried to do was to carry out the program that had originally been budgeted at a million dollars, for the same $78,000.

KOHL: That's right, that was my goal.

LOPATE: There were six proposals originally, I don't know if you remember them, but one was for sending writers into the schools; one was for developing curriculum materials; one was for Saturday storefront writing classes; one was to distribute free copies of the writers' works to the students; one was for administrating, and so on. And each of these proposals had something like a $150,000 budget. What happened was finally the budget came through for only $78,000, and you were still trying to do all six.

KOHL: Yes. Because I had a vision of the whole work, and I wasn't going to let money determine the work. That was the crazy thing: I wanted it all to be done because it all worked together. I wasn't about to just run a personnel agency for poets and give poets money to go into schools to do a one-shot thing. I wasn't about to just create a new magazine. I wasn't about to run a seminar for a bunch of teachers on an ad hoc basis. I wanted something that would affect everything—with respect to the schools that is—I don't mean the world: everything involving the schools and writing. And so I saw it as one coherent whole. And that's one thing I was conscious and explicit about: that if I do any of this, I'm going to do it all. But I think you can see why I exhausted myself. I mean, I ran myself thin.

LOPATE: I think—not to sound flattering, but—I think it was lucky that we had you as a first director, because you set the terms of the problem broadly enough. So that afterwards it could be either narrowed or broadened out. At least it started out with a broad base.

KOHL: That's interesting. I hadn't thought of that. Also, that has to do with the way I operate and the way I write: I try to set the conditions for my own life as broadly as possible so that I can follow the interesting leads. For instance, I met Karen accidentally, and the whole direction of the Fables Project came from certain interests of hers, that then engaged certain inter-

ests of mine. The other thing was really to develop all this curriculum on a totally different model. Remember, I was taking seriously the notion that we could do *better* than any of the mathematicians and scientists in producing materials that made sense for teachers. The only thing that made sense to me was that you have to have *content:* you have to really *teach* the subject, because teachers tend to be ignorant of what it is they're teaching, beyond the text. The other thing you have to do is be very honest about failure.

LOPATE: How did Karen Kennerly join the organization?

KOHL: Nelson Aldrich introduced her to me. Karen was in publishing before. Karen was also a Kabuki dancer, and spent a lot of time in Japan... she was very intense and serious and very, very lovely; very capable of relating to the range and diversity of people who I insisted come through the Collaborative; and wanting to do something that was interesting; and willing to take a little bit of money. And I needed some help. I just couldn't do it all by myself. Karen knew hundreds and hundreds of writers, and she broadened the scope of the project even further than I had. We had a lot going on.

LOPATE: At the beginning there was: the Saturday classes with June Jordan, the Fables curriculum, the writers going into the classroom, the setting-up of an administration, the Newsletter, support for *What's Happening,* the Florence Howe-Goucher College project, Anne Sexton in Massachusetts, the workshop for teachers...

KOHL: That's a lot of things happening in a short amount of time.

LOPATE: I wanted to ask you about that: it looked like at the beginning there was a much more national base for the organization. How serious was this, or was it just an accident because of the Howe and Sexton contacts? Was there an attempt to establish a national organization, as opposed to a New York-based organization?

KOHL: I didn't. But you've got to realize, the truth is that I didn't have any commitment to the Teachers & Writers Collaborative as an institution. Which is one reason I could do all this. I wasn't trying to build an institution; I was trying to get a vehicle to do a certain kind of work. I was trying to help other people do their work through that vehicle. But I was much more interested in other kinds of struggles in the schools than I was in Teachers & Writers. You see, leaving Teachers & Writers was no very difficult thing for me to do.

LOPATE: Do you want to talk about that?

KOHL: Well—yeah, sure. I... I want to teach and I want to write. I don't want to run an institution. I just thought that I had one responsibility, which was to make sure that the thing would continue. I had no sentimental attachment to it. My passion was really consumed in I.S. 201. And in the writing. My God, having the privilege to be in the same seminar with Victor for a couple of years, seeing that flowering, the enormous discovery of self that was taking place, it was like, every single moment that I had to do administration and proposal-writing was pain. Stolen from something much more important. And, I guess I couldn't face the process again of raising money.

LOPATE: Did you ever fantasize splitting off, and becoming the ideological director, and getting someone else to do the grant proposals?

KOHL: No. No, I wanted to go back and teach. I wanted to get more involved with the school. If I could have, in my mind, envisaged the kind of work that you've done, Phillip—because it never occurred to me that could happen as a vehicle through Teachers & Writers—I would have done that. But that was not something in my imagination. It wasn't around as an idea then. And the other thing was that, even envisaging it, I couldn't have done it, because there was too much dependence on me. The government people wouldn't talk to anybody else; the funding sources wouldn't touch anybody else; Columbia wouldn't allow anybody else to come in and use the facilities. By doing all these things, and creating as you say a broad definition in so many different areas, I had made myself too indispensable, because I was the only connection. A person like June Jordan didn't have the slightest idea of what the Fable unit was all about. In fact, one of the problems I ran into, and I've fortunately been able to solve, but it's taken me ten years to solve it, was that all of these elements in the life of a few organizations I've been involved with exist in my mind alone. Nobody else sees the whole. Everybody else is looking at the parts, *their* parts, and that's overwhelming enough to people anyway. So I've got at the whole, and *I* disappear, and all of a sudden it seems incoherent. I've learned recently to really—

LOPATE: Teach people the gestalt of the whole.

KOHL: To teach what? Most people don't want to *know* the gestalt of the whole. I've learned to work with one or two people who do, and to withdraw some of that energy and some of that vision, and keep it separate from the institution.

LOPATE: It's really an important problem.

KOHL: It's very difficult.

LOPATE: When you finally decided that you were going to withdraw from Teachers & Writers, how did you, in the words of the Vietnamese War, manage an "orderly retreat"?

KOHL: I turned around and did what was done to me when I first got started. I called Bob Silvers and said: "Let's have lunch at, um, the Russian Tea Room." We met there. And I said: "Now it's time for me to tell *you* something. To tell you that we need a new director." And I explained to him, because he was someone who could see the whole and could understand it, and whenever I ran into serious problems I could call him and get some fast intelligent advice. I told him, "Look, I'm not gonna do it." He said, "Well can't you do it if this, or this or this...?" I said, "I'm just simply not going to do it. There are no thises, there are no thats, there are no other ways around it, and I have my plane tickets to California."

Journal of a Living Experiment

by Anne Sexton

June 16th, 1967

Last night Bob* read me his one page summary of what we'd be doing in the classroom. (I wrote the first proposal and he agreed to write the second. The things a writer will do to get out of writing!) It sounded like a bunch of bologna. He read it to me over the phone. I didn't tell him it was bologna but questioned him instead. It sounded intelligent and full of bullshit talk about education, fancy talk and I asked him quietly what his *selfish* goals were? Why was he willing to do this experiment in the classroom rather than teach a regular class? He talked about what the kids would get out of it in a fumbling way. "Just for the kids' sake?" I asked. He then opened up slightly, half afraid to speak of why.

He crawled away from the question as if it were a bad question, wrong to have a selfish reason. Then he tried to talk a little like one of the *saints*. (*Saints* were the teachers at the Huntting Inn Conference, we had agreed last year. We always referred to them as the *saints*. But we never felt we were one of them.) It just now comes to me that one of my reasons for wanting to do this is so I can get to be more a saint and less an egocentric writer. Bob agreed that he could perfectly well teach the class as his proposal described it all by himself. He could. But he added, "To tell the truth I want to get back at them." *Them* is Weston High School where Bob taught for four years and who two years ago decided to turn down Bob's proposal to hire a real poet to teach.

A poet in residence, he called it. He had three poets in mind. I was one of them. They wouldn't vote it. Now Bob wants to make his point. Poets can teach. Not only that, but he can find money and backing from some other source for his idea. He can give them the back hand.

Bob likes the idea of the discipline of the journals we will both keep. He needs discipline in his writing—but not when he teaches. When he teaches he's a pro. I've seen him. When I write I guess I'm a pro. Bob thinks of me that way. I do too. I don't like the idea of a journal. I'm afraid it will show all my weakness. It is not disciplined enough. A poem has more rules, either inner or outer. Is it my conceit as a writer, or is it fear of finding out too much about myself? Or both? I, who reportedly write so truthfully about myself, so openly, am not that open. I have an actual writer's block about a "journal." Thus I jump into it ahead of time, counter-phobic, fearing the worst. Perhaps I need to prove I can do it before Herb and Company give me the money to do it. Once my first psychiatrist said, "Anne, you've got to learn how to fail." That was ten years ago. I've never learned. If this experiment is a failure, I'll

*Bob Clawson, who would be co-teaching with Anne Sexton. In a letter to Herb Kohl, Sexton wrote: "What is different about our plan is that there will be two of us, a teacher and a poet who approach 'English' from different disciplines but with a mutual goal. Our thinking processes are not similar and we identify with certain books in very separate ways. To put it plainly, we often fight, loud and passionately, about books we have both read. This will certainly be a new experience for students who are used to being passive recipients of 'one truth' 'one analysis of a poem' etc."

44

find it hard to blame the Government for only giving us one school term. But perhaps by then I'll be a different person, one quite acquainted with failure.

My selfish goals. First of all, Weston has offered me a job to teach. Now that I'm a Pulitzer they all want me. But I'd rather, for less money, do this. Selfish reasons only. I'm afraid to teach. Bob will be the teacher. I will have no responsibility (no adult responsibility), I will be a noisy kid, a student who talks back. I was always a noisy kid, except in school when I kept quiet and looked out the window. I hated school. I was a drop-out. What do I know how to teach! I only know how to write. I could teach some of the writing I like, all categories, not just poetry. But I'm interested in what the kids like because I want to be more in touch with my real audience. I write for kids. People who grow up, half the time, most of the time, they forget how to feel. Back to the point. I want to drop into school again with a really engaged teacher. I took two courses at Brandeis seven years ago. I got so hopped up! My God how it felt to be taught. I was on fire from the books I'd never known existed: Dostoyevsky, Kafka, Faulkner. No poetry. I found Rilke alone in a bookstore. I mostly learned how to write while alone in a bookstore. This time I'll be alone in Bob's bookstore; alone in the students' bookstore. I'll bring mine too, piggy back.

I also know something about moments in time, the sense of a good, right, clear moment: confusion getting rinsed off. I call these moments *Truth*. But actually they are moments of understanding in people I'm with or in the books, of what is alive. I think I am more sensitive to what's *alive* because so much of my real life is dead. Bob said, by way of me knowing little academically: "It will be good for the kids to see some fool like you fucking around, making silly statements and still being a real writer." I kind of liked that. It was so much better than his proposal. It sounded like he *meant* it. I told him to write it down. I don't know if he dared or if he wanted to bother with the truth.

A psychiatrist friend, a social but close friend, always tells me that I keep talking about the truth, I write the truth but that I live a lie. To clear this up in the beginning, she is right. My husband kills animals in Africa and eats them, and I am, in truth, a vegetarian and pick at meat and threw up behind the dining tent in Africa. What's worse I hate killing of any kind, and protest the war in every way and my husband thinks we ought to "win" the war. I live a lie, she says. In other words I don't leave him. Too chicken. Married at nineteen he is my habit, and when he comes home the house seems real again. We just don't talk about the war. A lie.

I have a tendency to wander, what's more to wander into introspection. I told Bob last night, worrying that my journal would be all "me, me, me" and he said, nowadays it is hard to say *me*. Perhaps the kids will learn their own *me* from the writer. I liked that. I had something to offer. I went on to remind him that he was to be the teacher and I was to be the protesting student. Why hadn't he mentioned this in the proposal? He said "that sounded stupid." I said angrily, "Two months ago at the Villa (local pub) you thought it was pure genius. Why didn't you tell me you changed your mind? I even spoke of it at the meeting last week!" Damn Bob for letting me be a fool!

Maybe I will have to learn this year how to live with being a fool. Bob knows so much; reads so much; is so articulate. I'm verbal but it never makes

much sense. Further, stop worrying about Bob's journal, knowing it will be better written. He writes lots of letters. They are well written, funny and full of life. Wastes his life writing letters, I tell him. He tells me, "Maybe you'll learn how to listen." Being a teacher is listening.

In a journal, one must listen to oneself. The main reason I never kept a journal before was I didn't want anything but a poem "to last." But I'm willing to make the leap, the experiment, not because I'll write a good journal. No, in fact, I'll let it be as sloppy as I am. But I think the experiment, journal and all, will teach me how to teach. "You'll learn how to listen." I hope so. All the while crying "me, me, me." To fail is a little daily death. When I get good at it perhaps I will learn to listen. When there is less *me* in this journal I will have won. The Dostoyevsky, the Kafka, the Faulkner in the kids will have won. I am a selfish person. I need to learn. I am a stubborn person. The class, the life of it, will teach me or destroy me. I'll take a chance on it. I don't want to be a "safe poet" or a "safe person." I don't want to be dead.

<div align="right">June 29, 1967</div>

Today, tonight, twilight, looking out the window at the clouds and the remaining light, I thought, "These are the eternal things, the death things."

The life things, these (clouds) are why I want to die. Clouds moving, hanging on to the sun, hanging on to life like clothes to a line. I want to stay with it and go. Go just that way. Not the ignorance of disease but the knowledge of the sun.

Why death thoughts? Yesterday Bob came over and told me he had found us a *home for our grant,* our experiment, *a school who wants.* He asked for "hoodlums and darlings," seniors. He got a *YES.* He said other good things but my husband and I (in front of Bob) fought about pot. My husband won't talk about his values.* He thinks I will go crazy from it. I'm already crazy. A child's prayer, to live like a cloud. Smoke, pot smoke wouldn't hurt, and to sacrifice something good and to get something good. A class. An honest class.

There is already too much of *me* in this class. They will be people. I am afraid of people. Will I ever learn their names? Will I learn what flows from them? I am deserted in front of them—waiting to be filled with...with... with... with their dances. Let it be their dances. Hope so. The clouds are moving. A fine line of them. Students, unknown to me or to themselves entirely are moving into summer. What will autumn fill? Will it be nothing but winter, the dull set in? The dumb doorman of snow?

Not with Bob. He is as alive as his fish (who he smacks ten times on the head to kill.) It will be an enormous room that I will enter. I'll take a notebook and learn to listen. Nothing pretty or ugly will go by me. I will swallow. One must learn to swallow. I will go solitary and empty. I will eat words...

<div align="right">September 8, 1967</div>

Yesterday the class started. Both Bob and I were nervous. I still am. We

*I've only tried it three times. Bob is growing it.

met four other English teachers before class. Three new ones (nervous) and one old. They seemed receptive to us just as Ben Massa the department head and Julian Demeo, the principal have been. Everyone is nice. The town paper wrote it up. Zip! All but the students who seem uneasy.

To begin with we have too many students, twenty-four. They kept pouring into the room. The class is now shut but it seems too many. Perhaps with ten or fifteen...perhaps with fewer I wouldn't be so confused. The girl-teacher who is taking our class the second semester audited (at our request) our first day. I think her first name is Marilyn, Marilyn Chumney. Afterwards she was very enthusiastic. She said it was a great class and that the kids liked it. I lean on her words, not knowing from the experience. Bob did almost all the talking, standing up to the right of the desk. I sat at the left. He explained that we had no rules, no texts, no grades. He started with attendance and told a knock-knock joke in the middle of it, between students named Knox and Knak. They loved that. He said I was a poet and he a teacher, and we would keep journals and we'd like them to do so if they would. One girl asked me what a journal was, was it a diary. I said yes, only longer and more truthful. I didn't know.

Time for class, no more time to type...

September 10, 1967

I spent a lot of time in Friday's class talking about journals, diaries and trying to convince the kids to keep one with us. I told them I was blocked about keeping mine; told them it was hell and that I hated it; told them the first point about a journal is that it isn't supposed to have a lot of bullshit; told them a journal was a record of thoughts and emotions whereas a diary is a record of events and emotions. I made that definition up. I went on to say that all the journals I have read also had plenty of events. (Certainly this is all event—but the class is a series of events). Bob read from John Holt's journal. I read from Camus' *Notebooks,* then Bob read from the Teachers & Writers Newsletter, a journal. They liked the last the best, said the others sounded phony. From Camus I had read a fictional idea about one woman wanting to die with her best friend, to not die alone. This appealed to me. Bob said it was dopey. Later he said he didn't mean it quite that way but had wanted to start playing Devil's advocate. That's okay with me.

One boy had started his journal but he wouldn't show it to us, or rather have us read it aloud. There was some talk about the students wanting to write their journals anonymously. Bob didn't agree and disputed anonymity, but I did agree. I think I won. I was pretty adamant about it. I personally wish I could write this without a name. I think I'd be better at it. But so far I'm nothing but a bad reporter, but I'm afraid if I don't put down the daily events I'll lose them. One boy wants to tape record us. Neither Bob nor I like the idea (he who won't let them be anonymous, doesn't really want to be "watched" either).

The students interested me when they talked about what was phony, and I told them that what they wrote wouldn't be. One girl said, "But how can I use my own expressions and words and still *write?*" and I told her the whole point was her language and her "words." I think the kids have little chance to see speech in terms of writing, their speech.

47

The class participated quite a bit. We handed out examples of journals (me not knowing it illegal to simply give the books to the kids—that they were supposed to sign for them). Hell, the kids didn't WANT those books but I forced them on them, about six library books, three books of mine, two of Bob's.

After school Bob and I meet and discuss the class. On Thursday he said to me, "Don't be afraid of silences." I was. I said to him about a sentence of poetry I'd seen on a scrap paper in his house, a sentence that went something like this, "The dog licking moths off the french door." I said, "Why do you throw away poems on scrap paper that gets tossed away." He said, "That wasn't a poem; that was just something I *saw*." I told him that was the whole point: something I just saw is what I make many of my poems out of. His journal will be a full intensity thing because his powers of observation are really unclogged. Bob sees more than I but doesn't have the drive to make a poem out of it. In fact I think all I do have is drive.

The class has some wise guys in it, but so far I like them, wise or not. I'm bugged by names. I'm trying to remember the name of the boy who wrote a journal, who started anyhow. He talks up a lot but I feel he is quite shy. In fact, he reminds me of myself, a lot of talk but scared underneath. He showed his journal to a pretty blonde girl and to...Hold everything! I just figured out some names with help of attendance sheet. Paul Russell has kept the journal, and he showed it to Pamela Knack and she said aloud it was "OK," and then handed it to William Foley. Foley is very nice though pegged as a trouble shooter. Why pegged? We saw him after school in a convertible with two good looking blondes. He said he might cut. But he didn't cut on Friday. This surprised me. I wonder when he will cut and if he wants to even if he doesn't. William Mercier, who we'd been warned was a trouble maker, warned even when we said we didn't want any info on the kids, wanted to get them cold, cut on Friday. That shows what he thinks of a no rule class. No rule to come either. It kind of hurts your feelings when they don't show: a little failure, a little insult. We were also told that Torrey Reid was one of the smartest, most creative girls in the school. She hasn't said a word. Further, we assigned a paper on Thursday (what would your favorite English class be, or what do you expect of this one) and five kids didn't hand in anything. One of this five was Torrey. As Bob said, we already have expectations when we shouldn't. Still, maybe Torrey thinks the class is silly. What does she think? No way of knowing if she doesn't talk and write.

I was so excited when we got the papers on Friday. I felt honored to get them. I guess I am sensitive to "writing," even if it is just a rather stupid assignment. The trick on the kids is that this paper turns out to be a beginning of a journal as each paper discussed us and the class as they wished it to be. I don't need to discuss the papers at length, because they won't get lost. We are xeroxing them so we can keep first impressions in mind for future use. My feeling about this journal is that I must make notes, or else I'll lose what happens.

Talked to Herb Friday night, and he said that we could have three hundred dollars for books and one hundred for xeroxing. Great news. He also

said we could read our journals to the class to show them what it is like to try to write one.

I know there is more to write but the ball game is on, and I'm losing track as I'm keeping score. We are going to buy the kids books to keep their journals in. Sometime as soon as possible.

<div align="right">Friday, September 15, 1967</div>

Finally! You see I'm too tired from teaching to write in this; too tired from anxious feelings; too tired from happiness and fear to write, write write.

Yes, on Tuesday I wrote the homework assignment. No it wasn't Tuesday I wrote that *Winesburg, Ohio* thing, or maybe it was. I spent a whole morning on it and it was lousy. I figured I'd show it to the class to show them that a "real writer" can write lousy. I'll show them at more length later. But I struggled at that thing and hated it. Still, the day before the worst happened in class. Hatred. Violence. It called up all of my nerves. I was injected. I was shot full of it, drugged on power and power struggle.

I really watched the student and Bob fight, and I felt I couldn't move. I didn't need to move, because it was between them and not me.

William Mercier and Bob had a fight. I don't want to detail it here, because I know that Bob has done so and because of my own reticence. Yesterday, with my psychiatrist, I figured out that I was "blocked about the journal," couldn't write in it because I didn't want to write about the fight, don't want to keep it alive. But putting it in the journal is a way of keeping things alive. New definition of a *journal: A way of keeping things alive.*

Monday I was so excited I couldn't wait to get to class. The first thing on Monday Bob and Mercier fought it out. Mercier with a study and guidance appointment in his hand, defying Bob who stated, "Sit down. We can take care of guidance." Mercier saying, "I don't want to get in any more trouble." Bob saying, "We have more power than guidance. Sit down." And then Mercier left the room. We called him back and then (not sure of the order, too scared) Bob saying he would have hit a kid for less, or that he had hit a kid for less, telling him to sit on the left, and Mercier finally standing up and saying, "OK hit me, I have two teachers watching."

Both of their voices were loud and angry. They sounded like a father and son beating at each other. I couldn't stop them. I have never seen Bob get that way, and really he was angrier than Mercier. Mercier was insolent, fresh, testing but maybe in the right. After all, he's been in trouble, and his schedule was all messed up. We were so enthusiastic about class that we only wanted to talk with them and not bother with schedules and more bother. Bob says Mercier was using the mixed up schedule to play games, and he won the game. But Bob was very embarrassed that he had threatened to hit the student. He felt he "lost face." I'd say he did, but on Tuesday when he read his journal, he probably saved face. One saves face by using honesty, for one thing. I went out of the room when he read his journal, but I'm sure it was abject. I feel he was honest. It's hard to lie to a journal, or lie too much. Harder still to read it aloud.

Just notes about things before I lose them. Steve Rizzo borrowed *To Bedlam and Part Way Back* after I had read "Johnny Pole" to the class. He plays the guitar and was thinking of how he could make the poem into a song from Simon and Garfunkel. Steve said, "I can't believe you wrote those poems. You seem like us, ordinary." Then both he and Al Leone said, "If you could write, then we could write—anyone can write." Steve felt he couldn't make a song from the poem and started to hand back the book, but I suggested he keep the book and try an adaptation of the poem.

Priscilla Batten read "Bedlam" and "Pretty Ones" and baldly said she liked "Pretty" more. I wonder if she liked any of the poems. I felt that she hadn't read them but wanted to seem as if she had. She brought in some poems read to music, forget their name. I didn't like too much when we played them. Too much emphasis on the music, words too slow.

Everyone has now passed in their first paper. Mercier did on Thursday and asked if I'd like a second paper from him (note he didn't go to Bob, probably still mad at him or is using me to get even—no matter, he goes to one of us), and I said, "Yes please, if you could," and he said, "Monday," and I said okay. Much to the school's horror we are photostating all the papers for the record. As I recall no paper talked only about an "ideal English class"; all talked about "this English class." Ben Massa, department head, keeps asking if we'd like to order some books. So far the kids seemed pleased that there are no official books assigned. We have handed out a Beatles song and on Friday Grace Paley's piece, "The Sad Story About The Six Boys About To Be Drafted In Brooklyn," with a question, "Why did I assign this? Also what is it pertinent to, how does it apply, apropos of what?" Answer, ever since the fight I have told stories of violence (the safari and the elephant kill), wrote on *Winesburg* assignment, on the safari and read war poem (*Johnny Pole*). On *Winesburg* assignment Linda Cimini did a fine piece, warm and full of concrete detail. Mean to ask her to work on weak ending and submit it to the school magazine (name I've forgotten)... It's *Idiom*.

Told Ben Massa that we were only afraid that Torrey Reid would take her walking papers. She is one of the brightest kids in the school, and her papers are polished but lacking great creativity. She seems too much of a snob and yet has helped the kids who sit around her with comments. She volunteers little in class. Is it beneath her? Torrey is an editor of *Idiom*, maybe she could help Linda? Ben showed us a paper Torrey did last year. It was brilliant. Will she bother with us? She didn't follow *Winesburg* assignment, which was okay, but the paper could have used such an idea (The Story of Wing Biddlebaum is the story of hands. The Story of Kayo Sexton is the story of an elephant bracelet.)

This is the most exciting week I've ever known. Class today was beyond the pale. Everyone talked, almost everyone. They were excited by the material, and we were excited by their response. It's been a long week, and I know that I hid from my journal. But I sometimes feel the class is more important than the journal. The students are more important than my

writing. They give a quicker response for one thing. When you write you wait three years, and then they crucify you. When you teach you wait five days, and they give it to you, give it to you, give it to you.

During this week I have been bugged by five students. I mean they constantly talk. Paul Russell combs his hair, sings and talks to Pamela Knack and William Foley and sometimes William Mercier. They seem to form a little club. Sometimes including Maureen O'Reilly in it. They make enough noise so that I have to ask them to quiet down and for God's sake to shut up. Today in class Foley and Mercier were having a little chalk war. Mercier as usual was pretending to sleep. Foley threw some chalk at him to wake him up, and Mercier threw the chalk back and hit Bob instead. Bob was pretty irritated and told them off. Actually, Mercier doesn't sleep in my opinion. He just tries to get attention by putting his head on the desk. I think he's listening like a hawk. Otherwise, why the paper he handed in today? Foley is very nice, kind of a broad smile on his face as he writes, "Hi, there," on the blackboard.

This week we have taken to sitting in a semicircle, or actually a circle, beginning at the desk where I sit and extending from the seat beside me, where Bob sits, right around. Bob is on the right of me, and what I call the wise-apples are on the left of me. I dearly love my wise-apple kids, who bug me and hand in damn good papers, too.

So much has happened, and I know that I haven't written and have resented the feeling of guilt that I should have written. I have so many feelings about the kids that I mix them up with the assignments, and it's still incoherent. I don't know whether to go student by student, day by day or assignment by assignment. If you could see these kids, you know they seem more important than the assignments you give them. So far, as Bob said the other day, "Anne's given all the assignments, and if you don't like them, complain to her." At the beginning of the week we were talking about Grace Paley's "Six Boys Who Were Drafted from Brooklyn." Everyone was trying to figure it out. I was trying to figure it out right along with them, because although I liked it, I didn't understand it. Still, it is a good example of writing and the use of hyperbole, such as they had done on the Sherwood Anderson "The Story of Wing Biddlebaum Is a Story of Hands." I have been bugging the kids about getting their assignments in, and some of them have and some of them haven't. In giving them Grace's thing, which I handed them all copies of, was a way of showing them how the grotesque could be our language, their language. I said at one point, "Is this modern stuff your speech?" Most of them thought it was. Trying to figure out the Man With the Missing Finger bogged everyone down. At one point I said, "Well, Bob (as he was explaining it to them or explicating it) maybe the missing finger passed on is just the Jesus factor." Bob spun around and said, "Jesus factor! There you go again." And after class he suggested we give them some of my poems about Christ. So we gave them to the secretary, Mabel, to make copies for us. Then, after we had gotten the copies, and we'd had a dead class or two—pretty bad, Bob coughing with his cold— we'd both gone in sick, protesting that the other should have taught the class so both of us going together like twins...I thought, assign them what I had written about, so I gave out the assignment which went, "Pretend you

are witnessing the crucifixion and write about it." A couple of them said this was blasphemous, and they couldn't do it, and furthermore what could they say about it? It was all in the Bible. I said, "Be specific," which I'd been hammering at all week, "Be specific." Now we have their papers we know some of them don't know how to be. "Write it as though you were writing in a diary, or as if you were writing a letter to a friend to tell them what happened. Write it like a newspaper report. Report the news. It was an event. Tell people about it. Give details." They seemed pretty upset by this assignment. Linda Cimini protested that it was blasphemous. Maureen O'Reilly shook her head. Paul Russell combed his hair. William Mercier inched in from the door and picked his head up. William Foley sat up and listened. I don't know what Torrey Reid was doing. I don't even know all their names.

That's another thing—their names. Every day I take attendance. I am the class secretary. It is getting more and more embarrassing. I don't know all of them by name. Surely I know two cut-ups, the one brilliant girl from the school who is summering down here, Torrey Reid. Surely I remember all of them. Priscilla Batten comes in flapping her arms like winged Biddlebaum saying, "I can't write. You see I can't write. I can't." And hands in a non-assigned paper and when we read it, it's terrible. It's a prototype of the non-specific. It's about the Negro and the white and she writes as if she were Negro. And she writes from no emotion and no knowledge. She writes a stereotype, and today, when I handed back the paper, she came at me again and said, "You see, you see, I can't write. I can't write." And I feel that I have done her a disservice, and I lie to her and say, "Priscilla, you can write. But you haven't learned how to be specific yet. Once you learn that, you've got the whole rap beaten." And Priscilla looks at me and she's worried. And when she handed in her paper today she said, "I tried. I really tried, but I can't write." And I knew that I'd had a little failure.

Then the assignments have been progressing. The material we deal with changes minute by minute as well as day by day. The kids keep changing it. I had an idea before class yesterday of reading to them T.S. Eliot's "The Journey of the Magi." Bob agreed, so we raced into school to get it photostated or xeroxed, very illegally, twenty-seven papers. The secretary who helped us with the machine—which we broke immediately—said, "Twenty-seven copies? You'll never get away with it. We caught someone last year who wanted that many. You'll be caught." Bob, when he finally had caught on to the machine, worked it well and steadily. We weren't put down by her. We haven't told the school Herb has given us money for xeroxing. That's one of our aces in the hole. We'll use them as long as we can, and then we'll do our own with our own money for it.

At any rate we came into class with "The Journey of the Magi," handed it out, then I looked to my left at my cut-ups and asked them not to bug me and try to quiet down. Looking at William Foley I decided to call on him and asked him to sight-read "The Journey of the Magi." I kind of welcomed him to the desk and suggested he sit on it if he'd like. Sitting on the desk Foley did a fine job. Next, as was my plan, I called on someone else, knowing that sight-reading by students could be a good plan to gain attention. Rizzo was next. He read very well. Next came Mercier who read like a priest

despite the fact the cheerleaders outside were chanting Wayland High School cheers. After that I tried to have some discussion of the poem, and we got into it a little until I said to Bob, "I can't teach with those cheerleaders. You teach." And he got up and showed me I'd been teaching like the three blind mice. He said, "Who are the Magi?" And no one knew. I realized then that I'd been teaching in a fog. That I'd been reading to no one. They read it well, but they didn't know who the Magi were. Finally we had Maureen O'Reilly, Pamela Knack (who are both in the little cut-up group) and even Priscilla Batten singing "We Three Kings of Orient Are." After that, as the cheerleading got louder, "Forget it, kids, let's go out and join them." And the whole class exited to the field. Steve Rizzo stopped on the way to say, "Here is my first paper, and I can't believe that you're really a writer because you're ordinary like us." And that was a good thing. Out on the field Al Leone said he'd seen my husband with his license plate "SAFARI" drive by that morning, and would he come to class and talk about it. And I think John Sammons was there, too, and a couple of the girls. I said he'd be embarrassed to go to class, and they said, "Oh, no. He has a story."

Today class took off by itself. Bob questioned that I still want to talk about the meaning of "The Journey of the Magi." And the kids in the first papers had said the thing they most abhorred was "tearing apart poems." But I was going to explicate the poem, I told them. Bob was going to explicate the poem. They were going to. I began today by asking Pamela Knack to read it aloud. She had suggested Maureen O'Reilly freely in the beginning so I said, "Pam, you can do it." She read, as Bob said later, as though she were bored. Actually she read as if she were embarrassed. I think she has been hiding her shyness behind Paul Russell, or in the middle of Paul Russell singing his songs and talking in class.

So many people talked today. So many students had feelings that I can't separate the feelings and thoughts from the students. It was the most exciting experience of my life. Everyone was in it together, even Bob Ireland. He has never said a word. After class we talked to teachers who'd had some of these kids before and the teachers said, "Bob Ireland! He's never spoken!" So, of course, I remembered him, but unfortunately, not what he said. Barnes talked today, Batten talked today, Beane and Bruce and Cimini. Linda Cimini, she's very caught up in orthodoxy. She's having trouble with "The Journey of the Magi." She's going to have more trouble with my poem which we handed out after class, or at the end of class. Priscilla DeMartini, I don't remember her talking much. I know that Foley talked and maybe Higley and Pamela Knack and Brian Knox. Al Leone was absent. McCauley has never talked. Donna McEwen spoke. Mercier pretended to sleep. Diane Nagle spoke. Maureen O'Reilly spoke at length to explain the "Journey of the Magi." I really liked her explanation the most. It more agreed with mine. As a matter of fact as Bob started to discuss one point, I disagreed with him heartily and said I wanted to pass up my dissent for his opinion. Peter Parrish talked and Steve Rizzo talked a lot. He had Priscilla Batten's rain hat on like a sou'wester turned up, all black and white. Paul Russell talked, he often does. Torrey Reid spoke and she seldom does. Ira Scott spoke and so did Rebecca Senior.

I'm beginning to know them and they me. It is a small miracle in my life.

I note that William Mercier gives his papers to me not to Bob. But as Bob said after class, "As long as he gives it to someone it doesn't matter who." At the beginning of the week they didn't know why I assigned Grace Paley's piece and it was a stupid assignment. I mean why I assigned something that wasn't very important. I offered them a dime if they could guess, and Bob said later and quite pertinently that the dimes became larger than the questions. I piled the dimes up on my desk and no one really knew, and I myself couldn't remember. The dime intervened between them and the piece of Grace's. They became large and the subject became small. Foley and Rizzo seemed to talk about Vietnam with great intelligence and fervor. Maybe they will go.

At the beginning of the week Torrey Reid handed back *Live or Die*. She liked it somewhat, she said, but she added she didn't like facing them all.

We've talked about giving them free subjects for writing, and some of them have handed in some. One of them, most importantly Bob Ireland has handed in three poems, quite touching, too. Their papers today were very exciting. Peter Patch was pretty conservative about the crucifixion. Brian Knox had more to say. He talked about not getting caught and being someone who just watched, a kind of thief who got away with it and watched. Torrey Reid wrote a very bad abstract paper with her usual polish. It's unbelievable that the brightest girl in the school as they repeatedly tell us could have no, as Bob calls it, old mind. She writes with a new mind, all polish. Ira Scott—an interesting letter about the crucifixion—"Dear James, signed Love Cynthia." Becky Senior wrote a fair paper. Linda Cimini wrote a very orthodox loving God paper. "I have become his friend and together we shall see the father," kind of thing. Bill Foley wrote a marvelous paper. Quite original. Priscilla Batten wrote a pretty bad one saying, "I don't know really what to do but I try." I feel that I've done her dirt. Pamela Knack's paper was more readable. I'd asked her to type them, but now she's been a little more explicit in her writing. Paul Russell, our hair-combing singing talking boy, wrote an illegible, ungrammatical miracle. He can write. I remember when he first came up to me I thought, is he retarded, when he talked. I thought, what will become of him? Where will he go? Now I know that he has an old mind and will work it well. Russell Barnes did a marvelous one entitled "Jesus Christ Is a Fable." I wrote on it "Brilliant paper." I was pleased to get it.

Those are all the papers we've gotten. But they are better to me than any prize I've gained. The kids, for me, are all brand new, better than images. Don't mind being stupid. Glad I'm there. When they open, it's better than when I open. It's just more pleasing. Teaching is more fun. It's grimmer when it happens twenty-seven times, but it's better when it happens twenty-seven times...all good, all excited, all with you, and when I give a reading, I feel that I'm faking it, and when I'm in class I'm not faking it. No...not any more.

The story of Torrey Reid is a story of "I'm the smartest; I'm the smartest; I'm the smartest," all the time in her mind.

The story of Priscilla Batten is, "I'm the dumbest; I'm the dumbest;

I'm the dumbest; I'm the dumbest."

This week has been pale in comparison with last Friday's class when we explicated "Journey of the Magi." I'm getting to know their names slowly. This week I've counted them out, saying to each one, "You're Russell Barnes; you're Priscilla Batten; you're Brad Beane." As a matter of fact Brad Beane is a new name that I've just memorized. I know almost twenty of them, but there are seven that I'm not sure of, and those I work on day by day. I say, "Brad Beane sit in front so I can concentrate on your face," and now I've gotten it. The names seem to bug me because I realize how important it is to the kids. The biggest thing in our lives were the Crucifixion papers they handed in. I had said, "Pretend you're at the Crucifixion and tell us about it," and we got some really rare papers. We've had some of these papers, the funniest, the most original, xeroxed for future reference. We're still getting in trouble with that secretary. I told William Foley who sits beside me that his was a brilliant paper, and it was. He acted very embarrassed, smiled a little, and you could tell that no one had ever told him he was brilliant at anything. Paul Russell, after my admonitions, moved his seat to a different side of the class. He's trying to be good. He came in on Monday, Monday being the day we were reading their Crucifixion papers, late, and we'd read his paper already, and he talked the rest of the time to other kids and to William Foley. Finally I had to ask him to be quiet, then I found out he was just asking what had happened in the middle of class. Perhaps it would be a good idea when Paul Russell comes in late to stop everything and ask him what's happening. William Foley said to me the other day, "I was thinking of cutting class. What would you do if I cut class?" I said I really didn't know. He said did we hand in the attendance sheets. I said no we didn't. The following day, this was on Tuesday, Wednesday, he wasn't in class, and he wasn't in class yesterday along with Mercier and Russell. The three of them seem to be skipping class, and Bob and I don't know what to do. I suggested we report them, and Bob said we'd lose their trust. That we should speak to them first. Well, that's all right with me if they ever come back to class. I find it strange when I'd told Foley and Russell that their papers were brilliant, that then they run from it and don't attend class. We held class outdoors on Tuesday and Wednesday. It was such a beautiful day and William Foley suggested it. As we went outside and taught on the hill in the little amphitheatre, it changed all their positions so that I could see them in a new light and it was very good. We had a lot of talk about my poem "For God While Sleeping," and the great hush was still on from the reading of the blasphemous Crucifixion papers. Bob became embarrassed reading them, and the class was strangely silent as though they were aghast at it. There were very few comments. At what we thought was marvelous and original they were merely shocked. Maureen O'Reilly asked if we could read a serious one, a literal one, and so we did. Bob Ireland seems to be speaking up more and more and is drawing out of his shell. The whole class is talking more although not with the same enthusiasm as last Friday on the "Journey of the Magi." They seem to be more hesitant to discuss and explicate my poems. They keep turning to me for meanings that I refuse to give.

Finally, on Wednesday, when they had exhausted their own ideas on it, they asked me what I meant. Diane Nagle looked at me specifically and said, "What did you mean by this?" She had said a person was afraid of dying and therefore saw the cross and felt guilty. This hadn't been my intent in the poem and yet I admitted to her that I was always afraid of dying. When I said that, a frown came across her face and she said, "You shouldn't think about dying," as though she wanted to lecture me like a child. It was rather touching. Al Leone talks a lot in class but doesn't seem to always connect. He says kind of wild things. He came after class yesterday and told us about working in a doughnut shop—how he spends six to eight hours a day working the doughnut shop his father owns. It leaves him very little time for English papers which he admitted he left for last because we had no marks. John Sammon said the same thing. He handed in his Crucifixion paper late, and he handed in a first draft at my request, and I could see that he worked very hard. The thing we're trying to get them to do is to write spot papers and hand them in all crossed out and everything. Trying to teach them to write with facility, quickly and not perfectly. We're not looking for perfect English papers, we're looking for ideas. Steve Rizzo is becoming one of my favorite ones. He participates in class and with great intelligence. He hasn't handed in any spectacular papers, but his participation in class gives you the feeling that he's right there with you all the time. Bob tells me he's a football player. He's kind of a character, but not one of the bad cut-ups. The last two days, the cut-ups have been gone from the class, and it seems to go smoother, but I miss them for they were the ones that handed in the original papers on the Crucifixion, the blasphemous papers. I've found that about seven kids haven't handed in their Crucifixion papers yet, and that I don't want to read any more—although I keep saying, please hand in your paper, and I get after them. Charles McCauley has handed in neither the story of Winged Bittlebaum, the Story of Blank is the Story of Blank or the Crucifixion paper. He's very quiet and turns red when I ask him about it. Yesterday I asked if he'd stay after school, but he walked out with the rest of the class. I have a feeling we'll never get to Charles McCauley. He seems like a failure already—withdrawn and not interested. There is no one else in the class that I feel won't respond. Torrey Reid wasn't there yesterday, and maybe she's taken her walking papers. Who's to say? On Wednesday we sat out on the ground again and Bob read a paper about an American Negro who's moved to China and is wanted by the FBI for taking arms against the white menace—the white men fighting him, and that caused some discussion of Negroes and colored men such as Priscilla Batten had asked for. At this point in the conversation we discussed the rights of colored people, and there were some people who said, "Well if three percent caused the trouble"—and they were certainly against Rap Brown and people like that. Bob thought that perhaps we might read *The Invisible Man* by Ralph Ellison. That afternoon we ordered twenty-seven books of it from Hathaway House. We seem to have exhausted the subject of the Crucifixion, and I don't want to see the rest of the papers. John Sammons handed his in late, and said he felt as though he were copying everyone else since we read some of the better ones on Monday. It kind of put a block on his mind. His paper was uninspired, but I think also it's colored by the fact that I can't stand to

go through that Crucifixion again. It's making me into a religious nut. That shows they're doing it well. It's becoming more and more real. The kids that haven't done it have protested they don't like the assignment, and we've told them they can write on something else. Ira Scott said that wasn't fair —everyone should do the assignment. And Diane Nagle, who did the assignment and very well, said if she hadn't been given it, she wouldn't have written anything. And I think the value of assignments is good— although we like the free writing, too. The assignments make them think and work. I'm having trouble getting the papers in on time, but at the beginning of the class we said there would be no due dates. I try to go up before class and speak to them separately, and say, "Can I have my Crucifixion paper?" Yesterday, we were discussing what kind of assignment they might like, and one of them brought up the colored people; one of them brought up burning draft cards; one of them brought up someone they knew very well that they could talk about. I prefer things they know about to things they don't know about. I don't want papers full of propaganda. I want papers full of concrete facts. They got pretty concrete about the Crucifixion, and not from reading the Bible either. A lot of them were full of Biblical references, naturally, but each one dug in a thought about what it would be like to be crucified, an important event. When we were on the hill talking about it, they said Christ is going to come and knock us dead for doing this, and I said that if Christ comes, get out your notebooks and take a record, get it all down. You're the reporters. That's what a writer is really —a reporter of events and feelings. I haven't quite told them about the feelings. They're creeping in all by themselves. Yesterday after Bob discussed perhaps giving them a subject like a rug or a doormat or a dirty sock to put in a poem—use it anyway they want it—a canoe paddle. There was mixed feelings about whether to do it or not. Some liked it, some didn't. Most of them didn't. They wanted to make up a new thing. Bob had said this had worked in Weston and they resent Weston. So then I said I had an assignment you have to do which is "What do you think of this English Class," knowing that their feelings must have changed by now, and I said you all have to do this—not because you want to but for me, and I think they'll do it for me just as a favor. I said all I want is a paragraph. I just want to know what you're feeling and thinking—how you've changed. It will take a long time to get those papers in, too, and seeing as Russell and O'Reilly and Foley and Mercier were absent I'll have to go over the whole thing—if they ever come back again. Having looked over the Crucifixion papers, I can see that Bill Foley's is really the best—being not blasphemous, although he started out to be—because he came up with an image.I'm not sure when to talk about images and what they can do and what they mean. I'm afraid to frighten the kids. I just write fantastic on their papers when they use them. I think images come from the unconscious and you can't force them. I expose them to poems with images and hope that in this way they will catch on to the value of them. John Sammons is reading John Holt's Journal and liking it a lot. He has a hard time writing, and when he handed in his two drafts you could see that he was struggling with it. Yet he's a nice guy and thinks well. I think we'll be able to reach him and teach him something. I think we can teach them all something—how to write

what you feel and how to observe, be more accurate. That's a technical thing about writing, but it will help them show their emotions better if they can be concrete and not lapse into propaganda. Torrey Reid's paper on the Crucifixion was still propaganda. I think she's good at writing it. Propaganda in itself isn't bad, but it depends on how you do it. You've got to be specific. I think that's going to be my word. They'll be calling me Mrs. Specific soon. I hammer at it so much. I think it's most valuable. As a writer I know it's the most valuable thing I know—be concrete, be specific. Some of them are really catching on—very quickly as a matter of fact.

While all this is going on I've been having terrible anxiety. Bob, on Monday, left me with the class. He was having a coughing fit. He left to get a drink of water and handed me a paper to read and my heart started to pound and hasn't stopped yet. I've even thought that I'll have to stop teaching—the thing I love so much. And I know that if I have to quit I will be in great depression, and it will be a terrible failure, because this makes me happy although anxious. The anxiety doesn't go away day by day, although I know it's desertion of a sort, and Bob was an image of desertion leaving me there. The fact that he often says, "You'll have to teach the class alone. I thought I wouldn't come today," fills me with horror. I lean on him. I'm never sure what to say. Some days I do very well and can take the class over. Other days there's nothing in my head—nothing but a pounding heart and no curriculum. I find teaching without a curriculum is an added strain for me. I know we're giving them my poems, and now we've ordered *The Invisible Man,* maybe I'll feel better when we have that to dig into. We have Hemingway's *The Short Happy Life of Francis Macomber,* and we have a Safari poem I wrote to my husband, but they haven't seemed to come up. By the time we got them mimeographed we were off the subject of safaris and I'm not sure how to get back on it.

Yesterday they started "In the Deep Museum" with Brian Knox reading it very quietly and hurriedly and then Steve Rizzo reading it. Steve came up to me before class and said he still had my book home *To Bedlam And Part Way Back,* and I said "Steve, what are you doing with it?" And he replied, "Trying to make songs out of it." I said, "Would you bring some in?" and he acted a little shy, but maybe he will. That would add a new dimension to the class. Perhaps I'll mention it in front of the class, but I hate to stop this creativity by making it public. He said something about writing in class and the difficulty. I said, "You don't think it's difficult for me? Well, I haven't written a word." He frowned and thumped on the desk and put his head down. I said I mean I've had to write on the journal. I haven't written a poem. But he looked at me with a sadness and a kind of disgust that I wasn't following my art. Last night in the middle of all the anxiety I worked on a poem. I worked on it originally for Steve Rizzo because he'd looked so disappointed—as though a writer should write and it would be easy. I've tried to show them that it's hard to write—to write quickly before their superego comes in and says that's no good. I'm trying to get first drafts out of them to get them fluid and going. It was obvious with William Foley's paper, with Paul Russell's paper that these were first drafts and brilliant. They just kind of let themselves go. Can it be that the naughtiest kids are the ones with the most intelligence, the most creativity? They're creating

a scene in class and they can create a scene on paper as well. Whereas the good conforming kids have a harder time. The conformity has gotten into their blood stream, and even when they try to write they can't get rid of it.

I think the thing that's made the class so sad or quiet or nonresponsive was this in depth concentration on the Crucifixion. Maybe I bombed them too hard too soon with something that difficult. Most of them are Roman Catholic, although Diane Nagle wrote a very good paper about the fashion news at the Crucifixion, and she later confessed that she was a Roman Catholic but she just wanted to see if she could do it. She was the one yesterday that said she would have never written it without an assignment. That's the value of assignments, to get them writing. If I could just think of another original assignment. Bob says I've thought of them all so far and now I'm running dry; nothing comes to me; I'm blank; stopped up. Maybe that's why I wrote a poem today. My creativity in class is going down. It's coming up for the typewriter even though the anxiety prevails. I've had this worry that I'll have to stop class, that I won't be able to go any more, that I can't face it, and yet I love it. It's a paradox and it's all inside my body. The body's rebelling and the brain's rejoicing. Bob said, "You know those kids love you," and I keep trying to hold that and cherish that and keep it in mind when my heart is going pound, pound, pound. If I'm loved, why am I nervous? Because I'm afraid there'll be nothing to say and there will be that dreadful silence. I'm afraid of silences. Bob can pull more out of the hat than I can. He calls me a practice teacher, but I'm not even that. I haven't read enough to be a practice teacher. I'm just a practicing writer. That doesn't seem to affect them too much. They're not too surprised about my writing. I don't think they're impressed, which is all right with me. I don't want to impress them. I want to stimulate them. So today we'll be doing "The Deep Museum" again, and I'm so afraid they'll find out what it's about and hate me for it. It's about Christ waking up on the sepulcher knowing he's alive and didn't die on the cross and then being eaten alive by rats to keep the miracle. I know they'll find this blasphemous. "For God While Sleeping" is about the Crucifixion and isn't blasphemous at all compared to the holy miracle all of these Roman Catholics expect. Maybe I'm afraid of their disapproval and their disgust. I have to remain very anonymous when they read my poems. I made a mistake having the secretary write "Anne Sexton" on the papers. I had meant to hand them out anonymously so that they could really pick them apart. As it is, my name is glaring on the mimeo, and they can't get away from the fact that "she" wrote it. This is not true about all of them. Paul Russell wrote a very blasphemous paper. I would like to quote it:

"Well, I think it was when the few cats with the fuzz on the chin had a wild bash one night, and no one ever knew that that would have been the last bash. Without the fearless leader, Leroy, I guess those crazy authorities who wore half metal thought he was responsible, so he got nailed for it. You see the crazy men who wear half metal is like the army and they are always picking on us kids who like to fool around and hold an occasional party. So they thought the only way we are going to teach these guys to behave is to put one of them up on a pole to rot in the sun in front of everyone. This might stop these bad cats of all their frolics. The next day, I remember, it was real hot, and I still had a little bit of a hangover, but I still had to go and see the man be nailed, and everyone was throwing beer cans at the crazy men dressed in half metal, because they didn't want our good buddy, Leroy, to be put up to rot on two flimsy pieces of wood chips like some kind of a nut in the sun while all the other kiddies were out playing with all their

new Mattel chariots. This was pretty bad, and everybody I guess felt sad. So poor Leroy stood up there like a nut in the sun without his Koolaid.''

You notice that Paul Russell can't speak grammatically, but he had some amazing words for the Last Supper like ''last bash'' and the ''occasional party'' and ''frolics.'' The men in half metal are the soldiers and the best is the ''new Mattel chariots'' that they were playing with. And it's unbelievable when he says, ''like a nut in the hot sun without his Koolaid,'' which makes one think of the vinegar and water they handed to Christ at the last. I notice in this that he doesn't dare call him Christ. He calls him Leroy. It's a really satiric paper. This is from the boy that I worry is retarded. Maybe his grammar is retarded but his ideas are good. Why isn't he coming to class? Did I put him down too much when I gave him hell and said he'd have to move, or asked him what was I going to do with him, move him? And then he offered to move his chair to the other side of the room. Bill Foley starts out to be blasphemous and ends up not blasphemous at all. He says:

> It's now high noon, and I can hear the crowd struggling their way up the mountain. I'm about to witness an execution...a fellow named Jesus H. Christ will soon be nailed to a cross as if he were a piece of paper tacked on the wall for everyone to stare at and gaze over. He's forced to carry this cross up the mountain, which is like tying the noose to be put around your neck. He's accused of many things and sentenced to death. However, it doesn't seem to bother him. He's wearing a crown of thorns which are digging and gouging his skull causing blood to trickle down his cheeks and the back of his neck. He's being cursed at, spit upon, whipped and kicked. He is suffering a great deal of pain but still the crowd looks upon his face as though he were dying for a worthy cause. The crowd is only moments away now. Jesus will within minutes tower over the village like an ornament dangling from the top of a Christmas tree.

You can see in this that Bill Foley has made an image, and a rather remarkable one at that. ''Jesus will within minutes tower over the village like an ornament dangling from the top of a Christmas tree.'' I wonder if I'll ever hang another bulb on a Christmas tree without thinking of Christ dangling from his cross. This is the kind of thing I write ''excellent,'' and yet I haven't taught it yet. I haven't taught the value of an image, but it will come. I want to get them writing first before I get them tangled up with how to make images which come from the unconscious and are not that easy to make. Maybe I'm afraid to teach images, because I don't know how I get them myself. I'll have to work on this—work with myself and perhaps with the class when we come to it. It's the most important part of writing—being concrete, being specific, making an image that's something else, then you see it clearer than ever. I don't know if they can read what I write on their papers. My handwriting is so bad. I complain about Pamela Knack, and I am worse. Ira Scott has always wanted to be anonymous. She wouldn't admit which paper was hers when Bob had forgotten her ''Dear James'' letter about the Crucifixion. Yet, there's something about her manner that says I don't want to be anonymous. Certainly Bob Ireland when he hands us some poems about death and wanting to die we let him be anonymous. And I said when I assigned the paper ''tell us what you think of the English class'' that they could remain anonymous. I want real communication from them—the written kind —the things they don't dare say about class and what they think of it. I want a little feed-back for the record. I think it was Ira Scott who said, ''How can I tell you what I've been thinking of English class? It's all in my journal,'' and then I said, ''Crib from your journal. Take it easy.'' I only asked for a

paragraph, and I feel that those who have more to say will write more, and those who don't have much to say won't write much. Who knows, perhaps even Charles McCauley will write a page saying why he can't write, why he won't put anything down. He's handed in nothing but the first paper. He's kind of a goof-off and never speaks and blushes when you speak to him. I don't like to bring him out and embarrass him, but I've got to get the papers out of him. The job is to write, and sometimes with a little pressure they write better and write more. Diane Nagle said, and Ira Scott said, give us assignments. I wouldn't have written it without the pressure. So I'm applying pressure just for writing, quickly, sloppy papers, misspelled papers, crossed out papers. Anything they've got, we'll treasure it. So I'll keep trying despite the anxiety, keep trying to teach the class that I can't teach alone. I know Herb said that I'm getting less self-centered, and yet my body is still self-centered. It goes pound, pound, pound, though with the kids they think I'm relaxed and easy. Maybe they can have a hint of my nervousness but not very much, not yet. I'm full of them, and I'm full of myself. That's good.

Last night I wrote a poem called "The Papa and Mama Dance." Steve Rizzo had spoken to me yesterday saying, "You mean you don't write? What's wrong with you? You're a writer." And I said, "Well I've been writing in the journal but I hate it. It's hard to write." He made a big face and put his head on the desk. So last night in the middle of a lot of anxiety I started a poem and worked on it for two hours. Today I xeroxed it very illegally and brought it into class and said, "I'm going to blow your minds now. I wrote a poem." "Blow your minds" is one of Bob's terms. I'm rather taken by it. So I wrote the "Papa and Mama Dance" and brought it into school, passed it out to them and said, "Hold everything. I've written a poem just last night, and it's all because of Steve." Beyond that it was because of Bob's description of his kids with his scholar robes from Kenyon at a Tufts procession. Bob's kids had said, his daughter had said, "Daddy has some priests' robes in there...priests' costumes," and his son said, "No, it's scholars' costumes," and that had given me my original idea. Aside from the fact that I had written on a paper in my typewriter these words, "Taking into consideration all your loveliness..." and I'd left it there for three days, four days. Last night I decided to bomb myself out and I wrote this poem. I read it myself to begin with and passed it out to everyone. Then I had William Mercier read it. He didn't read it very well, but he read it pretty well, rather quickly. Part of my job I think is to get them to speak in front of the class. I think English has something to do with speaking and being part of a class as well as writing and responding to class. I think everyone should learn a little bit of how to get up in front of people and read—particularly sight reading which is so difficult. And I feel the class will gain from this....understanding and perhaps they'll listen to each other when they read a poem. Perhaps it won't sound so foreign—and such a garbagy language after all. Then Torrey Reid read it. She read it very intelligently, pronouncing everything correctly without skipping any words. The best was when Maureen O'Reilly read it. She spoke loud for one thing and that was good. She seemed to have more feeling when she read it. As class discussion about the poem went on Priscilla Batten said, "It sounds like somebody's going to a funeral," with reference to the fact they all had black priests' and nuns' costumes on in the poem. Bob Ireland felt that it was about chil-

dren who were friends, playmates. Ira Scott felt that they were playmates, and perhaps that he had already gone to the war and come back. But she kept asking me what was the right answer and I avoided telling them. I wanted to hear how they discussed it. Maureen O'Reilly said it was about a brother and sister. There was a lot of discussion about whether it was a brother and a sister or two playmates or friends, whether he'd gone to the war or hadn't gone to the war. It was pointed out that it was a papa and mama dance and perhaps they had papa and mama in common. There was a lot going on in the discussions. Most people didn't feel it was a brother and sister, but perhaps they were worried about the incest detail because the poem is one of incest. I pointed out at the end instead of telling them what it was really about, "You've been missing the lines 'I tell you the dances we had were really enough...your hands on my breast and all that stuff'." Then they seemed to understand. I'm not sure how many of them know what incest meant, or what kind of incest it could be between brother and sister. I'm not even sure, now that they have read it and talked about it, that it's good, that it's about incest. Maybe I should make it just about two children who are in love, and she doesn't want him to go to war and they had their times dressing up in their black costumes playing nun and priest and making love a little, jumping up and down on the sofa. I told them that I was giving the poem to them today to see if it worked, and if they didn't understand it, it wasn't their fault. It was the poet's job to write to be understood. It isn't the reader's job to always go out after meaning and try to figure it out. Poems shouldn't be hieroglyphics. They should be explicit, easily understandable, moving. Not that you shouldn't read a poem twice. I had them read it four or five times aloud and to themselves as well, and still their guesses were wild. Not that I wanted them to guess what I meant, but I wanted them to guess what the poem said. I kept referring to the text. They tend to lead away from the text and talk about their own things. I guess it was the black that made Priscilla Batten think it sounded like a funeral, or maybe it's my own depressed stance about life that would make her think it was about a funeral. Perhaps all my poems are about a funeral in the end. Paul Russell talked a lot in class, and William Mercier mentioned his grandmother a couple of times although not in context with the poem. Torrey Reid after class handed in another description of "The Story of...is the Story of...." It's far more polished and better although lacking in any direct originality. The boys that I had bugged yesterday about passing in their papers seemed to pass them in. Brad Beane passed in a Crucifixion paper. Paul Bruce handed in a Crucifixion paper. Florence Higley. Charles McCauley passed in his, too. After yesterday I had made him blush when I asked why he hadn't written at all. William Mercier handed in his Crucifixion paper. His grandmother, of course, went to the Crucifixion. Today we got the papers on what people think of our English class. They were very mixed. I think we will photostat them when they all come in. It shows that they are not entirely satisfied with English. Some of them want less poems, hate the poems. Some of them feel the class is too large. Some of them want a definite book. More than any want a definite book but Hathaway House bookshop has told us that *The Invisible Man* is in, twenty-seven copies, so we can start on a book to give them a feeling they're doing something. They have the feeling we're doing nothing because we have no curriculum. We're kind of playing it by ear, and yet that doesn't satisfy them.

They want more work. They want a regular English class. Although we have assigned them more papers than any other English class could expect to get, they seem to want more papers, as if we hadn't been giving real papers. Yet our papers are about real things and the way they feel. I would think they would like it when we read papers aloud in class, but perhaps they don't. Perhaps they're embarrassed. Perhaps we need more literature and less of the class' writing. Some of them worry about their English boards and think this won't help them. I don't know if this will help on English boards. I know it will help them learn to express themselves. Is that what English boards are about? I'm not sure. Teaching them to be original, will it help them to get in to college? Is originality a commodity that's usable? Can you give it a mark? Can you do anything with it? Is it good for their life experience? Yes, but I'm not sure if it will help to get them in college. They've all been brainwashed. They want to get into college. I wonder if this will change—this preoccupation with college, with marks, with due dates. They seem to think this is an easy, greasy course. I wonder if it will prove to be so in the end. I know some of them are giving it their laziest effort. Not all. I thought Charles McCauley was hopeless until today when he passed in two papers. When I spoke to him today he turned red. Many of the students seem to blush. They seem shy—shy in front of each other, unaccustomed to the other's presence. John Sammons and Albert Leone when they stayed after class spoke about wanting a smaller class—ten or twelve kids, and yet we feel that if we have this twenty-seven, it will be more of a typical English class and will prove more about what can be done in English if anything is to be done.

Today Steve Rizzo wore my rainhat, yellow and white plastic. I brought it in just for him to use the way he'd worn Priscilla Batten's a couple of weeks ago. Steve is a really good guy. He doesn't hand in those papers on time, but he speaks intelligently in class and he listens. Steve is our football player, but still he becomes deeply involved in the subjects we discuss. I think Marilyn Chumley's journal, although she isn't always in class, will prove more effective than ours for we are both sitting at the front of the room, both teaching, and it's hard to see what the students are doing, except for the cut-ups who make enough noise you can't help but notice them. When they look out the window you're not quite sure whether they're listening or thinking about something else. Yesterday we read them a part of Herb's letter in which he said he found the interplay between our comments and the childrens' own words fascinating. But he was surprised that Bob and I came on so strong in our commenting on the papers. He felt the children were obviously scared, and we might be a little less distinctive. On the other hand, he added, it is a matter of style. We read this to the kids and they all laughed every time he said children. I wonder if Herb knows we have a class full of seniors, who don't consider themselves children in any way? If we should call them children, it's when we say to Paul Russell, "Are you a freshman or something who needs to be moved?" He gets embarrassed then and acts a little bit better. It's difficult giving such a free class with no set time for assignments to be in, with no set assignments as a matter of fact, with its totally free non-marked class to keep a sense of discipline, and yet, to maintain the enthusiasm that's there. Those with the discipline problems come up with the best papers. It's a humbling thing to find out they don't need to hear every word you say. They can do the

assignment without you.

Last night I was very depressed, I handed out the assignment "What do you think of English class now?" And the papers coming in were diverse and depressing. I called Marilyn Chumley at home just to get encouraged. She was very helpful and understanding. Priscilla Batten thought the class was too big: it should be split in two parts, Bob taking one part, me the other. She wants a review for college boards. Brad Beane found the class dull for two weeks, likes to talk about Negroes, wants us to help him write in class, to give assignments and then walk around helping them. Paul Bruce, who never hands in papers, wants topics everyone likes, then the assignments would be in on time, he says. Linda Cimini says she understands poems better and wants a book, *The Invisible Man,* which we have promised them, asked for assignments and doesn't like the bad kids in class. Priscilla DeMartini thought at first it was a farce but now likes it—likes what we're doing better than Shakespeare. Pamela Knack says that we are not learning enough "English." She wants me to talk about poems more and help them, that's why I'm in class after all. Charles McCauley felt let down. Said we were going nowhere. Wants to read something. Dianne Nagle was scared at first, now she's not so shy to speak but hates to read in front of the class. She found the first few weeks boring, wants a book, *Invisible Man.* Peter Parrish learned to speak without being embarrassed for the first time, likes sharing thoughts with everyone. Paul Russell said it was dull, hated poems, said if you read my journal you'd see there's nothing in it, I don't pay any attention. Bob Richards said it was good, this recent stuff, that he'd loosened up and wasn't as scared. John Sammons liked the free expression. The ideas that were respected. Ira Scott worried about College Boards and the senior thesis. All the kids have to do a senior thesis before they graduate. She wants a book, she thinks the *Invisible Man* is a good idea. Rebecca Senior said we were doing too many poems, that they were dull. Why were poems all camouflaged language that you don't understand in the first place and if you try to, then you never get it right and you're always wrong. She said there were too many immature kids in class and wants more assignments and a long range one. I read them all their papers anonymously today, and they seemed quite impressed. They were still and didn't talk. Paul Russell was silent except for volunteering within the class. Marilyn Chumley later told me that Steve Rizzo was angry with their papers, that he didn't agree. Torrey Reid handed in her paper and said she thought we were doing fabulously well except that our written comments on the papers were too caustic. I think she means Bob because mine are usually not caustic with the exception of Priscilla Batten on whose paper I once wrote, "This is a clear example of a non-specific paper." Maybe I was too hard on her. Then we worked on "In the Deep Museum," read it and worked on it. The first comment came from Priscilla Batten, who said, "It sounds like the Crucifixion." She was right but we didn't tell her; we wanted more class discussion. Al Leone said it put him in some museum, in some place. After class he came up to Bob and was discussing it and said, "Well, it's like the Crucifixion. OK maybe it's about after the Crucifixion." Bob pointed out there were rats. That's when Al said, "Maybe it's like after the Crucifixion." Bob said, "Pursue the idea." In class, Bob Ireland, who now speaks up often and very happily it seems, said it sounds like an in-

ternal dream. Paul Russell said it sounded like the pit and the pendulum, the gory details. We're going to discuss it again tomorrow in class. It's a hard poem, and I don't know if they'll be able to come up with the answer. I wonder if it's all camouflage as Priscilla DeMartini said. Maybe that's what poetry is, camouflage. It's a good word. We told Ben Massa that we'd work for him the rest of the year if he'd pay us as much as Teachers & Writers Collaborative, which is very little. We'd like to be able to continue throughout the year and follow up with this class. We feel we're just getting the hang of it with them and we ought to go all the way. It will mean that I will have to give up going to Europe, which I've been looking forward to, but I'd like to hang on with these kids and see what we can do with them.

...I've been troubled with a constant kind of panic with my heart pounding. It's been lasting for a week at least. I don't know if it's the class or the fact that Bob left class one day coughing and I felt deserted. Soon I'll just think of the class and not myself. When your heart is going bang, bang, bang, you tend to think of yourself. However, today, reading the papers I got more involved in them than I did my own heart and the anxiety stopped. I haven't read *Invisible Man,* but I hold it now in my lap and look forward to it. It starts out simply and specifically. I think the class will like it. I think it will liven things up. It's the first long piece of literature. It's what they wanted...culture and stuff...negroes and stuff. They're tired of God, and maybe I am, although today I assigned everyone to write a prayer because someone was saying a poem is like a song or like a prayer. I said in what way like a prayer? Prayers are in old language. And Steve Rizzo spoke up and said, "Let's write a prayer," and so I assigned it. You don't have to make it more than two lines but write a prayer. William Foley said does it have to be to God? And Priscilla Batten said, "Couldn't it be to the flower God?" And I said yes, it could be to anyone; A prayer to anyone is the assignment for today.

IN THE DEEP MUSEUM

My God, my God, what queer corner am I in?
Didn't I die, blood running down the post,
lungs gagging for air, die there for the sin
of anyone, my sour mouth giving up the ghost?
Surely my body is done? Surely I died?
And yet, I know, I'm here. What place is this?
Cold and queer, I sting with life. I lied.
Yes, I lied. Or else in some damned cowardice
my body would not give me up. I touch
fine cloth with my hands and my cheeks are cold.
If this is hell, then hell could not be much,
neither as special nor as ugly as I was told.

What's that I hear, snuffling and pawing its way
toward me? Its tongue knocks a pebble out of place
as it slides in, a sovereign. How can I pray?
It is panting; it is an odor with a face
like the skin of a donkey. It laps my sores.

It is hurt, I think, as I touch its little head.
It bleeds. I have forgiven murderers and whores
and now I must wait like old Jonah, not dead
nor alive, stroking a clumsy animal. A rat.
His teeth test me; he waits like a good cook,
knowing his own ground. I forgive him that,
as I forgive my Judas the money he took.

Now I hold his soft red sore to my lips
as his brothers crowd in, hairy angels who take
my gift. My ankles are a flute. I lose hips
and wrists. For three days, for love's sake,
I bless this other death. Oh, not in air—
in dirt. Under the rotting veins of its roots,
under the markets, under the sheep bed where
the hill is food, under the slippery fruits
of the vineyard, I go. Unto the bellies and jaws
of rats I commit my prophecy and fear.
Far below The Cross, I correct its flaws.
We have kept the miracle. I will not be here.

FOR GOD WHILE SLEEPING

Sleeping in fever, I am unfit
to know just who you are:
hung up like a pig on exhibit,
the delicate wrists,
the beard drooling blood and vinegar;
hooked to your own weight,
jolting toward death under your nameplate.

Everyone in this crowd needs a bath.
I am dressed in rags.
The mother wears blue. You grind your teeth
and with each new breath
your jaws gape and your diaper sags.
I am not to blame
for all this. I do not know your name.

Skinny man, you are somebody's fault.
You ride on dark poles—
a wooden bird that a trader built
for some fool who felt
that he could make the flight.. Now you roll
in your sleep, seasick
on your own breathing, poor old convict.

 Anne Sexton

October 3rd, 1967

On Monday we were talking about prayer in connection with the crucifixion poem, I think. At any rate I suddenly thought of the idea to assign them all a prayer and write one by tomorrow. So yesterday they handed in their prayers, and we read them. Some of them are rather good. One by Steve Rizzo was so sad that Linda Cimini cried. Priscilla Batten I spoke to ahead of class and apologized for speaking so abruptly to her on my paper and she gave me two ceramic earrings which she'd made. All of a sudden they asked me what I'd been doing that day, and I said I'd dictated to my secretary and gone for a swim. They said a swim, and I said yes, we have a plastic pool in the back yard and I invited them all to come swimming on Thursday. It's heated. About 17 of them have decided to come. Also last night the audio-visual man taped my program Poetry USA to show the class on Thursday. We had an early class today...at 8:30. It was pretty hard to get up for that. Now I understand what the students have to go through. I don't think I'd like to go through school again. I wrote a prayer, too, yesterday, and last night I made it into a poem. The title of the poem is "Turning God Back On."

Brothers of the storm,
Shoes and bottles and stones of the storm
listen to this, this bolt, this long shot...

Oh God, give me the stage directions.
I'm sleepwalking inside your building.
My heart is impossible to carry on my back.
My fingers and limbs will not fit in a suitcase.
Every word I speak is a panic stricken.
The noise I try to make is invisible.
It always wears a mask and a gag.
Prayer on such a day is a dead day.
I'm an end; a phone off the hook.

Brothers of the storm,
Those of the kitchen and the summit,
Those of the bowels,
Those of the powders and the voltages, listen.
We are the ones who are ailing and speaking.
Turn on God. Here? The noise steps forward,
and takes off its skin.

And I read them the completed poem today in class. The first one was just titled "Prayer" and was a much shorter version of this and was on the blackboard. Other classes had noticed it and wondered about it. The teachers have asked about it, too. Bob wrote a short prayer, too, but it wasn't as poetic as mine. The kids said, oh it just sounds like your poetry, your prayer does, and of course that's true about me. I'm always trying to write a poem—making poems out of everything. In Laurence Higley's criticism of the class, he says at the end, "I would also enjoy having Miss Sexton read a poem with a happy ending, without death, incest or related subjects." That strikes me very funny because none of my poems are happy—hardly any of them are. They'll just have to take me as I am—unhappy being.

The class itself was rather quiet today, discussing "In the Deep Museum." Bob kind of forced me to tell them what it meant before I felt that they were ready to hear it. I wanted more discussion on it. Priscilla Batten really got the idea first that it was about the Crucifixion and about God waking up in the sepulcher. Al Leone followed this and agreed. There was some discussion about how it was possible and how horrible it was to be eaten by a rat, what an awful thing to happen. Bob pointed out that Christ was the one who kissed lepers—not the beautiful people but the awful people, and that indeed he might want to be eaten by rats if he hadn't died on the cross. From all the papers it is plain to see that they still don't understand English class. They're a little bit terrified and a little bit liking it. They like the free discussion and not very much homework. They're all looking forward to the book, and they are way ahead of me in reading it. I'm still on the Preface. Some of them are on the 4th and 5th chapter. Steve Rizzo is in the 5th chapter, I think. They're already talking about things I don't know about. I'm late in my assignments. The interplay between the kids is going very well. Our naughty cut-ups were pretty naughty today, whispering and giggling. They don't seem to go for these discussions of what a poem is about, but they do listen when papers are being read in class. The class was totally silent yesterday listening to all the prayers. Some of them were hippie prayers and some of them were honest. The prayer that's on the blackboard went this way. The first version of it was called "A Prayer":

Oh God, give me the stage directions.
Every word I speak is panic-stricken.
The noise I make is invisible.
It wears a mask and a gag.
I'm a phone off the hook.
Pay off my demons!
Here—the noise steps forward and takes off its skin.

Flower God

I pray thee, dad, for all youse done.
I pray thee dad, for beating the rats
I pray thee for the lucious grass which
has really hit my ass. I pray for thou
heavenly acid and thy pot-in.
Dear God I really must admit that I'm really
a bad shit for taking that crap that made
me a mess. P.S. But most of all of it,
It made me feel good and forget all my
troubles. Amen.

Here's one that's unsigned. I think it's Brad Beane, but I'm not sure.

Asleep, my hot rod parked across the street.
If it rolls before I wake, I pray the Lord
to put on the brake.

Last night at cocktail time the doorbell rang and it was Priscilla Batten at the door. I thought she said to my husband, "Is your mother here?" but he later assured me that she had said, "Is your wife here?" I'd given them all directions of how to get to my house for when they come tomorrow for a swimming party—probably a very illegal swimming party. I'm sure that the school wouldn't agree that it was the proper thing to do, to ask kids to come over and swim. Priscilla came with about eight pairs of earrings for me and sat and talked for an hour. I told her that if she could make earrings like this perhaps it wasn't important to write. Maybe it's not important to write at all if you can do something else, if you've got your thing going why do you need another thing going? She said how she'd always had trouble with tests. She told us how she blacked out during tests and couldn't remember them at all and got a D later. They thought perhaps it resulted from a concussion when she was in the sixth or seventh grade. She sounded very nervous and neurotic to me and my husband felt the same thing. I feel she is more nervous than I had thought previously—in more trouble perhaps. After school today she took me to see how she made the earrings, and instead of being hammered out by herself, I found they all came in a little drawer shaped in hearts or spades or whatever shape.

October 10, 1967

Last Thursday the kids watched a tape of me on the school's television. They saw the "performing me," but did not seem too shocked by it. Torrey said to me yesterday that they probably didn't listen to the tape, or they would have been shocked. The room was hot and dense and uncomfortable, full of sweat, and my strange white and black face larger than life on the screen. I think they paid more attention to what I looked like than what I said.

William Foley, Paul Russell and William Mercier were absent much to my disappointment. After the tape we excused the class early so that all who could came to my house for a swim. They were very fascinated with Kayo's skins and heads from Africa and the pictures I had taken of our safari. However, while swimming they seemed more like "children" than they had in class. The quality that was most apparent was one of shyness. The pool was warmer than a bathtub and the boys made brave dives off the diving board and the girls clotted together in the shallow end and talked. I threw in some change and the boys dove for that. However, it wasn't the breakthrough Bob and I had hoped it would be.

The breakthrough came yesterday when we introduced them to graffiti and discussed what we had seen over the weekend in the johns of various public places, on the underside of bridges. We talked about the new originality now being found sometimes in graffiti. Before class I had written on the board, "God might be dead." Then Bob explained graffiti to the class and suggested they put up their own. However he didn't have courage to put one of his own on the board. Everyone was terribly shy. Torrey Reid scored after ten minutes of silence by giggling in the back and whispering "graffito" to her seatmate. I persuaded them to say it aloud and she added to the blackboard "DeGaulle picks his nose." One of the boys added "with a spoon," and the ice was broken. William Foley stood up and became master of the blackboard writing down six or eight things of his own as well as suggestions from others. I was sitting with my back to it so I could not see who wrote what. The whole class was

laughing. Sometimes six stood in line for chalk. When I told Foley that I gave him A plus for courage, it stimulated Russell and Mercier to participate. They have never really participated in a class project as much as this. Priscilla Batten carried the girls' graffiti and was brave, too. Finally the question of obscenity came up, and I asked Bob if he wouldn't please teach. He started drawing analogies between the redeeming quality of our blackboard to the redeeming quality of the incest chapter in *The Invisible Man*. Brian Knox said he thought the chapter was unnecessary and had nothing to do with the book. Bob started to teach as I had asked him. Foley, Mercier and Russell continued to laugh. Although I told them to be quiet I didn't stop them from continuing to add to the board, and Bob later was mad with me, and said I had asked him for help and he had given it to me, and I had worked with the opposition in continuing the graffiti. I had hesitated to stop them because this is the first time they were turned on. They wouldn't listen to talk about *The Invisible Man* because none of them had read it. I had made the dilemma by asking Bob to teach and to discuss obscenity. He had put me in a dilemma previously by asking me what the morally redeeming value was of the board.

I don't think I thought there was one except that it's fun to thumb your nose at the world. However, now that I think about it, this is what the Negro farmer does when he commits incest.

At any rate, the graffiti-making was a happening and like a sculpture that destroys itself had to be erased after school. We both wanted to keep it, but in view of the fact that there were vulgar words on it, we felt we could not inflict it upon other classes. So to speak, we're keeping our incest in the family.

October 19, 1967

Bob has been doing all the teaching lately...teaching *The Invisible Man*. I looked over his book and saw the markings in it and realized that though I haven't quite finished it that I have to read it all over again in light of teaching. It's a totally different thing to teach a book than just to read it.

October 31, 1967

I have been hiding from the journal lately because the class has seemed to go along on its own momentum, mostly taught by Bob, very little of it taught by me. I have now come to a passive position where I let the class happen. The discussion of *The Invisible Man* has put me off my stride because it is beyond me, and I am incapable of discussing it intelligently. I experience the book, but I can't discuss it. This happens to me with many things. I think a poem, when I read it the first time, I experience it, and a book is so much longer I have to read it in light of the fact I need to teach it, and I didn't do that. As a matter of fact, I haven't finished it yet. I find the book rather boring, and I don't think that is helping me. The few things that I have contributed in the past weeks was a suggestion I made to Bob after our graffiti blackboard. I said to him that day what a great short story it would make...The Graffiti Man... all his experiences, the hidden man publicly declares himself in johns and in tunnels...on bridges, the hidden life, a rather Dostoevskian character you could make out of him. Bob was so turned on by the idea that by the next morning he had the first draft of "The Graffiti Man"—about four or five pages of it, and I suggested we read it to the class, and they liked it, too. Then

I assigned them to write graffiti papers of their own. They could make up new graffiti or they could follow our story of "The Graffiti Man" and write up new experiences for him. They always moan when you give them an assignment. They seem disgruntled, but after they've had it for a while, they give you back good papers on it. Torrey Reid did a marvelously original graffiti man, and Steve Rizzo, who handed his in quite late, came in one day in class and said "Oh, I really was turned on. That's a marvelous assignment. I did a good graffiti man. Wait 'til you see it." And he did. He wrote clearly and precisely and with specific details about a man evacuating and then the water splashing up at him as he put it, "his droppings spilled into the bowl." I wasn't there the day Bob read it to the class, but I hear they really liked it too.

Bob Ireland called one day about a week ago. He sounded as if he was in real need of help and said, "I need some sort of help with my poetry. You've got to tell me where I'm going." So I talked to him about the need for poetry to be more specific, to have more objects in it, to be there, wherever it is, and he said, "But I'm nowhere. I live in a gray void." I felt quite sorry for him and wondered how desperate he was as he was calling me. We had a very intimate chat. I asked him if he wouldn't stay after school so that we could talk together in person, and he said that after school he goes to the theatre and works the lights, crawls up high around the ceiling working them, and then he added, a bit unhappily, "And I hate heights. I'm afraid of them, and you know I'm a little fat. I'll probably fall." But the next day he handed in a new poem which was more specific and was better, and that evening when he had talked on the phone he mentioned that he couldn't do a graffiti paper, he didn't understand a graffiti man. I said, "Well, make believe that he's a loner, that he lives in a gray void and this is the only thing that he can do actively to fight the world." And he handed in a good paper with that idea going for him.

This is the month when I will be away quite often. I feel I am deserting the class, and I feel in a way I have already deserted them. That I'm not with it. The novel and then Bob's need to assign them an essay, and I couldn't write an essay if I tried, I feel that I don't know how to teach. I can create little excitement for them from myself. Maybe I'm best at poems or stories and fiction. It comes to the clear precise thought even as in writing in this journal, and I flounder. We have four pages of *Idiom* that are going to be just for our class. *Idiom* is the literary magazine of the school. They seem to want a poem from me, something I'd prefer not to give them. I'd rather show classwork in our four pages. I suggested perhaps they'd like to do a new graffiti blackboard for *Idiom*, and they liked the idea, and a couple of days later we did, and it was all led by Bill Mercier who was in competition with Bob. Each one of them putting up a saying on the board, and the other putting up a saying on the board. The men are really good at this and rise to the competition and the need for courage. Not specifically to be original, but the courage to put your writing up on the wall. The public graffiti man, that is, is the opposite of the graffiti man who writes in private. These are public demonstrations of courage and guts. I am a coward and have little courage. I always write my one graffiti first, and it's really rather timid and pale, but I'm afraid to write in front of people, to have them see my hand shake on the board.

During the interim when I haven't been writing in my journal, we had

back-to-school night when all the parents came to class. It was quite frightening. Bob discussed the graffiti blackboard of all things, and the parents asked if their children were being taught any grammar or spelling, and we said no. If they hadn't learned grammar by now, it was too late to learn it. Russell Barnes' mother came after us to tell us how terrible her son was, how we shouldn't believe him, how we shouldn't trust him, and we became much more sympathetic to Russell's needs and problems at home.

I try to think over the class as a whole, and think what I've accomplished in all. I think they see that as a person I can't fake it in the way that I'm ineffectual because I can't fake it. So much of my public readings are faking it, but telling the truth from my own poems. It's hard for me when I'm cast adrift without the poems to tell the truth—the real kind of truth that one would spend days in finding when writing a poem—to tell that kind of truth daily. I try to be real with them. Bob is very turned on. I don't think Bob is fake at all, although he likes to shock other teachers, disrupt things, make a noise. Marilyn Chumley was quite put off and Ben Massa when the day of the back-to-school night a South African student came to audit our class, or so we thought. Instead, he was being put into our class. Bob wanted to fight this, and said, "We must maintain a united front." The more that Ben Massa pressed us to take the student, the more Bob fought him. I really didn't care and wouldn't have minded bringing him in, but I felt the necessity as Bob wanted to make a united front out of it. Marilyn tried to talk us into it, and I said, "Tell it to Bob, tell it to Bob." She was mad later and said I'd passed the buck, but Bob was so angry about it that I was afraid of his anger. I wouldn't meet him head on. I ducked the issue, until finally we went to the guidance department. When Bob found there was no outside pressure, and he was doing this, he said, for my sake, no outside pressure on the part of the community for us to take this South African boy, an AFS student, he agreed. He felt that if there was pressure on the part of the community, the community ought to pay me. It seemed to me part of the regular school regime that one might get a student in the middle of the year, though this was my fear for Chris—his name is Chris—that he wouldn't understand what the class was all about. On the graffiti we just did lately, I said, "Chris, you've got to add to it, too," and he wrote, "Himmel, this is civilization?" And underneath it someone wrote, "Cannibals are literate." But God knows what he thinks of our class. It's a strange one and not much happens. Bob brings in very interesting different things from *The New Republic* and *The New Yorker* in a way making the class more like social studies than English. Something I think that is very good.

As we were discussing something else, "What are you writing, Willie?" I asked. And he said, "The class sucks," and they laughed. I said, "I heard that," and he said, "No you didn't." And I said, "Yes, I did, you said the class sucks." I wish that I could have kicked him out right then, but I let it go. After class he handed in his paper and said, "Well, you asked for an honest one, so I hope it doesn't hurt your feelings." The paper was mostly negative, but honest which was good. I didn't like the part about the class sucks, but at least the rest of his paper went along with it and wasn't just fresh. In his paper he said he would try for two more weeks. After we had left class, I said to Bob, "The thing we ought to do is call on his parents...get to know them." We

know some of his history, that he ran away from home last year and his parents had tried to have him put in reform school as a wayward child, and his grandmother stuck up for him, and he won his case last month. Perhaps he is very disturbed. Bob says to me, "He's mentally ill, he's emotionally disturbed. We can't let him go." And granted that he is, but I feel he's pulling down the rest of the class with him. We're all sinking into a pit not able to discuss anything or do any work all because of Mercier. It doesn't seem fair to sacrifice all the others for one, so Saturday night I was at Bob's, and another couple and Bob and Sarah and I were discussing what to do about him, and I decided at 11:30 at night to call him up and ask if it was all right to come visit his parents. Of all times, I called up at 11:30 at night, and he seemed quite willing and arranged the time. Of course, that was a little booze bravado I had on Friday night, now, today, just before leaving, I'm quite scared. I don't know what I'll say to his parents. When I talked to him Friday night, I said, "We won't talk anything about you. We won't say anything bad about you, we'd just like to meet them." And he'd been quite agreeable, much to my surprise, so off we go to meet the Merciers. Can they kick us out? They may invite us in. He may have set it up so they're all gone at that time. I said to him at the time, "Perhaps we should call to see if it's all right with your parents." He said, "No, that's all right. Come along 1:30 or 2 on Sunday." So now I'm sitting in my study waiting for Bob to arrive to pick me up. It seems a terrible errand now. I'm even having a drink to fortify myself, but I don't think one drink will do it. I don't know what the school would think if they knew of our plan. I don't know if it's legal for parents to be visited by teachers when they're seniors, but we have to do something. We must strike out and get to know him, before we lose him entirely. It's an effort at least. I don't want to kick him out, I want to win him over, but I think it's impossible. I don't think we can win him over. He's bored by the class unless he's running it. He's really afraid, afraid to get known, and yet he didn't mind us coming to visit his parents. However, he may have set it up so they won't be there or kick us out. Having known him I can't imagine what his parents will be like. However, the back to school night when we met Russell Barnes' mother, we had new understanding into Russell, and I feel we have a chance now for new understanding into Mercier. Maybe his grandmother will be there. I hope so.

The call on the Merciers was pretty nervewracking. First of all they didn't expect us, although Mr. Mercier knew we were coming but didn't communicate it to his wife. They had a lot to say about their son. They seemed almost proud that they had had him in court as a wayward child. Mr. Mercier told of spanking and beating Willie when he was young and that he didn't cry no matter what they did. Bob said, "He'd make a good Marine. If I had to choose a company to go into the field with, I'd choose Willie." I think the point in that is if Willie were on our side, or if we could find a common enemy, he would fight with real courage. He turned in a very shocking paper about what he thought of English class—full of swear words and vituperative statements. However, now that we've met his parents, his mother especially who almost enjoyed telling us that the psychiatrist had given up on Willie, it is easy to be more sympathetic. His mother is a hostess in a restaurant weekend nights. His father's an electrician. There are three other younger children. When they spoke about their son, they acted as puzzled about what he feels as

73

we are. Willie's father didn't like the hour that I called on Friday night, and I felt quite ashamed. I suggested to Bob that we call on all the parents of our students, but he demurred saying it would be an impossible effort.

The effort of not firing Willie out of the class is turning the class into one large group therapy. We're going to try for a while at any rate, but I don't feel too optimistic. Willie's grandmother was not there. She lives in Dorchester, and his parents were surprised that he mentioned her so often.

[Here the diary breaks off.]

To Mrs. Sexton and Mr. Clawson

If you think that the class is a failure you are crazy. As I understand it the class was designed to motivate us to write honestly and to write more. I know that I have ever written more this year in English than I have written before. I can write what ever I want and not have to sling the bull to please the teacher to get a good mark. In your class was the first time I had ever heard anything of Larry's. I was surprised that Larry could write so well. I think that you surprised the class more than you think. Nobody in that class had ever thought that he could write so well. You think you are failures because you think that you are not reaching every body in the class. But you are wrong, you are reaching everybody and I mean everybody and that includes Willy. Willy has taken alot of brow beating in the past and it doesn't seem to bother him. Because he knew that the people yelling at him couldn't care less. But it hurts an awful lot when some one you like and some one who likes you gives you alot of grief. Willy likes you, and thats why he skips, not because the class is boring but because it hurts to come to class and have some one who is your friend put you down. Some of the kids are bored, sure, but not because of you. They claim that the class has nothing to offer. How would they know they never bothered to find out. They never write any thing; they never volunteer for anything, not because they are bored, but because they are lazy. That class offers a great opportunity to sit back and do nothing then give yourself an A at the end of the year. There is nothing wrong with them except for the fact that they are just plain LAZY. If you think you are a failure to communicate with the kids you are wrong again, and if you think that you are a failure because you can not find out what counts to us, you are also wrong. You are the only teachers that I know that can have almost the whole class stay after school for an hour without even asking a single one to stay. The only reason it was only an hour was because you were the ones who had to leave. If you want to know what counts that one hour after school should give you the answer. The kids care about you and they care about other people. If you noticed it was the kids and not you that defended Willy. They care about the class and thats another reason why they stayed and talked. We tried to tell you in maybe a very round about way that we do WANT *YOU* TO *STAY*. If we didn't care and didn't want you to stay there wouldn't have been one person after school. I know because we did it to Mrs. Lee. I had her for Geometry. She was the worst teacher that I have had in high school. She had absolutely no

control of the class plus the fact she couldn't care less about the people in the class. It doesn't take very long for the people in the class to know whether or not the teacher cares or not. We finally gave Mrs. Lee so much grief that she gave up and left. And you want to know something not one person in the class tried to stop her and not one in the class was not happy to see her leave. I know that there is not one person in the class who wants you to leave. Since there is no one who wants you to leave they know that you care and that is the most important thing to do. You think you are a failure because some of the kids are skipping but you are wrong again. They are skipping not because they don't like the class. But because it is the first time that they have been given the opportunity to skip a class and they are taking full advantage of this grand and glorious opportunity. It is simply a new toy to play with. No you're not a failure, because you made the students care.

Russell Barnes

Some Impressions

RECORDED AS A PARTICIPANT-OBSERVER
IN THE SUMMER EXPERIMENTAL PROGRAM
IN DEAF EDUCATION
GALLAUDETT COLLEGE FOR THE DEAF
KENDALL ELEMENTARY SCHOOL (FOR DEAF CHILDREN)
JULY 29 to AUGUST 4, 1967

by David Henderson

One of the black boys there, he must have been 10, wd always embrace me when we met. Sometimes he wd sneak up behind me, and throw his skinny arms around me. At first I thought his effusive expression was attributed to the great warmth that deaf children have. (something like the natural rhythm of blacks). But then I took a head count of all the adult black male teachers at Kendall and found *none*. There was one black female teaching, and that is all. I understand Dr. Beherns has an entirely new staff under him, less than three years old, since the school desegregated. Well he certainly didnt think it important to have black teachers. One aspect of the controversial Moynihan report that no one can argue with is that black children need black adults to look up to. Call it the father figure, Oedipus rex or what. What the Moynihan reports didnt do was broaden the significance of that aspect. The family is one area where the black child could use some males around leading purposeful lives in front of them but also they need to have black adults in places of authority everywhere they go, and especially in such a vitally important place as a school.

It soon came to me that I didn't have to do anything for those kids except show up on their scene and they were charged. Not only the black kids but also the white children were quick to pick up on my beard and attribute me to some hippie echelon. They probably could not communicate "hippie" or distinguish black man from Negro man, to me, but they could with each other. They seemed glad, relieved that some "other" people had come to see them.

The pretty college campus, their brand new school, the latest in machines and equipment, educational films slides and machines, all provide a nice background for the mind, but for the mind to be gotten to I believe human contact and love can do the trick better than a machine. If someone from the hearing world could love them (the deaf), just as they were, without appearing so hung-up on changing them, leading them, aiding them.

I got tired of all the emphasis on what is spoken and written: "The Word". Perhaps, because I deal in words I am more aware of how badly they are used. Of the grand lies perpetrated on the public by people who appear to be talking in our interest, for our edification and happiness.

I tried to think of something to show them that would say that words, spoken and written, are not the acme of expression. I thought of Charlie

Chaplin. Using his body and his mind, he made some of the most profound statements in film, long before the time "Sound" was an entity in films.

I rented three of his silents running about forty minutes in all: Easy Street, Love Pangs and Laffing Gas. The younger kids couldn't quite follow, but the older ones followed every gesture and nuance of expression. I was amazed because I myself could not keep up with everything on that screen even after seeing them three times. But they *moved* along with the film; instead of repeating the funny lines, they repeated the funny movements. /they had never been shown Chaplin before. Gallaudett College with a huge film library has no Chaplin? (They have very little jazz in their record library, as well as some of the corniest music ever produced. They are behind in some very important fields: film and music.) /After the films the kids took over. They waddled like Chaplin, twirled an imaginary cane and performed those exaggerated punches. The room was in a turmoil and frenzy as group after group duplicated a favorite phase of the films. I was in a tizzy because I had wanted to record some of their expressions: but that would be impossible as they are not used to large discussion groups, and the teachers find it very difficult to hold the attention of but a very few. As i asked some of the teachers to help me start a discussion that was organized or to at least interpet what they were saying, the teachers told me that they were not that well versed in the signs, that the kids had signs they didnt know and that often they had to have a deaf child interpet remarks for them. /so finally i had to settle with just watching the kids express amongst themselves. from the fervor in their faces i was sure they had gotten *something* from the films.

I returned to a classroom with a teacher and her bright group of kids. In the few minutes remaining before lunch I had hopes of getting a closer reaction to what they had thought about the Chaplin films. In trying to make some introductary remarks to the kids I was bugged because i could not say it to them myself. I had to say it to the children thru the teacher. Hearing her talk and sign it to the kids at the same time gave me an eerie feeling. In the discussion they were curious about Chaplin himself. Many wanted to know if he was still alive; and where he was living; and how old he was. I got the impression they wanted to know much more than what they asked.

One boy asked the teacher if he might not be able to be a movie star someday. the teacher thought for a while, wagged her head and said "I doubt it, Jeff, I doubt it." I sought right there to interject a comment. If I had been able to be more active in initiating the discussion the deaf children might not have been given an answer like that. (they certainly would not). I asked the teacher to say to the class for me that there were movie stars before they even had sound in movies; and that actors were publically acclaimed for their skills which did not include the spoken word. I mentioned pantomime and the teacher chose that moment to introduce that word to the class. Evidently they had never used it before. Another girl who *spoke* better than the others be cause she had more hearing going for her mentioned that she would also like to be a movie star. The female teacher seemed quite embarrassed about that. She was about to give another doubtful remark when I interrupted her to say that it is possible for a deaf child to be a movie star, or to work in the movies. There are many other jobs in making movies that deaf children could do. There are the "underground" movies which very often use no sound at all,

rather relying on the poetic movements of the actor to convey what's going on just like the oldtime movies. In terms of child psychology I dont know if I was wrong or right in insisting that all is not hopeless for deaf children, but a child dreams and it could be some weakness in me that would have me wont to shatter them. / The female teacher mentioned the yearly play put on by the elementary school. I asked her if they did anything else in dramatics with the kids. She said no. I wondered out loud why they had no mime theatre. They have one in the college but not in the elementary school. / Just as a regular elementary school or high school has a chorus that is looked up to by the whole student body as having the best singers in the school, might not it be applicable in deaf institutions. If in the deaf elementary school there could be a mime troup, organized by selecting the best mime actors, I believe that would serve the mass of the deaf children very well by showing them that there are things they can do amongst themselves that are beautiful and important and that require skill and sensitivity to do. Everyone needs someone or thing to look up to.

I observed a black masters degree candidate work with some black youngsters on a dance called "stepping out". The masters degree candidate was a female with a commanding air about her. She was firm and business like yet I saw her get responses from the children that did not happen with anyone else. She told me most of the kids she was working with were "problem kids" and that the teachers were all too glad to get rid of them.

Some of the kids she had taught the dance step to without the music, the others she had taught with the music. The music consisted of thirty-two bars of syncopated music, along the lines of the current rhythm and blues hits. Then the recording went silent for eight bars and picked up again for the final run. The test was to see if the deaf children could maintain the rhythm during the segment of the recording when there was no music.

Her name was Miss Artisst. She told me that most of the deaf black kids could do the current dances, like the bougaloo and the shing-a-ling, which are done in their neighborhoods.

The recording was highly amplified so that the beat was palpable in the vibrations felt through the floor; also the beat was of a low enough decibel level to enable the child to hear something.

The results of the test were not so important to me. What struck me was that she had ten and twelve deaf children dancing in a line together. Just about the oldest form of dance is the tribal line dance. I wondered if the kids could not be encouraged to chant, as a way of getting them interested in talking.

At the jazz concert, again, the proclivity for dance among the black children was shown. A little girl called Eva, did one of the most sophisticated of the current dance movements and she was no more than five years old. The Jazz Group was a hip group of Black musicians from the D.C. area. Dr. Beherns had told me the group would play dixieland; imagine my surprise when the group played modern progressive jazz. Their taste in numbers was right in line with the need and the desire of the deaf kids to relate to the beat of the music.

Though the music intervals brought fine moments to the children and the teachers as well I thought it a shame that music was not more a part of the

78

curricullum, and that also black teachers and musicians were not in evidence more. The musicians were imported for the event. Miss Artisst was working on her Masters Degree and had not the opportunity (or facilities) to develop anything out of her line dances.

The kids loved so much to express themselves through their bodies. They did it all day long amongst each other. I had a number of running bouts with several of the kids. We would punch and joust and duke it out in a kind of playful sparring session. That's what they liked to do, and I was lucky enough to have the freedom and impartiality to be able to do that with them.

After watching Miss Artisst (no expert in signing) work with these kids and using a minimum of signing achieve an amazing degree of response, I began to get more of a feeling for non-verbal communication; that it is as necessary to develop as the verbal (sound) language.

It wearied me to be introduced to a kid by a teacher and have the teacher make the deaf child say (mouth) his name. It took a lot of wind out of introductions for both me and the deaf child. It was not unusual for a teacher to yell at a child "talk. Talk. Use your voice. I can't *hear* you." I wonder what 'talk, voice, hear' means to a deaf child, if they can *conceive* of these words.

Dr. Mark Gold, a professor of Sociology at Gallaudett, told me that at one time, not too long ago, sign language was considered "low class", that sign always predominated in the poorer institutions; while the more well-to-do middle class deaf institutions emphasised spoken language as the ideal./ He theorized that instead of being concerned with communication among the deaf, these well-to-do institutions were impressed with *traditional* middle-class aspirations. He said that lip-reading was at best a hit and miss operation; that the best one could expect was a 65% comprehension of what was being said; and that being face to face.

I read over a number of compositions written by deaf children, the general topic being "News", in which they were asked to report on the interesting things that happened to them over the weekend. / I will agree with the teachers at-large that there is a paucity of language and word usage among deaf children as explained by their grade levels. I take that for granted where *any* child is to be graded. It happens that it is more of a sure thing among deaf children that they score low grade levels. It can be understood that they would learn the language slower than a hearing child//

What struck me about these particular compositions was their lack of emotional truth. If a deaf child goes out with his family he writes, ". . . and then we got back home. I had a good time." I know it's good manners to say you had a good time, but when it gets carried over into expressions of communication... Even with watching television they will say they had a good time. Good time, bad time, nothing in between.

Mrs Rosenbloom told me that there are few signs for emotions, yet for the hearing world to get in on what the deaf child's feeling it could hardly be through written language.

Again in these compositions we have the problem of corrections. Before the kids learn what a sentence is, they are being corrected. Their tenses are being spruced up, capitals put in, sentences rounded. With no sense for whatever word rhythms the deaf child might have going in *his* head. Luckily the

compositions I saw were, usually: the original, the corrected copy and the paper copied over. Before my eyes I saw language destroyed by the well-meaning teacher who allowed the *book* to come between him and his student.

The problem of corrections is one we face at Teachers & Writers Collaborative in dealing with regular elementary school systems. That is probably what led me to compare the deaf child to what is commonly known as the "culturally deprived" (sic) kid, or meaning the ghetto child. Both have communication handicaps; poor reading ability, writing trouble. Both form a sub-culture. The deaf speak of the deaf world. In T & W we have found that lifting the correction ax from over the child often spurs him on to a fuller expression in writing. Might not the same tactic be used with deaf children.

The kids seem to have been blessed with an added sensitivity because of their deafness. You can see it in their eyes, their facial expressions; the way they come close to you to communicate, touching and gesturing. The way they treat each other, touching, smiling and making faces. I wonder if the material of, say, an academic program gives them sufficient material for a successful life. This summer at Gallaudett very little art was included in the programs. I don't mean arts and crafts, but mature expressions of self. Like what Bud Wirtshafter and Karen Kennerly were doing. Like what Miss Artisst was doing. Bud had the kids pasting themselves into huge collages on the walls, free to scribble whatever they wanted. Karen used oriental mask, films of eastern dances and certain dance movements of animals. She found that the kids were quick to pick up on expression thru the face hands and body. It was a cinch for them. So easy that it appears thought never developed among the administration to work with the deaf children's easiest modes of expression. Which, when developed, might turn them on to the more traditional modes of expression with a *reason*, a tested reason, for wanting to speak and read and spell.

Karen told of being approached by several girls who asked her, "to go out into the world and tell them that deaf people are capable of holding intelligent positions in the business world." I think that no matter how well the deaf child develops his speech and lip reading he still faces quite a battle to be accepted in the hearing world. It would seem to me that this problem cannot be left solely in the laps of the deaf children. That the public should be educated. That the hearing cannot expect the deaf to travel the entire distance to meet our standards. The hearing peoples can come part of the way too. If we showed the deaf more consideration (down the line across the board) it would further encourage them to *want* to become part of the world.

As I would link their educational problem to that of a ghetto child I would also think that the deaf needs a civil rights (human rights) campaign similar to the negro peoples of america.

A pet idea that's been in and out of my mind is to make sign language itself an international language for all peoples, with international symbols. It could become a fad or something, where everyone would think themselves square if they did not know them. This would enable tourists to communicate more easily in foreign lands. And more importantly for us it would let deaf people in on what's going on to a larger degree. It would show that we consider them.

Uses of the Arts in the Education of Children Who Are Deaf

by Karen Kennerly

TO: Dr. Thomas Beherns
FROM: Karen Kennerly, Teachers and Writers Collaborative
RE: Use of the arts in the education of children who are deaf

David Henderson, Bud Wirtshafter, and myself were sent from the Teachers & Writers Collaborative to spend a week observing and teaching classes at the Kendall School at Gallaudet College, Washington D.C. On Friday, August 4, 1967, we met with the faculty and an evaluator of the summer program to discuss what sort of projects in the arts might be beneficial in the education of children who are deaf. Here, I will attempt to reconstruct the positions held by the evaluator, and by us. The tentative proposals we suggest arose from that discussion, and have been amplified in subsequent conversations with Richard Lewis and Herbert Kohl.

The evaluator appeared to believe that in the education of the deaf, top priority must be given to acquiring verbal skills. The only way to achieve this is through the direct teaching of reading, phonics, speech, etc. Classes not devoted to the teaching of these skills are using academic time that the deaf child can hardly spare. One senses in this attitude a fear that if the child does not begin to master oral language at an early age, he may never master it at all. Therefore communicating with the deaf child as a person is less important than training him for the *type* of communication that prepares him for the future. It could be argued that the either/or implicit in the above does not have to exist. But we believe the struggle involved for the deaf child learning language skills is so great that the chance of simultaneously developing any motivating desire to use the tools he's learning is sadly minimized. As people involved in the world of art, we are particularly concerned with modes of communication not necessarily of an oral type, and how the various non-oral and oral mediums can transfer to, and fulfill one another. We also know—from our own individual searches for the mode of expression most satisfying to each of us—how important internal motivation is for performance; that motivation and a teacher's approval are not one and the same. The fundamental disagreement between us and the evaluator is that we believe communication and verbal language are not equivalents; that the child should be given the concept of communication as something not inextricably tied up with any single medium; that language be presented as one of various ways we speak to one another; that the hearing world also will turn to non-oral expression for some of its most meaningful discourse.

These premises can be born out only if the other mediums are taught with the same high seriousness that language is: art—painting, sculpture, graphics—etc. should come in conjunction with art history, just as reading is with writing; drama and mime as a disciplined art that brings about the merger of several mediums; music, with special music written for the deaf in the

81

low decibel range they are able to receive and electronic instruments created to let the children hear what they play; dance, emphasizing the symbolism of gesture inherent in dance; film making, where the concepts of sequence and progression are made more immediate, and where all the activities of the school can be brought together in a logical resolution.

We feel such programs would be particularly successful with children who are deaf because of the extraordinary imagination and inventiveness which we found them more willing to communicate than their hearing counterparts. All children have the need to come to terms with experience, and the deaf child, in lieu of an oral tradition of question and explanation, turns through gesture to imitation, representation, assimilation. Here he must be continually inventive, for he has inherited little of a conventional system (even much of signing has to be recreated with every generation). I found, for example, that when I showed a film of Japanese dance, the children began to dance with it—imitating for a while, going off into improvisation, returning to watch and imitate more. Bud Wirtschafter set up an overhead projector for fluid painting during a jazz concert, and almost immediately the children adopted the beat of the music for the rhythmic color patterns they were creating. In his work with "collage happenings" we observed not only a ready imagination that needed no prompting, but an attention to visual and mechanical detail that gave them a staying power beyond their years.

We feel these children are capable of participating more actively in the making of their school curriculum, which should be geared more to who they are rather than paralleling a standard school structure. To begin with, the physical environment could be more of their creation. Since the school is a particularly important place to deaf children (in most cases the only place they can communicate naturally), they should have possession of their classroom the same way a child has of his own room at home—the walls painted the colors they want, the pictures that are hung be of their choice. The rooms should team with fantastic clutter. This self-styling of environment was argued against by the evaluator on the grounds that the variety of social background from which the children come would permit no agreement. But in a democratic society, one wants to create an atmosphere in which all children can share, and we found the children at the Kendall school particularly willing to do so. Witness the total integration among the student body. (We did notice, on the other hand, only one black teacher in a school where almost 50 per cent of the children are black.)

The tempo and pattern with which children who are deaf absorb knowledge was profoundly interesting to us. The process appears to be revelatory rather than meditative; that is, they accept and understand new material in short, but lucid spurts, in between which they will involve themselves with their own preoccupations. When I was teaching them the steps of a Noh dance, they would learn only two or three at a time, and improvise thereafter. My experience with hearing children showed that they were more interested in learning a complete dance first, and less urgent about making up their own. This leads us to wonder if the pattern of class scheduling might not be reconsidered. Hours of unrelieved language drill can go against the grain of a child's learning rhythm to the point of lowering his potential learning ability.

The very equipment used for instruction—cameras, projectors, overhead projectors, radiographs—could be put in the hands of the children at certain times during the day. Let them play with it: draw pictures where words are usually written; make sounds on the radiograph that please their eye or sense of rhythm. Let them film these experiments as well as their classroom work. We feel it is important that the equipment they are in such close contact with have connotations other than that of struggle. Also, control over these machines in an enjoyable way may transfer to a desire to learn language through them.

If the children produced their own books on a hand printing press, the concept of a book—of the relationship between many sentences—would be more meaningful. The text could be of favorite stories, interspersed with their own writing. The finished product is therefore a real book no longer inaccessible to them, for it bears the stamp of their choice and creation. From a professional standpoint, such work relates to the whole field of printing, where deaf adults have made such inroads.

The forms of drama most relevant to the education of the deaf child are probably mime and puppetry. We feel that a professional mime actor working at the school could accomplish a great deal. Showing the children how their natural expressiveness can be channeled into something more subtle and precise would provide them with a form of communication complete in itself, as well as a way to get into language. Puppetry works with all children, but we think it would work particularly well with these children, where making an object they could then will to gesture and to speak is yet another way to yoke their natural gifts with verbal training.

And with pictures: good photographs, paintings, replicas of sculpture. Objects charged with a great variety of facial expression and atmosphere is one way to get at concepts that lie between, say, happy and sad. Let each child settle on a picture he likes; cut it out and pin it up. Let him look at it, forget it, come back to it. Eventually, when the child is secure in his sense of what the picture is about, a word can be brought to him.

Through music, the rhythm in words and musical content of poetry is reached. Poems could be written for these children with a Cumming's sense of stress and visual spacing. Contemporary poetry is becoming increasingly concerned with the relationship between the meaning of a word and its placement on the page. The children could write their own poems, allowing them the use of those words that are significant to them for reasons of their own, and using the space on a page however they choose.

Light art, and computer art should be explored.

Artists in the school can be effective only if their program is long range—a minimum of one day a week for six months. Also a given program must be part of the regular school curriculum. If it is treated as a recreational diversion, the integrality we have been speaking of all along will be lost. The artist should bring in as many visiting artists as possible, to give the children contact with the outside world.

Interview With Karen Kennerly

I showed Karen Kennerly first the evaluation she had written of the Kendall School for the Deaf and asked her to comment on her own piece ten years later.

KENNERLY: Some of the ideas still seem good. And the tone of it, platitudinous. There's too much of the *other side* of the academy—there's just too much of a political hysteria.

LOPATE: When I go back to this material, I find that in many ways we're still doing exactly what was done then, but the rhetoric has diminished. For instance, now one might do something with dance. Then, when you did something with dance it was a victory for the non-verbal.

KENNERLY: Right, exactly. That struck me as being a bit embarrassing, although I also could hear Herb's [Herbert Kohl's] influence through that. I myself do not naturally approach things from a causist view, in general: be it fem lib or anything else.

LOPATE: From a "causist" view?

KENNERLY: Causist—that is, a political point of view. Some of the ideas and experiments, especially the ones that I recognize as pertaining to me, I still like as I read through it. But the rhetoric between the lines would strike me now not only as being self-defeating because of the anger in the stance, but also as being alien to me. Then as well as now. I don't mean to say that I was being forced into a position which wasn't mine, but that I sort of automatically turned stuff out with Herb's rhetoric behind it. Which makes me realize, and which confirms the main memory I have of that first year, that it was one of struggle; of trying to get things to work; of trying to maintain our integrity—a lot of conflict, a lot of really good ideas and good experiments being sometimes shortcircuited by a struggle that sometimes wasn't even our fault.

LOPATE: By "struggle" do you mean in the political sense, like "Dare to struggle, dare to win?"

KENNERLY: No, just dumb old wasteful struggle. Necessary but wasteful—I mean, nothing that I could dignify. But a lot of it was inevitable and necessary. I don't know how much got ironed out, but it was a year really of ironing-out: of taking those ideas that came from the Huntting Conference, and trying to implement them; and when they failed, figuring out where they went wrong and how to correct one's mistakes. For example, one of the biggest problems was choosing the writers. We failed more often than we succeeded. It wasn't our fault. That is one aspect that was absolutely inevitable and is probably still going on to some extent. What writers are going to be effective when they get into the schools and what aren't? Who are really going to work with the kids and who are going to be threatened by them?

LOPATE: How *were* the writers chosen?

KENNERLY: Randomly. I'm trying to remember...One writer who I brought in and who was not published—since then he's had some plays produced—was Lenny Jenkin. He really was the best, I think. One of the writers that Zelda Wirtschafter brought in Herb and I had a lot of trouble with. We found him very square; we found him playing right into the system that we

were trying to break down: bringing out the goody-goody aspect in kids, and perhaps even bringing out the kids who were already apple-polishers. That's hard to know if you're not in the classroom with the writer all the time, but that was the feeling we got. And this was probably accentuated on my part when Herb left and Zelda took over. I really didn't like Zelda. And that was a big problem for *me*. The year is sharply divided for me between Herb's tenure and Zelda's. In fact, at the time my attitude toward the Collaborative was that once Herb left it was totally useless.

LOPATE: What was your problem with Zelda?

KENNERLY: Zelda was the schoolteacher who dotted all your "i's" for you, who would make comments about your coming in ten minutes late. It's as niggly as that. She was very threatened by the memory of Herb, the discipleship he elicited from all of us. She very much had the attitude that, "Okay, now that I'm here and Herb's in California, there are some things Herb did which are very fine, but there are a lot of things he did which are wrong and I'm going to correct them." It was like changing parties in Washington: you trash on everything your predecessor did. Not that Herb was perfect by any means. But Herb was alive, inventive, intelligent in a way that made sense to me, that I recognized as intelligent. He was wonderful with the teachers: You know, we had those Friday afternoon seminars. Whereas with Zelda the teachers stopped coming.

LOPATE: It's often the case that when Daddy leaves, people, especially teachers, feel that no one can take his place. Often also because of the sexual roles: there have been times when I've taught a workshop, given it over to a colleague who was a woman, and the teachers, often mostly women, would have very negative feelings toward her.

KENNERLY: That's interesting. That's interesting. I wish I could make more use of that in this case.

LOPATE: Well it may not be true, I'm just throwing it out—

KENNERLY: No, I think it's an interesting idea, and it might have been true in any event. But my negative feelings toward Zelda at the time were such that I know it would be impossible for me to separate those two points out. In other words, I think what you're saying could very well be true, and Herb's presence was pretty powerful. When he plays Daddy, he really does it! It's a hard number to follow, Herb's. Still, it might have worked with another woman. Also, I don't feel my antagonism toward her was caused by competition; because I'm not in education; I didn't want her job. My main personal interest was in the curriculum material, the fables. And for the rest of it, I really enjoyed watching what was happening, but I wasn't going to become an educator. It wasn't that I realized, "My God, this is my calling." So insofar as two women can be uncompetitive, that would have been the case with, say, another woman. And I can think of one woman teacher in the Collaborative who, if by some fantastic chance she could have become the director, I would have loved to work with her.

LOPATE: How did Zelda get chosen?

KENNERLY: First, she had a higher position. The woman I'm thinking of was basically a high school teacher, and was also teaching at that time. Zelda was free to take this job. Herb's main justification, as I remember, was that Zelda really had an "in" with the principals, that she could be very useful

because she had power in that area. Secondly, she was, I think, a part of the original group. And then Herb told me that she had been a very good teacher, when she was teaching, in the second grade. I was afraid she might destroy the atmosphere of the office. Because there were people who would come in, like the kids, you know, Alvin and Robert, Dolores, the sister of the boy who was force-OD'd; and then David Henderson was around a lot. Also Joan Jonas came in part-time for clerical work; Dolores and I were the only full-time people. This was at Horace Mann, so there was an office atmosphere. There wasn't just the two or three of us on permanent staff; there were five or six others who would be there three days a week; and all of us had trouble with Zelda. Except Johanna Roosevelt, who didn't actually know Herb that well. I mean, Johanna was a really good woman, I liked her, I could talk to her. I think she was in some ways a little more grown up and mature than the rest of us. We had also been around Herb more, and knew what Teachers & Writers *could* be.

LOPATE: I just want to interrupt with a thought. I'm surprised there wasn't more anger at Herb for leaving.

KENNERLY: Well, I guess I'm probably suppressing some of it. I think I was really pretty angry. If I'm suppressing it, it's because I suspect that at some level I knew I couldn't afford to be that angry, because I knew I wouldn't be there forever myself, knowing I wasn't going to become an educator. Also, he really was freaking out by living in New York, and being an administrator. It was hard to say, "Hey come on, quit being indulgent, we all have these same problems." I mean, that's true on one level, but it really did get to him. He wasn't easy to work for. I'm not idealizing Herb at all. And I got the brunt, because I was the administrative assistant. But at least sooner or later we could talk about it. I could say, "Hey look it's not fair. You're laying this on me, and I didn't do it. And it's because *you* forgot." And he would stop and think about it. And we would talk about it and work it out. But the plus is that he was so damn smart. It was a joy to be around him and watch—but I mean, he really was difficult. Sometimes I'd have to go to his house at six o'clock. I'd have been at the office from nine to five and then I'd have to go to his house at six and present the material of the day, because he'd been too freaked-out to come into the office.

But the other side of it is that one really learned from him. It's very hard for me to separate out what I learned from him about education and kids, and what in fact the Collaborative got from him, as their administrator. It's clear that they got a great deal from him as their brainchild, but as their administrator is something else. I got a lot from him just in terms of general intellectual ambience. He taught me a lot of things about thinking: the most important one being courage. He never articulated it as such; but as I articulated it to myself, it was, not being afraid of your best ideas. You know how sometimes you'll have an idea and you'll think, "My God, that's way up there, that doesn't belong to me. Should I run away from it?" Herb never ran away from anything. If he had an idea he would talk about it, risk, he'd go out on the limb. And he *wouldn't* run away from it. I wasn't aware that most of us did that until I saw how Herb didn't do it. So that was important for me. "Courage" is a funny word.

Other things were important to me, that didn't necessarily have to do

with the Collaborative. That was the year of David Spencer and the I.S. 201 fight, and they were plotting their strategy for I.S. 201. Herb was very tight with them. A lot of that went on in the office, and I was not a part of it, but sitting in on it. But none of this could be very interesting to you, because it's not about the Collaborative itself.

LOPATE: No, on the contrary, it's all interesting. I wish you wouldn't think that I'm such a narrow company man. In fact your description of the way Herb taught strikes me as the way people teach anyway. They very often teach things that are not the specific subjects they were ''supposed to'' teach. I've always thought a principal, for instance, should be the head teacher rather than the administrator. And an administrator should be a teacher as well. And that means what you teach is always yourself. That seems very pertinent to me.

KENNERLY: Well, no, I think that what I question as I speak is whether anyone else in the office or in the classroom got the same thing out of Herb that I did.

LOPATE: Well, Anne Sexton, in her correspondence with Herb, seemed to derive a lot of stamina and courage from things he said. I was interested in this, because Herb was so young at the time. It leads me to wonder what was the quality that Herb had at the time that led people, not only yourself, to believe in him.

KENNERLY: I see. I'm trying to think...

LOPATE: What happened when writers came in and said, ''I don't think it's going well,'' or ''I messed up today?''

KENNERLY: They didn't. Perhaps that was one of the problems. The writers, except for David Henderson, worked independent of the office. That probably was a mistake, that we didn't make them come back in. The rule, or the condition, or the stipulation was that they write these diaries after the class, and what they would usually do was mail them in. Sometimes they would bring them in.

LOPATE: What about Victor Hernandez Cruz?

KENNERLY: It's interesting that I forgot to mention Victor in my list of people, because knowing Victor was important to me. I don't know what went on when Victor was in the classroom. He didn't teach that often, did he?

LOPATE: Not from what I can gather.

KENNERLY: Victor was like a mascot. All ''symbol,'' but very little presence. I mean, he was there a lot, but he didn't do much. I do think Victor was really gifted; and it was a groove to come across an eighteen-year-old kid that was a mature writer. And he was funny; he *is* delightful. But I think that I desperately needed for Victor to like me, need me, accept me mainly.

LOPATE: What were you like in those days?

KENNERLY: I don't know. In general I don't perceive my life in separate stages. I perceive change, but very fluidly, so it's hard for me to answer a question like that. I was intimidated as hell in that office. I was scared of Herb, I was scared of Victor. Well, Herb was (*was*; he has changed quite a bit, he's really softened as a human being)—but he was very, very intimidating. He had his favorites one week, and other favorites another week. I mean, I couldn't fall into that even if I broke my ass trying to do it, because I was a constant. I was there,and I had my job to do. But it happened in little ways.

The days when Herb gave me my pats on the head made me feel I was sort of terrific. He really instilled terror in me. But I had to work my way out of it: that business of saying, "Hey look, this isn't fair," that came months and months after I started working for him. I finally had the guts to say that, but I'm sure there were at least five episodes like that before, in which I should have said the same think. But I was too frightened of him. What Teachers & Writers brought out in me was a tremendous insecurity about being liked and being well-thought-of. And it brought it out on two fronts: because Herb was intimidating, intellectually; and then because of the whole hip black front. Would they accept me, would I pass? There was a heavy dosage of that. Victor, on the one hand, and the I.S. 201 people in the office, on the other, and, and other stuff that was going on in SNCC—they were using our office as well. Did you know Jim Hinton? He's the one who did the photographs in that graffiti book. Jim appeared on the scene in the context of that June Jordan article that was originally published in Urban Review. Jim really liked me. He made it very comfortable: there was something about his presence that said, "If I like you I like you; you don't have to prove anything more, it's fine." And Jim became *very* important for me. My God, as I'm talking about this I'm remembering more and more. This isn't quite as much about my neurosis or Herb's as a situation that would have frightened anyone. Those kids were very scary, Alvin and Robert particularly, and when they brought in their friends. And Herb would leave them with me—alone. You know, all day! And they got—I had no control in that office when Herb wasn't there. Jim came in one day—Jim was really my Daddy, he was my protector—and he came in one afternoon and they were really fucking me over.

LOPATE: What would they do?

KENNERLY: I can't remember, it was more Robert, who did have a real mean, resentful streak in him. And then Alvin would go along with him. They'd taunt me, not get out of the office when I wanted to leave at 5 or 5:30. There were situations in which I had no control short of a physical fight, in which case I would have been flat, leveled immediately. They would make a lot of noise even though we had to do work. I mean they just were totally—it was scary. I'd forgotten about that: it was very very scary. And Jim came in on one of those afternoons and was *really angry*. He went over to Herb's house, and chewed him out for about three hours straight. But he could get away with it because he was a black man. And he was telling Herb, you don't, you know, fuck over white girls.

LOPATE: I see. Let's say Herb had reached a point where he was very comfortable with kids who would be considered ghetto toughs: that doesn't mean everyone feels comfortable with them, and it doesn't mean one should force people into dealing with them in situations that are stressful. It's putting everybody out on a limb, just because you are.

KENNERLY: Yeah, it was very bad of him, that. I suspect if Jim hadn't been around, I would have walked off the job. Somehow it quieted down in second semester. Well, I think when Zelda was there, that part of it changed. The kids didn't hang around. She was the head of the office, so she could really do whatever she wanted: she could have gone to Teachers College guards and thrown them out. I couldn't do that because Herb would never have allowed it. It was his office, not mine. And also, they didn't like her as much. Robert

disappeared; Alvin was still sometimes around, because he was still writing and working, and he needed the office as a second home. And Zelda liked him a lot. I'm sure that, even when he would make snide remarks about her, he liked her affection. Actually Alvin was very soft: left alone he was not a ghetto tough.

LOPATE: It's interesting, this whole courting of the Third World at the time.

KENNERLY: Yes, I noticed that with Herb. I mean Herb's gifts do arise out from whence he came. He is a wonderful upper-middle-class Jewish thinker. And he's constantly putting aside that part of his mind, and getting involved in Third World rhetoric. It's like a constant apology for who and what he is. I think that part of what went on that year, the best and the worst of what went on, came out of this very conflict in Herb that we're talking about. Sometimes his ideas would be way ahead of what could be practically implemented. And then there'd be a reversal: of deifying the Third World, or in those days the Blacks, and over-praising what was coming out of the schools, the kids's writing, etc., etc. That's a main axis of the conflict that was going on. I certainly feel that Herb should have left, for the Collaborative's sake, after the first year—it was too bad he left earlier, *mid*year—because I don't think Herb could have ever resolved those two dynamics too well. I don't know what's been happening with the Collaborative since and therefore I don't even know if what Herb did was ultimately that useful or not. Assuming it was, his value would be to set down those precepts and those goals, and those ideas, and those possible directions. And then, after a second year, a third year, whatever, have someone else come in who can see the middle of the road. And use them when they were valid.

LOPATE: For instance, there was nothing intrinsically about Teachers & Writers Collaborative that required kids to hang around the office. There was nothing in the nature of the work that said, it has to be a clubhouse for kids who were dropping out of school. A lot of things that were specifically connected to Herb's personality got projected onto the organization, and later got detached from the organization when he left.

KENNERLY: One thing that I tried to fight for was an interest in white kids. An interest in white middle-class kids. My notion of the Collaborative was always that it was about education in the broadest sense. It was about writing too, of course: but the problems that we set down as problems, wanted to break through, open into, correct—afflict the white middle class as much as they do Blacks, or the white upper class, *all* of them. Every single basic problem and basic goal could be applied to every strata of society. For example, I was interested in the idea of sending someone into a couple of the really posh private schools in New York, and see what came out of that. Especially since this was an experimental year. But there was a certain amount of subtle prejudice operating against the idea, directed at me. They were, if not consciously then unconsciously, trying to make this WASP girl feel really bad about being a WASP. Herb and I really did talk about this when I got gutsy. The first thing I said was, "Look, you're coming down heavy on me because of my upbringing. I don't have to stand for that."

LOPATE: Well, what happened to your idea about the posh schools: were you able to implement it?

KENNERLY: No. Zelda wasn't interested either; I don't think I pushed all

that hard. And, of course, Anne Sexton was working in a white middle class school, so we did have that representation. (Pause) I'm having trouble saying why I didn't push harder. I suspect because Herb's coming down on me indirectly for my so-called "class" intimidated me enough. And, I went to one of those schools, I went to Chapin. Obviously that was the easiest place to start: if any of them would have accepted any of us, Chapin would have done it through me. And it certainly was about as posh as you could get. It would have been a very good example to use. But I hated it when I went there, and my loathing of the school was very easily converted into a self-loathing, that Herb then picked up on. I mean, it's like my accent: there were times when it was so clear that just the sound of my voice drove him up the wall. It was obviously reminiscent of his Harvard days, when he was playing at hanging out with Nelson Aldrich and those people.

LOPATE: You mean he'd been humiliated by people that he associated with you?

KENNERLY: Right. And we had this out. We talked about precisely these issues when I finally got really mad. But I think that's why I didn't push it. And in the second half of the year, it took so much energy just dealing with my feelings about Zelda. But I did mention it to her, and of course she had the same bias: like, those kids aren't worth caring about.

LOPATE: If anything, sometimes they seem to me in much worse trouble.

KENNERLY: Well I think so too. I also think that if a writer did go into a school like Chapin he'd have a lot more trouble—not in getting the papers, but in getting something real on them.

LOPATE: Yes, I've taught in wealthy suburbs, and I always felt that I needed twice as much force to go into that situation, as to go into a typical inner city school. Now when Herb left, you mentioned that you were researching. What did this researching entail?

KENNERLY: Oh, I did all the research for the fables that appeared in the Fables Curriculum Unit. The research itself was reading through tons and tons of fables, myths, folklore, to see which ones might capture kids' imaginations. It's funny because I got into a kind of polemical problem: the more I read, the more I realized that fables, in fact, were not very interesting to kids.

LOPATE: That's right! This is one of the other mysteries that I wanted to ask you about—

KENNERLY: You want to know how it got going? This is before I came on the scene, before the Collaborative was established. When Herb was down in Washington trying to raise the initial funds, this honcho whose name I forget, his office was across from the Capitol, said to Herb, "Okay, so what's the curriculum unit going to be on?" He said: "Um, fables." Because he had been playing around with them for a day or two.

LOPATE: You mean, "(Gulp!) Fables."

KENNERLY: (laughs) By the way, when I did leave, I went to Random House to see if I could get a job as a reader or anything that wouldn't be a secretary, and talked to John Simon, whom I barely knew, and he asked me what I'd been doing, and I started rapping about fables and how in fact it was a *very* adult form. Probably *the* most adult form, that it's probably the last you come to. So by the end of lunch he said, "I'd rather have you as an author than a reader. Here's a contract, go do a book on fables." Which I did. That's how it

all came out. And the book I did produce is very sophisticated indeed. There's everything in it, from variations of Aesop to a hunk of *Finnegan's Wake*.
LOPATE: What was it called?
KENNERLY: *Hesitant Wolf & Scrupulous Fox*. Anyway, I realized that about fables when I tried to teach them. I did go into a couple of classes to work with fables. Also, that's the one area where those kids in the office came in handy, because I used them as guinea pigs. I asked them, "What do you think of this, what do you think of that?" I think that it was a nice one-time exercise for writing. In fact, the kids enjoyed writing them a lot more than they enjoyed hearing them or reading them. As soon as they got the idea of what a fable was, they wanted to write them, but they did *not* want to read them. Not interested. In fact, some of the pieces in the curriculum unit are not, strictly speaking, fables—which is what my book is about: What is, strictly speaking, a fable? But I tried to keep it close. Herb wanted to take it into lyrics and the folktale area. But then, that was his job: I was to do the research and he was to do the educational part. So we put together what you know as the Fables Curriculum Unit.
LOPATE: I'd like to say something about the whole Fables Unit. To speak honestly, it always seemed to me like one of the blind obsessions of the early Collaborative. What seemed to me like a nice idea was taken further and further and further. And in the grant proposals and progress reports, it's always treated like something that must not die, that we must continue to do: tell the teachers the kind of fables to teach, they'll report back, and then their experience, successes and failures, will become a new curriculum unit. It always seemed very perverse to me. In the first place because I knew that fables represent a kind of allegorical approach to language which is not as accessible to kids as people were saying it was; in the second place, the whole notion of taking a writing idea to its extreme, in terms of feedback of feedback of feedback of feedback in the teaching area, seemed to me misplaced.
KENNERLY: That's an interesting point. The first one, that fables was not the best medium to choose, is no surprise (laughs) to me. I don't remember whether I told Herb how strongly I felt about fables not being good for kids. It took me awhile, first of all: it took me several months to realize that.
LOPATE: Was it coming up through the reports from the other teachers?
KENNERLY: They didn't use them very much. Fables were always good for a one-shot class. So that the feedback—it was kind of a fake study, probably. Herb promised that he'd produce a curriculum unit and it was going to be on fables. But the feedback was fake because, except for someone who was as creative as Alvin, none of the kids had to or could write them again and again. If it was constantly being recycled, in fact they were always one-shot deals. It's just that we had more material, because we'd tried it in more classes.
LOPATE: It struck me as a sleight of hand curriculum. The sleight-of-hand was, we don't have a full curriculum but we're going to build in this reverberation factor of feedback, and say that *that's* the curriculum. That's purely my take on the matter, but it never really fell together to me as a curriculum. And by the way, I have a very loose notion of curriculum.
KENNERLY: Well I think the second point that you made, which is that no one form should be recycled that way, is very good. That point I frankly didn't know to suggest; I wouldn't have thought of it on my own. Again, it was not

my field. See, I thought it was only the problem of the fable, which I *did* understand. I didn't know how it would work if we'd chosen the "perfect" subject, the perfect form.

LOPATE: Well the farthest I was ever able to go, the most perfect form, in terms of the kids going on with it even after I was bored stiff, was comic books. They were willing to make comics forever. And different kinds of comic books. I certainly got exhausted with that way before they did.

KENNERLY: Did they stop growing? Did they continue to grow?

LOPATE: Well we kept introducing technical elements such as color theory and things like that. It was very successful. What I'm saying is that there probably are forms which can be taken longer—just because they're the kids' forms.

KENNERLY: I see. But I think that somewhere, though, there is a misunderstanding about Herb's intent with this, as he called it, "paradigm curriculum unit," and what finally got written down in the reports. He didn't intend any of this one, or any of the others that would be modelled on it, to be used for a given length of time. Time was never built into it: like "Here is a unit you can use for *a* semester. You can then plug in blues, lyrics, made-up folk myths or poetry or anything, and it will work the same way, for a semester." I don't think he ever had that in mind at all.

LOPATE: Yes, I agree completely. Actually, the extenuation of the project, the time-element that I was thinking of, had more to do with the Collaborative's commitment to the idea, than to the imposition on teachers to continue it.

KENNERLY: First of all, not as much time was spent on it, I think, as is probably reflected in the reports. I had to do an awful lot of reading for it, probably too much, and a lot of testing. But, aside from my role, I don't think anyone else spent that much time on it. I suspect it was a handy thing to trot out and to show Washington.

LOPATE: Well it seemed to have two good uses. One was as a camouflage to Washington. The other was that it resulted in a book. In *your* book. I never knew that something so useful had borne fruition from the Fables Project, because I think that's wonderful.

KENNERLY: Yeah, that was probably the nicest thing about the Collaborative for me, was that that book came about. (laughs) It couldn't be farther away from the original intent. The introduction was written in very tight, Cioran-esque style, where you put down one idea, and another idea, and another, and you really compress. Do you know what I mean?

LOPATE: I've read Cioran's *The Temptation to Exist*. It's basically like Nietzsche, in a way: epigrammatic, one idea leaps to the next idea?

KENNERLY: Yes, that's sort of the way. And what I did was to compress fifty pages of what would have been an academic introduction into seven pages of that stuff. I'm still kind of fond of it. I think I overdid it, maybe it should have been fifteen pages, or ten. But it's the kind of fancy intense scholarly writing that Herb just did not relate to. And I don't think Herb likes the book. I kept the Caxton in the original. I didn't keep the Chaucer in the original, but instead of using the trot, I used Dryden's version of "The Nun's Priest."

LOPATE: Well look, you were holding up a mirror to him, in a way, and you were saying, "This is where you came from."

KENNERLY: I also think it's a testimony to the fact that he hasn't lost that self. My first remark was that Herb taught me to have courage and not to be afraid of my best ideas. And now an hour later I say that I produced this kind of book. And it has nothing to do with the Third World or with simplifying language.

LOPATE: Exactly. I see it as a tribute to him as a teacher, that even though you did something that you think he doesn't like—and by the way I'm not convinced of that, he very well might—you had the courage to do it. That courage is something he stands for.

KENNERLY: Well actually, it's a fable in itself. I've never thought of it myself, and I'm sure Herb hasn't either!

The Owl and the Pussy (cat)
by Alvin Curry

There was once a very wise owl who always went to Staten Island to see his Pussy (cat). One day while he had gone on the ferry he was stopped by a old man, who wore ragged clothes. The man after asking the owl to sit down beside him started to tell the owl about how when he was a young man how he used to go to parties and fool around with girls, and how he found that all girls were all alike in the way that none of them was any good. This is where the Owl disagreed with the old man by saying, "That's a Dirty Lie! Because I remember how I tricked this girl that I'm on way to Staten Island to see now!" "And how did you trick her?" the old man asked. "Well you see it was like this, I always tell her how much I love her, and how much I care for her but it was all a collection of my professional lies."

"So that's nothing new I remember when I used to do the same thing myself in my days of youth, the problem is what her reaction was toward those sweet words that you always whispered in her ears."

"I was just going to get around to that, if you would please stop interrupting," said the Owl. "Okay I will stop interrupting go ahead and tell me what her reactions were if you don't mind!"

"Well as I was about to say: I told her how much I loved her, and all, but I told her that in order for me to love her more that I would have to take her out, and in order for me to take her out I would need suitable clothes to wear like italian knits and silk pants; and I also explained how my family had always been very poor, and that I couldn't afford to buy my own clothes, so that I could take her out and love her more."

The old man with his mouth wide open exclaimed, "Why that's one of the most fantastic lies that I ever heard! What are you one of those young cheapskates or something, that use the weaker sex to buy you clothes and pay for all of your social expenses or something?"

The Owl with a certain pride about his voice answered, "Why yes that's exactly what I am!".....A voice came from the front of the Staten Island ferry saying, "That's all I wanted to hear." With this the owl got out of his seat while the Ferry was still in motion, and he walked to the front of the boat, and was very surprised to see that the Pussy (cat), that he was going to see in Staten Island to get some more money from, was sitting right in the front of the boat, and by the expression on the Pussy (cat's) face the Owl knew that the Pussy (cat) was sitting there all of the time that he was bragging about himself to the old man. The Pussy (cat) stood up and she took the owl by his ear and led him to the front of the boat, and she threw him over board. After she saw the Owl go under the water for the fourth time, she went back to her seat and finished reading her newspaper.

The moral of this story is: It doesn't Pay to Brag!
<div align="center">or</div>

Live Fast, Die Young, and Have a Good Looking Corpse! (6)

The Wolf Who Cried "Boy!"
by Alvin Curry, "The Man of Many Fables"

There once was a lonely deserted place on the outskirts of town, where a pack of wolves carried on their daily tasks of scrounging, killing, eating and loving. The part of their tasks that was the hardest was loving. This was so because of the boy who lived inside of town who was always snooping around to find the wolves making love or something similar to that. Well anyway the wolves set up a warning signal, which happened to be another wolf who didn't have a chance of making love with the girl wolves because of his bad breath. You see he was an outcast because while the other wolves liked to eat deer, rabbit and all that kind of wildlife he always stuck to eating sheep and lambs. I guess that's why his breath had that awful smell. The wolf would cry, "Boy!" every time he saw the "two-legged party pooper" from inside of town. So the wolf who was the warning signal got kind of jealous, because he wasn't hip. Or to put it in milder terms, he got mad because he didn't know "what was happening." Because of this he kept crying "Boy," "Boy," and more "Boys," until all the wolves jumped on him and broke his collar bone. The wolf getting up from the ground exclaimed, "Damn! They got Scope and all that other kind of junk to make your breath smell sweet, why did ya hafta go and give me more problems by breaking my collar bone?" And with that the wolf lived sadly ever after

By Hisself.

Moral: Love is a hurting thing,
 or
Get "Scope" and you won't have to be a signal wolf.

TEACHERS AND WRITERS COLLABORATIVE
-NEWSLETTER-

Volume I Issue I
SEPTEMBER, 1967

ALVIN CURRY:
"THE MAN of MANY FABLES"

DIRECTOR: Herbert Kohl
RESEARCH ASST: Karen Kennerly
SECRETARY: Dolores Carter
DESIGN: R.G. Jackson, c/o THE SOUL SYNDICATE.
EXECUTIVE SECRETARY: TINKA TOPPING

HORACE MANN - LINCOLN INSTITUTE
TEACHERS COLLEGE,
Columbia University,
NEW YORK, N.Y.

FABLE

by Muriel Rukeyser
for Herbert Kohl

Yes it was the prince's kiss.
But the way was prepared for the prince.
It had to be.

When the attendants carrying the woman
—dead they thought her lying on the litter—
stumbled over the root of a tree
the bit of deathly apple in her throat
jolted free.

Not strangled, not poisoned!
She
can come alive.

It was an "accident" they hardly noticed.

The threshold here comes when they stumble.
The jolt. And better if we notice,
However, their noticing is not
Essential to the story.

A miracle has even deeper roots,
Something like error, some profound defeat.
Stumbled over, the startle, the arousal,
Something never perceived till now, the taproot.

Part Two:
Clashes

Issues of Language

by Phillip Lopate

The Centrality of Language

The founders of Teachers & Writers Collaborative, the Huntting Conference members, perceived the educational crisis as first and foremost a crisis in language. They diagnosed an alienating separation between standard English as it was taught and the language people actually spoke and used for communication; they saw a rusting of the tools of language, partly as a result of the influence of public speech, which was "a language for evasion, for cheating and lying...." The argument of Orwell's famous essay, *Politics and the English Language,* was recalled daily as the newspaper carried Pentagon neologisms and euphemisms such as "pacification." There was a growing sense among writers that cleaning up the language might not only be a culturally ecological activity, but an act of political protest as well. Language binds us all to a common fate, like a metal conductor whose electricity is immediately spread in all directions. Or, as Paul Goodman put it, "When a man is known for a liar, there is less speech altogether."

At the same time, the federal government also was interested in language programs, especially in ghetto areas. It is interesting to note that the idea of artists "going to the students" had been proposed earlier in other media as well, but little funding could be found. At a seminar in 1965 on Elementary and Secondary School Education in the Visual Arts, attended by such notables as Robert Motherwell and Buckminster Fuller, we find Zelda Wirtshafter proposing (before she had any involvement with T&W): "There are many able artists, particularly those who are young and relatively unknown, who are both interested in and capable of teaching children. To continue to deny them access to the schools is to deprive our children and teachers (classroom and specialist) of a major potential source of reform and improvement in art education." Yet, supporters of this idea were unable to attract funding for such a program in visual arts or musical education, according to Ms. Wirtshafter. She is of the opinion today that it *had* to start with literature. The reasoning would be that writing is verbal and therefore closely linked to reading, the linchpin of the educational system. Reading scores are to school boards and superintendents what Nielson ratings are to television executives: a few points either way can mean the difference between promotion and having to look for another job. Such interested clients might be willing to listen to the argument that student-generated texts would have a positive effect on reading comprehension.

Thus, language arts were central, both for those who wanted to maintain the educational system and those who wanted to undermine and transform it. For, if language is the door through which all else that the school teaches has to enter, it is also the gate that excludes. The writers attracted to T&W in its infancy were, as a rule, anti-Establishment in their politics: either radicals or reformists sympathetic to the anti-war movement, and the struggle for social and racial justice. It is no accident that they formed the Collaborative around the question of language. If, as I will attempt to show later, language can be

100

considered the strongest force holding the educational apparatus in place, then, strategically, to attack in this area would be to get at the most crucial, vulnerable spot.

Challenging the Code

One way for writers to attack the schools was to honor and appreciate precisely that student writing which had formerly been discredited, if not despised. This approach can be traced back to Herbert Kohl's ground-breaking essay, *Teaching the Unteachable,* which begins with the following comparison:

SHOP WITH MOM

I love to shop with mom
And talk to the friendly grocer
And help her make the list
Seems to make us closer.

— Nellie, age 11

THE JUNKIES

When they are
in the street
they pass it
along to each
other but when
they see the
police they would
run some would
just stand still
and be beat
so pity ful
that they want
to cry.

— Mary, age 11

Kohl goes on to say:

Nellie's poem received high praise. Her teacher liked the rhyme "closer" and "grocer," and thought she said a great deal in four lines. Most of all the teacher was pleased that Nellie expressed such a pleasant and healthy thought. Nellie was pleased too, and her poem was published in the school paper. I was moved and excited by Mary's poem and made the mistake of showing it to the teacher who edited the school newspaper. She was horrified. First of all, she informed me, Mary couldn't possibly know what junkies were, and moreover, the other children wouldn't be interested in such a poem. There weren't any rhymes or clearly discernible meter. The word "pitiful" was split up incorrectly, as well as misspelled, "be beat" wasn't proper English, and, finally, it wasn't really poetry but just the ramblings of a disturbed girl.

Kohl's response was one of outrage. (Personally, I've always liked the grocer poem too; it seems no less observant or rooted in experience than the one about the junkies.) But the essay's point was essentially well-taken: the values which had been traditionally rewarded in classrooms were orderly exposition, logical progression, correct grammar and spelling, neatness, length and wholesome attitudes. By contrast, the first writers going into the schools (and this is still to some extent true today) favored the jagged, the harsh, the surrealistic, the poetically disjunctive, the visceral, talky, vivid, possibly antisocial point of view. The new standard called for was "authenticity of voice" —honesty, immediacy and freshness, however ungrammatical—and this was counterposed to safer, grammatically smooth, "middle class" compositions, which sounded deader or more socially conditioned to the writers' ears.

One course, one style can ultimately become as mannered as the other. But that issue would have to be dealt with later: the point was first to redress an old imbalance which had had its way too long, the result of the school-approved code that tended to penalize certain groups of children and deny the validity of their voices through mechanisms of shame.

Underlying this effort at redress was the assumption (sometimes articulated, sometimes not) that schools were racist and classist institutions, which held back, or kept in line, whole populations by their normative operations. This position has received much scholarly corroboration of late, by the group of revisionist educational historians which has emerged in recent years: their work has challenged the old assertion that the public school system has been the historical instrument of upward mobility for immigrants and the poor. Writers like Gintis and Bowles, Michael Katz, Colin Greer, and Joel Spring in the United States, or Pierre Bourdieu and Jean-Claude Passeron in France, have maintained instead that the universe of the school tends to reinforce and reproduce in succeeding generations the social class relations that had obtained in the former. In their view, schools act more like threshing machines, directing students to their "proper social stations" in life. The business of the school is mainly to train a "schoolable population" that will go onto the next stage; and the casualty rates that result from this selection process inevitably fall more heavily, all along the way, on working class and poor students.

In examining "the principles by which the school system selects a population whose pertinent properties, as it moves through the system, are increasingly the effect of the system's own action of training, channeling and eliminating,'.' Bourdieu and Passeron concluded that language was paramount. "The 'pure,' 'correct'—i.e. 'corrected' language of the classroom is opposed to the language the teacher's marginal notes stigmatize as 'vulgar' or 'common'...." "The ideal is to 'talk like a book.'" "The teacher cloaks himself in the livery of the Word, which is what the white overall or jacket is to the cook...." They go on to say:

> Of all the distancing techniques with which the institution equips its officers, magisterial discourse is the most efficacious and the most subtle: unlike the distances inscribed in space or guaranteed by regulation, the distance words create seems to owe nothing to the institution. Magisterial language...is able to appear as an intrinsic quality of the person...There is nothing on which he cannot speak...language can ultimately cease to be an instrument of communication and serve instead as an instrument of incantation whose principal function is to attest and impose the pedagogic authority of the communication...

Given such a situation, the notion of meritocracy may well be a false front, Bourdieu and Passeron argue; the scholastic hero from the lower classes who rises to the top is an overly celebrated exception, seized on as proof that the system is one of equal opportunity. But basically, examinations only "conceal social selection under the guise of technical selection, and legitimate the reproduction of social hierarchies by transmuting them into academic hierarchies." The student most likely to succeed in exams and to understand the teacher is one who has some "*linguistic capital*" to begin with, mainly derived from his or her social origins. "It follows logically that the educational mortality rate can only increase as one moves towards the classes most distant from scholarly language...." Whether this occurs in the early grades, or—as we

have seen recently with college open admissions—is deferred to a later point, the result of the screening process is the same. Working class and minority students often find themselves in an atmosphere which feels inimical to their whole way of being. Bourdieu and Passeron argue that the problem hinges on their different relationship to language:

> So it is in the relation to language that one finds the principle underlying the most visible differences between bourgeois language and working-class language. What has often been described as the tendency of bourgeois language to abstraction, formalism, intellectualism and euphemistic moderation, should be seen primarily as the expression of a socially constituted disposition towards language, i.e. towards the interlocutor and even the object of conversation. The distinguished distance, prudent ease and contrived naturalness which are the foundations of every code of society manners, are opposed to the expressiveness or expressionism of working-class language, which manifests itself in the tendency to move from particular case to particular case, from illustration to parable, or to shun the bombast of fine words and the turgidity of grand emotions, through banter, rudeness and ribaldry, manners of being and doing characteristic of classes who are never fully given the social conditions for the severance between objective denotation and subjective connotation, between the things seen and all they owe to the viewpoint from which they are seen.

We might be inclined to dismiss this paragraph as a symptom of that modern French intellectual seduction which sees everything as a manifestation of language; but on the other hand, there is a good deal of research and common observation from other sources to support the distinctions underlying it. Basil Bernstein, in his work on the differences of syntax between lower class and middle class children in London, made similar findings, though he explained them in terms of group versus individual expression:

> Lower working class children have a society limited to a form of spoken language in which complex verbal procedures are made irrelevant by the system of non-verbal closely-shared identifications—plus more naked, less internalized authority...Inherent in the middle class linguistic relationship is a pressure to verbalize feeling in an individual manner. To make explicit subjective intent...The lower class child learns a form of language which symbolizes the norms of a local group, rather than the individuated experience of its members.

Bernstein comes to the conclusion that middle class speech, with its stress on individual expression, is far superior—which must be why his studies have been disparaged by one camp of social scientists while embraced by another! But it is unnecessary to choose either class's language over the other. I agree with Paul Goodman: *"Both* are defensive languages."* The rest of Goodman's opinion is worth quoting in its entirety, not only because of the chances he takes in these dangerous waters but because it shows his characteristic will to fairness.

> Each has its virtues, which are not class virtues but human virtues: the poor child's speech has the human virtues of animality, plainness, community, emotional vulnerability, and semantic bluntness (though not frankness—they are frightful little liars); the middle class child's speech has the human virtues of prudence, self-reliance, subtle distinction, the ability to move abroad, and responsiblity to the verbal truth (but they are already terrible little hypocrites). In both types, however, we can see developing the outlines of pathological speech. The poor kid has to prove his potency; if his stereotyped sentence is not accepted at face value, he has no back-up, is acutely embarrassed, and bursts into tears; he has to diminish anxiety by impulsive reactions and can become totally confused and lose all prudence:he becomes stupid out of spite. The other kid escapes from physical and emo-

tional contact by verbalizing; he speaks correctly to control his spontaneity; he rationalizes and deceives himself; his consciousness of 'I' isolates him and makes him needlessly competitive; he is guilt-ridden.

The poor kid's use of language does not get him enough of the cushioning protection that symbolic action can give; as Kurt Goldstein put it, he is liable to catastrophic reactions. But the other lives too much by language; he tries to make it do more than it can or should, and so he immobilizes himself and loses vitality.

The preference which writers in the schools showed for earthy, blunt products can be interpreted, in part, as a manifestation of self-hatred for those very middle-class traits Goodman enumerated. In any event, the legitimacy which these writers gave to an aesthetic of *vitality* translated practically into more support for lower class and black children's ways of expressing themselves.

Not all the writers who first went into the schools were acting from a conscious analysis of language and social class: many of these connections were intuitively felt (they have since become more buried). But certainly, the pioneer writers in T&W *were* united by an awareness of the need to defend voices that had been repressed, for whatever reasons. They came on as champions of the repressed. Sometimes this repression was spoken of in psychoanalytic terms— the wasted or untapped potential in the individual child's unconscious; sometimes it was connected to larger social forces.

Contemporary Poetic Language

The sympathy which writers had for students' blunt, everyday-language expressions might also be understood as a reflection of trends in contemporary American poetry. There had been a revulsion against the ornate diction and ethical posturing of the so-called "academic poets," who had commanded most of the public attention in the 1940's and 1950's, and a turn toward a plainer diction, understatement, anecdote—a recovery of what William Carlos Williams called "true American speech."* The influential work of Williams, Denise Levertov, David Ignatow, Gwendolyn Brooks, Robert Creeley, Frank O'Hara, Leroi Jones, Gary Snyder, Kenneth Koch, Allen Ginsberg, and many others, all gave support, in different ways, to the proposition that contemporary American poetry should be rooted in daily, common speech and experience.

Contemporary poetic language was actually foreseen as a possible bridge to street language and the students' everyday vernacular. The degree of confidence in the efficacy and accessibility of contemporary poetic texts as a powerful instrument for reaching the kids may be glimpsed by this statement of David Henderson's:

The best way to teach black kids to write is to bring in large doses of Gwendolyn Brooks, Langston Hughes, Don L. Lee, Sonia Sanchez, Nicholas Guillen, Mari Evans. These are

*See Kenneth Koch's discussion of the different schools of American poetry, at the start of his interview. The urge to seek the genius of the language in common speech is a recurrent one among poets, particularly after a gilded literary age. Wordsworth turned to "rustic speech" for the source of his poetic language. Auerbach, in *Mimesis,* represents all of literary histroy as a kind of dialectic between periods excluding or admitting the vernacular.

contemporary poets, from them we can get to the great heritage of black literature. From the particular and familiar of contemporary black poets and writers we can capture the enthusiasm of the young student and really begin to teach.

Henderson was right: this did prove to be an effective and dignified approach to introducing children to poetry, in many ways less condescending than "writing games." But one may still go on to question the assumption that contemporary poets, black or otherwise, do share the same language of the particular and familiar with schoolchildren and high school students, or that the words mean the same to both of them. The willed simplicity of a Robert Creeley or a Gwendolyn Brooks poem, with its complex acts of discrimination, suppressions and multiple meanings, is of an entirely different order from the bare statement of much children's writing or dictated expression. The sophistication which produces poetic *understatement* derives from an understanding of centuries of literary practice.

Nevertheless, the efforts to join these two sorts of simplicity, by pretending that they were more similar than they actually are, has turned out to be a fruitful one; and perhaps there is a point of commonality, as in two discrete circles that overlap in a shaded zone. We are getting into that hazy, psycho-archeological zone where childhood and poetry are said to be twins, or made of the same stuff. Whether there is any truth to this or not, depends perhaps on each person's attitude toward his own childhood. It does seem to me that there are certain fertile misunderstandings in this business from which we have all benefited, like the proposition that "every child is a natural poet," which is certainly doubtful, but which has helped to get programs started and writers-in-the-schools accepted, if, at the same time, raising false hopes.

In the early years of the Collaborative, writers introduced contemporary poetry and fiction language into the classrooms not merely as an enrichment, but with the intent to supplant or subvert another code: "school language." In this sense, the antagonism toward standard school textbooks may be seen as a kind of rivalry. One may note, for instance, the curious and persistent hostility on the part of the founders of T&W toward the *Dick and Jane* readers. Eric Mann, an early participant in the program, wrote a diary about working in Newark with Herb Kohl, that shows a clear-eyed understanding of the rules of the visiting writer game, with its implicit antagonism to school texts:

> Herb began the lesson by showing the class the cover of a new book he had written. The book cover was a photograph of wall graffiti. He asked the students if they thought such a book would be used in the public schools, and the students dutifully replied that it wouldn't because it was "too cool." Herb asked, "If they won't use a book like this, what kinds of books will they use?" Willie and Tiny said simultaneously, "Dick and Jane" with a tone of voice that expressed both genuine distaste and a desire to please Herb and me.
>
> Herb was really turned on, dropped whatever plans he originally had for the lesson, and said, "OK. If you don't like Dick and Jane let's write our own Dick and Jane." His enthusiasm was contagious. The sentences came forth quickly.

OUR DICK AND JANE

This is Dick.
What kind of Dick?
A boy named Dick.

This is Jane.
What kind of Jane?
A Mary Jane. Boy do they taste good and last long.

I wonder where they live.
They live in a cardboard box on Washington Street.

I didn't know they could afford a TV.

Dick was playing with matches and the house caught on fire.
Somebody call the fire department quick before Mary Jane melts.
"You bad boy, I told you not to play with matches," said Jane.
He said, "Aw shut up, you aren't my mother. We better get out quick or else I'll burn and you'll melt."
Dick jumped out the window and Jane melted into peanut butter.

This piece, a favorite of the staff, was a perfect example of the genre of children's writing celebrated at the time, with its street-wise, risque first two lines, its conversion of Jane into Mary Jane (not only a candy but slang for marijuana), the irreverent toughness ("Aw shut up, you aren't my mother") with which it stands the conventional moral pieties on their head. And yet, through it all there is a childish innocence which must have been reassuring to the writers—after all that cynicism, courted and elicited—and which tangles with the tone of sly innuendo that seems to promise even more rebelliousness than it finally delivers. Double entendres, double meanings: the fable and the satire, those two literary forms that flourish in repressive regimes, were favored as lessons in the early days of Teachers & Writers Collaborative, which tells us something about the political convictions and assumptions of writers then going into the schools.

The Great Spelling Question

We have already seen how the aesthetic viewpoints of writers and classroom teachers sometimes came into conflict: the classroom teacher might show off a lengthy composition by the student she considered her "best writer" to the visiting author, who could barely suppress a yawn, meanwhile pulling out a short punchy paragraph by another student, which he praised for its vivid speech and images, and which left the classroom teacher wondering why the writer was being so perverse as to laud this illiterate stuff.

What disturbed some classroom teachers even more was that the writers did not correct the students' errors. "What should we do about a child's spelling and grammar errors?" was an inquiry so persistently raised (and with such anxiety that it was clearly the tip of some iceberg or other), that it came to be known jokingly among writers in the schools as The Great Spelling Question.

At the Columbia Conference in 1966, teachers were blamed for cutting off individual expression by caring more about spelling and punctuation mistakes than content. Seymour Simckes was quoted as wanting "a child's 'errors,' his experiments with language, to be included in such stories, so that learning to write would not be a process of correcting and limiting, but of building on all the original sense for language which a child has." Note how the word *errors* has been placed in dubious quotation marks, and coupled with "experiments in language," so that what was formerly viewed as a mistake is now being seen as a potential linguistic playfulness.

Why should professional writers have been so sympathetic to student writing which was, on the face of it, indifferent to proper usage? One might think that, as "guardians of the word," they might just as easily have been appalled. Part of the reason may have to do with the particular historic moment, the late 1960's, with its strong ethos of anti-elitism and people's culture, and its impatience with distantiating professional codes of discourse that put off the layman—which was felt in medicine, law and social work, as well as the arts. But there is another reason, which points to an identification of the writer with the errant student, as fellow deviants. Paul Goodman makes the point this way:

> Powerful writers are not normative—indeed, they are often "incorrect"—but they add to meaning, they are authors (from *augere*, "to augment"). They keep the language alive, just as the drive to slang, "bad English," keeps the language alive....What kills language is dull, stereotyped, lazy, or correct speech.

Here, correct speech is tagged as one of the enemies of live speech. Authors and speakers of "bad English" are in the same boat, both pulling in their miscreant ways toward freshness of language. I think it is generous of Goodman to extend the umbrella of inventiveness to both groups; and from an elevated philological point of view he may be right; but he has failed to take into account the enormous difference in human freedom between the two acts. The writer has very wide means of expression at his or her disposal and may choose perversely to invert or to challenge the code—from a position of strength—whereas the ordinary linguistic rule-breaker is not conscious of the choices, has very little option in the matter. What the speaker of bad English says may result in a very exciting recombination, to the trained ear, but it does not carry with it, for the speaker himself, the same heady pleasure of destroying old codes and creating new.

By the same token, the subtle eye of a trained writer may find Joycean richness in a child's misspelling, but that says more perhaps about the lushness of the writer's own education than the child's originality. This is the nagging question, that has dogged the movement from the beginning, of differentiating between the child-writer's own intentions and the virtues found by adult writers in the child's composition.

I suspect that part of the attraction for writers of "raw" writing is that they could enjoy the "authenticity" of the voice, while transforming it, automatically and unconsciously, into something else: part of an interior monologue, which is a highly self-conscious and artful form. Contemporary writers have a special sensitivity to, and appreciation for, vocal forms in a text, the informal paraphernalia of speech. Hence their greater liking, at times, for children's dictated compositions. As Meredith Sue Willis has observed, "A century ago, the exploration of character usually took the form of describing actions or manners, but much of twentieth century writing is based on the world view and thought processes of the character, the *voice*." Besides which, writers feast on raw, unliterary language: from Stendhal's love of legal codes to Burrough's appetite for leaflets from crazies in the street, the undigested or "unfinished" state is precisely what makes this language so evocative, so open to discovery, so suggestive of a hidden narrative underneath it. In its ellipses lies its charms.

In any case, Simckes' recommendation was adopted. The *noli me tangere* approach to correcting student writing became standard procedure at Teachers & Writers Collaborative. The organization's official statement, which appeared in each newsletter, explicitly stated:

a) Children who are allowed to develop their own language naturally, without the imposition of artificial standards of grading, usage, and without arbitrary limits on subject matter, are encouraged to expand the boundaries of their own language usage;

b) Grammatical and spelling skills develop as a result of an attachment to language and literature, not vise versa. The attempt to teach skills before they are proved to have relevance or relation to the child's interests and needs has been one of the primary causes of the stifling of children's interest in language;

And this policy was backed up: the Collaborative offered the service of typing mimeos of all the children's work, exactly as written, and the writer distributed them to the class, so that the children would have the confidence-building experience of seeing their words in print.

In retrospect, this was an adventurous and advanced position to have taken. Yet, the desire to preserve the exact flavor of the student's language, understandable as it was, sometimes had the effect of making into a precious "found poem" what had not been written with that intention. For instance, in typing a child's piece of writing as it was written and scrupulously following the line-breaks, there was the danger of reproducing as a delicate, artfully laid-out poem what had actually been a hastily written prose paragraph (children are not great respecters of even right-hand margins). Or a mistake might have been patently made out of sloppiness, rather than personal expression, such as when a child left out a key verb: should one respect the "purity of the text," as though one were copying out a Dead Sea Scroll, or slip in the one word that would make the whole passage intelligible?

In a sense, two contradictory agendas were being followed: the visiting writer as anthropological archivist, or folklorist, collecting artifacts of child-language in their natural state, and the writer as guide and model, teaching young people how to go further than their original art-making capacities. Eventually the praxis of revision, which plays so large a part in a writer's life, would have to come into conflict with the goal of not tampering with the original language. But before that point even came, the Collaborative workers were confused about procedure in the matter of corrections (see Lenny Jenkin's diaries), and their frequent questions intimated an uneasiness among the writers in the field which was not dispelled by the Collaborative's front office, partly because the office staff was loath to lay down directives and guidelines for matters which they knew could be complex and devilishly local. What might work in one school, or in one classroom, or with a certain child, might not be appropriate practice in another situation.

Zelda Wirtshafter, the Collaborative's second director, articulated her own position in a recent interview:

On the one hand, if your purpose is to help children to use language to deal with their own experience, inner and outer, then you as an adult have to make distinctions. You don't lay on him a whole bunch of red marks and chicken-pox up his paper. However, at the same time you can use his interest in dealing with experience to help the student write more clearly. *Then* you begin to develop the awareness of how grammar, spelling, periods, affect

the communication. Don't mark up their writing during the first period. Use what kids give you as your cue into teaching grammar and spelling separately.

This seems to me a very sensible and well thought out position; but it is the approach of a former classroom teacher with years of experience in the schools, who has had full responsibility for thirty children throughout the year and knows how to make time work for her. The writers were in no such position. Not only did they lack classroom savvy, but they only came in one day a week; they were not around enough to implement such a sophisticated approach of teaching writing in tandem with grammar and spelling.

Moreover, they did not see correcting grammar and spelling as part of their job description. Perhaps they even viewed it as a kind of janitorial function, best left to the teacher. Their job, as they saw it, was to recharge, revivify, reconnect. For many teachers, on the other hand, the correction of student errors was central to their sense of identity as professionals, much as if they had taken an Hippocratic oath to do so. To let errors go by uncorrected was equivalent to tolerating the perpetuation of misinformation; it was like a doctor standing idly by while a patient is bleeding. The writers (to take the bleeding analogy one step further) were decidedly squeamish about teachers' red-inking, as though it had for them symbolic connotations of maiming. One might well ask if the children could possibly have felt as deeply as the writers did about the red ink which the writers were protecting them against. On the other hand, one does meet cases of people who say they were scarred for life by a high school teacher's red pen. Be that as it may, the different associations which these two groups brought to the issue of correcting spelling and grammar suggest that it was partly a battle over professionalism and territoriality. Who was to be the "professional" in the classroom in this matter of language: the classroom teacher or the writer?

The writers, aristocrats of the word, had formed an alliance with the lower orders, the students, over the heads of the teachers. Since the writers had so much command over language and its operations, they could afford to dismiss grammatical concerns as petty. Just as the rich and poor are both said to have an "inability to defer gratification," though for entirely different reasons, and to share a dislike for the middle class's emphasis on this frugal virtue, so the writers and scholastically poorer students had in common an antipathy to the punctiliously "correct" language of the teachers in the middle—though, again, from rather different points of advantage.

So we return to the question of language in relation to social class. American public school teachers, as a general rule, come from the lower middle class. Bourdieu and Passeron, who make the point, citing Calverton, that in the United States it was the lower middle classes that marked the cultural and academic traditions from the very beginning, (whereas in France it was the *grande bourgeoisie* aping the aristocracy), go on to draw the following intriguing analysis:

> The distinctive features of the language of the lower middle classes, such as faulty hypercorrectness and proliferation of the signs of grammatical control, are indices among others of a relation to language characterized by anxious reference to the legitimate norm of academic correctness. The uneasiness about the right manner—whether table manners or language manners—which petty-bourgeois speech betrays is expressed even more clearly in the avid search for the means of acquiring the sociability techniques of the class to which

they aspire—etiquette handbooks and guides to usage. This relation to language can be seen to be an integral part of a system of attitudes to culture which rests on the pure will to respect a cultural code more recognized than known...

It is always dangerous to make sweeping generalizations about the language or manners of any group; but this particular characterization of the lower middle classes as given to hyper-correctness of speech has become almost a literary truism, from Flaubert's Monsieur Homais on down. Even if it were not true, it would be sufficiently in the back of most writers' minds to account in part for their more *cavalier* stance toward grammatical corrections. Writers are keenly aware that language, including grammar, is alive, dynamic, flexible, never finally fixed. They are in the business of trying to change it—but they know that history would do it for them even if they never existed. Schoolteachers generally do not have—nor are they allowed the privilege to take—such an anthropologically and historically relativistic attitude toward language instruction. Their professional tendency is indeed "to respect a cultural code more recognized than known," like the cloaked authority in Kafka's *The Castle*. Its unknownness helps to explain the vague, pressing insecurity with which most classroom teachers relate to "correct" spelling and grammar usage. There *is* no stable, fixed code; and yet they are expected to teach one. The test they take to be admitted into their profession is often more heavily graded for spelling and grammar than for content. The result is a general paranoia about these issues in the schools; the anxious sense that one can be caught off-base at any moment;* and the fostering of "the peculiar dialect of New York school principals," as Paul Goodman observed, "carefully learned, for the Board of Examiners, to provide a standard for the children of immigrants from all Europe in 1890, but that nobody ever spoke on land or sea."

Black English, Racism, Reverse Racism, and Double Binds

The language barrier between classes is complicated in the United States by the racial issue, since Blacks and Browns constitute a noticeable portion of the lower classes. The dialect spoken by many Blacks (as is true with Chicano or Cajuns or Native American Indians) differs in many ways from Standard English; and too often these differences have been regarded by school authorities as evidence of a slowness to learn. Apologists have explained the assumed language inadequacies by "deficit theories" which cite, among Blacks for instance, the brutalizing influences of slavery and segregation, and the black family structure. But with defenders like these, who needs enemies? As J. L. Dillard points out in *Black English*: "the explanation, 'He's not responsible for his failure because he's deficient in language' is so close to meaning, 'He's not responsible for his failure, he's not quite a human being'..."

Dillard argues quite persuasively, it seems to me, that Black English is a distinguishable language strand with a history, grammar and syntax of its

*Recent exposes by the *New York Post* about the supposed rampant illiteracy among public school principals and schoolteachers rested all their evidence on grammatical and spelling errors—as though there were nothing more to literacy than that.

own: The unwillingness to recognize this fact, and the tendency to treat Black English as a sloppy or lazy imitation of Standard White English, has resulted in condescending and wasteful programs aimed at "concept-building," as though the difference were one of intellectual faculties rather than cultural patterns. Dillard cites many examples of this misapplication of energies, which he compares to giving swimming lessons to fish:

> A national magazine ran an article in 1966 in which teachers were encouraged to teach the disadvantaged that "things have names." Undoubtedly, the three-year-old is in reasonably good control of this kind of esoteric information; the fact may be, of course, that he has *different* naming patterns from those of the dominant culture. Here, as in so many cases, difference from the middle class is interpreted as lack....
>
> Another was convinced, because the Black-English speaking child has a different prepositional system from that of Standard English (e.g., *put the cat out the house* instead of *put the cat out of the house, I'm goin' Grandma's* instead of *over to Grandma's, she teach Francis Pool* instead of *she teaches at Francis Pool*), that the children did not understand locational relationships! Her teaching device was that of the infamous ducky wucky; she carried about with her a little plastic duck and a little plastic red barn, and demonstrated by saying, "Look, the duck is *under* the red barn" as she picked up the red barn and put the duck beneath it, etc.

Dillard manages to maintain his good humor through it all; but the situation, if clearly absurd, is also wrenching and bleak, especially when one considers that these dialectal differences have serious economic consequences in terms of these youngsters' future chances for advancement. Goodman addresses this problem of ghetto black children:

> Consider when the children go to an official school. They do not really use the dominant code. They are not allowed to use their own dialect, and certainly they are not encouraged to improve it. Then they are made to feel stupid, as if they did not have intellectual powers. Humanly, they have no alternative but to affirm their language all the more tenaciously. But then they have still less access to the common goods. The situation is explosive.

Dillard's *Black English* appeared in 1972, Goodman's *Speaking and Language* in 1971. But many of the points they made had already been known, in a gut way, years before, by the group that formed Teachers & Writers Collaborative. Its decision to get involved in the New York City public schools at that time meant nothing less than a conscious and bitter fight with racism.

By 1967-68 the issue of racism had been brought North. It could no longer be seen as only a problem of Bull Connors using cattle prods or rednecks spitting at Autherine Lucy down South. During the 1968 teachers' strike in New York City, a good deal of black-white animosity came to the surface. The Collaborative's sympathies were largely with the Oceanhill-Brownsville and other local black and hispanic school boards that wanted community control of the schools, and against the teachers' union, the UFT. Not that anyone asked us: T & W was too inconsequential to matter in that major struggle. But it was such a raw civil war that it left a deep effect on anyone coming from the outside, trying to work in the schools that year. Black and Puerto Rican writers in the Collaborative were turned off by what they saw happening in the schools, in ordinary classrooms, where minority children

seemed constantly to be getting the short end of the educational stick.

It is important to remember that the Collaborative's first crew worked mainly in all-black or mostly black schools. Although funding may have had some bearing on this, the much weightier reason was perception of need. Reputable writers were drawn to the program by, among other things, the chance to exercise their social consciences by spending a term in the ghetto. Guilt, no doubt, was a factor, though this in itself should not discredit the effort—many civilized improvements come about partly through guilt, as one can't always wait for the right moral act to be precisely aligned with one's self-interest. In any event, racism was seen very keenly at the time as everyone's business: not only as a social disease but an individual one, and each thinking person was asked to look into himself or herself to ascertain the degree of personal contamination.

What was being demanded, in fact, was a very high degree of personal honesty; and not everyone was able to rise to that standard. There were, inevitably, defensive over-compensations, and a tendency in the early days of the Collaborative to make an "overvaluation" of black children's writing, as Karen Kennerly has stated. White writers, aware of the charge made by some members of the black literary community that they had no right to judge the work of young black writers since they were ignorant of the standards and oral traditions from which it grew, tended to lean over backwards in assessing black children's written compositions. Slogans of black pride were accepted as, *ipso facto,* poetic. Writing with a Black English tinge that purported to "tell it like it is" was acclaimed without reference to any original perception it may or may not have had. As Dillard was careful to insist, Black English, while a language-system on its own, was not necessarily or invariably a more expressive one: "In the same way that Jim Crow can become Crow Jim (attaching excessive value to the incidental features of the Black culture), statements about the richness of the vocabulary can become as embarrassing as the more prevalent mistakes about 'deprivation.'" Certainly, the work in a book like *The Me Nobody Knows* is rather pedestrian and meager from the standpoint of language and imagination, yet it sold thousands of copies because it corresponded to a momentary hunger on the part of people, mostly white people, to hear deprived schoolchildren expressing—deprivation. Drugs, roaches and muggings—what had seemed at first a breakthrough in honesty, became in time a mannerism: was this all that was in these children's minds, or was it what we were asking of them? Were we not perpetuating another folly of "authenticity," another Noble Savage? While it is one thing to meet students "where they are coming from," it is quite another to leave them there—or to insist that they stay there.

June Jordan's powerful letter to the Collaborative (reproduced in full on P. 145), goes straight to the heart of the question:

One should take care to discover racist ideas that are less obvious than others. For example, one might ask: Will I accept that a black child can write "creatively" and "honestly" and yet *not* write about incest, filth, violence and degradations of every sort. Back of the assumption, and there is an assumption, that an honest and creative piece of writing by a black child will be ungrammatical, mis-spelled, and lurid titillation for his white teacher, is another idea. That black people are only the products of racist, white America and that, therefore, we can be and we can express only what racist America has forced us to experience, namely: mutilation, despisal, ignorance and horror.

112

June Jordan, one of the Collaborative's most dedicated workers and a fine poet in her own right, in fact supported strongly the greater awareness of Black English and the notion of reproducing the children's original language as written; but she was angered by what she detected as a preference for ghetto sensationalism on the part of the front office. The original letter which touched off her reply has been lost in the holes of time, so it is impossible to assess or to take sides in this controversy; but one senses that the anger came from friendship, that she cared enough about the people in the Collaborative to want to clear the air. Jordan defended her student Deborah's falling under the influence of Robert Louis Stevenson and writing in that high style, rather than in her own native Brooklyn-Black tongue, by saying that children should learn what is in the libraries, and that poets have always developed by creative mimickry. But, beyond that, she says, "a poet does not write according to the way he talks. Poetry is a distinctively precise and exacting use of words—whether the poet is Langston Hughes, or Bobby Burns."

These remarks strike us today as salutary and professional. Her distinction between poetry and speech is a valid critique of an originally useful pendulum-swing (towards colloquialism), which unfortunately was taken too literally and applied too religiously, as so often happens with educational fashions.

What also seems to be happening is that the training of a poet and the insistence on literary quality—one's personal tastes, perhaps—may not always be running on the same track with one's broad political and social goals. They may frequently come into conflict within the same person.

Censored Language

Another source of linguistic tension and controversy developed around so-called "filthy language": four-letter words or slang terms for animal parts and functions. The writers felt generally that such words were part of the students' everyday vocabulary, and were used often for colorful and expressive effect; and even when that was not the case, these words were an inescapable fact of language-life, and they, the writers, were not going to "launder" student compositions or be placed in the role of censors. School administrators and teachers, on the other hand, reacted with immediate nervousness to the political pressure they feared might be put on them through infuriated community-members, even when they themselves were not shocked by seeing such language on the page (though in many cases they were shocked).

Within the school system, custom had established a range of behavioral and bureaucratic responses to a nicely-graded series of provocations which, if hypocritical, were pragmatic. Cursing might be tolerated in the halls but not in the auditorium; a four-letter word might appear in a written composition so long as it was kept isolated to that classroom; the moment it was reproduced in any form and allowed to leave the school grounds, there was trouble. Herbert Kohl and Zelda Wirtshafter, with their classroom teaching backgrounds, were more sophisticated about and able to operate within this grey area than most of the writers. Kohl once told me that he introduced students to the possibilities of euphemistic substitutions from other languages, like "merde" for "shit," or code-words that gave the student-writer

the pleasure of saying something forbidden and getting away with it. (Again, the double-language of allegory and fable, now applied to the individual word.) Zelda Wirtshafter's attitude was:

> It just boiled down to case by case. Depending on the community where you were working, you did have to respect where the parents were at. When I was a teacher I would discuss with the kids very openly the fact that we do have double standards about using words or ideas in certain contexts, and we have to be sensitive to the particular situations.

Still, the Collaborative's administration leaned much more toward total free speech than toward double standards. Its position, as stated in the 1968 Final Report, was:

> No arbitrary limits should be placed on the range of experience and language used in the classroom. If children or teachers feel that words or references or ideas that are important to them must be censored—or are "out of bounds"—then the classroom itself can become a sterile and irrelevant place.

And this was not only a position on paper; the front office backed up writers publicly and privately in any controversy over censorship, of which there were a goodly number in the early days of Teachers & Writers Collaborative. School after school went off like a chain of firecrackers. The Berkeley "free speech" affair and Lenny Bruce's conflicts with the law over language were still fresh in people's minds, and there was a tendency to re-enact this confrontation over censorship in one school after another, like a passion play, with the writer and his students on one side, the Principal and his supporters on the other, and the ones with torn sympathies wringing their hands in-between.

I was involved myself in one such confrontation in my first year with the Collaborative, when I encouraged the students at a commercial high school to edit their literary magazine by themselves. The students got in trouble for distributing a leaflet (to me, incredibly bland) which said: "Contribute to *Transition*, run by students this time." The Principal was hurt by the implication that there had ever been any adult censorship in the past—and also had the leaflet confiscated because it had not been cleared first by his office! At a public meeting to resolve the matter, he asked me ingeniously, in front of everyone: "Surely you don't think the students know enough about proper English, grammar and style that they can be entrusted to do all the editing themselves." It was an appeal from one professional to another, completely sidestepping the problem of content, as if the only question were editorial polish. I answered that I thought it was more worthwhile for high school students to have the experience of running their own show, even if they made mistakes. My days were numbered in that school.

High schools particularly were tinderboxes in 1967 and 1968, and high school administrators tended to over-react at the first sign of "revolutionary" student activity. The growth of underground newspapers was one phenomenon that kept administrators on edge. A student publication might be censored not only for off-color language, but for controversial subject matter or tone, such as an irreverent piece on drugs, religion, or politics. Or it might be suppressed merely because it came from other than official school channels. Art Berger's account of the storm over his Newtown High School poetry

114

workshop (see p. 171) is a classic portrayal of a rigid high school administration, for whom free verse alone is a threat—as well as of a righteous, somewhat cloyingly naive visiting writer of the day.

It is obvious that writers have a professional interest in fighting censorship. An attack on the freedom of the word anywhere is felt as a threat to all. Speaking out is our bread-and-butter; we come, or should come, passionately to the defense of other censorship victims, even the seediest, because we know what it would mean to our own writing process to have to circumvent whole roped-off areas of thought. But the situation has its paradoxes, as Paul Goodman has pointed out. "We cannot tolerate censorship; yet when there is censorship, we at least know that our speech has energy—it has hit home. Censored, we have the satisfaction of righteous indignation, we can expect the solidarity of our peers, and we can have a fight."

In the end, there were plenty of fights, and plenty of righteous indignation; and the American Civil Liberties Union and *The Village Voice,* among others, came to the aide of Teachers & Writers Collaborative personnel wounded in censorship skirmishes. Yet, even these free speech advocates had their sympathies strained when a poem written by a black student in a writing workshop, and read over Pacifica's WBAI-FM, contained material which seemed to caricature Jewish merchants in black ghetto communities. There was clearly more to be nervous about than four-letter words, when once you took seriously the principle of encouraging students to write anything that was on their minds. The Collaborative was learning that honesty may be the best policy (especially in drawing writing out of young people), but it may also be the most dangerous one.

One of the side-effects of these confrontations was that Teachers & Writers Collaborative gradually pulled out of the New York City high schools —which had become simply too hot to work in—and, for a number of years, concentrated on elementary schools, where there was more tolerance in the community for small children's creative statements, more of a "kids say the darndest things" attitude, and less chance of running into a fully articulated piece of either revolutionary or anti-social student writing.

Grant Proposal Language

There is finally one more irony about language to consider, which has to do with the difficulty for people, opposed to the Federal Government at that time, writing to that same government asking for money to fund their program. As Kohl pointed out in his interview, two-thirds of the initial Board of Teachers & Writers Collaborative were also on the National Board of Resistance. The question then becomes: what language does one put in one's mouth, to plead for survival from a benefactor one would like to injure?

Teachers & Writers Collaborative was established in April 1967 under a grant from the Office of Education; and its final report to the O.E., issued in September 1968, both plays the game and doesn't. There is the usual "Summary of Objectives" and "Significant Findings" at the beginning, followed by sections of "Philosophy and Aims," "History and Achievement," "Description of the Program," and "Conclusions and Recommendations for Future Research." In typographic layout it looks exactly like a final report to a

funding agent: that is, it achieves its genre (this strangely modern form of "epistle to a patron"). Early on, in the section intended to give the philosophy and pedagogic rationale for the program, there are passages such as the following, which I quote in full in order to suggest the flavor of the language throughout:

> The immediate purpose of Teachers and Writers Collaborative, therefore, is to involve teachers, students, and writers in the creation of an English curriculum that is relevant to the lives of children in schools today.... It is our belief that the study of English begins with the words a child learns to speak. The small child's first words usually refer to highly important aspects of his life (e.g., "mama," "bottle," etc.). The elementary school classroom, and later, the English classroom, ought to be a place wherein this vital link between life and language is maintained. The classroom ought to be a place for talking about important things, i.e. things of immediate concern to the children involved, which ought to lead to writing and reading and talking some more. These activities—writing, reading, and talking—are interrelated and inter-dependent; they develop best when they are developed mutually. We believe that the English classroom ought to encourage children to use their language, their experience, and their imagination to create their own literature, both oral (dramatic) and written.
>
> Children who are allowed to develop their own language naturally do learn easily and rapidly to extend their language. When, for example, children write their own books and read them to others, they are, in fact, extending each other's language. Furthermore, we believe that the love of language and literature precedes (or at best, accompanies) the learning of skills. Children who are encouraged to write stories will be better readers of stories, and, in the interest of making their own work readable, will have reason to improve their spelling, punctuation and grammar.

The ideas are decent, even correct. The argument contains little anyone would be tempted to argue with; and there is even a certain shrewdness in its disguising the controversial potential or politics of the program with an appeal to improving reading skills and grammar.

But beyond that, what can we say about this sort of prose as prose? First of all, it is undistinguished. Boring. It can be rolled out indefinitely like carpet runner. Each sentence follows a lock-step rhythm, "present-arms" with the same monotonous syntax of subject-verb-object; yet, rather than falling into the gait of a march, where regularity at least has the chance of becoming dramatic, the sentences stall in their middle with hyphenated or parenthetical qualifiers, and repetitions cautiously masquerading as distinctions. There is a love of lists, and strings of twos and threes. Take the sentence: "These activities—writing, reading and talking—are interrelated and inter-dependent; they develop best when they are developed mutually." Aside from the fact that everything is interdependent on some level (but especially in grant reports), such "clarifications" as the second half of the sentence are often made when one fears one is writing to an idiot who won't get the point the first time. Skepticism about the intelligence (or even the existence) of one's reader has a deep effect on the language of such reports.

The verbs all seem to be either passive, predictive, or hortatory.

The words themselves might come from the same scrabble box. They are, above all, abstract: one gets no pictures from them. And notice the sprinkling of directional signs that orient, or rather, reassure the reader that an orderly flow of logical processes is being pursued: "Furthermore...wherein...e.g.,...as well as...for example...regarding...insofar as...." This is the language of legal contracts. Of course, grant proposals and progress reports *are*, in a sense, legal

116

documents, which bind the author to a course of action, and can be introduced in a court of law to show breach of promise; this alone would make for a certain caution and reluctance to specify.

The paradox is that even the attempt to jazz up the passage with words like "vital," "immediate," "real life" and so on, adds no spice to the bland tone, because these terms are so maddeningly vague themselves! *Involve, relevant, immediate*—this whole sixties vocabulary is so non-referential, it is amazing how little it actually conveys ten years later. Perhaps they meant more then. Or perhaps the ideas which such words pointed to, vaguely, were still incubating; they referred more to an unhatched wish than objective circumstances; and the biggest romantic fiction of all was "real life," that vague, longed-for, always-invoked symbol of everything missed or missing. "Real life" seems to be at times a protected middle class's yearning for some unattainable contact with the world, projected outward as an indictment of the schools.

Consider this effort to elucidate "the vital link between life and language": "The classroom ought to be a place for talking about important things, i.e. things of immediate concern to the children involved...." Does this explanation bring us any closer to an understanding of the "vital link," or are we witnessing merely a subgroup using its private language in an incantatory, self-reinforcing manner (in this case, open education language, with its stress on "immediacy and involvement"—though it could just as easily have been Marxist, Freudian or EST terminology)? Between the mesh of legalistic caution, and the hermeticism of ideologically self-reinforcing jargon, very little "world" manages to come through.

By no means should it be assumed that I am attacking the authors of the Collaborative's progress report or saying that they could have done better: on the contrary, their writing sounds precisely the way everyone else's language does in grant proposals and reports. They are writing within the linguistically prescribed bounds of a fairly deadly genre. This is committee language, safe even when it wants to be risky. The instructive part is that it doesn't much matter whether the speaker is an open classroom advocate or a C.I.A. operative reporting from the field. Radicals, moderates, fascists—all speak the same language on their knees. It is a language designed to conceal as much as to inform. For if it did reveal one's precise thinking, the statement might be too far out of line with the funding agent's political position; and one might never receive any money from them again.

So a dizzying set of translations has to be effected. In the case of the early Collaborative, this meant translating from the languages of university-trained intellectuals, Blacks, street kids, radical political rhetoric, to research bureaucrats, who want to see evaluations, goals and test scores. But at the same time as they were playing this game, the grant-writers were careful to save their souls (in case God was looking) by inserting statements that sideswiped the system and mocked its ideological assumptions. So, in this 1968 Final Report, the put-down of "authoritarian education" becomes a code-attack (for those who can read between the lines) against the whole military and the government in Vietnam.

The melancholy comedy is that these touches, these refinements for integrity's sake, make no difference to anyone. Finally, the medium is the

message here; and progress reports are scanned, not read: like radar screens.

Roland Barthes has made the brilliant point in *Writing Degree Zero*, that the French communist novelists, by writing in a style of hackneyed nineteenth-century realism and baccalaureate exams, undermine their very efforts to create revolutionary consciousness. It matters little how doctrinarily "right on" their story is: the sub-message, embedded in the style, is one of conservatism. So language betrays—especially intellectuals, who so often fall into the trap of reinforcing linguistically the system of power relations they are denouncing.

The grant report is a particularly fiendish trap in this regard. But it is exciting to see Wirtshafter and Kohl address themselves to this very point, and —for one moment—break out of the cage. To their indifferent sponsors, the Office of Education, who have already abandoned them by refusing to re-fund the program, they declare bitterly:

> Why produce another document to be filed away that records frustrated hopes and unrealized possibilities? But a final report is required of us and so here it is. It would be better if we could submit the 300 pages of writers' diaries and more than twice that of young people's writings we have generated, and ask people to read and feel what we have done. But we can't, people don't have the time. Instead this report must stand. Only it must be said that the passion and the frustration, the hope and energy that have gone into our work are only indicated obliquely here. The frustration of facing an ending to our work when we were only beginning is implicit in this report, yet it too is suppressed through the conventions of "objectivity" and "research" reports. Therefore these few words must stand to indicate what we feel about our work and its premature ending—something no one has asked us.

Perhaps it is not too far-fetched to see in this passage, which is so different from the other in its honesty, directness and personality (not to mention flexibility of syntax), a strength which finally kept the Collaborative from going under. In cutting free of both public relations and bureaucratic educational parlance, it opened the way for more honest work to take place— because you do become the language you use, make no mistake about it. And in understanding the value of the young people's writing and the writers' diaries, it pointed to the future course of documentation which Teachers & Writers Collaborative was to take.

Frantic Letters And Memos

by Zelda Wirtschafter

December 18, 1967

Herb Kohl
c/o Dept. of English
University of California
Berkeley, California

Dear Herb,

WHERE ARE YOU? Please send to my home, *air mail, special delivery* an address and/or phone number where we can reach you. I'd assumed you had left this info at the office.

The following things have come up and I need to hear from you IMMEDIATELY in the following order of priority:

1. NEWSLETTER

Since you had told me you were compiling the Dec. *Newsletter* "as you went along," and had given me the distinct impression that it was more or less ready to go out with the exceptions of 1) a covering memo from you (promised over two weeks ago!), 2) a note from me (which I will write immediately on receipt of your memo), and 3) a short paragraph from you on just what we mean by 'curriculum unit,' I was highly distressed—that old Victorian APPALLED is more like it—to discover today that the *Newsletter* is actually in the same nebulous state as was the fable unit: i.e. consisting mainly of a general list of items to be included, some specific examples of which have been selected by Joan and Karen, but none of which have actually been *reviewed and edited by you* and tied together in some kind of coherent form. SOOO—Karen is now writing short covering paragraphs for each of the sections, and I guess we will just have to make do with the examples she and Joan have chosen, or we're never going to get it out. Please send your introduction NOW if you haven't already, and let's forget about item #3 for this issue and include it in the next one, when hopefully, we will also have a trial approximation of the fable unit as well. Naturally, I will take a look at the completed *Newsletter* draft, and will send it over to Bob [Silvers] for general editorial-type comments (he has agreed to do this), before it goes to the typist. Because of the holidays, etc., please send your part to me at *home*, AIR MAIL SPECIAL.

2. CCNY PROGRAM

Who is involved? What is our commitment to them? What are they doing for us? David Henderson has been coming in with whole books to be reproduced, etc. "for use with his class?" and generally seems to be under the impression that Joan is running a printing service. Comments, please!

3. ERIC MANN

What was your final understanding with Eric? What did you have in mind regarding his diaries, or article—how and in what form did you intend to use them for Teachers & Writers??? He says we still owe him $120. A short summary and recommendation please.

4. T & W ANTHOLOGY

My understanding of the *Anthology* was that it was to be a loose collection of prose, poetry etc. that various writers in the schools had actually tried out with children and found to be useful (their own work and/or work of others). What specifically did you tell the writers—i.e. are there any guidelines or criteria for selection? My feeling is that some of the writers are under the impression that this is to be a 'showcase' type of collection of examples of their work for publication to a wider audience. Is that what you had in mind? Did you plan to or do you think we should mail out the *Anthology*? If so, to whom?? My own feeling is that if the *Anthology* is edited on the basis of material *actually used with children,* together with short notes describing how each piece was used, with what age level or levels etc., and the general reaction in each case, that this could be a useful document for teachers in and of itself.

Also, we need to clear up the whole copyright problem. Is there any need to copyright the *Anthology* as such? Frankly, I don't see how we can do this at present, since the individual contents should first of all belong to each author and we are merely reprinting 'with permission,' and since the *Anthology* is a changing thing, for the use of the writers working in the schools, and not a 'publication' being distributed on a wide basis. However, what, if anything, have you found out regarding this, and whom would you suggest I contact for further information, in view of the fact that we are a government-supported operation?

Hope you and Judy have survived THE MOVE, and are at least well-enough established to be able to enjoy a happy holiday, etc., light the lights, and muster your forces for a good 1968.

Best,

Zelda

TO: Ben DeMott
 Betty Kray
 Bob Silvers
 Tinka Topping

FROM: Zelda Wirtschafter

RE: Emergency Meeting on Status and Future of *Teachers and Writers Collaborative*

Date: Thursday, January 4, at 12:30 P.M.
Place: Oak Room, Plaza Hotel, NYC

AGENDA

1. Background

On Friday, December 15, Herb spoke with Charles Blinderman of the National Endowment for the Humanities, and told me that this man was very enthusiastic about T & W, was interested in supporting us through the Endowment (as opposed to the Office of Education which is where our money now comes from), and in addition wanted to give us an extra $10,000 to set up a program using university graduates as interns in elementary and high schools. I explained to Herb, that setting up the latter type of program is a very involved affair which would take at least 6 months to a year of negotiations, UNLESS Blinderman already had a university and receiving schools in mind and it was just a question of finding a coordinating agent. Herb said he didn't know exactly what Blinderman had in mind, but that I would receive 1) application forms for submitting a T & W proposal for support, which I should send to Herb to fill out, and 2) details regarding the graduate intern project. We received the project grant application (addressed to Herb, but with no covering letter), and I am holding it pending our meeting on January 4th. We have not received any material regarding the internship proposal.

On Saturday, December 16, I met with Florence Howe (whom I had seen the night before at our party) for approximately 4 hours. She told me that she and Paul had made the original contact with Blinderman, who is an old and close friend of theirs, and that she had repeatedly asked Herb to set up a meeting with the executive board so that she could explain the possbilities of our getting support through the National Endowment, and we could then follow up on submitting a proposal, etc. (The last date for submitting proposals was December 14; the next date is approximately six weeks from now, and Blinderman told Florence that the reason we had not received a continuing grant was the Herb had never sent him a proposal. Herb had told me nothing of all this.

I asked Florence if she would be willing to contact Blinderman on our

behalf, maintain negotiations, and write up any proposals (at our normal honorarium rate), since she already had a relationship with him and would be in Washington. She said she would, but that her main interest would be in setting up some kind of internship program using college English students to teach in high schools (along the lines of the project she had previously submitted to Herb), which would eventually lead to the development of a new kind of MAT program. We discussed this at some length, and concluded that before we could do this on any legitimate basis, we would need to have developed a body of curriculum materials and entered into negotiations with both universities and the school system, all of which would be at least another year in the offing. However, some components could certainly be worked into our over-all program, especially once we had a clearer idea of what Blinderman had in mind, and after I have seen Elliott Shapiro regarding setting up a program in district #3. In any case, Florence agreed to help us with getting a proposal into Blinderman as soon as possible, find out how we should go about it, and what should be included.

On December 27, I spoke to Florence again and learned the following:

a) Herb had not told Blinderman that he was leaving, and Blinderman had no idea of who I was.

b) The policy of the Foundation requires that proposals be submitted along with the names of a project director and any other key personnel, with the understanding that these individuals are thereby committing themselves to carrying out the project on a full-time basis. They are not concerned with "Big Names" as such (and actually discourage this) but with ensuring a serious commitment that the project will in fact be carried out, before they hand over any money.

c) Blinderman apparently has great confidence in Florence, and became interested in T & W under the impression that she and/or Paul would be playing an active role.

d) Unless Herb actually intends to return as full-time director of T & W (and at this point, I don't know if even that would help), we will have to find someone who would be able to commit himself full-time, before we can submit a proposal.

I think the thing for us to do now, is to set up a meeting with Blinderman directly, and find out exactly what our prospects are, and if it would be possible to submit a proposal under our existing set-up (or with some kind of shared directorship).

2. Current Status of T & W

On Thursday, December 21, I met with Mr. Summerscales (Ianni's assistant and the person in charge of all our money). He told me that we had no legitimate status on our own, our board of directors was in fact illegal, (or

122

at least, non-legal) and that all salary appointments, etc. were made by Teachers College, Columbia University. This meant that our proposed raise for Karen is impossible, and she has accepted this with good grace. It turns out that the Office of Ed. money was given to the Horace Mann Lincoln Institute of T.C., and we are merely carrying out a special project for them. (I had been under the impression that the money had been given to *us*, and was simply being held in trust for us by T.C.). This also means that we cannot in effect fire anyone on appointment.

Furthermore, the budget changes on which I had based our current budget (according to the information Herb had given me) have never gone through, and there is some doubt as to whether we can make transfers of money from one classification to another (take money out of the Transportation Budget and put it into the Honorarium Budget, for example). Herb and Summerscales had previously gone over all of this on several occasions, and Herb had told me it had finally all been worked out. In order to clarify this once and for all, Mr. Summerscales and I will make an appointment to look at our actual contract which is kept in a vault and cannot be duplicated or removed from the financial office. Unfortunately, we cannot do this before the week of January 8, since the man in charge and Mr. Summerscales will both be on vacation.

3. Support from April to June, 1968

Dr. Ianni has made a verbal commitment to Herb and me regarding continuation of support through this period, either through Columbia's Ford Grant, or through Office of Ed. money (Junius Eddy has apparently expressed interest in continuing or renewing support). I will set up an appointment to see Ianni for the purpose of finding out exactly what he wants in the way of a proposal, and Herb has promised to write it up. I think it might be a good idea for Tinka to go with me.

4. Support after June, 1968

This of course is our most pressing problem right now, and we need to make a decision as to what course to pursue (see background comments above). My own feeling is that we should try everything possible to switch the source of support from the Office of Education to the National Foundation on the Arts and Humanities, which would then enable us to get out of Columbia, have more independence, and use our funds to better advantage. Under our present status, we are burdened with an enormously complex and time-consuming bureaucracy as regards our budget expenditures, and a great part of our grant (taxpayers' money) is simply going to support a private university. In addition, I personally feel a moral discomfort at being part of the intricate government-university-war and defense effort relationship. To the best of my knowledge, a grant from the National Endowment for the Arts (Carolyn Kizer) and Endowment for the Humanities (Charles Blinderman) could be administered through Betty's Academy of American Poets, and I think we should find out about this in detail.

Another possibility is incorporating as a non-profit organization along the lines of the old ESI.

Happy New Year!!

Zelda

Letter to Benjamin DeMott

January 15, 1968

Dear Ben,

Unless Ianni (who I have not been able to see, despite repeated and urgent requests) comes through, or we are somehow able to cut through the very intricate web we're now entangled in at the O.E.,* there seems to be the very real possibility that T & W will be out of business come March 31, 1968 (end of our current contract). Junius Eddy is probably the one person who understands all the specific details of our entanglement and their various implications, should you want or need this information quickly.

As far as my "personal" interest is concerned, I would be just as happy to be finished with it, since certain administrative (budget and fund-raising) aspects, which Herb had assured me were all taken care of turn out not to be, as well as a number of other items (the December *Newsletter,* etc.). These have burgeoned into an enormous take-home load of after hours work and T & W is now threatening to engulf my living room (in both the literal and figurative sense).

The balance is way off—and the proper work of the Collaborative is being neglected as a result.

However, my "professional" opinion is that from the evidence collected to date (writers' diaries, response of teachers, students, etc.), we are definitely on a promising track and it would be criminal to cut off the program at this premature date, when we are just beginning to set up a solid core of writers who are ready to go into a variety of schools (in NYC and *elsewhere*) on a semester-long commitment. At the very least, the April-June extension would enable us to provide a substantial body of evidence testifying to the validity and worth of this kind of program in terms of its potential for curriculum development, teacher training, and in its larger implications—the feasibility and desirability of employing "artists" in the broadest sense of the term, to work directly with children and teachers in public school situations.

The latter has been and continues to be a very tough nut to crack. School people and others "in positions of responsibility" tend to think of artists— painters, writers, musicians, etc., as irresponsible (bunk) madmen (true enough, in the best sense of the word!) who might, if let near them, contaminate, pervert, incite to riot (?), etc. the precious children. Meanwhile, the children die in school, and get out as soon as they can, and what do they do? —they run, fly, take refuge in the nearest available madness (sanity) they can

*United States Office of Education

find: some of it "responsible" (the Beatles, etc.), and some of it not (LSD, and other trips).

I seem to have gotten off on my own trip here—(it's Sunday night, 2 a.m.)! Anyway, to get back to the point, everyone of the writers who has gone into schools, has shown "responsibility" to his craft and to the task at hand, as well as the ability to seriously and enthusiastically engage young students (most of whom "hate English") in the business of what prose and poetry is all about.

BUT, we've only a tiny beginning to date.

BUT, we have the writers ready to go, and schools here, who want them, and I could, with a few phone calls set up more (writers and schools) in St. Louis, Chicago, and other non-NYC places.

BUT, T & W may not exist after March 31——

BUT, the returns in terms of effect on the children and useable, "exportable" material, from a writer going to a class three or four times are negligible, whereas continuing for the whole semester (more or less to June) would yield real results.

BUT, T & W may close down on March 31—and so it goes.

Ben, my standards as an "educator" are uncompromisingly high—out of the whole morass of "pilot projects," curriculum projects, teacher training programs etc. that are currently causing so much brou-ha-ha, there are very few that I would be willing to endorse in any way.

I am equally impatient with the enormous waste of public funds involved in so many of the government-sponsored "studies," and to be brutally frank, I think T & W has been guilty to a small degree as well, and much of what we "produced" this past fall is fancily-iced crap. But the pages that belong in the waste basket are an inevitable and necessary part of the whole—and we'll probably have more before we're done. Meanwhile, T & W should go on—there's real stuff and good people to work with there.

As requested, I am enclosing some excerpts from writers' diaries. I've also enclosed some from kids—use them or not as you think best.

Regards,

Zelda Dana Wirtschafter
Director

ZDW/dlp

June 19, 1968

Dear Herb,

...The final typing, reproducing of the required number of copies and all of that will be done in September here at this office, so don't worry about that end of things. What I really need from you is the heart of the report itself, and if you could get it to me sometime within the next few weeks (sent to my

home address), it would be a great help. I am hesitant to leave any of the major writing until September since (1) we may not have an office, and (2) I don't know how much time I will have to devote to coordinating the thing, since I won't be on salary any more.

Also enclosed is a packet of materials which should help you pull everything together. Since the progress reports and Endowment proposals have not been publicly distributed, feel free to crib word for word anything that serves your purpose. Since we have already distributed the *Newsletter* and the Fable Unit, and since they exist as self-contained materials, I don't think we should include them as part of the final report proper. What I thought we could do is append a list of materials produced during the year with a note to the effect that sample copies of these can be obtained from Teachers & Writers Collaborative, or whoever is our follow-up liaison at Teachers College.

The Arts Council, which met last Friday, June 14th, never brought the subject of support for Teachers & Writers to a vote (Carolyn Kizer had set up a proposal that they give us $60,000 on a non-matching basis) so at this point we really don't know what's going to happen next year. The Arts Council doesn't meet again until August, which leaves us with the only firm commitment being the Humanities Endowment offer of $40,000 for a writers-in-the-schools and teachers seminar program (no curriculum development). I am reluctant to accept this kind of chintzy grant, but since I won't really be involved next year, I am leaving the final decision up to Fritz Ianni and Joel Oppenheimer. The failure of the Arts Council to make a decision was really a blow, as you can imagine, and I am feeling very bitter and exhausted at this point.

I have also put through a $200 honorarium for your work on the final report. I am putting it through in advance so that I can take it out of the current budget, rather than the $500 set aside for the final report. Since there is a possibility we may not have our own facilities next September, we are probably going to need most of the $500 for the actual typing, printing, etc.

Love to you all.

Warm regards,

Zelda

May 28, 1968

Dear Herb,

Thanks for the introduction for the black/white anthology. I really appreciate your speed.

I have received unofficial confirmation that our Humanities Endowment grant has come through, i.e. $40,000 but so far we have not received an official letter. I have also been riding the merry-go-round with Caroline Kizer [National Endowment of the Arts, Literature Section] and it looks like we will be getting money from them but at this point they still have not received their appropriations from Congress and so are unable to finalize their budget for next year. I hope to know that some time in June.

Have you done anything on your section of the final report? Is it too impossible to hope for something from you by the middle of June? As I visualize the thing I see it including the philosophy section, a summary of statistics and logistics, and an anthology of the kids' writings that has come from the various arms of the program. How does this strike you? Can you think of anything else that should be included? The statistics and logistics section can be put together fairly fast from the four quarterly progress reports (copies of which you already have), plus the 5th report, which I will have done by the middle of June.

Among the significant things which come to mind are the following:

1. All children—white and black, poor and wealthy, city, country and suburban—have an intense inner life that has been revealed in their writings (as evidenced in the anthology), but which had never before been exposed in school.

2. This inner life as revealed in the children's writing testifies to the intuitive understanding and awareness/or perception that children have of the complexities of the society around them. Children are aware of and concerned with sex, violence, social and economic power.

3. In almost every case writers who have gone into public school classrooms have been able to relate directly to the children and elicit written responses in a way that their teachers had not generally been able to do. In addition to the children's writing which resulted from their direct contacts with professional writers, the writers' diaries provided a wealth of teaching ideas which were disseminated through the *Newsletter* to a broad segment of the educational community. These ideas proved both stimulating and practical, as witnessed by the number of responses we received from teachers throughout the country who had seen the *Newsletters* and used many of the ideas contained in them. Furthermore, the accounts of teachers who have worked with our materials thus far, suggest that they have been encouraged to think not in terms of a single lesson, but rather in terms of developing classes, one from another, as they are led by the interest of their students and their own inventiveness.

4. We were not, however, as successful in developing working relationships between the writers who taught public school classes and the regular teachers of the classes. In a few instances the writer and teacher worked together as a team. In most cases, however, the teacher simply turned the class over to the writer and made no attempt to follow up with additional activities in between the writer's visits. In one or two cases the teacher's overwhelming concern with a particularly rigidly enforced classroom discipline—silence and immobility on the part of the children—led them to interrupt the session, thus making it difficult for the writer to function smoothly. It is clear that our limited success in this area was due to lack of adequate planning and orientation sessions before sending writers into the respective classrooms. I feel fairly certain that this problem can be overcome next year by arranging special planning sessions with the teachers and writers who will be involved, with particular attention to devising ways to make the teachers active participants in the project.

5. In every case, both writers and teachers felt it was important to type up and "print" the children's work, in either mimeographed or rexographed form. Seeing their work in print affirmed for the children the validity and impor-

tance of their own thoughts, feelings and words, and inspired them to write more and more and more. They also, when confronted with the printed page, became more aware of spelling mistakes and more interested in spelling correctly. (Note: Include here excerpts from June Jordan's and Lenny Jenkin's diaries pertaining to this whole problem).

Herb, the above is rough and just my thinking out loud for an outline to start with. When I really sit down to cope with this I will probably think of a lot more things. If you have other ideas and/or want to write up this section, please be my guest.

Love to you three.

Warm regards,

Zelda

Letter to Executive Board

June 28, 1968

TO: Ben DeMott
Herb Kohl
Betty Kray
Bob Silvers
Tinka Topping

FROM: Zelda Dana Wirtschafter

Since our meeting on June 4th, things here have progressed from mildly hectic to total chaos! Everything was held up (progress report, *Newsletter,* revised budget for The Humanities Endowment, etc.) while we awaited word from the Arts Endowment.

The National Council on the Arts met on June 14th but did *not* vote one way or the other on granting us support. Their next meeting will be late in August.

We then put out a brief final *Newsletter* (enclosed) devoted mainly to Florence's project in Baltimore, and, in the interests of saving time, sent it to the Teachers College printing office. The resulting job was so bad that we had to have it done over at a regular printer's, thus putting us even farther behind schedule. In addition to all this, Ianni and I decided that we might as well accept (at least for the present) the Humanities Endowment offer (if they decide to give it to us) of $40,000 for writers-in-the-schools and teacher workshops, and hope for the best from the Arts Council. This necessitated more budgets and a new statement of what we would do with the money.

We were also trying to raise money for June Jordan and Terri Bush to enable them to have The Camp Of The Children in July as an extension of June's Saturday classes.

The upshot of all this, and a hundred other odds and ends, is that I have not had time to follow through with Peter Felcher regarding incorporation. Since we as yet have no commitment of money for next year, perhaps we should just let it go until September when we'll have a better idea of where we're at. I don't even know if Joel Oppenheimer and Shelly Halpern can sit around waiting for a job that might not materialize. I plan to meet with them early next week.

In addition to copies of the *Newsletter*, 5th Progress Report, and the memo to Ianni, I have also enclosed the following:

a) Copy of my letter to Herb with suggested outline for the final report (due for the U.S.O.E. early in September).

b) Copy of Robert Coles' letter replying to an idea I had about holding a "symposium" in the fall on the importance of and need for teachers to recognize and capitalize on ghetto kids' natural language and culture. Our biggest problem in this area has been with black children and parents. My thought was that we could organize an intensive series of workshops for teachers in the demonstration districts (I.S. 201, etc.) or any other ghetto district, starting off with a "big-name" symposium and then following up with workshops and classes conducted by some of our writers such as David Henderson, Larry Neal, etc. Anyway, the main reason I'm enclosing it is to send you a little cheer and expression of enthusiasm amongst all the other gloomy news!

Hope you all have a good summer. I'll be out-of-town through July 8. After that, I'll be in Sag Harbor, L.I. (c/o General Delivery) for the summer.

Warm regards,

Zelda Dana Wirtschafter
Director

ZDW:jr
encls.
Letter to Florence Howe

June 28, 1968

Dear Florence:

We've had one catastrophic operation after another here—the latest being the *Newsletter*, which we held up to include your stuff and hoping to get some news one way or the other re money. We finally got it done—it looked beautiful!—and sent it down to the T.C. printing office to save time. The job they sent back (one day late) was so awful, I decided to have it done over at a regular offset shop, even though it means coming in next week to get all this out.

It's really the last gasp I'm running on!

I did manage to find a house in Sag Harbor (will send you the address when I get a P.O. box), and have a room for occasional guests. So—maybe we can set up a board meeting (small) out there—it's close to Tinka's if you and Paul could come down before leaving for N.H. It's a great drive from Boston—you go to New London, Conn. and get the ferry to Orient, L.I. then transfer to the Sag Harbor ferry and you're there. Much less driving, too.

How about extending one of your N.Y.C. weekends and coming out for a few days' sun?

Meanwhile I'm going to hibernate for a week at my aunt's in Hanson, Mass. If I get into Boston (which I doubt) will give you a call.

Love and tired XXXX's,

Zelda

General Delivery
Sag Harbor, N.Y.
September 5, 1968

Dear Herb,

Great news of a new little Kohl on the horizon—as you say, *some* things at least are good!

I have to apologize for my long delay in answering your letter. Here's what happened. I thought we had decided and agreed that the so-called final report would only *incidentally* be for the USOE, and really directed to the hundreds of teachers, administrators, etc. who have been reading and using our *News-letter* and who have requested as much material, information, etc. as we could give them. It was my understanding that because of this tremendous response, and since we had to make a final report anyway, we would try to make it a useful document and not just an officialese rehash of everything we've already done. What I was hoping for was, in addition to the required project descriptions, etc. which could be cribbed wholesale from the various proposals, progress reports, etc., that you would put together some *new* material from the writers' diaries and the final evaluations which would give an over-all perspective of the project from a fresh point of view (your own unique vantage point as being intimately knowledgeable about the project but at the same time having a certain distance from the day-to-day pressures and problems) AND at the same time provide additional ideas and information for our real audience—the teachers. SO-O-O I was really disheartened to find that you had mainly used excerpts which had already been published in the newsletters, (which the teachers really *have* read), and just generally defeated at the thought of having to edit all the cut-and-paste sections, several of which were

repeated wholesale in different sections of the report, and so forth and so on—in other words I was simply overcome by the same feelings of futility and frustration which you labored with, and just couldn't bring myself to look at the thing for a while!

Anyway, I've pulled myself together and started the editing job, and it's really no great catastrophe. As it turns out, we probably won't have enough money to reprint it in any quantity, so it really doesn't matter. The introduction and other sections which you wrote are fine, and the report as it stands, for people who have not previously gotten our *Newsletters,* is certainly interesting and far better written than most government crap. I've made very few changes other than editing out the repetitions, and adding a few strong paragraphs (in the beginning and at the end) re the stupidity and futility of making a one-year grant to a project like ours, and then refusing to support it further. Also, I've cut out Anne's poems, because the inclusion of copy-righted material in an OE final report entails endless forms and approvals, etc., and there is already a whole batch of crap like ERIC abstracts and report summaries that I still have to do. As it is, I'm going to have to go back to the city sooner than I would like, *only* because of this damn report. I still haven't received Florence's section—and can't locate them at all. They're somewhere between New Hampshire and Baltimore with no forwarding address. I can see myself writing that section from the preliminary report in the June *Newsletter,* and then, just as the thing is about to be typed, Florence's report will arrive with all kinds of new and great stuff!

As for the charts, all that information will be included in the appendixes, as well as a list of materials produced. This is part of the report specifications and I think makes sense. Also, I think it would be prudent to include only isolated quotes from the Fable Unit rather than the total sections, to avoid any problems when the unit is eventually published.

The feeling of the Board was that we should hold off on publishing the Fable Unit until we had a chance to edit it somewhat and until we had more diaries from teachers to include. Also, it was felt that we should have a better idea of what our status was going to be re rights, royalties, etc. The same goes for the diaries and the kids' work—with a little editing, there's a great book there, although again, we will have to clarify the problem of the individual writers' rights, etc. Let's discuss this when you come to NY.

If you think the past few months have been an exercise in futility and frustration—NOW HEAR THIS: I just called the Arts Endowment and found out that we will *not* be getting any money from them. An official letter will be forthcoming with the old story about budget cuts and over-commitments, etc. So, that leaves only the $40,000 from the Humanities Endowment, and they have been giving us static all summer, requesting revised budgets, and so forth, and still have not made an official commitment. Even if that money comes through, they refuse to support either the *Newsletter* or any curriculum development—the money can only be used for sending writers into schools and conducting teacher seminars, and the salary budget allowed is only for

part-time positions! So, the most important and exciting and promising work—the creation of curriculum triggers—is down the drain. SHIT.

Your Berkeley scene does sound interesting. I've always felt that integration per se is actually irrelevant (despite friend Coleman!)—what is important is changing the concept teachers and supervisors have about teaching and learning. To this end, something like wholesale integration *can* be important in the sense that often, a drastic change of this kind can throw everybody into such a panic that the system up and down the ladder is more receptive to other kinds of experimentation, new ideas, etc. It's like the scene in NYC in the late 50's when I started teaching. Everyone was at a loss as to what to "do" with the mass of Puerto Rican kids (although of course the system never admitted this officially), so the chances were, that if you taught in a hard-core ghetto school, you could pretty much teach any way you wanted, as long as the kids weren't running mad in the halls. I remember my principal telling me, on that first interview when I confessed I didn't have the slightest knowledge of official curriculum and couldn't care less,—"Don't worry about that, just as long as you feel you can work with *these kids.*"

I'd love to come out, if you have a budget for consulting fees and expenses. The thing I'm really interested in is developing parent and community adult education about education programs, and in devising some kind of internship-training program that would use community people in the schools—not as para-professional "aides," but as full-fledged members of the staff—in other words, a *professional* training program that has nothing to do with previous college courses, degrees, etc. and which will ultimately lead to an entirely different concept of licenses, etc. And of course, my old bag of tricks —"learning by doing," real reading, real math, real writing, at the early grades, and all that jazz!

Let me know when you'll be in NYC. Love to you all.

Zelda

TO: Board of Directors, Teachers and Writers Collaborative

FROM: Zelda Wirtschafter

DATE: December 13, 1968

As you know, I have reluctantly been continuing as the director of Teachers & Writers Collaborative until such time as funds for the current year were assured and a suitable director was found. I am happy to tell you that we have finally received official approval for a grant of $40,000 from the National Endowment for the Humanities for the purpose of sending writers into schools and conducting teacher workshops. I am also pleased to inform you that Mr. Joel Oppenheimer, poet and former director of the Poetry Project at St. Marks Church in the Bowery, has agreed to serve as our new director. He will be assisted by Mrs. Sheila Murphy, a former classroom teacher, who will serve as

associate director. Joel and Sheila assumed their duties on December 1st, concurrent with my resignation as of that date.

Part of the long delay in our actually receiving this grant was due to bureaucratic problems at Teachers College, where our final budget which was to be submitted to the Endowment sat in an office for over three weeks. At that point I began to investigate the possibility of our finding an alternate fiscal agent so that problems of this sort could be avoided in the future. There was also the question of the high overhead or indirect cost rate charged by Teachers College to which the Humanities Endowment objected strongly. As a result of these various problems we were able to find a new fiscal agent in the City of New York's Cultural Council Foundation, which was established for the purpose of receiving funds to be used by the Department of Cultural Affairs. In addition the Cultural Council Foundation and the City of New York are providing us with office space, typewriters, etc. without charge and as a result of our association with them we have been able to add approximately $8,000 (the amount Teachers College was demanding for overhead) back into our budget for writers' honoraria. Our new office is in The City's Department of Cultural Affairs, The Arsenal, 830 Fifth Avenue, New York, New York 10021. Our new phone number is 212-360-8216.

I feel confident that I am leaving the Collaborative in the best possible hands, and that Joel and Sheila together will carry on the work of Teachers & Writers in the same spirit with which it was originally organized.

With best wishes for the new year.

Warm regards,

Zelda Wirtschafter

ZDW:jr

"The Voice of the Children" Saturday Workshop Diaries

by June Jordan

October 7, 1967

It was cold and an almost early morning time when anyone coming, they thought, to teach somebody else how to write, or to write with other people at their elbows, had to walk in one of three or four ways up and down streets in order to reach The Community Resource Center.

You could walk along 116th Street where, towards noon time, there would be a lot of people with very little money, altogether, ransacking cardboard boxes for two dollar dresses and socks, six for one dollar. One Hundred and Sixteenth Street is where you can't find a bathroom if you need one. It is not similar to Macy's. And the movie houses on that street always offer you a choice of rubraw garbage which depends on monsters for entertainment; entertainment here is taken as distraction. If you distract families who live in completely pre-occupying boredom/crises, then you have entertained them. So there are monsters, and then there are horror stories and then there are varieties of "the incredible"—offered to all the families who know that unbelievable things are hopelessly routine.

I approached the Center from 2nd Avenue, walking West on 117th Street and I felt cold, but I saw a beautiful brick building that rose from the broken sidewalk squares to a low height I could easily hold within my comfortable eyes and the bricks were separating one from another and the coldness of the morning was steady freeze into the separation of the bits and pieces that come together and eventually mean disintegration of shelter and of heat, which is to say, the falling apart of possibilities of survival that is worth writing about. Or living. I am not sure, any longer, that there is a difference between writing and living. Not for me. And I thought, maybe I will say that to the kids and maybe that is how we will begin writing together, this morning.

I am not sure that words can carry hope and longing from hand to hand and that hands can carry words into the honesty that does not separate people the way bricks break apart on cold, October mornings.

There were six people in my class. One of them, white, is twenty four years old. The others, not white, are anywhere from 12 to 14.

They all said they were interested in writing. Next week I will try to find out why, or perhaps the question is: What they've read that makes them want to be writing.

Except for the 24 year old member of my group, the girls seemed alternately shy and super-shy. Therefore I asked them to write "An Introduction of Self." The second project, to describe somebody else, was judged easier by everyone except Thayer Campbell (12) who objected on the grounds of not knowing anyone else well enough.

One of the group, Deborah (13) appears almost to have physical diffi-

134

culty with the act of writing. Moreover, her written work shows an enormous unfamiliarity with the spelling of words, the sounding of words in one's head and the translation of sounds into symbols, etc. She is very nice and rather intimidated by the others who readily call her "stupid." (I am not sure that having family relatives in the one group is such a good idea.)

The third project, writing about "white power" or "black power," seemed interesting to all except Deborah who seemed quite upset. I asked her why. "Because," she said, finally, "I don't never win. I always lose. Everything." So, with predictable banality, j. jordan then asked her to write about that. She did.

I think Victor's poetry, my poetry, poetry by L. Hughes, G. Brooks, poetry, poetry—that they can keep, *Books* of poetry that they can keep will work best. I will call the office about this. Also, I am keeping all of their work —to try and understand where to begin—which is how.

<div style="text-align:right">October 21, 1966</div>

This day's workshop continued for a bit more than an hour and a half, and it would have easily continued longer except that I had obligations elsewhere, as well. During the time we were together many things happened. Indeed, so many moving things happened that I wished, that I wish I could simply talk it into a tape rather than scrunch the experience onto paper.

First, I would like to say I do not know what I can offer the kids who come on Saturday. Except for two of them, (sisters) the others come with a shocking history of no education in language. That they come ought to shame all the so-called teachers who have perpetuated this history of no education. But shame will not help these young people. And my question is, what will be helpful?

I had to control my sense of desperation. I wanted to say, "Wait a minute. Let's stop right here. This is a sentence. This is not a sentence. *Him* is spelled with an *m*, not with an *n*. Words that sound alike, or a little like each other are not spelled the same way. For instance, *along* is not the spelling for *alone,* and *dried* is not the spelling for *died.*"

Then I thought, if this total lack of preparation characterizes the English "education" of these kids, then editors, and personnel managers are just going to have to take the consequences. And/or portable tape recorders will have to replace the ballpoint pen. But, horribly, this is absurd. *The kids* are going to take the consequences of all the shit treatment and despisal-pedagogy imposed on them. So, I repeat, what should I try and do? How should any of us try to alter the probable consequences—on Saturdays, yet?

For further instance of the meaning of the question I am raising: Now there are two weeks of writing on paper. It is obvious to me that one thing to do is to have them typed up and, eventually, made into folios that each kid can keep. But apart from making something they have done seem more permanent and seem more valuable via a kind of simple-minded, physical change of appearance, what should I do? Should I "correct" them? How can you correct completely illiterate work without entering that hideous history they have had to survive as still another person who says: You can't do it. You don't know. You are unable. You are ignorant.

<div style="text-align:center">135</div>

So, for the moment, I am not doing that. And the question is what *am* I doing?

We sat about the large table and I set out paperback copies of Gwendolyn Brooks' poetry and poetry by Langston Hughes and modern poetry in Africa. I said, "Why don't you look over these books and then we'll talk about them, or we'll write about something in them, and you can keep whatever you like—if you like them."

Some of the kids looked at me to see if I was kidding. The hesitation was so real, I finally handed around copies.

Pat Curry (13 years old) and her sister, Linda (14) ventured, "We wrote these things. You want to see them?" Pat had written a composition called, "My Theory of Lies." Linda had written a poem called "Who Am I." Both of these things are worth reading, indicate talent, and were furthermore voluntarily undertaken—and accomplished on their Friday lunch hour.

Then everybody started reading. In the extreme quiet, Marion B. gave me a story David had written, called *The Big Bear*. He has even illustrated it. It's a good story, very carefully crafted and written down in a fastidious painstaking way. I started to say something to him. David was holding on to the Brooks poetry book for dear life. I waited until he began to turn a page. Your story is beautiful. He really smiled.

Around the table a fantastic thing was happening. One would show another a particular poem—secretively, with extreme delight, nervously, giggling, furtive—as though they could not really believe what they were reading. As though they were reading "dirty books" and might be caught. The furtive sharing grew into a very animated kind of interaction. Finally I asked Linda if she'd had any books like these in school. She looked at me to see if I was putting her on. "No," she said. "We don't have any book! They give us *Scope.*"

"*Scope?*" I asked. "What's that?" Marion B. volunteered, "It's a paper the schools distribute. Like a scholastic magazine."

"You mean," I asked Linda again, "You mean you don't have any poetry, any stories. Any books like that?"

"No," she said managing her surprise at my ignorance, politely.

Then I suggested that if anybody wanted to read any poem she liked, or he liked, aloud, they should just do so.

Well, it got to be like the most beautiful kind of neo-Quaker meeting: There would be this extreme silence, and then somebody would just start reading aloud a poem. Victor read a poem. Thayer Campbell read a poem. Everybody except me read a poem, or two or three poems. Some read aloud embarrassed, or defiant, or giggling, or quiet. Others, like Deborah, who last week said she couldn't write about power because she always loses everything, Deborah who is ridiculed by the others as stupid, so slow, etc. *Deborah* said, "I want to read one." We all stared in surprise and waited. She read "Freedom" by Langston Hughes. Later she read "Christ in Alabama." David sat next to me fantastically intense in his meticulous copying of a poem by Gwendolyn Brooks, "The Chicago Defender Sends A Man To Little Rock." I said to him, "You can keep that book, you know?"

He shook his head, "I know," he answered.

David wanted to copy it down. First he copied the opening five-line stanza. Firmly he declared, "I want to read one." And he read what he'd copied.

Then he copied two more lines. And later read them. Finally he read three more lines he'd copied. In more than an hour and a half, David had copied, in an indescribably devout manner, 10 lines of poetry.

"What will you do for next week, David?"

Without the slightest pause he answered, "I'm going to write poems. And bring some I wrote already."

December 2, 1967

When Christopher [June Jordan's son] and I arrived, we found Terri Bush, a young, white classroom teacher originally from Mobile, Alabama, and fifteen kids she'd brought from Brooklyn where they attended Sands J.H.S., in the Fort Greene section.

Five of the group were happy, high-spirited boys. Roughly one-third was Puerto Rican and the rest were Negro children.

A kind of pandemonium reigned. The kids seemed bursting with restlessness and a 360 degree-radial energy, undirected.

More or less at the top of my lungs I tried to get things going—passed pencils around the table, gave paper to everyone, etc.

First: They were going to write what they wished would happen when they came to what I decided we should call the Saturday Center.

Second: They would write why they wanted to have music.

The boys finished rather quickly. In particular, Jerome Holland, who wrote the two stanza rhyme. His pals wanted, instantly, to set it to music, percussive accompaniment. They gave it, in unison, a funky driving tempo. So far: great, hectic fun. But the fun of it got them utterly hysterical, giggling and out of their own control. I told them to go upstairs if they wanted only to kid around because the others, the girls, were still writing—slowly and with solemn demeanor.

They left and you could hear the uproarious playing from downstairs. Evidently they were having a marvelous time. Christopher, with them, later reported he would like to do that kind of screaming and throwing around, every week.

Peter Sourian eventually went upstairs and seemed to have provided a welcome, adult witness to their free merriment.

Downstairs, we went ahead with the writing. Apart from that, the following occurred: 1. A discussion, How would you like this place to look?

Answer: Like a library. A beautiful building. Not like a slum. With books all over. And records. And boys, and food.

2. Do you really want a club?

Answer: Yes. So they made a poster: SOUL SISTERS. And they were going to finish coloring it, and then post it.

Question: If we put up the club sign, will somebody tear it up? What do we do if they tear it up or tear it down? Will we have to start every week?

Finally, Karen [Kennerly] came with orange juice and cookies and Victor [Cruz] arrived and cups were found and everybody grabbed some stuff and drank and a few continued on the club sign, while I gathered the compositions.

I have now re-read the enclosed papers, and reconsidered what happened. Today.

A. It is pretty damned clear, from reading what they wrote, that these kids would like to board a Saturday subway and get off at a place like home is supposed to be. They want a kind of permanent inter-attachment to develop among us. We would be a family—swimming when it's hot, going to museums and to places other people go, like Columbia University. The main purpose would be happiness—as a reliable relief from the other six days.

B. I think it is absolutely necessary that a phonograph and a decently varied collection of records be part of the equipment.

C. It would help if we could have or build a bookcase with maybe twenty or thirty books and different magazines in it, the library.

D. How could trips be incorporated into the program?

E. Fifteen is too many for one person, or at least too many for me. In the absence of trips and a library look and a beautiful refuge from the other six days, the certain intimacy of a group of five would probably help to make the difference they want, so obviously, to be an unmistakable difference in their experience.

F. I think Terri Bush is a rare person, and thanked her, today. I also think that Peter S. is very nice and he seems to be the kind of person kids can trust—as real.

G. It's crazy to try to teach or elicit writing, in vacuo, per se, isolated from as great as rich as wonderful a stimulating, welcoming environment as can be created with chairs, tables, paper and pencils.

H. Would anybody be willing to work with me to create "the library"? Also, can we get a phonograph and records on the premises?

I. Next week, willy-nilly, it is my belated intention to get the kids writing and composing their own songs.

December 9, 1967

Following the conclusions of last week's report, Christopher and I came to the Resource Center equipped with a phonograph, copies of fables produced through Teachers & Writers Collaborative, photographs likewise produced, paper, pencils and these record albums, (long-playing): Dinah Washington, Billie Holiday, Little Walter, and Johnny Griffin. My intention was to introduce the kids to Little Walter who makes latter-day Rock groups look silly and sound trite, to introduce them to the completely different, roots-originating styles of Washington and Holiday, and to try and interest them in jazz via the Griffin group.

We were going to write songs. Nobody was there. Nobody came.

Victor and I sat talking, dispiritedly. We both felt demoralized. Victor said this was the last day, anyhow. I was stunned to consider this might be so.

"What do you think was accomplished?" I asked him.

"The experience of failure."

"But is that worth having?"

"Oh yes, it's very valuable."

So we were gloomy with value. "They didn't like this place," I said. "They thought it looked like a slum."

"It does," says Victor.

"No books," I remarked.

"No continuity," says Victor.

Instead of the kids coming all the way from Brooklyn we, or I should have gone there. It's too far. It's too much on a Saturday. It's too little: only Saturday.

"For an hour," Victor added. "These people have problems plus then you start telling them times and places, they can't make it. Should be where the people are. Get to know them. They get to know you. Come when they can."

Should be down on a first floor. And local.

Victor and I fell quiet. He would soon be moving into East Harlem and have a pad on the premises of a local workshop. If things worked out.

I would not. When I said "the kids" I had faces in my mind, and names and a difficult accumulation of memories geared always to "next time." There would be no next time, now. What had happened, then? I wanted to throw the phonograph out the windows on the third floor, the windows that could not be opened. But I wanted it to be playing as it went down. And I wanted the kids to watch it go and hear it crazy in the air and all of us dancing where it would land. Tough. The ashtrays were clean on the table and I left the empty room empty.

December 30, 1967

Terri Bush had arranged, with a Mrs. Taylor, that the Ft. Greene Brooklyn Community Center would be opened by 11 A.M. on the last Saturday of 1967.

Terri, Christopher and I duly arrived. So did eleven year old Debbie, Vanessa and Gena. Mrs. Taylor did not appear. The door remained impossible to open.

In a rage and quite frozen, we decided to drive back into Manhattan, to Terri's house. There we warmed up a bit. The kids listened to records I offered as music for songs to be written, but nothing happened mainly, I believe, because they were a bit abashed to be in Terri's rather posh apartment with three adult strangers.

They enjoyed looking at the books I brought out—Haiku poetry, Wm. Blake, Langston Hughes and a simplified version of *Aesop's Fables*. Also they enjoyed reading fables written by Terri's regular class.

January 6, 1968

The preceding week, demoralized by freezing problems of accommodation for our group, and faced by the prospect of perhaps giving nothing to children who count on Saturdays as the day of possible difference in their lives of awful experience, all involved had determined upon a trip, an adventure away from this city and homebase.

I checked with Zelda [Wirtschafter] the following Monday, and was told trip expenses would be reimbursed. That left only the planning which, as it happened, preoccupied Terri and myself for the better (worse) part of the ensuing four days. By railroad to Sleepy Hollow, the former residence of Washington Irving, transportation would cost just under $50. Between the railroad journey (requiring a subway bit plus an unlikely hike from the depot to the restoration) and travel by car, the choice seemed easy. Terri and I, accordingly,

attempted to arrange for volunteer cars and drivers, with no success. Finally, we rented two cars, again for just under $50. This meant that the Brooklyn caravan consisted of three cars, including my own.

Altogether, the trip cost roughly $85.00, consumed seven hours, and carried eighteen children plus three adults into the snowy whitelands—and back again, to Brooklyn. I do not think there is any question but that the money was well spent.

More than eighteen kids undoubtedly showed up, but we left a few minutes before 10 A.M. in recognition of the hazardous overcrowding of cars already evident. I judge that moving along the highway from center city turf, past suburbia, and into semi-rural countryside provided plenty of visual interest and reasons for new thoughts. Brooklyn is such an ugly, unmitigated injustice against human life that seldom grows there, and barely survives, if it does, that I, for one, am addicted to the different scene, per se, and addicted to anything that can be described as beautiful, by contrast. And I have not lived in Brooklyn for many years.

Sleepy Hollow is open to the public in a Westchester town called Tarrytown. Irving's estate itself is called Sunnyside. *Tarrytown, Sunnyside*, and *Sleepy Hollow*—What beautiful words for the way a place for people can be remembered! Try *Brooklyn*, now. (The word, Brooklyn, is originally Dutch, and means *broken land*.)

On entry, the kids in my car commented on the houses: "I like those pretty houses. Look cozy." It was remarked that the houses looked like "Christmas cards."

On entry into Sunnyside I had the sensation we were in a movie, a Hitchcock flick: the lay of the land, the stone posts, the precipitously varied terrain, the quiet, the everywhere, soft snow—it was An Estate out of Hollywood.

Our female hostesses were attired in hooped-skirt costume and appeared to be part of the general relic—at least a century old.

On sighting our kids tumbling toward the warmth of the house, (it was 12 degrees cold outside), on hearing their free laughter and loud calls to each other across the suddenly great space available to them, our female hostesses went into asthma—high-pitched terror not particularly concealed.

First we saw "a film" about Irving which amounted to the worst piece of visual-illiteracy-preserved that I've ever seen. The kids were marvelously controlled. I alternated between amusement and shock. Anybody wondering why "American history" fails to interest "underprivileged children" ought to see this flick with kids from anyplace that is wornout poor. It seems that Irving was fabulously well-to-do and that events such as the War of 1812 were quite incidental to his writing career except as they disposed or indisposed him to travel to Europe or to tour America, for kicks.

We were, despite their conspicuous dread, (the dread of our costumed hostesses) taken through the main house—which proved to be rather a lot of fun in a ridiculous sort of way mainly thanks to the astonishing patter of our elderly guides who, oblivious, stood prattling about where Irving had his silk rugs designed and woven, and the fact that the dining table is set with sherry because tea gathers scum on it, after a while. But the house is a wonderful house full of odd windows and happy colors and they liked it. Some of them kept asking the most faithful questions like, "Is this exactly where Irving

wrote his stories," etc.

The thing is that the house and its placement overlooking the Hudson river, and the porch and the many trees all sum up to the obvious furnishings for a happy life. I think this was borne in on the kids. (What do *they* have?) Then they played rather raucously and gladly in the supplementary sheds and outhouses.

We rounded up, at last, and made for the local Howard Johnson's.

Customers there also went into asthma—which was not lost on the kids. Some of the kids handled the experience of eating at a (*white*) restaurant with bravado—yelling a bit, and so forth. Others of them sat and spoke and ate in what they believed an impeccable manner. I think that actually eating in a restaurant, despite the reactions of personnel and other customers, was possibly as valuable as the visit to Irving's pad. It was all a kind of abrupt throw into that other world that knows you exist, if it does, and if you are young, black and poor, because newspapers say so—when they wax statistical about "urban centers." Tarrytown and Sunnyside and Sleepy Hollow are places, like the local Hojos, that still give me pause before I will enter there, and I think the kids were great and gutsy and forced, by these circumstances, to think a bit and maybe inch further toward understanding the full, social inequity that means you have to travel more than an hour into a neighborhood that will not welcome you before you see clean snow, pretty houses and a home set up for happiness.

On the way back, all the way, the kids in my car kept volunteering directions. The idea was that we should get lost.

"I'll say one, two, three, and then we'll be LOST. One...Two... Three..."

But, I know my way back, and we didn't get lost.

MY TRIP TO SLEEPY HOLLOW
by Debbie Burkett

I belong to the Saturday Center Writing Club. We decided to go on a trip to Tarrytown N.Y. to see Sleepy H. Everything was planned. So on January 6th we decided to go. There was twenty-two children all together. There was Mrs. June, Miss Bush, and Gregg (Miss Bush's brother). Miss Bush, Mrs June, me and Vanessa plus another girl was sitting in one car. The rest of the children was in the other car which was a station wagon. But it was too crowded in the station wagon so we had to go to 14th Street and rent another car. We went to the rental place while Miss Bush, Miss June and a few other children waited in the rental place. Greg went to get Miss Bush's roomate Molly who was two blocks away she was going to drive the car.

We waited in the car rental place for a long time. That's when we started "Where's Molly." Then they finally returned and Greg parked the car forward when all the other cars were the opposite. When we finally got started they remember none of the adults knew the way. We got to the bridge. From then on we followed signs. Molly kept coming up in front of us then falling back behind. It was like she was racing us. Then we noticed Molly wasn't in back of us. We pulled over to the side till she caught up with us. She continued to get out of our sight but caught up with us again. Then Miss Bush's brother started to race. But we stayed up ahead most of the time. And oh yes I forgot to tell you about when we got started from the rental place we was going along then all of a sudden Miss Bush swung open the car door and ran out to her brother's car to tell him something. And then we went a little farther when Miss June parked her car and went into a bar. When she came back she said she had to go to the bathroom. We kept going along and Molly continued to get lost when we finally reach a sign that said Sunny Valley that was what we was looking for. We parked the car and went into the house. The house was the former home of Washington Irving. Then we went to the barn. Well

it wasn't a barn anymore it had rows of chairs in it. A lady dressed in an old fashioned wide dress talked to us, then she showed us a film about Washington Irving and Sunnyside. It told the life of Washington Irving, (I am going to skip some things) and about when he was going to get married and his wife died. It also showed when he was planning to go to Spain and went and when he went up the Hudson. They told us how the legend of Sleepy Hollow came about. When the film was over we went to his house. We saw the parlor, the dining room, kitchen, bedrooms and his study. We also saw the vegetable and fruit bin, all the rooms had English furniture. We went outside to the ice shed and wood shed. The whole scenery was beautiful.

We went to the souvenir place and on one side was the ladies and men rest rooms and the lady behind the counter told us that, and said that one is the ladies and the other is the mens as if we couldn't read. We left his house and went to the Howard Johnsons restaurant. They let us go in a special room because it was so many of us. We were given a menu. We chose what we wanted and a drink and dessert. The boys were being unmannerly in fun. The waitress came over to Mrs. June. "Where are those darling kids from I could eat them!" Mrs. June said Brooklyn. When she left Mrs. June made a funny face because she said she could eat them. Then Vanessa started making jokes about that.

Then a man came in the room where we was and said "Whose birthday is it?" because we was acting like it was a party. Mrs. Bush said Vanessa's. She was kind of mad she didn't want anyone to know. We all finished eating and the rest of the kids went out to the station wagon but me and Vanessa stayed with Mrs. June because the car was locked and we didn't want to wait outside. Then Anthony Holmes went in the station wagon and stepped on the brakes and made the car start rolling back. I know the children in the car then were scared to death. Miss Bush stopped the car in time. Anthony was ashamed and scared. Mrs. June threatened him jokingly. We was on the road again and continued to get lost. But out of all the adventures we had today we got home safely, and I enjoyed the trip very much, and I am sure the others did too.

January 13, 1968

Terri and I arrived, duly, at The Church of The Open Door in Brooklyn. It was locked. Shortly, I am delighted to say, it opened and we went inside to rather pleasant rooms with sunny windows.

In anticipation of this workshop I had repaired a portable phonograph since the church had none on the premises.

The Collaborative has already received some samples of the writing our kids did after the trip to Tarrytown. This week I brought an enormous variety of records and books. Again, the kids mainly liked Langston Hughes—reading his stuff with their lips silently moving. The *Pictorial History of the Negro in America* fascinated a new member of our group, Sharon Holmes. She wrote an awkward thing about Lincoln. But the point is that she was moved to try and write something. The turnout was not what we'd hoped, but enough to make the effort worthwhile.

One of the other new kids, Veronica, wrote in an almost illiterate style. However, Terri told me Veronica had never even attempted to write before this morning. She will come again. Hopefully we'll be able to continue at The Church of The Open Door.

January 20, 1968

We had a great session today at The Church of The Open Door, in Brooklyn. Fifteen kids showed up and wrote happily and well. Terri's arranging to have their things typed and copied during the week. I will submit same when I get same. As said, repeatedly, it is extremely important that the kids receive something in return for their efforts.

Today I brought rather more books than usual. The new one, *African*

Myths and Tales, interested enough kids to prompt me to buy several copies on Monday so I can give them out, next week. I also intend to get some Haiku poetry, if I can find a really good selection, and anything else.

They really enjoy making a kind of a home out of our getting together— writing, talking, laughing, listening to records, hot chocolate and cookies. In fact, one boy, Michael Goode, wrote that Saturdays with the group are when he *lives.*

At their leisure, and as they feel intermittently inclined, the kids wander to the phonograph and also over to the books and look through them. At least half of the kids spent a noticeable amount of time reading from the books I brought. There is a hungriness that is very clear.

I had the kids write under the title: "I Am"—it could be about themselves, or someone they know, or an invented personality. Anyhow, a story on one side of the paper. And a poem or song on the other. That was the assignment. We got back about an 85% return on the request, which was exhilarating, to say the least.

The kids are now writing confidently, and eagerly and with a lot of style. Those who gave me straightjacketed stuff, first time around, I then asked to write about "I Will Never Be." That change of angle worked.

We'll go on with the latter, next Saturday.

Altogether, our group remained in extremely high spirits today. The kids were obviously proud of their accomplishments. And a kind of coherency has begun to emerge. Terri attended to the chocolate and cookies. Nobody wanted to leave. "Is that all we going to write today?" An hour and a half on the weekends begins to make a difference. And the obligations, on our side, increase.

During the week, more and more kids write on their own—poetry and stories and dreams—and bring them. I'll show you what I mean when I get the typed versions from T.B. who ought to be interviewed about the kind of teaching she does and the kind of administrative jungle she has to shred, Monday through Friday.

Lest my gladness obscure anything, may I pointedly observe that much of what the kids expressed today, in writing, amounts to an unanswerable indictment of the world that would term these children stupid, ugly, hopeless and wrong.

Linda Curry wrote so well and showed up today. Linda does not attend Sands J.H.S., it should be remembered; she has been suspended from her high school, and simply hangs around the local institution. Today, at the workshop, she wrote distinctively well, and movingly.

January 27, 1968

It looks as though we've really got something together. Fourteen kids showed, this morning, along with the happy sunlight.

As said last week, I had planned to continue with the "I Will Never Be" compositions. And that's what happened. The kids wrote a great deal, possibly more than any previous time.

These days sessions are difficult to terminate much before two hours. Nobody wants to leave.

The circumstance is so very pleasant and the space we have so large and

143

perfectly proportioned for children that the esprit is not difficult to understand.

A kind of pattern has been emerging: first the kids sit around looking at the books I bring, then they read copies of the former week's work, and then they undertake the day's assignment. Meanwhile there is an enormous amount of noise and music.

Today, however, a few kids complained about the interference from noise and I eagerly complied by quieting the piano and substituting a long-play recording of jazz for the rock and roll 45's. This seemed to help during the major, creative thrust.

It would be only fair to finally put all the work into book form and give to the kids. I took photos today. If they come out well, we might illustrate the book accordingly.

February 3, 1968

I must insist that the first two pages, the first two poems of the attached writings by eleven and twelve year old children are, unequivocally, two of the most beautiful poems I have read, ever. I trust that the Collaborative will concur. Regardless, I count my reading of the first two poems among the happiest, most sobering events of my last year.

We had some fifteen kids again. A nucleus of about five girls refused to participate other than to play a rather raucous selection of rock and roll records. My way of confronting this was to ignore it. Nevertheless, the other kids wrote, and well, I think. As shall be seen. If the nucleus acts again as today, next week, I shall do something. What, I don't know. Probably point out the absurdity of their coming if they will not work with words.

MY LIFE

My life is just a dream
That wonders all the time
Sometimes it goes into a shell
But it is hard to come out
My life My life
What have I done to you
You're wasting away
What shall I do?

Shall I dream
Or shall I scream
What shall I do
My life My life.
 by Juanita Bryant

TRAVEL

I would like to go
Where the golden apples grow

Where the sunshine reaches out
Touching children miles about

Where the rainbow is clear in the sky
And passbyers stop as they pass by

Where the red flamingos fly
Diving for fish before their eyes

And when all these places I shall see
I will return home back to thee

The end
by Deborah Burkett

I will never be a tree because a tree is the most beautiful thing
that you will ever see—it is tall dark and brown with its
leaves all over the ground

It's something I would never be so all I can do is dream dream dream
and wish it was me

I will never be a wall
Because a wall is so big and tall
And people would write on me like I was nothing at all
And people would kick and dirty me just like they do
All that why I shall never be
Something so big and tall like a wall.

by Linda Curry

JUST LEAVE ME ALONE

Just leave me alone and let me roam these empty streets alone
Because my home was there and now it has disappeared to a world of unknown
That world has collapsed around me
And no one is able to find me because I am lost into infinity.

by Linda Curry

February 12, 1968

Dear Zelda:

Enclosed please find a copy of the children's writings from last week.
They are my report on our Saturday Workshop. Here, I wish to answer your
letter of the 9th.

Deborah's poem, as you acknowledge, differs from Stevenson's. You say
hers is superior. I say hers is her own poem. I submit that Deborah's not only
equals the arresting force and loveliness of Stevenson's, it makes a very differ-

145

ent statement—as any proper reading and comparison of both poems would reveal.

Contrary to your suggestion, Stevenson was not "foisted" on Deborah. In my opinion, Deborah is a clearly gifted writer. And she has presumed, she has dared to do what other clearly gifted children do: they learn by a kind of creative mimicry. They consume and they incorporate, they experiment, and they master. Perhaps your letter derives from the fact that this particular gifted child is black and poor. Black children who are poor, (or, one might extend it to black children poor or not) are supposed to learn nothing in school, and life from the streets. That statement's awful accuracy depends upon the facts that teachers of black children do not, generally, teach, and that the street, or that being alive, per se, provides inescapable instruction.

Evidently, Deborah is an exception. And, there are exceptional children who are black. Deborah has been learning the streets and she has been learning in school and in the library. Rather than question her demonstrated learning, one should feel relief. Would you have her know only what she fears and what threatens her existence?

Contrary to your remarks, a poet does not write poetry according to the way he talks. Poetry is a distinctively precise and exacting use of words—whether the poet is Langston Hughes, or Bobby Burns.

One should take care to discover racist ideas that are perhaps less obvious than others. For example, one might ask: Will I accept that a black child can write "creatively" and "honestly" and yet *not* write about incest, filth, violence and degradations of every sort? Back of the assumption, and there is an assumption, that an honest and creative piece of writing by a black child will be ungrammatical, mis-spelled, and lurid titillation for his white teacher, is another idea. That black people are only the products of racist, white America and that, therefore, we can be and we can express only what racist white America has forced us to experience, namely: mutilation, despisal, ignorance and horror.

Fortunately, however, we have somehow survived. We have somehow and sometimes survived the systematic degradation of America. And therefore there really are black children who dream, and who love, and who undertake to master such white things as poetry. There really are black children who are *children* as well as victims. And one had better be pretty damned careful about what one will "accept" from these children as their own—their own honest expression of their dreams, their love, and their always human reality that not even America can conquer.

According to your letter, one might as well exclude 19th, 18th, 17th and 16th century literature from the libraries frequented by ghetto students. For, inasmuch as they are young, inasmuch as they are children, *they will learn,* and they will assimilate and happily, they will master.

Do you suppose that ghetto schools should merely extend the environment that has murdered millions of black children? The inculcation of self-respect and healthy race identity does not follow from the mere ventilation and reinforcement of deprivation in every one of its hideous forms.

No great poet has emerged without knowledge and mimicry of precedent. Even William Blake is no exception to this generality. And yes there *are* black children who will insist on becoming not merely "great black writers," but

great writers who are black the way Shakespeare was an Englishman.

I think Deborah may be one of these children. I hope so. And I will continue to try and serve the kids who come on Saturdays, one at a time, as this child and that child—rather than as black children wholly predictable and comprehensible in the light of statistical commonplace.

Yours sincerely,
June Jordan

February 17, 1968

There were handily more than twenty kids waiting inside our workroom when Chris, Terri, her brother, Gregg, and I arrived a bit late. Undoubtedly the great size of our group reflected Terri's invitation, issued at school, to the Brooklyn Museum following a writing session.

As promised the last Saturday, I produced two yellow folder covers and a heavy amount of lined paper for Linda Curry and Miriam Lasanta, respectively; they had both expressed interest in writing their own books. So this was the equipment they required. Linda and Miriam seemed pleased and quite entirely serious in their determination to become authors of lengthy substance.

Another member of our club, Arlene Blackwell, spent the time progressing on a story that serves as her distraction from a play she's also trying to write. So Arlene's work will be delayed; it's in process.

The kids' seriousness increases, steadily. Thus, the background prop of phonograph music has become an annoyance for several, and the music has been limited—in volume and in the period of playing allowed—by the kids.

Different officials of the church have come by and seem slightly incredulous that anything worthwhile might be happening. But they've not objected to our rather free-swinging conduct of the workshop. Reverend Frazier has manifested a warm and friendly pleasure in our being there, Saturdays. None of this is lost on the kids.

Today the excitement about the trip rather pre-empted the more usual leisure and exploratory behavior of the kids. So none of them, that I saw, bothered looking into any of the books I spread across the tables. Instead, they concentrated on reading last week's publication, as they think of it, and then, one by one, asked me for titles, as they do, and sat to writing with an almost depressing dispatch. By depressing, I mean *adult*: let's get it over with so we can make it to the museum. However, group morale and group writing morale was unmistakably high and happy. A number of the books I've been bringing have been borrowed, at this point, and not yet returned. All good news.

The plan for me to visit Sands J.H.S., next Friday morn, appears to please the kids who know about it. We're all sort of very attached to all of us, I would say.

February 23, 1968
Sands Junior High School

Above the front board, Miss Bush has printed a poem about holding onto a dream. It's a poem by Langston Hughes. Around the room, current articles and photographs representing black American life attract attention. And,

indeed, I saw a few children spontaneously leave their seats at odd moments and wander toward one or another article. The class seems to be holding on. So does the teacher. I'm not sure they are holding to a dream. But they are holding together in a kind of determination difficult to word.

During the class I observed, Miss Bush distributed a short play (written by a student and typed and copied by the teacher) to each student. A moderator or narrator was chosen and parts assigned. This informal enactment of a schoolmate's drama about a party seemed entirely to keep the interest of the kids.

In the hour during which I tried to "teach," the class would have to be described quite differently. Restless, uncertain, and unsatisfied. First I read a number of my own poems to them and when the whispering began, I stopped and circulated different advertisements I'd torn from *Ebony* magazine.

I wrote "advertising copy" on the board. Asked them to read the different copies and then to try and sell something: the local pizza place, candy, records. Most of the students set to writing copy. A few could not be interested; I could not interest them to really try. So they kidded around.

Several of the students finished copy they wanted (were willing) to read to the rest of the class in order to gain a reaction. But the noise, taunting, and general playfulness of some made the reading farcical.

I would say my efforts were preponderantly a failure. Maybe things would have cohered better if I'd been able to offer a deluge of advertisements and if I had then asked the kids which ones they like best and if we had spent a whole class in this way—considering how words work.

But maybe not.

March 2, 1968

Close to thirty kids were waiting when we arrived. They sat along the window sill wearing their coats although some had been waiting for more than an hour.

I had decided, after talking with T.B., that a somewhat different offering should be offered to them. So, while I brought the phonograph and a few records, I did not bring as many books, nor did I bring the same books. This week, my Yucca Pak was full mainly of *National Geographic* magazines.

Today, I told them, speaking to groups of two and of three, at a time, we will practice interviewing people. The first thing is to think about the kind of information you want, then the best five questions to ask that will give you what you need. The kids interviewed each other, intently, and would come to me, one by one, with a list of facts—height, weight, color of eyes, etc. Then I would ask them, on the basis of these facts, to write a description of the person. They did. I think the second part of their work quietly clarified the importance of questions. Often the information they had would not yield a particularly interesting description.

I told them this was practice for an interview they should conduct, during the week, of some grownup nobody else knows: the mailman, the grocery clerk, a teacher, the janitor, etc.

The intentness of their work was extraordinary. Those students who have been working on books have now written so much that Terri and I have split the amount of typing—quite beyond the typing done by M. In addition,

some kids have begun to write "books," on their own. It all means hours of reading. And I felt a bit harried—turning from one manuscript to the next while trying to provide prompt response to their work of the moment.

There are now four books in progress, i.e. over twenty pages long! *Each.* At this point, as much writing, or more, takes place *between* Saturdays!

In addition to all of this, Linda Curry proposed we officially determine a newspaper staff. So this coming weekend we will hold elections and proceed to publish a newspaper. I wish we had a camera for the staff to use. I wish we had a typist, and a publisher for their writings. I wish everybody could read the forceful, clear and morally pivotal ideas troubling these children. I wish I could give everyone of them a beautiful tree.

> Michael Gill
>
> Where were you born?
> Cumberland Hospital
> What school do you go to?
> Sands Jr. High.
> How old are you?
> 13 years old
> Do you like New York City?
> Not very much.
> Do you travel much?
> Yes I do.
> Where was your mother and father born?
> As of now I do not know.
> Which part of Brooklyn do you live in?
> Farragut Park.
> Do you attend parties much?
> No, not much.
> Would you want to move from Farragut?
> Yes, and soon.
> Do you attend the writers' workshop regularly?
> No.
> Goodbye
> Goodbye.
>
> From what I was told and what I have written about Michael, he is very quiet and he would like to move from the city. He doesn't attend parties very much so if you add all that together, your sum would be a quiet person.
>
> by Michael Goode

March 9, 1968

The kids went on with interviews and descriptions of people. I felt the many of them as almost too many, if the aim is to be able promptly to respond to work, as it happens. It was a good morning with the rain outside. Then we held elections of the newspaper staff, and voted in a title for the newspaper, namely:

<div align="center">

The Voice of the Children
Editor in Chief: Linda Curry
News Managers: Michael Goode, Arlene Blackwell

</div>

Mainly, the paper will present people who interest our group. A camera will have to be bought. The three of our newly formed executive staff sat discussing news assignments to be distributed, immediately, and to be fulfilled by this coming Saturday.

Meanwhile, a stranger group of boys, at loose ends during the rainy afternoon, wandered in and out of our room. Insults were exchanged, and a fight ensued. It was unpleasant and two of the girls were really banged about, badly.

T.B. took these two to her home and gave them lunch and, finally, they joined the rest of the kids at The Frick Museum.

March 16, 1968

Saturday was rainy again, but calm. We all seemed lowered and gloomy, in spirit and drive, because of the rain.

A couple of kids had attempted to interview during the week, but most had not. An effort to do "some kind of writing"—not to completely waste the morning—got going.

When élan emerged was when, at the end of the morning, we held a newspaper staff meeting. Assignments were given and a sense of clearer purpose, or, at least, of determination to make the thing happen, became apparent.

This newspaper requires, I do believe, a different typing format than formerly pursued, starting immediately, (i.e., the newspaper ought to be typed on stencil and have a journalized head as well as formal listing of the executive staff).

March 23, 1968

The kids who came today came despite the raining, chill weather. More of them were prepared with work accomplished during the previous week—editorials, interviews, and poems.

We had visitors whom the kids were curious about mainly as regards attachment—were these two new adults to whom one could safely begin a relationship; would they come again, would they stay.

Writing went well, I think, and the idea of interviewing is slowly clarifying. As an editorial subject, I offered (to those students asking for a subject) *school.*

The first edition of *The Voice of the Children* looks beautiful to me, and the kids seemed equally pleased. We held another newspaper meeting and assignments were distributed by Linda Curry. I believe the newspaper has really been born.

March 30, 1968

The amount of writing now produced by a morning's work, in addition to the during-the-week newspaper assignments, approaches the incredible and certainly has reached unwieldy, piling-up proportions. I should remark, at least parenthetically, that over the last couple of weeks, books have not been read; instead they've been borrowed. This amounts to progress of a happy kind, and I will have to find the time to replace and refurbish the selection.

Rather than describe what will be overwhelmingly obvious once typed, I will confine myself to the following: The subject on which everybody's supposed to prepare for next Saturday is civil rights. Terri Bush, who had been away last weekend, returned to a rowdy array of insults heavily laden with black-white references. It would seem that none of these kids is remote from

Memphis, Tennessee, for example, nor remote from the palpably growing tension we all share and help along. T.B., specifically, I think, stands, as a white southerner working in the black ghetto, between two impossibilities. The kids, anyway conditioned to cynicism, because of repeated experience, make it pretty rough for anybody white unless whitey will either play slavey or else stoically bear up under an accumulated, long delayed and suddenly released expression of fear and anger. As for the paper, the kids were very upset about typing errors, and very concerned to have their stuff reprinted in corrected form. There was a lot of asking about how to spell this and that, for instance. I have promised to arrange to have their work corrected before it appears in type. As the Collaborative knows, I regard this kind of thing as effectively pedagogic and therefore regard the kids' concern as most positive and forward moving.

May 4, 1968

We were back together, and I'd read the letter from the Collaborative's office saying it's almost gone.* There were problems; I was feeling lousy and drugged, while the kids were feeling testy and wanting to be told it'll go on and on, what we have.

So I broached the idea of a summer camp. Told them we'd have to solicit money, equipment, etc., from people who couldn't even imagine The Church of the Open Door.

They found it hard, and stiff trying to talk about what would be nice to have happen. But they tried. Finally I suggested they approach the thing from the opposite angle; try to think about what summertime would otherwise mean: what summertime would mean if they did not have a country place, together, set aside for their growth.

This last provoked much better writing from them. However, I think the quality of their work shows the impact of any idea related to disintegration.

I want to excerpt from the second batch of writings statements that could be included in soliciting letters.

May 11, 1968

This morning went very badly, indeed. Linda was in a mood, and her current sidekick, Arlene, was in that same mood. Consequently, a lot of kids were turned off, and left early. Plus, there was an extraordinary amount of rough teasing, and actual belligerence. The main victim was Juanita Bryant, who, twice, broke into tears that were justified. Things were really out of hand because I would just as soon not challenge Linda in any way that might embarrass her, and because I was trying to establish the principle of "right," i.e., something is *not right* to do to *somebody else,* in the least heavyhanded way I could, and without much success.

Afterward, Chris and I went along on today's trip in an effort to contribute to a feeling of solidarity. And the trip part of it was useful to that end. However, where we went, to a Children's Festival at a Brooklyn school a cou-

*At this point, the Collaborative was close to financial collapse and its interim director, Zelda Wirtschafter, was trying to raise any temporary funds to keep it going.

ple of miles away, proved disappointing. There was a magician who took too long to gain the kids' confidence. But there was a live boa constrictor and the kids were able to touch her and also have "her" wrapped around their necks. And there was a live glassworks artist at work, and African and Guatemalan masks you could put on, and seashells you could buy for a nickel and rocks and stones and geododes and books for a dime, and all this was quite okay.

Then when we were leaving, close to 5 P.M., a fight ensued over copies of *The Voice of the Children*. Same participants. Same person in tears. Well.

Next week I'm going to try to borrow a slide projector and bring some slides, then offer them "a choice" they can consider at least: to write about what we did this afternoon which, during the outside rain, had some elements of cozy excitement to it and / or the slides.

There's tension about the Camp of the Children, among the children, at this point. And this tension was worsened by the fact that I spent some twenty minutes during workshop time trying to get our lawyer on the phone in order to check the legality of the mimeos we're sending out to the public, on behalf of the Camp.

May 18, 1968

As planned, T.B. brought in a borrowed slide projector and showed slides: mainly recording classroom candid shots, lunchroom candid shots and trips to Coney Island shots of students from Sands Jr. H.S. Thus, our kids were either seeing themselves on the screen or else they were seeing friends.

This proved distracting beyond plan. In particular, Linda Curry became rather upset since she didn't see the reason for spending time looking at pictures rather than working with words. It seems she was, once again, in a rather hostile mood, generally, and her complaining and truculence created a crisis one can claim to have overcome only to the extent of the writing here enclosed.

Yes, I know something will have to happen vis-à-vis Linda. But my questions continue to be, what, exactly. I have, this week, received a reply from Linda's guidance counselor at Washington Irving, Miss Heenan. She reports that L.C. has not been to school at all, has failed all her subjects, etc. Asks me to discuss this with L.C. Which I will try to do. I guess I am describing a group situation affected by the personal crisis of one member.

I hope I can figure something appropriate to do about our groups, this coming Saturday, about Linda and Miss Heenan.

Meanwhile, work on the camp continues.

MY ENEMY

My Enemy is the world
The world hates me it's trying
to get rid of me Somebody
up there don't like me
Why I don't know
I've try to prove them
 wrong but it doesn't seem
to work
I don't know what to think
 or do I just
wonder till I find
what I am searching
for And then I will kill
the one who hates me.

 Linda Curry
 age 14

LIFE

At the age of nine you feel fine almost all
 the time
When you start in your teen
 you start to get mean
 and all you got left is
 a dream.

 Linda Curry

LOST

I am in a maze
with only a beginning
many times I feel
I am near the end
 only
to find a stone wall
I begin to try again

 Linda Curry

 June 1, 1968
 Today's workshop happened quietly; it was eerie, even. I had the feeling
that, in their own way, the kids who were there thought that, by quietly wait-
ing, working and reading, the coming termination of our weekend efforts
could be, possibly, evaded.
 For example, Linda Curry conducted herself in the lowest-keyed manner
I've ever seen. Anyway, this morning I brought some different books, mainly
big "picture" books on Africa and on family and so forth. Their ready interest
in pouring over these heavy volumes reinforced my notion that one kind of
material egregiously neglected, most of the time, is bookbound visual stuff.
 I asked them to write on "family." And they did. Please see the en-
closed.
 In case it may be of interest, I here list the books they seemed so naturally
to like wandering through:

The Hampton Album (Mus. of Modern Art)

153

The World of Winslow Homer (Time Incorporated, N.Y.)
African Kingdoms / Great Ages of Man (Time Incorporated)
The World of Werner Bischof, E.P. Dutton & Co.
Family, by Margaret Mead and Ken Heyman, Macmillan Co.
The Family of Man (of recurring interest)

The Last Workshop at the Church of the Open Door
June 15, 1968

We met. We were in that room where so many poems, so many night-
mares, so many beginning ways of wording the reality had begun and had be-
come a finished proof of trial. It was a peculiar morning. The kids and Terri
talked excitedly about the camp and still I didn't know whether we'd have the
money or not. And I would not be with them...

I felt sad and at an end. As I looked at all the children, plus my son
Christopher, I could consider the twenty or so reasons for my commitment to
the idea of a safe and happy summer place for the workshop to expand. My
son had grown tremendously, by contact with the Fort Greene contingent.
And I had grown by coming there and trying to do whatever I could. And
they had written more and more beautifully, well, and unforgettably.

* * *

[In the end, money was raised to continue the group at a campsite in
Toronto, Ohio for two weeks during the summer. Terri Bush served as volun-
teer director of the camp. She reported that "in the extraordinary freedom of
outdoor space, the twenty children played, fought, swam, watched cows being
milked, and grew. They also wrote, publishing four issues of *The Voice of the
Children* with the aid of the local high school. The town officials were most
cooperative: the mayor of Toronto, Ohio carried in survival supplies of water
and organized the local Civil Defense Corps when the camp's water was
turned off. The pool manager welcomed the children and set aside an hour for
them every day, in spite of the fact that only a year before, non-whites were
allowed in the town swimming pool only one day a week. At the end of their
stay, the kids put on a candlelight show of poetry, African dances and rock
and roll songs, converting the dining hall into their theater."

The workshop continued meeting, and in 1970 an anthology of the writ-
ings that came out of it was published under the title, *The Voice of the Chil-
dren*, in a Holt, Rinehart and Winston paperback that achieved some success.
Following are some of the children's writings composed during the period
covered by June Jordan's diaries.]

My Sister

Forward: This is a story of my sister her past history and present life history and her future.
In case you don't understand some words (slang words) in this story there's a slang diction-
ary at the end of this story

My sister name is Linda Janet Curry she was born October 12, 1953 She came into this
world as a girl. Her *slang name* is Lashina. She's sort of fat, She has brownish red hair black
eyes and a sort of dark complexion She sometimes acts like a bully She dresses pretty *hip*
She know *What's Happening* but when she gets with her friends she's very rowdy She has
several boyfriends who all look nice and dress *fly* the first school my Sister attend was P.S.

154

103 the *bean school* there she always had my mother coming up for fight's etc. The next school she attended was P.S. 79 this was a *dino* school P.S. 103 was the annex. These school's were both in Manhatten there we moved to brooklyn. And she attended P.S. 133, She had lot's of fight's too many to begin counting. I especially rember one fight she had with a girl name pearl because she told my sister to "Get her rags off the lines and she said that my mother was ugly so my sister punched her in the mouth. that was a good fight because my sister won!!! then we moved to Adelphi St. where we live now. there she attended Sands J.H.S. where she got suspended two times and the third time they kicked out the first time she got kicked down for smoking in the bathroom. the second time she got suspend for walking down the hall singing "LSD got a hold on me" And acting like a fool. the third time I don't care to mention well anyway after she got kicked out of Sand She attended Harriet Beecher Stow J.H.S. in Manhattan there she graduated and went to w.e. Washington Irving H.S. so far she's only got suspend once for fighting in school.

She plans to be a nurse so she can work in the *butcher shop* and make it a *slader house* (just kidding) She also plans to become a writer. She is now working with the jr. working work shop. All in all I'll say my sister is a pretty hip child with a *rotten* school record and a high ambition

Slang Ditionary

1 — Slang name—Nick name.
2 — What's happening—She know's about just about everything
3 — hip—knows what's Happening
4 — Bean school—always serving beans.
5 — dino—nice, boss
6 — butcher shop—where the hospital like to chop you up (Cumberland hospital)
7 — Slader house—where Cumberland hospital wants to kill you
8 — rotten—Bad, not good

by Pat Curry

All things that a wall is made of is
paint stones wire and plaster.
a brick wall is made of cement and bricks
And a walnut is made of a hard shell and a nut inside of it.
And to me there is a wall of Love and it is made of a boy and a girl

a kiss and a box of candy to eat.

—Lonzell

ISOLATION

 Isolation is like
a can of sardines
 and being the only sardine in the can
 Isolation is being alone
on Halloween night when

 all of a sudden someone
rings your door bell. You
say to yourself who could it be
 It can't be my mother
for she out of town. You start like a
leaf blowing you start toward the door
 foot by foot inch by inch. You put
your hand on the doorknob with great speed
 of lightning. You pull
 the door open and there
you stand face to face eye to eye

155

 nose to nose with a normal boy
 in
 a Halloween costume saying
 TRICK OR TREAT

 Michael Bryant, 5th Grade

 The sea was calm
 As a breath of
 Cool air was
 moving from
 the sea

 And the moon arose
 revealing the long
 line of the jungle
 trees

 As they stretch to the
 mouth of the
 open sea.

 The moon draws up
 Like a draw bridge
 To let the
 Stars see.

 Carlton Minor

IGNORE THEM

 Some of you feel the way I do. Can't walk in the streets at night especially girls because
there's boys or mens that don't care whether you're that type of girls. Ignore what you hear.
There's no place that isn't like that, at night.
 You see in the news pictures of Vietnam hear about them. Just pray and ignore what people
say about how good it is to kill those Vietnamese. They're human beings also. They were made by
the same God. Isn't that true?(!!!)
 You hear different color people talking about our your or their color. Ignore them. Colors are
beautiful. If their beautiful on nature you know what I mean they have to be beautiful on us. Ig-
nore everything that are dirty. Just dream up a beautiful clean wonderful place to live in. One of
these days this world will be like that Dream.....

 Miriam Lasanto

 "White Power"

 Well, Really, someone came up with this Phrase and then everyone decieded that
they would use it. when I said everyone I meant everyone that belongs to the K.K.K. in
case you don't know what the 3-ks stand for they stand for klu-klux-klain and also some I
won't say white but light people haters of mankind also use this expression. Well look at it
this way: define white—white is a chalky color, the lightest color there is. Power means the
force to do something. Well, put these two meanings together and what have you got?
"Chalky force". Does that make sense? "No". So you see why it doesn't make any sense
to me.

 "BLACK POWER"

 This is also meaningless to me. The People use this as an poor excuse for violence or killing
and robbing and stealing. so to sum this up

 ALL MEN WERE CREATED EQUAL IN EVERY WAY

 Patricia Curry

Once upon a time, oh several centuries ago at least, there used to be white folk and black folk. Now the white folk were a little confused as to who they were, claiming certain short and slant-eyed yellowskins and certain tanned and hairy types for their kin while the black folk likewise felt these in-betweeners were of their stock. Confusion was helped along by fake political posturing, some groups claiming to be Red, some claiming to be Red and Yellow, and some insisting they were Rainbow Free. Well the black folk lumped together all those who had claimed and proclaimed themselves underprivileged, undereducated, underpaid and undermined by the Other Side (which was mostly true), while the white folk lumped together their own team (with a large area of overlap) and worked on keeping most of the Invisible Enemy underprivileged, undereducated and underpaid, at the same time programming, free-lunching, more effective schooling and selective hiring the majority into continuing oblivion.

The end came sooner than anyone expected. The yellow-reds swooped up the under-developed pure blacks and the tanned folk joined in, the developed black folk and the developed white folk saw the buttered side and joined ranks, determined to perpetuate political posturing. Then the underpaid, undereducated, underprivileged black folk sent their leader to the yellow-reds and joined up for poverty and racial unity (despite disparity). Then came War, The Nuclear Thing, and Black Power neutralized White Power at last... and too late. Too bad.

Now we flowered folk feel we might survive longer—if the chrysanthemums don't try to move up to the orchid bed.

<div align="right">Gena</div>

DREAMS

by Jonathan Baumbach

Feb. 21, 1968

Grace Paley and I went to Lincoln High School in Brooklyn today to read briefly and discuss writing with students.

Months before actual arrangements were made, I showed some of the stories the students would be given to take home to Elaine Spielberg, an English teacher at Lincoln (the wife of a Brooklyn College colleague) generally sympathetic to the aims of Teachers & Writers Collaborative. She told me that, as much as she'd like to, she couldn't give out any of the stories to her students. Nothing with four-letter words or sexual detail could be given to students to take home. Parents would object. Her principal would be upset. She would get in trouble. I could read or say whatever I wanted, she said, but her principal didn't want anything in print for the parents to see. We talked about it. Didn't such hypocrisy bother her? Yes, but that's the way it is. It is a city school with children from mostly middle class homes. The principal does not want to offend the parents. In fact, she told me, last year there was a story accepted for the literary magazine that used the word "ass" and the principal insisted that it be changed to "rear."

A few weeks later Mrs. Spielberg called. You may want to cancel your reading, she said, after you hear this. "I am to tell you that you cannot read anything with obscenity in it. My principal asked me to be sure to tell you. He's afraid it will get back to the parents." She suggested that I read what I had been planning to read and say "blank" for "fuck"—that is, make clear that the story was being censored. I said—blank blank blank. I said that I didn't know that I wanted to come to her school under these circumstances. I thought the restrictions themselves obscene and insulting to the students and to me. She said that she understood my position but that's the way it was. I said also that it was my experience that students found it liberating to know that it was permissable to write about real things in their own language—to tell the truth about themselves—instead of having to lie to their teachers (to be "good") through evasion and euphemism. She said she agreed completely but the place was as it was. "Look," she said, "I'm not responsible for what you do." It was enough, she said, that she had passed on the principal's warning to me. What I did when I got there was my business and she couldn't be held responsible. (What the blank did she think I was going to do?) I said I would think it over, thinking at the moment that it was best to call the whole thing off. The prospect of being moral-danger-in-residence at Lincoln High School held no pleasure.

I decided reluctantly to go. I asked Grace if she would come with me, split the bill as it were, and she said she thought it might be fun. So we went together.

Though I like to play things by instinct, I had a general notion of what we would do. My idea for the first visit was to read two very short dream-like narratives from a story I had just finished called "Dream News and World Report" and have Grace read her fable, "The Sad Story About the Six Boys About to be Drafted in Brooklyn." Then ask the class to write a "dream" or a

fable for the following week when we were to make our second visit. I thought for the rest of the time we would go over one of their stories with them. As it turned out after we finished reading, Grace and I spent about forty minutes answering students' questions about writing. The questions were important to them. It was a good class. I had the sense that the students (some of them, some of the time) trusted us to tell them the truth and we did insofar as we knew what it was.

Censorship didn't seem to be an issue—or was less of an issue than I anticipated. In one of the pieces, I substituted "frigging" for "fucking", though I don't know that it mattered. Grace read her fable as written. Our behavior was natural—slightly charged because of the situation, something of a performance—but mostly we talked as we would to friends. I at no time censored myself or felt constrained to.

The questions mostly concerned practice and career (who we were, what we were about)—how much did we know about a story when we started writing, did we begin with theme or character or plot or what, at what age did we decide we were writers, how was such a discovery made, were we encouraged by teachers, what writers did we admire, how do you go about getting a piece of writing published...?

The session lasted about an hour and a quarter. We see them again next Wednesday at two.

February 28, 1968

Grace and I went back to Lincoln today for our second visit. We were made to feel (in small ways not worth discussing here) less welcome than before. Some tension in the air. Does the teacher feel we're stealing her children from her? Undercutting her authority? (Have others had similar experience?)

Nine of about thirty-five had done the assignment we gave them. I read one of the "dreams" aloud and asked the class to talk about it. A girl named Rory questioned the assignment, said she was only interested in a dream if she knew the person who was dreaming it and had reason to be interested in that person. I tried to explain as much for myself as for the class why I had asked them to write dreams. Improvising, I said something about the relationship between dream and myth, but it was a made-up answer (a teacher's answer) and not a real one. Dreams interest me, I said, are important to me. Why? Because they are at once devious and unguarded. Give us the truth in mysterious and sometimes witty disguise. I talked about how one feels the need to censor real feelings that are socially unacceptable. In the process one cuts oneself off as writers (as people) from whole pieces of one's experience. Dreams are coded messages from the hidden self. One way for a writer to get closer to himself. Are revelatory. The mystery of them intrigues me as a reader—how to get at their secret, how to read them.

Grace read a student dream dealing with the funeral of the narrator's mother. It was a more interesting piece than the first and class discussion was excited and alive. I asked about the line, "My father didn't even get a good hug once," why the narrator (apparently a girl) had made such a curious observation. The class tended not to want to see that the girl was doing away with her mother in the dream, was frightened of the prospect of having her father to herself, was by implication blaming her father for her mother's

159

death. I had the sense that they knew (had known) some of the things I was saying, but felt constrained not to talk about them. (It takes awhile for a class to loosen up, hard to establish a relationship on a one hour a week basis, though this group at Lincoln is especially trusting and warm.)

At 3:05—our meeting with the class started at 2:15—about half the group had to go to a class. (Why this Wednesday, I wonder, and not last?) They wanted to stay but their teacher, a man whose name I didn't get, seemed adamant about them going to class. I said that if they wanted us to return, we (one of us anyway) would be back next week. The students indicated that they wanted us back, seemed pleased that we wanted to return.

We stayed another forty minutes answering questions—the class diminished from about thirty-five to fifteen. The questions were serious and interesting—how much better these kids are than professional interviewers—but after awhile covered ground we had gone over the week before. I heard myself giving same answers to same questions. I would have liked more time to discuss their writing with them. Left feeling somewhat dissatisfied.

I would like to go back for at least one more visit. (My sense is that Mrs. S. doesn't want us to come back, but doesn't want to say she doesn't want us back, so handles it by putting obstacles in the way.)

I'm climbing. A rough, dark tunnel encloses me, with only a pinhole of light ahead to guide me. I keep crawling, more frantically now, but the pinhole remains the same size; I'm getting no closer. I dig into the rough, earthy walls, in a frenzy. I must get out. I call for help. Suddenly the pinhole gets closer. The light, blinding, brilliant—I can't stand it. I wrap my arms about me, clutching the ribs of my back. My head sinks down. The pinhole and I are one. I slowly unravel and start running. I run down the street into the playground. I hear distant laughter. It gets louder, louder—one continuous laugh. It doesn't stop. It becomes deafening. Little girls in lace dresses with golden tresses, swing back and forth. Mouths open in laughter, hair flying, back and forth they swing in slow motion. Little boys, in rattling suits of shining gold armor, go up and down on see-saws, in machine-like rhythm. They almost meet the swinging little girls, when in the air. Back and forth, up and down, little boys, little girls, meeting, together. The action gets faster; the music gets louder. I spin around in circles. The children abandon their playthings and joyously dance around me. I sink down into a crumpled heap. All movement stops. The children melt and fade. Their bodies become a sea of color and just a sea. I'm on a beach or am I? At one end of the beach stand the tombstones. The water licks the stone and quickly wears it away. Up rise shadowy, formless, jellylike corpses. They dance in what might grotesquely be called a circle. I seem to remember something like this happening before. I am reminded of the children. I am horrified. "No, death, no," I scream. I run, fall, start digging in the sand. I see a pinhole in the sand. I look into it. I see a tunnel and feel myself falling down and down.

Adrienne Lobel

Grey Existance

I arise every someday; my eyes are grey.
My Family; All amist before mine eyes.
My Mother, *"Father,"* all hail to thee.
Sister: the devil's advocate?
Little brother: Ah yes, Little brother.

Cat—Hi Cat! High Cat?
 I wish you were I

Bye Mother, *"Father"*. Sister, Brother.
 Don't be grim, me.
Leave grey thoughts with Families.

Alone. Cold, Icy Wind
Catharsis of mine bitter mental tears.
Platinum ground, Blonde Sun
My mind feels white, maybe even yellow.

Close of my "Second Home"!,
Grey once more sets in.
Blonde Sun, Platinum earth now gone from me.

Hey me! Smile to the beautiful children.
 Smile to all the pretty rushing people.
 Me, are you grey?
Put on your personality, Put on your mask,
your two round green circles,
that shield you, hide some of your greyness.
Oh round, green, circles. You are my fortress, my womb.
Rush, bustle, hurry—are all others as grey as I?

Almost 6th, almost 8th, will we stay?
Maybe circles can come off.
Now, you are the quintessence of my joy.

Fishman: Intelligence, wit, love.—man.

Why am I still grey? Why am I Still with Circles?
Problems, discussions: Why don't I pour?
Why must my "damn" be so tight?
Why does it not send waters rushing forth?

Be happy me: Beautiful children are here.
 I like them? I like them.
 Why am I grey?
 Children have their buddies.
 I am number 13.

Me! You can be a buddie.
Your greyness here is your own.
Yes. I should be yellow.
But no. You want to be grey.

Friday: Thank G-D?
No People now, now beautiful children.
Weeds before mine eyes, I drift among weeds.
No Hellos, No Goodbyes; Odd you say?
 Not for Weeds.

Once my mind felt pity?
Once I wanted to help?
Not Now! What was grey then is even more so.

Michelle; understanding, warmth, beauty.—Friend.
 But I cannot lean.
 She lives, I live—We talk.
 But each must live alone.

Hey me!—You are not happy drifting through grey fog.
But you are afraid to leave on your own.
You want Lancelot to come and rescue you.

Huh? What Folly.
No. You are one, you are alone.

Forget Love, Forget Yellow?
 No! Only for now.
 Think, dream,
 Yes, think, dream.

5 Tomorrows From now
May be White, or black.
 But not Grey.
You won't let there be grey any more.

 But now, yes now,
 You drift, you Float,
 through a grey existance.

<div align="center">Shelly Stelpner</div>

It was my mother's funeral. I was sitting and crying. Hoards of people came and comforted me. He came and gave me the greatest hug and it was the best thing that I had ever felt. More people came.
—Poor thing.
—Poor baby.
—Poor thing.
More tears. More great hugs of sympathy. My father didn't even get a good hug once.
—The poor kid.
—What will she do?
—Do you need help?
—Anything you want. Don't forget.
We carried out the coffin. Teary-eyed I ran off to a secluded part of the forest. He came. He kissed me. He told me not to worry. That he would always be there. Mme. Bovary all over again. We returned together. More people were milling around.
—I feel so sorry for you. You know I knew your Mother so well.
Mother?

Dream #2

. It's dark. Where am I? Wait. I feel something grainy under my feet. It's sand. But what am I doing on the beach? It's winter. A shipwreck. I see a shipwreck in the distance. There's a man out there calling for help. Must swim to him. I jump into the wild, frigid waters with all of my clothes on. I find it hard to swim. Can't take my shoes off! Why?

Current is against me. Miraculously I am reaching the point where the man is. There are rocks jutting out everywhere. Must be careful. Why can't I remove my clothes so that swimming will be easier? I am reaching the man. Very near to him. I look again—suddenly he's gone. No. Wait. Not completely—I now see that he's about another mile away from me. But he was just near me a moment ago! Can't turn back now. I'm in the middle of nowhere. Must go on. Suddenly, I'm not alone. I see faceless people swimming with me. Yet, I feel that I've known them for a long time. We seem to be swimming towards the same goal. There is money floating all around us. Dollar bills—all. We decide to divide it among us. Then, I see a ten-dollar bill float up. I take it without telling the others. Suddenly they disappear. I'm alone again. Afraid. I realize that to live, I must get rid of all the money I have amassed. It wasn't necessary. I didn't make it.

<div align="right">Lois Stein</div>

A Dream

It was a spring day. I remember that I was playing outside just under my window with my pink sweater on. I was playing hop scotch and I threw the pebble into the ones box. Then I saw him. His name was Ali and he was the negro porter. He lived in the basement of my apartment house and I was terrified of him. He reminded me of a rat with little black eyes and a skinny, almost emaciated frame. He looked at me for a moment and I remember his laugh. It was a strange kind of sound. Then he put his hand over my mouth and started dragging me down to the dirty basement. I remember him carrying me over a large pond of water. He had to walk on a plank of wood to get across. I remember yelling and kicking but he just laughed. He placed me down and started taking off my clothes. First my saddle shoes, then my socks. Finally I was standing naked in front of him. I remember shivering from the cold. Ali told me to wait and he went into another part of the basement. Now was my chance to escape. But I couldn't run out into the street without my clothes. People were outside and they would see me and laugh. I would be embarrassed. I have to stay here. No one could see me without my dress on.

Fran Bardash

[Editors note: According to Jonathan Baumbach, "All of a sudden we were notified by the teacher that the class didn't want to see us anymore. It was hard to get any further information: we were just simply cut off. The sense of the whole thing was that she felt overmatched or undermined. Since we were the entertainment, she probably ceased to be the entertainment at all, and became the one just enforcing work they didn't want to do. We were very hurt, it was mystifying, and we never went back. Too bad; I had had a very good time doing it." (Interview, 1978).]

A Class Novel
by Lenny Jenkin

March 4, 1968

We have begun a novel. Its tentative title is "Eddie and Miss Booker: Their Adventures." We began by making up a character. I explained to the class that we were going to write a long book, which would be a combination of everybody's work. The first thing was to invent a leading character. This was done by my going around the room and asking one kid after another questions about the person. This was also done by the "inside—outside" method, first asking about the physical appearance of the character, and then about his likes and dislikes, his personality, is he nice or mean etc. I reminded them of their previous work that they had done with me, and this seemed to make it all somewhat clearer to most of them. The character they invented in response to questions of mine like: "Describe his face"; "Is he healthy"; "How tall is he"; "What kind of thing does he like," etc. etc. turned out to be somewhat of a monster. His name is Eddie. He is nine feet tall, has green skin, and wears clothes and shoes made out of green paper. He is a mute, is redheaded, and is missing an arm. He is a thief, and although he is married and has a large number of children, he also likes to "get girls." The group was fairly good at being able to fill in details, and some were very anxious to add to the portrait freehand. There were others who would not respond to questions like "What color hair does he have?" except with an "I don't know." I could not make these few understand the idea. There were one or two girls, as I went around the room, who simply did not understand my questions, and I assume that they have as yet (they are Chinese) very little English.

When we had completed the character, we began on his place of residence. They were not nearly so fantastic where this was concerned, as the initial response to "Where does he live?" was a New York apartment at a very specific address. They took off quite soberly from there, giving him a filthy three rooms and orange crate and cardboard furniture. As another character, they invented Miss Booker. This was the name of a previous teacher in the school who was apparently· quite unpopular with the kids. It took a while for me to make them understand, and with some I was unsuccessful, that the Miss Booker we were inventing was not necessarily the same as that one. They would keep bringing up the real Miss Booker's characteristics even though opposite ones were already on the blackboard for our character.

I explained to them carefully that next time we were going to write for a long time, and that they had to have a lot to write about as far as what these characters would do was concerned. In a very simple way, I asked them to derive from the characters as given, possible actions. I don't know if this idea of motivation got across, and next time will tell. When they heard that if we each wrote five pages there would be a one hundred and fifty page book about Eddie and Miss Booker they got very excited, and asked questions about when it would be published, and how much money they would get for it. I told them I didn't know, but that we had to make it as good as it could be first, and then think about all that.

Today everyone in the class spent the first half-hour writing a first adventure of Eddie and Miss Booker, the two characters we had invented last time. I reminded them before we began that they should think about Eddie (and Miss Booker), and that what he would do and the kind of adventures he would have would be based on what he was, what he liked, etc. I talked to them about the cartoon character Mr. Magoo, who gets into all kinds of adventures because he can't see very well. This example seemed to help them understand motivation etc., and what I had in mind. For the first ten minutes or so they had difficulty settling down to write, but after that they all became involved, and most wanted to keep writing, but I stopped them so that we would have time to make up two new characters. These were Eddie's dog, *Dick,* who is a German Shepherd who protects his master and can do a whole series of impossible tricks, including doing the boogaloo. The other character we invented was a police chief, Chief Candybar. He is thoroughly inept. He trips over his holster, he is scared of robbers, he doesn't know how to shoot his gun, and he loves candy bars. I explained to them that next time we would have four characters, and they would be able to write more complicated adventure stories with them all involved. They were excited about the possibility of their book being "published," and I told them that if they all wrote well, it would be, and they would get copies (I'm counting on you for this).

After coming uptown to pick up the copies of *The Adventures of Eddie and Miss Booker,* I found the entire school assembled in the schoolyard watching some kind of police and fire department demonstration. I went over to the class, and gave the teacher the copies for the kids, telling her I'd like them not to take them home but to have them next time so that we could talk about them. Quite a few of the kids rushed up to me, asked me if I had their book. They were, of course, disappointed it wasn't bound in solid platinum, but very excited about it. I told them we would talk about it next time, and they went back to watching the display.

Tell Zelda I've decided that I agree with her, not that the grammar should be corrected, but that the spelling, where it makes no particular point should be. I'm becoming less of a purist...

I wanted to discover what the class' reaction was to their own writing. They all had copies of The Adventures of Eddie and Miss Booker in front of them, and most of them said that they had read it. When I asked them if they liked it, most said yes, and were able to point out particular scenes that they liked the best, mostly the ones with action. There was no grasp of the idea that I inserted through the arrangement of the scenes that Eddie has turned to crime because everyone rejects him because of his monstrous appearance. They also were not bothered at all by the lack of continuity; in fact, they didn't recognize that there was any.

They had a lot of objections to the book. These were mostly not to do with its content. Quite a few kids said very strongly that the spelling was all wrong, and that this was a thing that they didn't like. A few ran up to me to

show me this before the class. They also objected to the fact that it wasn't printed up with a hardcover and all like a regular book—a book has a cover, etc. This isn't a *real* book. Quite a few also objected that "My story isn't in it," and some made that objection even though their stories were in it. To any *why?* questions about likes or dislikes I drew a blank, and their attention would wander. I had them write down this list of questions to have the answers for next time I came.

1) Does the ending make you sad? or happy? Why?
2) Do you like Eddie? Why?
3) Do you like Miss Booker? Why?
4) Do you think The Adventures of Eddie and Miss Booker is a good story? Why?

I ended the class by telling them we were going to begin next time with a new kind of writing that we hadn't done before. I was surprised that they seemed very interested in doing this. I'm inclined to think it was because the kind of thinking I'd been asking them to do—understanding—is really something that's not so much *difficult* as it is something they don't want to do with this story. They'd rather write another.

<div align="right">Monday, May 13</div>

I asked the class those questions that I had them write down and think about for the next time I came. The answers were a little more comprehending than they had been, but not much. There were just some of the usual reactions, such as "I like the ending because everybody gets killed." "Why do you like that. Doesn't it hurt?" "I don't know." All the reactions to liking or disliking the characters were based mostly on physical appearance. "I don't like Miss Booker because she has a hunchback." This whole line of questioning was, to say the least, not a success. It seemed definitely to be asking too much of them for them to know whether they liked a character in a book. It was easy for them to like what the character did, if it appealed to them.

I tried an experiment on them, rather than letting them find out what they could do. I gave each kid a piece of paper and had them divide it in half horizontally. I asked them to write a description on each half, on the top a description of their mother, and on the bottom of a lady on TV, any one that they saw regularly. Each description was to be both "inside" and "outside," a physical description and a description of how the person acts. They didn't seem to relish the idea of doing this at all, and most of them got bogged down in the mother part, and never got to the TV lady. The descriptions tended to be dull and ordinary. Most went like these samples:

"Mother—you is a good woman. I love you. You all day to do a housework and morning you go outside to work made money to help family so every people said you is a good lady."

"My mother is short and fat and she is respectful and she be careful with things. And she stays home and sometimes goes to the movies. She is old."

"My mother is look like her eye is little, her foot is big. Have a big

<div align="center">166</div>

mouth, she look very angry. You better not bother her, she going to kill you she's tall, and strong, but she not fat.''

The kids seem to have, generally, no trouble at all writing about, and want to write about, their fantasies, but reality is a little stickier, and ties them up. Maybe it's not basically because the reality is unpleasant, but simply because at their stage they are a lot closer to their own world than they are to anybody else's, and it comes in a lot clearer.

Final Diary—Evaluation

I don't have that strong an impression of what Teachers & Writers has been doing generally to evaluate that in any way, so I'll just be talking about my own experience in the program.

The kids I was dealing with were really too young. This is not so much a question of chronological age, as it was of "young with the English language." Almost all of them had either Chinese or Spanish spoken in the home, and this really made things rough. There were always some students who could not even grasp what I was asking them to do, much less actually do it, well or poorly. Perhaps there could be a way to use language, words, writing, to really open up these kids, but their English is still far too primitive to really respond to VERBAL presentations very well. The words only signify so much to them; they haven't yet drawn power around them in their minds. I think with kids at the stage of development these were, some kind of curriculum approaches based a lot more on what they HEAR and SEE would be more effective than writing or reading, but again, this wouldn't be for Teachers & Writers, I don't think.

I do think some of the techniques and ideas I used with them are good ones, but I think the response would be a lot greater on a junior high or high school level to these same ideas.

This is a little sneaky to use as a technique, or to incorporate into a curriculum, but I'll point it out anyway for what it's worth: the reason *Eddie and Miss Booker* was so successful with them is because, largely through their own invention, it was centered around certain "psychological keys" that caused a lot of energy to flow from them into the writing. *Eddie and Miss Booker* is a long tale of murder, robbery, rejection, family arguments, infidelity, injury, and isolation; these are things that are really close to them. If they are confronted with this kind of lead off, their follow up is bound to be loaded. As I say, it's sneaky to use these things, in one way (of course, if you ask these kids to write on how much they hate their fathers, you are going to get some funny stuff) but in another, if they can be the driving force behind an exploration of the fact that words can say things that mean something, OK.

This may be a sidelight I haven't mentioned. With these kids, unless a tremendous amount of fear is present (a principal or someone like that) anyone standing in front of the room and talking to them is only going to get a limited amount of attention; the main method of getting *everybody* to do something is yelling. This is what they are used to, and it works. The more you attempt to break out of the pattern the regular teachers they have had used in your presence in class (as you are doing it in the type of work you are giving

167

them) the more wild the class gets and the less happens. You get the feeling you are working against yourself whatever you do. I imagine working with individuals among the kids this wouldn't be the case, but I didn't get involved in anything like this.

With a little prodding something like *Eddie and Miss Booker* comes out of them naturally, and while it, I think, is a wonderful story in a lot of ways, I don't know what reading or writing it did for them. Not that much, I'm afraid. They can do a thing, but any of the whys behind it, or any sense that the writing is an extension of themselves out into the world, that they are telling someone something, or feelings are going out from them, or information or whatever, just isn't there yet. OK there is a glimmering in some kids, a waking up to possibilities in themselves through this, but I'm sorry to say just not that much.

As I've said above, I think a lot of the ideas I came up with could be used very effectively in classes with older kids, particularly the ones that emphasize the direct connection of writing with modes of perception, ideas of how writing (or the language generally) focuses perceptions and feelings, as it changes them.

This is about all I could come up with in terms of a final evaluation. It doesn't seem to have as much in it as I'd like. If I come up with anything else, I'll send it along.

Cheers.....

The Adventures of Eddie and Miss Booker (Abridged)

ONE DAY EDDIE go to school with Miss Booker. Miss Booker was very crazy. And Eddie was very smart. Miss Booker like to bit his friends. His friends was very angry. When she got zero on his test. She will bit his teacher. And Eddie tell she don't bit the teacher. And Miss Booker said you got a hundred. But I didn't. I don't bit the teacher. Now I has to bit you. So they fight together. Then Eddie got crazy too. The teacher bring Eddie and Miss Booker to the hospital. In the hospital they bit all the doctors and the sick people. Then the doctors put Eddie and Miss Booker into a cage. And bring them to the zoo. They was going to the zoo. The children saw Eddie and Miss Booker. They all laugh at Miss Booker and Eddie. They was very sad.

ONE DAY A party have come. Eddie is a ugly man but he always want to dance with pretty girl. That make they laugh. So he run out the door and go home.

ONCE UPON A TIME Eddie saw a lady on a bench in the park. So he decided to snatch he packet book. When he was coming he couldn't do it and he fell in he laps. She told him he name and Eddie to Miss Booker. Thats how it all began the Adventures of Eddie and Miss Booker.

THEY HAVE FIVE CHILDREN. The children was so funny a big one is have a big hant and three eyes he is look ugly he so every bad he always hit his little brother. his little brother was a nice boy he has two eye and a nice hair Miss Booker is love a the one they hate the big one they live every happy. But they hate the big one.

ONE DAY MISS Booker told him that she was going to fix him up. The first thing she did was give him a bath than buy him new cloths than comp his hair nice than she buy him sunglasse he begian to look hansome. She buy him good shose. Miss Booker send some mans to clear his house an put it very pretty. She paint his hair black.

EDDIE AND MISS Booker were ugly. They was a secert people. One day they want to the store.

They saw the hippies was steal the thing. And Eddie go to choose him. The hippies told Eddie don't tell the storekeep. Eddie ask why. They said because if you tell the storekeep he will call the police. And I will be in the jail. But it is a bad thing. I must tell he before you get out said Eddie. Oh please don't tell him.

EDDIE AND MISS Booker they like to eat dogs. They sacred people and at or mice. They like to play ball or play fire. They are a giant they like to jump. They like to eat animals. Some tim Eddie like to fight or made something. He like to cut the trees and he like to painting. And he like go to trip and he like to go fishing. He is very tall. Miss Booker she like the people and do work.

ONE DAY EDDIE and Miss Booker hit a little boy in the face to take his ice cream. Chief candy bar came after Eddie and Miss Booker. The chief ran after Eddie Miss Booker was scared and ran back to the house. Eddie bit the chief in the leg. The chief ran away. So they were planning bank robbery but they need a strong dog. So they want to the A.S.P.C.A. to get a germans shepherd. They name him Dick. On the day of the robbery they put Dick in a box. When they got the bank they lit Dick out and Dick started to bite the bank and manger and the employees from ringing the alarm. After a few moments Dick join Eddie and Miss Booker. One of the goofiest police chief was sent over to investigate the robbery. The chief came with a dog catcher. The dog catcher caugh Dick the do Eddie was crying. He said mame I want my dog dick came threw the night and broke the cage and got Dick the dog out now his girlfriend Miss Booker was stealing jelwes the police saw this and ran after Miss Booker she ran for he live she finaly got home and Eddie, Miss Booker and the dog got out of town and went to New Jersey. They live there for a year and the dog and Eddie and Miss Booker lived there happy untill there next ad-vanger.

ONE DAY MISS Booker fell down and brok a window and she cut her hand with the glass. And eddie said she cut her foot to and the face she said help help help when chief candy bar came to the house chief candy bar said I call the doctor and you get some band-aid for her fase. The fase is the importan thing chief candy bar said

AND EDDIE RAN to the batroom and get some band-aid and in that moment the doctor came with the ambulance and chief candy bar tell him to fogat the band-aid he said! And Eddie ran back again. and chief candy bar said! "you want to go to the hospital too. Ah? Eddie?" And he said! "yes chief candy bar I want to see Miss booker."

EDDIE TRYED TO get a taxie no taxies will stop Eddie said I have a friend that will take me his name is John the ran to John's house he took them to the hospital they ran in the nurse said to Eddie boy you really need sargery I got to call the doctor. no, not for me, for Miss Booker she's in this hospital the nurse said room B-G 7th floor. they ran up to the 4th floor and got tired and walked the rest the way up.

THREE WEEKS LATER Miss Booker came back to house and eddie said! "Good good Miss Booker came back
And Miss Booker and eddie said! "I dont know how you can tell me that eddie I dont going to wash any more windows I promise you eddie I promise you.

EDDIE BLINKS A lots and dosen't let Miss Booker sleep. And Eddie's fat belly touch Miss Booker's hunch back. They both couldn't sleep so he went to his other wife's house so she was so pretty that his thick eye brow's bang out. So he got to sleep then the next bay the pretty lady had 25 babies. But Miss Booker came and beat her up. The next day she was in the hospial.

ONE DAY EDDIE sleeped with Miss Booker the Miss Booker lay a fots and Eddie began to ran out he went to his dog named Dick and went to the chief named candy bar the chief candy bar said I am sorry I'm going to see my girl friend named Bazooka So the chief went to Bazooka's house and said to Bazooka I got some busness to fixed with Eddie you said that he was here last night right so I am going to beat him up So he went and beat Eddie up and then german shep-herd jump chief candy bar. Then Miss Booker came a said who beat my poor Eddie I did said chief candy bar because he went to bed with my wife yesterday that why. And that was almost quites for eddie and Miss Booker.

ONE DAY AS a little boy was walking by a candy store Eddie had a gun he said stick em up so the little boy said here is my candy. So Eddie went to his house and gave his girl Miss Booker. She kissed him and she had no lipstick on and Eddie fell down because her lips make a person sleep for 5 min. Then it hit the newspaper Eddie and Miss Booker robbers. They hit banks and hit store for fun they robbed candy from kids. Kids all over New York were crying but Eddie was too ugly and police were afraid of him he was the riches robber in the world. Miss Booker would stay home and count the money they would go to differt houses and live there. One day when Eddie was eating a hamburger he got sick he foregot that he can not eat hamber with onion. So he went home and fell asleep his wife had to rob for him she took some milk, candy, bread, cookies, gum, eggs, and for kicks she would rob some tobacco to chew on the way people would see her and would run away so they bouth fell asleep when she got home and they stay there for a week. They went to egyt for a week and where happy.

ONE DAY I saw a german shepherd down the street. I said well I will take you to chief candy bar but the ran away I went after the dog. So I went to the house of Eddie. I konck on the door. You know who came out. Mr. Eddie. He said Dick come in a dance the boogoloo with me. I said well I saw him so I was going home I told him I will take him to chief candy bar and he ran to his home.

ONE DAY EDDIE went to see Chief candy bar and Chief candy bar wasn't there he was with Miss Bazooka on a trip. Eddie went to Chief candy bar because Miss Booker was sick. Miss Booker was sick because Dick the dogs bite her hunch back. So he went to a place that was own-ed by manuel the millionaire he asked for help so manuel went to Miss Booker house and manuel couldn't believe his eye his furniture was made out off card board. Then Miss Booker said help I am dieding so went manuel the millionaire got there Miss Booker and Dick the dog died. So manuel the millionaire went to his beutiful house where there he had beutiful girls and manuel went and kiss them. And a couple of year later Eddie died. And that was the end of Eddie and Miss Booker.

MARGARITA HAD THIS dream: One day a group of people were walking down the street. And I was walking along to suddenly they took me away to a little room and in that room there was Eddie, Chief candy bar, Miss Bazooka, Miss Booker and the dog Dick and me as Margie. I took my knife and put it in Eddie's stomsch than everybody saw Blood and started creaming the F.B.I. came in an they started creaming and than my mother came in and she started laughing than the policeman came in and they started shoting. But everybody was bad when I told them I don it. They took me to the policeman and I told them the true because it was better to say a true. So they said you are good and trueful so you are free. Margie said thank-you and my mother was very happy with me. The other people went to jail Because they was the one who have took me. I got rich and I got them out of jail they were my best friends. They got rich and very happy.

ONE DAY EDDIE and Miss Booker and Dick the dog went to the bank to rob money He kill a man and his dog killed a boy and a girl because they had icecream. Then chief candybar came with his men. he had a gun he got amost kill Eddie and Eddie dog. the Bazooka caned and try to help them.

THEN THEY CAME too. The hideout. The leader of the gang came it was Miss Booker she was the leader of the gang. she said "there is no money eddie you should die. good thing I tooked some. if I don't I'll be a dead duck.

THE BOSS GOOD. Eddie said "now Miss Booker you will die" "oh no plece" "yes you will die. So there you are" "Oh no is Chief-candybar" "Oh oh you got me" "it is Miss Booker she is dead come on we better go oh is a time. Bond we can go we are trap. like a rat. good by Bazooka and Miss Booker and my dog.

A Grave for My Eyes
by Art Berger

```
maybe it is a
          conspiracy
maybe only
          important people
          come invade this
          place with a
          hundred siamese
          brothers
maybe the only
          thing alive
          is my imagination
          or my memory...

my delayed spontaneous
writing
was a delayed
reality
a picture that
wasn't
          quite developed...
it takes
          time
to allow yourself
to accept that

          you too
          are merely a piece
          of someone's

               memory...

     by Barbara Howard
```

October 9, 1969

This workshop is the result of a summer workshop at Queensboro Community College. Barbara Howard came back to Mr. Levy, the English department chairman, with enthusiasm for it and convinced him there was a need for it. He agreed after many reservations. The only space they could dig up for us was a corner of the lunchroom during the hours it was not in use.

The English chairman was also nervous about an 'outsider' coming into the school to lead a program with the students. Several conferences with him and some correspondence from Teachers & Writers seemed to have worked to quiet his fears. High school administrators seem to feel there is something subversive about poetry. (There is some truth in that.)

After several preliminary meetings with interested students we finally got together for our first session. Mostly we agreed on some minimal ground rules for passionate criticism without poison, and a day mutually agreeable to all.

[Editor's note: this material was originally published, in slightly longer form, as a separate pamphlet of Teachers & Writers Collaborative.]

We sort of felt each other out through a long rap. The talk was strong but not loud about:

Third eye: "Everyone is a poet"; Individuality—to know each other from the poems we write. This makes for the "openness" that is characteristic of a successful workshop, and rarely happens in a classroom.

(We also reviewed) some of my I.S. 8* material and spoke about the spontaneity of kids, their greater sensitivity—how they respond because of lack of "right and wrong" laws of what to say. We agreed to try spontaneous writing.

October 22, 1969

"Sound-words" appeal to the eye-in-the-ear: the label on Len Chandler's new album, *Eye-Lobe,* as symbol of what I'm saying. Modern-day poets and jazz and rock writers use "sound-words" as the basic gist of their poetry.

But nothing is ever really new. Shakespeare also used sound-words. I read "Hey nonny no" from *Twelfth Night,* "Ca-Caliban" from *Tempest,* something from *Hamlet* and even from *The Old Testament.* Mr. Levy, who was sitting in, beamed benevolently in approval of my concern with the classics. (In retrospect, I think that I may have fished them up to reassure him—but they really work.)

The sounds of Yusuf Rahman, *Lady-Day Springtime;* Norman Pritchard, *Gyre's Galaxy* coming off the *New Jazz Poets* album, and Jackson MacLow's raucous *Sea Gull* on the *Poems for Peace* album demonstrated how a poet's voice becoming a vital instrument for sound, strips away veneers enabling us to see through our ears and for "soul" to break through. Silence and noise take on powerful meanings with MacLow.

It was time for the Newtown poets to become extroverts like all poets—to wipe out the ego long enough to sound off with some exercises on using the sound of words, getting used to choosing words with the meaning apparent in the sound, and getting used to the projected sound of their own voices.

Something I did worked, for they started dashing off writings as furiously as my I.S. 8 sixth graders. Even Mr. Levy pitched in. It looks like we have won him over. He had to leave but insisted on reading his thing in an appropriate growl:

> Art Berger, grrr, grr, grrr
> Berger's grotto art
> ca-a-a-a-ve
> man!

The following pieces were written on the spot by members of the workshop as examples of writing intended to make the ears see.

> Cool, ool, spool, and drool
> school—no schools *not* cool!
> goddamn fool!
> goddamn fool, goddamn fool
> you goddamn fool, so-o-o-o
> You think you're cool

*An intermediate school also in Queens where Mr. Berger was working with younger students.

172

Curling, cooling, curling, squirling
cooling, churning
I have no tool with which to cool
so-o-o *slap-me-five*
and ooze, and soothe your cool
choose and roost
chew the noose, but cut it loose.

 Karen

pressed in, out, round, down
pain-press brain, strain down,
pressed..............in.
pressure, press......press down
pressure, pressing downward,
going deeper and deeper down,
pressing inside, outside, all—around
pressed.....out...........

I can't.....I can't I can't I can't
I CAN'T, I CAN'T
i....can't.................do it!

 Ruth

super swooper
swoop superly
or be super for the swooper

hey super air
swoop through my coattails
super cat flat on the rails
whatcha wailing for
you already are super swooper

 Barbara Howard

Snow snow oh oooh
oh snow
Dark! White! Black night!
panting panting
oh panting snow
snow snow snow
where did you go oh ooh
the snow the snow
 snow
 you go you go
go go! Don't go
Snow snow
you love snow
 love love snow

 Doris

Fribble
Ibdibble
ib
dib
ible.
Bibbly
bib
bib
bi;b
libib
dribble
ribs
siribs
rib
rib
sibib
Bibi
bibi
babi
BAH!

Carol

November 5, 1969

A new poem by Katia:

MIJITA

Wake up at 5 am
Take a shower
Dress and pack and walk away
while going down the staircase
Mama comes out and asks me why
—The sun sets Mom...I want to see the sun set down
and her puzzled face replies
—"The sun went off 12 hours ago and won't go off
until tonight"
—I don't care mama—and I walked out.
Come back at dinner time
Smile and say hello
Unpack and sing out loud
Stare at my wall and whisper low.
Mama comes in and says *hello!*
Oh! But thanks to God you did return!
—What do you mean "I did return"
If I was going to anyway.
I thought you were eloping and I cried so much
I cried all day
—Just because I went to see the sun set down mom?
But *Mijita* How do you expect me to understand?
.....Did you go by yourself or with a boy?
—Why do you ask Mama?
—Well I have to say to your Dad you know!

Comments:

Nina: Katia read it good—it's real, it's simple, no deep meanings.
Barbara: Delightful. Not really a poem, but the form chosen is the best. Not everything has to be classified.
Dori: Natural.
Art: Colloquial, earthy, nothing put on. Mother tongue flavor. It is charming because it is consistent. Stronger irony at the end would make it better. It reads like a diary. Katia would do well to do large work in this diary style.

November 26, 1969

Teaching the Blues

Okay, write me a blues, three or four lines, four beats to the line, like Woody Guthrie talked a blues. Beat of the blues is the life beat; beat of the heart, throb of the river and the sun, beat of the south and the heat. Listened to Lightning Hopkins and the way his last lines run of "And all my children were cryin' for bread" and for a lead line, to B.B. King "Why I Sing the Blues." For mood and beat while we write the slow surge of John Lee Hooker.

Uncertainty at first: "I don't know how to write blues;" "Start from the top?"; "No, start from the bottom." Uncertainty led to accomplishment. Dorothy did three separate ones. One about rain "cavin' in my mind" that we wished we had a musician to do a tune for:

The rain is getting bigger
It's getting bigger all the time
There's no where else to run man
It's caving in my mind.

I've got to brighten up my shadows
They're raining down on me
I'm gonna talk about my sunshine
Cause they're thinking mystery.

Oh rain, rain you keep running down on me
Comin', comin' all the time
And it's lonely—nothin's left
Cause they're caving in my mind.

Dorothy Schelling

Katia urgently stated, "It's so hard to get the real thing." She offered *Words,* asking "Is this or is this not blues?"

Get those words that mean a lot
and wrap them round your minds backyard
get the words and swing them 'round
around so much 'til they come down.

Yes the word that you denied
No the word I've heard at last
get the words and rap them round
swing them 'round and put them down.

175

Baby said his love is gone, it's gone
because a word just let it go
get that word and wipe it out
put it down and burn it now!

Words destroy my dreams and life
words will fade before I die
eyes can say what words don't have
so get the words and swing them round.

<div align="center">Katia Jiminez</div>

Comments:

Gets into it after a while; the first line needs a better beat; too classical and not
graphic enough; should be simple, direct. 'Nothing is exactly free' — Barbara;
Blues are not cerebral; have to be down to earth — in soul, not head. (Two
don't mix? Boy, am I in trouble!)

My old man is dyin' in pain
My old man is dyin' in pain
Took his mind, left his chains
Left to dig his grave alive.

Mama is workin', save her child
Mama is workin', save her child
Poundin' heart, cryin' wild
Child was dead before he was alive.

<div align="center">Nina Sterne</div>

<div align="right">December 2, 1969</div>
I said we should discuss Nina's poem so that she could get something out
of it and she said, "I got something out of it while I was writing it."

308 on a snowy Monday Night

soap-sud hands
washing the dishes
rapping the silver to a worn-out tune
started to drift
 when the blue tinted
 glass sank
cracked in mosaics
on an ivory sea of soap
and I guess it turned me off
or kind of shut me out
but the radio continued
and it wouldn't stop
it just wouldn't stop
 like a broken record
destroying my oblivion
reeling out the numbers
that meant my brother's life

and I thought
hell—what kind of world is this?

and looked down at the sink
and the ruby colored suds.

Nina Sterne

All agreed with Nina, successful poem—criteria for success: when author derives pleasure from *each* line or when listener (reader) derives pleasure from as little as *one* line. The poem gives exit from self, not in single words but whole phrases, the impact is from the whole poem, rare in the wreckage of sensitivity calloused by a machined world. The rap digressed into the salvage of sensitivity, how some try dope, yoga, deep thinking, deep breathing, anything or everything to open up the doors—in order to give out as a poet or person with the meaning that one intends rather than one for outside and one for inside.

The only criticism for the poem was for the word "oblivion," too hackneyed and abstract for the lean monosyllabic and concrete quality of the rest of the diction in the poem.

December 10, 1969

UPTIGHT is the word that best describes Newtown today. The policemen at the entrance telegraphed to my head some kind of tension in the school. Copies of the *High School Free Press* on the ground clued me further. A pair of crewcut individuals eyeing my bag as I rushed across the lunchroom to join my waiting group alerted me more.

The kids were already in session kicking around the question 'What is Happiness?' and their consensus was that it was not to think so much about your problems. The climate in this school on this day certainly was a problem. (For that matter, any day in any school is a problem.)

Barbara unrolled a poster she had brought in to show. Across the top shouted the line POETRY IS REVOLUTION, while below a picture of Leroi Jones (as bloodied by Newark police) and the famous "Up Against The Wall" poem. The crewcut twins swooped across the room like hawks for the kill. They bracketed Barbara, easing her to one side for some hushed words. Keeping our cool, we made like we were rapping about some of the poetry books I had laid out on the table. Meanwhile they briefed me that as a result of a censorship hassle on the school newspaper which some of the poets were involved with, the radical kids (including Barbara) had brought the high school underground paper into the school as a sort of reaction to the inhibited freedom on the school paper. The response by school officialdom was paranoid with the immediate bringing in of the law.

Barbara finally rejoined the group and the private eyes left the scene. She said that they questioned her as to who I was and what kind of literature I brought into the school, and where she had gotten the poster that had caught their eagle eyes. And how come no teacher was present (Mrs. Russo, our faculty advisor, was out sick). The two were unfamiliar to the group, but they told Barbara that one was a shop teacher and the other a gym teacher, assigned to a

security detail. Quite disturbing when what should be a hall of learning begins to resemble a house of detention. I was pissed off that I had been ignored, that not one of the characters had had the courtesy to talk with me. I suppose, in their eyes, all poets are subversives anyway. When I gave voice to this thought to the kids, they countered gleefully, "What's wrong with that."

Talk returned to the poster Barbara displayed at the opening and all agreed that a poster showing poems done by the group around some unified theme would be a good project to work on. We would talk more about it next week.

Mr. Levy showed up as the signal for the end of the eighth period rang. Normally we go on into the ninth, but Mr. Levy asked us to adjourn then as he had no teacher to assign as chaperone. Evidently the security-minded gentlemen had gotten to him to be sure that poetry wasn't going to happen in this school unmonitored.

January 7, 1970

WHAT WILL IT BE TODAY? was my opener, throwing the initiative to the 'shop. What will the rap be?

After a blank moment, Dori blurted, "How about onions. Every time I think of onions I see my eye crying." Not to be outdone, Barbara said, "How about when the sun falls into the ocean and comes up spitting watermelon seeds." And so the talk went around the table for a while "How about...." "How about the Readers' Digest—don't say it's bad—I read it in the bathroom every day." "How about will you be mine...yeah...yeah...yeah."

Seeing no poems on the table, I seized upon this theme; I said, "How about, How about? Instead of running off at the mouth, let's run the words off the end of our pens."

The following poems were the most successful of this "off the top of their heads writing":

HOW ABOUT...

How about living for a change
and seeing the squares as a circle full of sun
and how about reaching and getting a handful back
and how about building a wall without cement
 —with airplane glue and stamp hinges
and how about climbing a tree without a branch
 and swinging from the leaves
 like a Tarzan with a Jane
and how about living for a change?

 Nina Sterne

HOW ABOUT...

How about walking out on a teacher
How about running down a slippery road
How about trying to sleep when your neighbor is yelling
How about kissing someone and getting a slap right back
How about forgetting all about something
 you had to do and then feel low down

How about finishing this poem I just don't
 know what is this all about?

How about thinking it's summer
When the snow doesn't let you out
How about taking a walk
When you have a door locked up.

How about a word to say
How about a sun to shine
How
Can
You
Go
About a feeling by walking out?
How about that?
Tell me
How about smiling at me
Wiping your tears and talking your love out
Tell me love
How about that?

 Katia Jiminez

HOW ABOUT...

How about those great great moments
when the world was magnificent
How about those dolls
that acted out your dream
Ah don't scream
It's only a momentary dulling
of that beam.

How about the ocean as it rolled
to meet your pen
the paper plates for poetry
the thoughts you thought of then
were they all too crucial
that they've lessened all your schemes?
there's still another dream.

How about the tear drops
that made happiness your joy
or the crystal snow flakes
above your soldier boy
you've met them once
so try again
How about that? think back then.

 Dorothy Schelling

January 14, 1970
 THIS LUNCHROOM is as busy as a bargain basement, but the poets
seem to be otherwise occupied. While waiting for them I was chatting with
the faculty advisor to the Afro-American Student Society. He was complain-

ing about the inadequacy of material that had been given him by the school for a course in black history that the black kids had asked for. He said that he himself was really unqualified to teach in this area no matter how concerned he was with the subject. But he had been told to do the best he could and fill out time, that the thrust for black studies was really but a "fad" and would "blow over."

From all the vibrations I have been receiving in the schools this year I would say that that is the attitude towards the need for change; that it is a "fad" and will "blow over." Last year's crisis has been weathered. The price for failure and mediocrity has been the reward of juicy contracts so what is there to worry about. Everything is back to business as usual.

And the more creative kids, like the poets, know it. They can see the school merely tolerating their concern for creative expression. Why isn't poetry made an elective, with their workshop being part of the regular school curriculum in a regular room, rather than the stepchild it is, in a corner of the lunchroom, on their own time?

A few of the girls arrived putting an end to my meditation. They apprised me of the fact that Wednesday had turned out to be a bad day because of certain other commitments that had developed for some of the kids. Also there was a feeling that there was a need for more recruits, and that the English Dept. was doing nothing to publicize the workshop. On the basis of the discussion, we made some decisions. One, that the day for the workshop would be changed to Tuesday, which now was the better day for most of the members; and that they would try to convince Mr. Levy to use his office for recruitment, and that they would do what they could on a word-of-mouth basis. I agreed to prepare during the next two weeks a folio showcasing their work so they would have something concrete to show around the school.

January 21 & February 10, 1970

BAD VIBRATIONS keep coming from Newtown as I work on what had become a task of love and faith—*The Lunchroom Poets*. The kids were getting verbal crap from the English chairman while trying to secure the future of their workshop. He was not as yet banning it, but his stall on lifting the lid of secrecy on it and letting all the students know of its existence, and getting a room that would allow poetry to be committed in peace, brought us to the point of frustration. He kept claiming that he had no teacher available to chaperone us through the 7th and 8th periods. (This time was the kids' own as they were early session students in school for six straight periods and could go home if they wanted to.) Barbara and Katia kept me posted with telephone communiques from the school scene.

A lot of flack was coming Barbara's way. She was the one kid in the group who was involved in radical politics. Lots of little harrassments were being performed on her. I am convinced that this was consciously being done to demoralize her and bring her to the point of dropping out, thereby removing a potential leader of student dissent. A calloused policy of *adjust—adapt—or get the hell out*.

Barbara's mother, a very pleasant Cuban lady, told me, on the edge of tears, that Barbara was on the verge of leaving school and pleaded with me to

help keep her in. I assured her that I was urging Barbara to stick it out for the few months until her graduation in June. I also advised her that it would be a good thing if parents would inquire about the cold shoulder the school was giving programs like the Poets' Workshop, that seemed to be filling a need in their lives.

I persuaded Barbara to hang on—sweat it out. The publication of our folio, as a concrete manifestation of achievement, might sway Mr. Levy to be more cooperative.

As all this was going on and the pages of *The Lunchroom Poets* were shaping up, the two-week hiatus stretched out. Mr. Levy continued to stall and would not let the 'shop meet until he had an advisor to assign. We now were *The Street Poets*, as on Feb. 3, that is where we gathered. I invited the kids to my library workshop in Jamaica, that Saturday, Feb. 7, to which several of them came in spite of the long trip from their neighborhood.

Meanwhile, everyone was pinning their hopes for the future of the workshop on the forthcoming publication and were awaiting its appearance anxiously.

February 17, 1970

THE STREET POETS, (we met on the street Feb. 3 and 10) moved back into the lunchroom for the Feb. 17 session. The spanking new mimeo magazine *The Lunchroom Poets* spilled over from the carton onto the table. After careful inspection, everyone was confident that Mr. Levy would be impressed. (Young eyes find stars in a dark sky much easier than my old ones.)

Living dangerously we met without an advisor, after all, everything was going to be all right now. The kids exuberantly browsed through their publication. They each took a few copies, but we decided that after the session, I was to go up to Mr. Levy's office and make him a gift of the cartonfull and ask him to distribute the magazines to all the English teachers and interested students in all their classes. And, of course, I was to discuss the future of the workshop on the basis of this evidence of constructive interest.

Meanwhile, optimism prevailed and we made plans for expansion: a poems-on-posters project and some trips searching inspiration for poems, and a possible joint poetry reading with the Afro-American student club.

The rap led to an evaluation of the workshop and the moment for instant poetry had come—I said, "right on, put it in writing—make some poems about The Lunchroom Poets." Here are some of them:

snip the rectangle
to a circle—mangle sir
a croaking superiority
to be only frog to me,
your scissor fingers
dull—as then
snip was a snap
we're back to rap
to rip us was a slip up
we tripped the trap,
we sealed the cracks
with the wax of words.

Barbara Howard

181

THE LUNCHROOM POETS

Straight after sixth
straight down to the lunchroom
come & watch the poets.

Imaginations flying everywhere
upwards
 downwards
flying higher & still higher.

Poets in every corner
smiling
listening
inspired by every sound around.

Fingers bubbling with new words
on every line
writing
jotting...scribbling
all feelings of the youth.

The youth
the young
the highschool kids
come & watch them
describe the world around us.

 Karen Schnorr

He asks us what I think
about us meeting all the time .
in secret places when it's very light
and everyone can see.
And he asks me to remember
which way the wind blew last week
and whose eye I caught
in the Central Park zoo.
And he asks me to tell you things
that I hardly tell my friends
and I try
 beneath the rumble
 of an empty stomach.

 Nina Sterne

THE LUNCHROOM POETS

Barbara reads unbroken lines with faded dreams
Nina stares at my wrist...I have a watch
Dorothy and Karen silently smile about a word
And I'm thinking of a mountain to be rolled.

Miss Russo came back in. She was eating tuna fish
Doro and Barbara talked the rights to an island's pretty
 dream.

182

When Mr. Levy tumbled in I saw the rocks start to slip
And I'm thinking of the mountains and the honeys and
 the kiss.

Come on down Oh won't you please?
It's nice down there where we could dream
Mr. Berger and the kids about unmeasured scenes
Oh come on down, Oh won't you please?

I saw Dorothy in my art class
I saw Nina in Section Time
Barbara handles names in my Gym class
I'm still thinking of the poems that we rolled down the
 mountain.
 in the workshop.

 Katia Jiminez

 Paranoia has once again decided the fate of some Newtown students. The students seem to
be engaging in a revolutionary studies class once a week, within the walls of Newtown. The
leader, Art Berger, smuggles M-16's to approximately ten members. They now have an arsenal
that could blow up the school. At least, that is the way the chairman of Newtown's English De-
partment has construed it.
 I had the "privilege" of speaking with this fearful man on two recent occasions. Both
times he gave me numerous excuses for closing the workshop. Among the gems he offered me
were, "...any group that teaches young children four-letter words, I don't like"; "Well, this
Teachers-Writers Collaborative has a rather parochial ideology of poetry." But as a matter of
simple knowledge, as I have been in Newtown for two-and-a-half years, his faculty's classes are
rather parochial. When I confronted him with that, he replied, "Well, Barbara, that's what
I'm here for. My job is to see that classes are run in an objective manner." It was very nice of
him to say that, but I fail to recognize his actions to change the attitude of the department.
 Mr. Levy has dealt with his paranoia in other ways. For instance, Art Berger is not allowed
to run a workshop without the supervision of a faculty advisor. This is to deter the workshop
from a political stance that would upset the omnipotent Levy's position. The workshop was
apolitical at the outset. However, if the English chairman wants to make it political, he is doing
a fine job. He has given Newtown students another reason to be angry; he is the one who is
building up the students' arsenal.

 Barbara Howard

 Feb. 17, 1970 (continued)
 The workshop broke up with the usual scramble of some of the kids to go
to their after-school jobs. Others rush out of this lunchless lunchroom to line
their growling guts at the corner pizza joint. But Katia and Barbara escorted
me to Mr. Levy's office ceremoniously bearing the carton of *The Lunchroom
Poets*—and it was not like carrying coals to Newcastle—for there is no poetry
in the English office.
 Mr. Levy was at his desk in his little office, brooding, I suppose, over the
many threats to the orderly process of education coming from poets and other
such madmen. Why couldn't poets stay in the moldy volumes of his curricu-
lum rather than come to life. He looked up at our delegation in surprise,
mumbling, "Uh...hello, Mr. Berger. I've been meaning to call you in for a
conference," and looking over my shoulder at the girls, added, "alone, pre-
ferably."
 "We've come bearing poems by the workshop all done up in this little
magazine, showcasing to your department the output of the workshop. The

 183

members hope that this will convince you of the positive aspect of the workshop."

After this little speech I suggested to the girls that they leave so that Mr. Levy could have the privacy he seemed to need. Barbara looked at me uncertainly with eyes that were wet, and I said, "You better leave now. I'll give you a call this evening."

Mr. Levy, without so much as looking at the magazine, said, "I would have rather you had not gone ahead with the publication."

The discussion that followed made it clear to me that his uneasiness with an outside program in the school had come to a head. His decision to dump it was now made uncomfortable by the obvious positive fact of the little magazine. His remarks worked over the same rhetoric with wearying effect. "Your program is very parochial...you attract all the same kind of student...anti-establishment...same ideology...they all write in the same style...the traditional forms are important too...your style is parochial...blah blah."

While suggesting to him that since the kids were all from the same generation, their voice would be common in the contemporary sound, I mentioned that I would expect the grounding in traditional forms would be coming from the members of his department. And, anyway, even the needs of a parochial group need servicing. Not wishing to engage him any farther, I suggested to him that he read the magazine and then make a judgment. He grunted agreement, and I left sensing his frustration at having to put up with a live poet for another week.

February 24, 1970

Final Session

SUSPENSE had ruled my mind for a week. Could Mr. Levy ignore the positive achievement of the workshop and bring it to a grinding halt? Or would *The Lunchroom Poets* convince him that the workshop had provided some fifteen Newtowners with several happy, creative hours a week?

I read and reread the folio trying to anticipate what Mr. Levy could latch onto negatively. Each inspection proved the collection even purer. Calls from some of the kids voiced similar concerns. But no one could find anything that even a tight mind like our English chairman could fault. Unless, as Katia said, he sees something sexual in the image of "panting snow" in Dori's poem, or read marijuana into the smoke of Randi's poem. Or could he consider Nina's gentle reproach to the draft lottery system in "308 on a Snowy Monday Night" as politically controversial, or the abstract obscurity of Barbara's "Slide Rule Trade" as concealing a subversive double meaning. But this was really looking hard. Besides, wasn't Mr. Levy, according to his own definition, "quite liberal"?

Tuesday morning, at the appointed hour, I walked into Mr. Levy's office, where he stiffly awaited me. Blinded by my optimism, I asked what he thought of *The Lunchroom Poets*. His reply snapped me out of my starry eyes. Ignoring the content, he told me through tight lips that I should not have put his name on it. He waved away my concern that he might have been offended by omission and lack of recognition for his cooperation.

Next he ranted about the impropriety of including the little sound poem he wrote on the day that he had sat in on the workshop and had been moved

sufficiently to participate. He implied that one does not equate the work of the head of a department with that of his students and print them side by side. Then he claimed that Mrs. Berkon, a faculty advisor, also was peeved at having her poem on Time printed. Its inclusion was an act of admiration for the sensitivity of her writing. She had given us the poem in a spirit of participation, with no conditions about its publication.

Without so much as a word about the work of the students, he moved on into another bag. Picking up a copy of *Teachers & Writers Newsletter* from his desk, he said that he could not tolerate a program in his school that was so anti-establishment in style. He cited the piece on censorship of students' writing in Central Commercial H.S. Behind those words I could see lurking the thought that maybe next the *Newsletter* would deal with censorship at Newtown. Some of the members of our workshop were also involved with the school newspaper and already had experienced the slashing of his censorship.

Next he referred to the article on the World Trade Center [by Phillip Lopate] and its essay contest that was mandatory for all English classes "(except for those whose English Dept. chairmen have pull and get out of it)." That seemed to have stung him. It was obvious that Mr. Levy regretted that his powers of censorship did not extend to the writers in the *Newsletter*.

"And the use of four-letter words does nothing to enhance the teaching of English." With that he closed the *Newsletter* and thrust it at me. "The style of your program attracts to it one kind of student—those with a similar anti-establishment posture." He said that he would not have a program that serves only one kind of student.

From there he went on to what he called the artistic question. The poet has spoken in many voices but the kids in the workshop have only one voice. How about the traditional forms and what has come before now?

To ears that were not listening I tried to remind him that poets generally speak in the voice and idiom of their own generation. I cited the fact that in every period poets were generally critical of the status quo. Could it be that the "classical" poets were safe for high school students because they were dead? The kids in high school were going to speak in the voice of their time and it was up to their English teachers to connect what they were saying with what and how those that came before them said it.

The turn that this discussion had taken was disturbing, because, if anything, most of the kids in the workshop were apolitical. I pointed this out to Mr. Levy and tried to make him see that an attack on their workshop would feed their alienation. "I know," he said, "They will call it repression." "Isn't that just what it is?" I answered.

He shifted into a liberal stance, "Oh, I am all for change in the system. But it has to come from responsible elements within the system." He said that he would not be a host to those who want to tear down what he had worked for years to build. I told him that this denial of the needs of even so "parochial" a group of students would make revolutionaries out of them. "How does that fit in with your concern about the growing alienation of high school students and their turn towards violence?"

His response was a grim one. "Mr. Berger, you may be right, but only when enough students who feel as you do in numbers sufficient to overwhelm those who feel as I do, will your way be proven right." There he was asserting

the naked fact of power.

Seeing that our conference was at an end, I picked up the carton containing *The Lunchroom Poets* from where I had left it a week ago. I told him that I assumed that he was not going to distribute them. Therefore, I would place them in the hands of the kids who were waiting in the lunchroom for a report from me. I assured him that I would tell them that they did not have the sanction of the English Dept. and suggest that they were expected to dispose of the contraband outside the school building.

He showed displeasure at the fact that the workshop was meeting once more on this day. I headed off any action on his part by firmly stating that I felt obligated to report to the workshop and wind up its affairs. With that I walked out of his office, as he mumbled something about getting Mrs. Russo to sit in on this last session.

In the lunchroom, the poets were all there, wide-eyed and waiting. Mrs. Russo was also there, a flat, stony face, concealing whatever guilt feelings she may have had about what was happening.

Not having much of a stomach for prolonging this session, I reported briefly on what had transpired in the English office. What I had to say did not seem to surprise them. Nina reported that Barbara had already been spoken to by Mr. Levy and had gotten the ugly word of the repression of the workshop. She was so broken up by it that she had dropped out of school and that was why she was not present. I suggested that we leave the building so that I could turn the carton of their publication over to them and we could say our goodbyes.

It was a sad scene on the street. The silences said more than the words. We swapped addresses and promised to keep in touch. I invited them to attend my monthly workshop at the Queens Central Library. But what some of them were saying foretold a shift into activism. Making poems would have to wait until they made their world better.

My last words to them went to point out that I was a dropout from way back. However, now I was a dropin. I could not see leaving the school system completely in the hands of the know-nothings and the Yahoos. If at my age I could be motivated to get into the schools to try to change them—that certainly they could aim at becoming far more meaningful English teachers than those they had to face every day and all the Mr. Levys.

Postscript: A few days later, Barbara Howard officially dropped out of Newtown High School. Though she was only a few hours away from meeting all requirements for graduation, she decided there was simply nothing left in the school that interested her.

I Break Easily

I break easily—
he knows that, yet he does not;
we still communicate through telephone booths,
with each other's picture stuck in our hands
like arbitrary gifts of Fate...

laconic notes scribbled between appointments
are hidden in the crevices of our
meeting places...

holding hands & / or making love in the park
behind a rock, near a tree, above a spring yet
below a bubbling Hell—we still whisper—but not for
the right reasons—

 staring momentarily at each other
 as the elevator closes;
 we must meet downstairs
 where the hall is subdued by
 a nonfunctional door,
 a place which the maintenance man
 ignores—
 & we must meet there do some
 ignoring
 because everyone knows...

clandestine arrangements are not
terrible, they are painful—
I am aware of this pain, &
so is he, yet he is not;
we are two branches discouraged from
becoming one tree or spending any other
time together—
he knows all this, yet he does not;
& I know all this, yet I cannot stop...

 Barbara Howard
 "Air Conditioned Poems"

Part Three:
Teams and
Allied Arts Approaches

ATTITUDE TOWARD TEACHERS AND THE SCHOOLS

by Phillip Lopate

The Garrison-School

The initial attitude of Collaborative writers going into the public schools was largely one of horror and anger. They approached the schools with intense suspicion, and their first day's inspection of the plant usually furnished them with enough supporting evidence, as in this report by June Jordan of a school in Brooklyn:

> P.S. 45 is two years old. Mr. Zuckerman, my suspicious host, told me that the school opened "on the anniversary of Kennedy's assassination." He didn't seem to think there was anything odd in what he'd said, so I made no comment or inquiry.
>
> I was guided about the new plant by Mr. Zuckerman: He would say, "Now you're going to see what's different about OUR school." Then he would show me some rather pedestrian architectural peculiarity / convenience, such as partitioned sliding walls, etc.
>
> As we strode by the classrooms, I was busy remembering what had occurred upon my entry to the building. Four girls rushed me with the question, "Are you the poetry lady?" I said yes, wondering how they'd identified me. They wanted to take me to their classroom, but I had to sign here and there and there again, finally ending in the principal's office where neither of the two top executives believed I belonged. There was the ritual of trading credentials which I went through with increasing annoyance and therefore increasing hauteur. Mr. Zuckerman thought it was "fascinating" that I teach Freshman English at City College and I retorted that I thought it was "fascinating" too. Etc.
>
> In one class, very little children were already bending to papers on their desks. One boy, named Christopher, raced into the hallway and hugged Mr. Zuckerman. The boy's radiance of being so struck me that I interpreted the information that Christopher had "special placement" as meaning that he was verified as bright. On the contrary, Mr. Zuckerman corrected me. That glowing little person was "probably retarded."
>
> In another classroom, an overweight bitch was saying: "And you know who's coming to our class? A fi-er-man. Isn't that won-der-full?" With extreme sarcasm toning her distortion of each word by the trick of extending every single syllable into at least two nasally whined emissions. Her contempt was so egregious that I wondered if any of the kids, a few years later, would ever be able to hear somebody talking like that and not smash her in the mouth.

There is something mythological about this descent: as in a fairy tale, the children recognize the poet's special powers, while the adults do not. But it is also very typical of diary after diary filed by writers in this period, which record similar feelings of phobic alienation. From a literary point of view, it is writing in the grand tradition of documentary anger, such as Dickens' or Orwell's reports on mining conditions. At times, understatement and the cold marshalling of facts and details are made to convey the power of wrong: "In one class, very little children were already bending to papers on their desks"—this is pure Dickens. But then a narrative fury breaks in to clinch the point.

That the abuse of children, the contempt and condescension and neglect actually took place, as recorded by observers, there is no reason to doubt. It takes place in almost every school on almost every day. That there might be

another way of looking at the phenomena inside school buildings is also true.

For starters, one might question if some of the nerves-exposed sensitivity to brutality might be laid to the writers' own first day anxieties about starting a new job, which they have projected outward onto the environment. Yet, even discounting this distortion, let us take into account the mundanely oppressive atmosphere of most schools: doesn't it seem a little strange, a little false-naive for all the writers to respond with such culture shock to what they must have known, on another level, was a norm—most probably, one they had experienced themselves as children? The curious thing is that this "visitor-to-a-small-planet" description of the schools is not done so much any more. The fashion for it seems to have passed—although surely the schools could not have gotten so much better in the past ten years.

Its popularity then may have had something to do with the national mood generated by the Vietnam War, which tended to polarize the domestic population into doves and hawks. All of the American "tried-and-true" virtues had been redefined by opponents of the war as the root of the hawkish war-machine mentality. Education was suspect: the universities had been tarnished because of their defense contracts and intelligence functions; but so were the regular elementary and secondary schools, for being the socializing agents responsible for training good, obedient citizens and hence tractable soldiers killing innocent people. Once the schools had been identified as fortresses of the Establishment, then walking into one was like entering the garrison of the enemy. Consider the imagery behind popular educational titles of the day: *Teaching as a Subversive Activity* made creative pedagogy into a giddy adventure of infiltrating enemy lines, and altering the curriculum became a delicious sort of sabotage. *Death at an Early Age* and *Our Children Are Dying* reinforced the image of schools as, if not war zones or concentration camps, at least hospitals where massive triage was practiced. Other analogies came into play: the Americans, a physically large-boned people, were invading a physically slighter people, who looked almost like children next to them. It was a small step to seeing the children and teenagers in schools as a captive population, dominated by larger bullies, "overweight bitches."

The idealism of the time demanded symbols of innocence. The American Indian, the Vietnamese Girl, the Child, the Tree, the Schizophrenic, the Prisoner, were all adopted as figures of innocence, having been disenfranchised from power within the American system, hence not responsible for the war. What was the counter-culture but a wish to braid these elements of righteous innocence into a shield strong enough to hold off the dominant cultural message? In order for Teachers & Writers Collaborative to be understood, it has to be seen as, in its inception, part of this larger counter-cultural phalanx —*Movement,* if you will—which drew strength from the other parts and hoped to give its own strength to the whole.

At the time, it seemed all one package: political protest, sexual freedom, open education, communes, folk crafts, rock music, consumer cooperatives, natural foods and so on. Ten years later, now that the constituent parts have fallen into their isolated corners, and we have paid the price for permitting such glib neologisms as "life-style" and "anti-Establishment" to masquerade as world-philosophies, it is sometimes hard to remember that the rhetoric actually was substantiated by a great deal of social unity. For political people, es-

pecially, it was routine to assume that the counter-culture, or what was called "youth culture," was a powerful expression of revolutionary aspirations (this assumption has since been routinely challenged); that rock music was a kind of cry of working-class energy and black revolt which, if "channeled correctly" into political struggle, might lead to all sorts of transformations.

The conviction that schools were shutting out the students' real culture—rock music, protest, comic books, graffiti, the dozens—led writers to a stage of smuggling it in with their visits, like contraband, a file in the prison cake. Art Berger's "rockus and bluelets" lessons, David Henderson's disc-jockeying in class, Benjamin DeMott's call for more relevant ways to teach high school English, like bringing in two film clips of dance parties and asking which was more truthful, were all signs of an attempt to build a bridge to youth culture, instead of merely imposing a set of ideas about beauty and classical forms from on high. These attempts occasionally backfired, or smelled of pandering to the young. It was then the fashion to play, for instance, Simon and Garfunkel's hit song *I Am A Rock* as an entry into metaphor. Students were not always pleased to have their after-school culture co-opted in this way for an academic English lesson! Sometimes they were embarrassed for the adult, who seemed to be trying too hard to be hip.

At other times, however, the problem was that the strategy worked too well. The writer did establish a trusting relationship with the students which was far closer than usually obtainable in the school, and which became a threat to the classroom teacher or the administration. The writers could talk about themes and contents which the regular teachers did not feel they had the liberty to discuss. They watched with wide-eyed envy, disapproval and curiosity as the writers steered discussions again and again toward topics they would have considered too dangerous. In some cases they were too dangerous, and the writers ended up in the principal's office, and a big confrontation of community forces ensued.

The Collapse of the Writer-Teacher Alliance

Originally, the Kohl idea had been an alliance between renegade teachers in the school system and writers coming from outside who wanted to change the schools: hence the name "Teachers & Writers *Collaborative*." The symbol of this collaboration was a weekly Friday afternoon seminar at which teachers who were receiving writers in their classrooms, or who volunteered because of their own interest in writing, met with rotating staff authors of Teachers & Writers. At this seminar, ideas for evolving new curricula (such as the Fables Project) were discussed, and efforts to implement it reported on from week to week. The seminar was apparently very successful during the first year; but when Kohl left, the group was split with dissensions, lacked faith in the new leader, lost enthusiasm and eventually disbanded.

There were other reasons for the collapse of this fragile alliance. The two groups had professionally very different habits, career goals and modes of thinking. Also, writers got paid to do the Collaborative's work, and the teachers did not: while the justification might be that teachers were already receiving a salary from the government, it is hard to establish an equity of tone between two factions when one is getting paid to participate and the other is giving time voluntarily. (At the beginning it was proposed that it might be

nice to put the very active teachers on a stipend, but this was never carried through because there was never enough money for the writers' program.)

More important, one-half of the collaboration formula, the teacher component, depended on inside professionals who saw themselves as deeply disenchanted with the system—a posture which is hard to maintain forever, and which, if sincerely enough felt, usually resulted in the person's simply leaving the school system. It is hard to remain chronically angry and upset; even harder is it to see oneself indefinitely as a "subversive" operating in and against a huge bureaucracy. As Susan Sontag has remarked, "the thing that was wrong with the attitude people had in the '60's was the idea that they could have a permanently adversary relationship to the public. What they didn't understand is that everything eventually gets assimilated." When that began to happen in the schools, the sharp focus of the writer-teacher alliance seemed to blur.

Finally, there was the superior attitude that some writers had toward the teachers, and the teaching profession as a whole. Quite often, the close writer-student friendships seemed to be built on the backs of the classroom teacher, with whom an antipodal relationship was assumed. Consider this statement of method by one of the more popular writers, David Henderson:

> I had tried to be as nonchalant as possible. Sometimes i would disc-jockey, introducing records and talking a bit about the artist. While they wrote i looked thru their yearbook and other magazines. I didn't interrupt when they spoke among themselves. I tried to be the exact opposite of what a teacher is to them.

Surely this was one of the strangest bases for a working collaboration between two groups: the effort of the one to act like the exact negative of the other! From this statement, it would seem as if a regular teacher might gain approval in a writer's eyes only to the degree that he or she abnegated professional identity: that is, became an *anti*-teacher.

The truth is that the only collaboration envisioned at the beginning of Teachers & Writers' operation was between writers and *disaffected* teachers, with anti-establishment attitudes. These were the teachers who were invited to the Huntting Conference, and the Friday afternoon seminars. This fact may explain how it was possible to adopt the rather schizoid posture of proclaiming the goal of writers and teachers working closely together to build new schools, while acting often as if the classroom teacher were the enemy.

The situation became problematic when a writer went into a classroom and taught alongside a teacher who did not share anti-establishment values; and since most classroom teachers are pretty straight, the odds were that this would happen. Sometimes the problems arose not out of value conflicts, but standards of professionalism: the teacher thought the writer had done a poor job of teaching, or vice versa. In the evaluation form which the Collaborative asked teachers receiving services to fill out, one teacher asserted that the poet was not pitching his lesson at a sophisticated enough level, because he had not bothered to find out what the students had already learned about poetry. This charge of failing to consult with the teacher, to ask his or her perceptions about the children and their capabilities, was made frequently. From teachers' standpoints, the writer seemed to come in, "do his thing," get the kids all excited if he did it well, or bored and sullen if he bungled it, and leave: there was little opportunity for communication about ways to improve the program

or work it better into the classroom framework. One teacher accused a writer of merely collecting material for an article—of "ripping off" her students, in effect, to help his career. (Interestingly, there was some truth to this charge: an article did appear in a national magazine based on three visits to the class.)

From the writer's point of view, the teacher was often sabotaging his or her efforts because of jealousy of the writer's attractiveness in the children's eyes, and his or her ability to get them turned on. Stories of teachers undercutting writers were legion: during the writer's lesson the classroom teacher might noisily open windows with a window pole, or terrorize children with threats to behave themselves, when they were just participating and being excited, or show contempt for the lesson by yawning and filling out Delaney cards in the back of the room, or simply "forget" that the writer was coming, and be out on a trip that day.... The response of the writers to such resistant behavior from the teachers was one of hurt, superiority, and verification of their original convictions about the school system.

The Turning-Point

By 1971, after four years' experience, in which the ceiling had fallen on the Collaborative's head a number of times—after the blowup at Newtown High School, and the trouble at Central Commercial High, and Bill Wertheim's losing battle, and the uneasy experience of Jonathan Baumbach—workers for the organization began to develop a more flexible approach toward work in the schools.

Some of it was sheer experience: how to get one's way without turning it into a confrontation each time; how to avoid sounding too self-righteous, masochistically inviting disaster, and then saying, I told you so. What writers were learning was to put aside the self-fulfilling scenario of the Slaughter of the Innocent, and the Bringer of Beauty. They were realizing the degree to which they also had some responsibility for these shambles. Not that these struggles had not been necessary and educational for all involved, but they were becoming, to some degree, predictable.

Another major factor governing this shift was careerism. It was the newer, younger writers, who wanted to make a career of teaching writing in the schools, who had come to these pragmatic conclusions first. The more well-known, older writers who had been attracted to the program at first, had already had their "crack at" the inner-city public schools, and were now returning to college-teaching posts at Sarah Lawrence or City College. Part of the process of personnel turnover that occurred in Teachers & Writers during the first five years was the gradual substitution of big-name writers, who had been deeply concerned with public schooling from an altruistic standpoint but had no intention of sinking years of their time into it, with younger, lesser-known writers, who were not only involved with the schools but more in need of a job.

The schools' attitudes changed too. The national publicity given to poets in the schools, largely through Kenneth Koch's work, helped to legitimize these visitors in the eyes of school administrators, who saw them now as potential bringers of good public relations. And now that we were out of the '60's, and into the Nixon-becalmed '70's, schools were more willing to regard out-

194

siders as stimulants, and their additions to the regular curriculum as welcome gifts, rather than threats.

But the real change in attitude came about when writers decided to work in the same school, year after year—to become, in effect, a recognized part of one educational community. It meant a transformation of roles from short-term glamorous visitor to artist-in-residence. Once a writer had made up his or her mind to stay in a place, and sink roots, it became natural to identify with the interests of that community. And, working alongside teachers who shared an interest in the same kids, the same fate of the institution, the same daily gossip, it became hard to keep thinking of them as the enemy. No, it became impossible. One learned that some teachers were dedicated, some not at all, some were sympathetic or had good senses of humor, others eaten up with personal problems, and still others rather dislikable. But they were dislikable as individuals, no longer caricatures of the institution.

In essence, the decision of writers to stay in the same school year after year represented a willing absorption into the bloodstream of the monolithic educational system they had formerly denounced, and which had formerly treated them as a foreign body. "If we were going to be co-opted, then let us be co-opted in grand style," my own thinking went; let us become necessary to the school's daily operations.

Nevertheless, no matter how committed a writer might be in serving a school community, he or she would usually be quickly cut off, hemmed into two or three classrooms, unable to get at the school as a whole; and in moments when uncertainty set in, there was no support system of peers to turn to. A very charismatic or gregarious or industrious writer could, it is true, get around to a large chunk of the school, but the result was so often exhaustion and the sense of being eaten alive. On the other hand, if you had more than one writer in a school, say a small team of artists, then there was no telling how much you could influence the entire atmosphere of the place.

The Team Approach

The crowning investment in the permanent artist-in-residence concept, the most dramatic and dynamic project that Teachers & Writers ever mounted, was (and still is) the P.S. 75 Writing Team. Here, at a school in Manhattan's Upper West Side, the Collaborative has placed a team of artists, three writers and a filmmaker, since 1971.

It began modestly enough as a small grant, co-awarded to Teachers & Writers and Columbia University, for the Collaborative to train a group of interns from Columbia's School of Writing to teach creative writing in a local public school. I was asked by Marv Hoffman, then T & W's director, to supervise the trainees; and it gradually occurred to me that we had the makings not only of a fleeting internship program but of a team of artists who could act in concert to make a genuine impact on a school. We could all learn from each other, boost each other's morales, and pull off large-scale programs. Eventually, the team's personnel settled into a group of novelists Sue Willis and Karen Hubert, video artist Teri Mack, and myself. The development of this project has already been described in detail in my book *Being With*

*Children,** and I have no desire to repeat all that here. The main point is that it was the first full-fledged opportunity for the Collaborative to try out in force the new "environmentalist" approach, which said, in effect, that to bring out the creative potential in children and teachers, we would need to participate fully in the life of the school, and to learn the conditions and particularities of that social organism.

That meant it would be necessary to win the trust of the teachers and the administration; it would be necessary to cooperate with teachers fully, as co-teachers, and to tell them honestly about the procedure one hoped to follow; to organize support from the parents and paraprofessional and clerical staff for creative activities; to attend evening Parents Association meetings and present demonstrations of the children's work; to involve oneself in the problems and crises the school faced—budget cuts, vandalisms, district pressures; help out in schoolwide functions, such as graduation exercises; make any equipment one had, such as videotape machines, available to the teachers and parents, and train them how to use it; ask for a room of one's own, so that one could have a geographical identity and a way always to be reached; learn other media, to be able to reach children who might not be that interested in writing; become involved in the lives of individual children; try to reach out to other parts of the community, and take the students frequently into the community; involve students in every stage of an artistic process, from start to finish (i.e., from writing to printing shop to collating and distributing; from filming to editing to sound track and screenings); train older children to work in the same way with younger children; hold schoolwide festivals of art, and so on. Many of these ideas had been tried before, of course, by other Collaborative artists; but the P.S. 75 project presented a unique opportunity to do them all in the same place, over as many years as we wished to work there.

In part, the project has succeeded because the host-school, P.S. 75, was so helpful, the teachers supportive and warmly receptive to any new idea, and the principal, Luis Mercado, unusually sensitive to the necessity of the arts in the learning process.

Since its inception, the Teachers & Writers P.S. 75 Team has accomplished a number of impressive projects, and set up continuing vehicles within the school for the display of children's creative work. There is *The Spicy Meatball,* a regular literary magazine, and *The 75 Press,* which publishes novellas and collections of poetry by talented children. The school had its own weekly show on cable television of child-made videotapes, and the students were given a two-year sophisticated History of Films course. Their own Super-8 films have been selected for showings at the Los Angeles Film Festival, the Telluride Film Festival, the Pacific Film Archives and the Anthology Film Archives. Each year there is a spring festival of the new films made at the school. We have helped children put on ambitious theatricals, such as *West Side Story,* and presented other shows from their own scripts. Children have learned about all the different popular literary genres, from mystery to romance to adventure and horror stories, and have written their own. Children have worked collaboratively with residents in an old age home. We have set up a Comic Book Club, where children are taught to make their own comic books. This year, the team has built a radio station for P.S. 75, and children

*There the school's name was fictionalized to "P.S. 90."

have been learning to announce and engineer and write and edit radio dramas, the best of which are being replayed throughout the city on WBAI-FM. And the teachers and parents have been given writing and filmmaking workshops in the evenings for their own development.

Without the team concept, many of these large schoolwide activities could never have been realized. By working closely together in the same school, the members of the 75 Team have been able to accomplish an output significantly greater than the four of us could have, working in isolation. (See Karen Hubert's account of the dynamics of the team in her article, *Working On The Team*, p. 199).

The development of the P.S. 75 Team marked a decisive stage in the Collaborative's career. Not only did it signal a deepening in the work, but it was clear to educational outsiders that breakthrough work was being done. Its visible successes led the Collaborative administration to be less defensive about the whole organization. The existence of the 75 Team made it easier to raise special grants for it, such as the Comic Book Project and the Radio Project and a National Institute of Education research grant.

Not the least of its influences was the attempt on the part of the Collaborative to set up other teams along the same lines. Trios of artists were installed in P.S. 129 in Harlem and P.S. 11 in Brooklyn and C.S. 232 in the Bronx and in other schools. Combinations were thought of and discarded: would X get along with Y, did their temperaments mesh, what about sexual and ethnic balance? Some of the personnel kept being shifted from one school to another. In spite of the very superior work that came out of several of these sites, they never became functioning "teams" in the strict sense: they remained, rather, assemblages of professionals working in the same school without much contact. Occasionally two might share a project, as when artist Bob Sievert and dancer Sylvia Sandoval put on a festival together. But in general it can be said that they never crystallized into teams, perhaps because no one was willing to take on the leadership role, and no one wanted to submit to anybody else's leadership. Tasks often executed by one person in charge, like calling meetings, or dealing with the principal, were left amorphously to "group will," with the result that they usually did not get done. Perhaps the unique history of the P.S. 75 Team, its having begun as a unit for training apprentices, with a very obvious hierarchy and a strong supervisor having final responsibility, helps to explain its ability to establish a shared identity and division of labor.

In any case, the experiment of grouping the artists into teams had only partial success—less so than it seemed it would, from the first promising example. Some writers preferred to work alone; others who were put alone, began to feel neglected, and resent that they were not getting a fair share of materials and attention. They sensed a pecking-order, with the P.S. 75 Team on top and loners on the bottom. There was some justice to these complaints, as most of the Collaborative's attempts to gain publicity began automatically with the 75 Team, and the ambitious filmmaking and publishing projects at P.S. 75 ate up more money for materials than all the other schools combined. More subtle was the problem that arose at the Teachers' & Writers' evening all-staff meetings that began to take place once a month. The high morale and cohesiveness of the P.S. 75 Team led its members to set the tone for these affairs, and to dominate, in effect, with their self-confident analytical work re-

ports, leaving other members of the Collaborative to listen numbly, receiving, as it were, the group's new methodology. Ron Padgett remembers feeling envious of the 75 Team at some of these meetings. Since the Team met regularly on its own, it had achieved a high degree of articulateness about procedures and philosophy, and seemed almost to be a separate organization within the organization. In short, the leadership voice which the P.S. 75 Team maintained within the Collaborative as its due had, at times, an inspiring and model-setting effect, and at times a debilitating one.

Working On The Team

by Karen Hubert

I first heard about Teachers & Writers Collaborative while I was a graduate writing student at the Columbia University School of the Arts. At the time, I was working in a travel agency run by a crooked millionaire with a penchant for hiring blonde Barnard students. Before the travel agency, I had worked for five years at Children's Aid Society. Working for a travel agency gave me a free trip to Europe, but I still missed working with kids.

Destiny intervened. As I recall, I was fired from the travel agency for having been a brunette. I needed a job.

Shortly after being fired, I was sitting in Andrew Sarris' History of Film course when I mentioned to Sue Willis, another Columbia graduate student, who worked for the Collaborative, that I had lost my job.

"Someone's just leaving the team at P.S. 75. Maybe you could get the job."

"Who do I call? Who do I speak to?" I couldn't believe it! I'd have a crack at a job I *really* wanted.

The next morning as I dialed the number she had written down for me on a scrap of paper I thought, that Sue, what a pal.

"Hello? Mr. Lopotee?" (The name sounded foreign, maybe Spanish. I had heard from Sue that there had been some racial strife in the organization, so I thought I had better be careful how I pronounced the name of the Head of the P.S. 75 Team.)

We had a solid conversation, just like old friends, the difference being that I was trying to impress a potential employer and he was interviewing me.

Mr. Lopotee said that my background sounded great, but he'd have to meet me, find out what I knew about kids, and of course he'd have to see some of my writing. And another thing, his name was Lopāte.

At the time, there was a lot of talk in the City, and at the University, of giving minorities their rightful chance at positions of authority. Somehow, I had turned Phillip into a neighborhood-kid-makes-good. I expected a short, stocky Spanish, maybe Italian, guy, dark and tough like the guys I'd grown up with on the Lower East Side.

I came to P.S. 75 worried about my *faux pas* on the phone, but confident about my ability to work with kids, and confident in the manuscript I was bringing along. The Phillip Lopate I met was tall, white and wore a big bushy mustache.

I spent the morning watching him work with a group of girls, and I joined right in. I was immediately interested in the work, and Phillip made me feel welcome, no ifs ands or buts, openly inviting me to dig in and help him with the work.

Afterwards, we ate in a luncheonette and talked about the morning. One of the girls had been withdrawn and reluctant to join in. Phillip had coaxed her into the work. I told Phillip that I would have handled the situation differently, that the girl may have needed to hold back and watch. His open manner seemed to me to tolerate, even invite, differences of opinion. As I later found out, I was hired then and there on the basis of my remark about the girl.

199

So now that I had the job, how did I begin teaching children to write? What was the secret? Who knew how to do it? I began by using standard Teachers & Writers devices: write a letter you can't send, pantoums, disgusting recipes, comic books with words whited out, etc. After a month I was enthused by the work and impressed by Teachers & Writers Collaborative, but I felt something missing. I wanted more meat, more risk in my teaching. I was sure that somewhere inside me was a person who could help children write. The most logical place to conduct the search for this internal creative writing teacher was inside me. I began by asking myself questions about my own relationship to writing: Why did I write? What did I write about? What did I want to write? Was I on the right track, or was there, perhaps, a special book (Koch, Kohl, Klein) I should consult?

When I went to Phillip for advice, he assured me that he knew of no better way to discover the art of teaching writing than by digging into oneself. He encouraged me to dip into my tastes, dislikes and obsessions and bring myself into the classrooms I taught.

I began to teach what mattered to me most. My best writing lessons grew out of my life and imagination and soon, the lives and imaginations of my students. I saw that when a writing idea had the energy and sensitivity of human personality behind it, it was apt to yield successful, or interesting results in the classroom.

In terms of *process,* I came to believe that writing means *hearing* one's voice, and *holding* onto it long enough to *write* it down. My students and I owned many inner voices with which we pleaded, commanded, argued with ourselves, gave good and bad advice, complimented ourselves or others, silently. We were also voice banks in which voices, tones and inflections were deposited in our ears by other people: mothers, fathers, best friends, husbands and lovers. I often asked my students to close their eyes and try to hear their own inner voices as well as the spoken voices of people who were close to them. I developed exercises that strengthened their ability to hear themselves think; I treated this natural power like a muscle that needed exercising.

Consciousness of voice was the single most important tool I could give my students. From diaries to book reports, students needed to hear their inner voice in order to write words down on paper. Possession of inner voice was the key to possession of language. Without the ability to hear oneself, discovery and exploration of language was impossible. Without the power to hear oneself, there could be no writing. In classrooms or on walls.

I worked with classes, groups, and individual students, with a wide variety of people from a precocious ten-year-old novelist to a brain-damaged child who couldn't write his name and wouldn't speak, to a group of old women, ages sixty-five to ninety, some of whom had never written a story or poem in their lives. Half my teaching took place inside classrooms and institutions, the other half took place in the P.S. 75 Writing Room.

Before the Team inherited it, the room was the school library. Empty book shelves line the walls. Comic strips from the Comic Book Club are taped in between the shelving or pinned to any available wall space. The school's ricketiest tables and chairs, rejects from other classrooms, find a home in our space. Papers are always scattered on the floor along with lost pens and pencils. The window shades won't work, the linoleum is torn and where a black-

board should be there is a rough concrete slab, raw like a wounded gum where a tooth has been extracted. It's a big, junky room, bare of decoration.

I am convinced that 318 is inhabited by a spirit. Like an old recluse it rejects every attempt to beautify or brighten it. It has even resisted the Team's effort to furnish it. Over the years we have filled it with the insides of at least four different living rooms. When I think of the number of coffee tables that have found their way into that room! At one time we had a black leatherette couch that leaked puffs of shredded foam, mismatched with two arm chairs from two different periods of history, a rococo dining table and a Woolworth's "mustard" yellow rug. All that remains is the rug. We've done everything from painting walls to hanging curtains to building our own furniture! To no avail.

The room is clearly a work room, meant solely for writing stories, plays and poems. The Spirit of the Writing Room seems dedicated to the notion that beauty lives not on its walls or floors, but on the papers, tapes and films made by the children who come there to work.

Every year the Team holds the P.S. 75 Film Festival at which all the school children get a chance to see the films and tapes made by children in our workshops. The festival takes a lot of long, hard preparation, headed by Teri Mack.

Teri is soft-spoken, dreamy-eyed and tall. She towers over Sue and me and enjoys every pretty inch of it. Her manner with children is gentle but firm. She is a dedicated worker and it is her pattern, as she will be the first to admit, to drive herself until she is exhausted. No masochist, she knows how much work a job such as the film festival demands and she is reluctant to rest until it is done. She plunges into the work and sometimes she forgets how long she has been at it. This past year, the day before the festival was to begin, Teri broke down and cried.

Her husband, Dan, who was helping us prepare the room, was there. Phillip and I were there. Three girls who had just seen their completed film for the first time were there. Teri had worked all week, morning to evening. The night before she had been up late completing some last-minute editing so that the three girls could see their film, *The Broken Vase,* before it played at the festival, the next day.

None of us knew what to do exactly. I think I put my arm around her. Phillip, who would be leaving P.S. 75 in a few days for a year's leave of absence or longer, stood by guiltily. Dan shook his head to reassure us that it would pass.

The children's film had concerned a girl's loss of her father through death. It had marked an important emotional break-through for the girl who had written and starred in it who had herself lost her father that year. The film was a working out of her own grief and guilt. Such is the relationship between artist and art: the child watched the film as though it had nothing to do with her real life. For her, it was foremost a moment of great personal *achievement;* she had made a film. When the film was over, the lights came on and Teri was crying.

Sue Willis in Vera Selig's class, about to give instructions for writing, "Now Kids—"

Sue Willis in Neil Breindel's class, trying to calm down a class of laugh-

ing children, "Kids! Kids!"

Sue Willis in the Comic Book Club. There are sixty children present and some great scenes are going down in the room. Jared is selling magic spells for a nickel. Leo wears a paper crown on his head that says 6. Naturally the room is noisy, so Sue has to yell to tell them it's time to go home.

"Kids?" She cups her hands to her mouth.

Sue Willis has to leave the Writing Room for five minutes. She explains to Carmen, Jose and Maria that I will watch them until she returns. "Kids..."

Sue knows all the names of all the children she teaches, so why does she always call them Kids?

Sue comes from a small town in West Virginia. Her dad was her high school principal and her biology teacher. They didn't have much money and somewhere along the line, Sue became increasingly interested in the concerns of people who had less than her. She joined VISTA, was a student at Columbia during the time of the riots, taught in free schools.

Sue has always taken on extra jobs at P.S. 75, jobs she felt someone had to do. She learned Spanish in order to be able to teach writing to the bilingual classes in their own language. When the money to support the Comic Book Club ran out, she kept the club running anyway, knowing how many kids at 75 had loved it.

If you built a wall in the backyard of P.S. 75 and told Sue she was in charge of covering it with children's writing, she'd make sure that *every* kid in the school came down and got a chance to write on it. Not just poems to clouds, but signatures and curses and Kilroy was here. Sue embodies the true democratic spirit of the Collaborative. Everyone who wants to write, write! Everyone who doesn't want to write, write anyway! Sue wants to get to as many kids as she can. She will teach three children for fifteen minutes rather than let them go unseen for a week. She will go without her lunch hour in order to get to as many of her students as she can. Sue believes in giving them all equal amounts of attention, treating the gifted writer with the same fairness as the indifferent writer. If you had to sum up Sue's approach to teaching writing it would be: Every child is a writer. Treat everyone with equality.

Like the rest of the Team, Sue sees almost 200 children a week, in classes, small groups and individually. And she knows all their names. It is not an inability to individuate that makes Sue call kids, Kids, but the fact that they appear to her as a large family among whom porridge must be ladled out equally. The porridge is writing. It is Sue's favorite food. It is her down home gospel, and she is spreading the word to her brethren, the Kids.

When I worked for the infamous Icarus Travel Agency, I made a distinction between the work I did for a living and the work I did for myself. The job was dull and it took time I would have preferred to spend at writing. When I came to work for the Collaborative I learned how creative work could be, and I also learned *how* to work.

At P.S. 75, Phillip Lopate was a model hard worker. He knew how to travel non-stop from the beginning of a project, teaching or writing, to its completion. He knew how to concentrate, how to focus himself on a given task. Working was a muscle he enjoyed using. Whereas some people view work as a pool in which they may drown, Phillip loved jumping in.

I never saw Phillip squander his energy. Energy was meant to be used to

make things happen. And to Phillip, all work was work. When teaching took precedence over his own writing, he let it. He never separated types of work into categories. Phillip attacked tennis and vacations in much the same way, as things to be done well.

I find myself writing, "When you work with a human dynamo you become one too." But Phillip wasn't that. He was a person without the usual blockages and resistances to work so many of us have. Working with him I learned how to fall into work, head first, how to stay with it, carry it out and complete it. I learned that the energy you give out of yourself is returned; energy creates more energy.

I sometimes took my time on a job. Phillip understood this and he tried to strike a balance between letting me work at my own pace and reminding me of deadlines for articles or the layout of a *Spicy Meatball*. I'd get annoyed at his manner, his reminders; I often felt he was nagging me. But it would infuriate me when, if I had not tended to a phone call or letter immediately, he beat me to it. I'd call an organization and the secretary would tell me I had already called! The doing of work became a kind of race at 75.

Often Phillip was accused of hogging the whole show by not handing more responsibilities over to the Team. At P.S. 75 work was valued as an arena in which to prove ourselves.

Phillip was proud of himself and would say so. He would always toot his own horn, a fact which used to drive Sue up the wall, and she said as much to him. Much as it annoyed me too; I liked to see it because I had never seen anyone do that before.

Phillip knew he was a model, loved it and took responsibility for it. He understood the difficulties people had in relation to work. How it outraged them, made them feel ripped off, deprived, angry. He accepted and discussed these feelings outside the job. On the job, excellence in performance was expected; it was the order of the day. Not because Phillip demanded it, but because the work itself did. The teaching of writing to children through the Collaborative was a challenge for the privileged and neither Sue, Teri or I ever forgot that.

Phillip supported the particular content of my work with children through six years of changes, and provided a model of someone who embraced task and challenge rather than rejecting it for 'something better.' He knew his own capacity for work and never cheated himself. He knew how to use energy until work was completed, and finally, he knew how to congratulate himself on a job well done.

As a Team, Sue, Teri, Phillip and myself held frequent meetings in order to tend to school business and keep close contact with each other's work. We entertained and stimulated each other with stories about children and our teaching writing. Phillip would start by telling us one of his stories, which would always impress us. The next person would impress him right back with a story of her own. That led to someone else being impressive and soon we'd all start impressing the hell out of each other. Not with false stories, but real ones. We were always amazed, and impressed, by how good we all were at what we did. Truth is, the thing I remember most about those meetings was that we left them feeling like goddamn geniuses.

At one of these meetings a few years ago, I approached the Team with an

idea that we meet not only to discuss work related topics, but that an occasional meeting be given over to social intercourse; getting to know one another, talking about ourselves and sharing ourselves *as friends*. It seemed natural to me that people who worked together for the same goals for so long should begin to meet not just as workers, but as people. Personally I had shared intimate conversations with Teri, Sue was a close neighbor of mine, and Phillip and I had been good friends for years. I knew these three people on my own and more and more it seemed important to me that the beneficial aspects of our friendships find a way into the Team spirit.

I went so far as to suggest that getting to know one another was as much a part of our job as anything else. If overloaded schedules prevented us from meeting, we should take an afternoon off from work for the purpose of getting closer as people. I even suggested that such meetings, which had always taken place after work hours and on our own time, be viewed as work per se for which we were entitled to be paid.

To my surprise, people were slow to warm up to the idea. Phillip rejected it from the start. I was amazed that the idea seemed so foreign to people who called themselves a Team. No one wanted to take time out from their teaching, and Phillip admitted difficulty giving up his position of Team leader presiding over the business at hand at meetings. The notion of meeting as friends, in my mind, meant opening the Team up to more democratic, equalized forms of communication.

Most of the communication inside the Team went through Phillip. That is to say, when one of us needed support, supervision or just an outside opinion, it was Phillip to whom we went. Phillip was generous with his time; he made himself completely available to all of us. He didn't mind receiving late night calls, or early morning questions. He considered availability part of his job and he gave himself over to the staff's concerns willingly. He encouraged independence in thinking and teaching, the taking of risks and the digging into ourselves to solve our teaching problems. So, it was not to each other that we went when things got rough or perplexing, but to Phillip whose helpfulness kept the three other Team members from ever having to rely on each other.

"Working at friendship" was my way of suggesting that a new spirit of Team self-reliance and separation from Phillip begin. I was not the only one who felt this way. Sue voiced her resentment of Phillip openly, arguing with him about what he said, did or suggested, often admitting jealousy of the position he held as Team leader.

Phillip and I had our own spats and feuds. One of them being over my contention that *process* was sometimes more important than *product*. In truth, Phillip didn't really disagree, yet he'd maintain just as doggedly that sometimes product was more important than process. We'd grumpily nod hello at the coat closet, and try to avoid talking to each other for the rest of the day or week when these flare-ups occurred. Finally our relationship as close friends would make us talk and bring us back together. There were times when we worried that our work would get in the way of our friendship.

Teri, newer to the Team than Sue or myself, was still in need of Phillip as model and support during this time that Sue and I were breaking away from his influence. Sue and I watched as Teri became a kind of favorite younger

child in our family constellation. Phillip and I spoke, and joked, openly about the family phenomena taking place in the team, of jealousies and fears of changing loyalties. When Teri began her work she said she was most comfortable as a collaborator, but after a year she decided she needed to work more on her own.

Sue, Teri, and I were conscious of being a three women staff headed by a man. The implications of the situation were obvious. We always spoke openly about this fact, and the issues it raised, amongst ourselves and with Phillip. We met a few times without Phillip just to experience ourselves as women co-workers. Our conversations covered a wider range of subjects and we spoke more about our personal lives.

It was at this point that the Team began to realize itself as a body of four people relating to four people, rather than three people relating to one. This is *not* to say that over the years we hadn't worked well together, even taken orders from one another. When Sue coordinated the *Spicy Meatball*, we all followed her directions. When Teri instructed us on the care and use of machines, we listened and took notes. When I described my work with popular genre, the Team asked questions and respectfully and enthusiastically experimented with the approach. We had always shared our work, at meetings and apart from meetings. Now we had to find some way of sharing ourselves. I again brought up my wish that we find ways of becoming friends as well as co-workers. This time, people listened with half an ear. After five years of working together, our relationships and our feelings about one another were complex. We all sensed that we wanted to do more than just get along with each other. And we wanted more than separate but equal. We vowed to make our meetings more "comfortable" and informal.

Some of our attempts were artificial, even disastrous. At first, our meetings were a confusing hodge podge of intrapersonal, and 75 business. At one meeting, Teri, Sue and I started talking about women-related matters and Phillip threw his hands up because he felt excluded. Another time we had a dinner at Teri's house to which husbands and lovers were invited. By including mates, we multiplied our problems. Mates and friends knew less what to say to one another in a social context than we did. They didn't even have work in common. The evening ended in disaster. Sue thought it was to be a completely social affair, whereas I, of all people, had some Team business I was burning to bring up. Everyone took sides on the salary issue I brought up, mates included, and a hot debate ensued followed by Sue breaking down into tears and running into the kitchen to cry. Later she chastised us by reminding us that she was "just here to be with friends." I remember dessert was very quiet blueberry pie that Phillip had brought for the occasion.

The dinner was our last great experiment in enforced friendship. We decided then that such things could not be made to happen, they had to happen on their own. Now, instead of turning our energies to each other, we turned our energies in the direction of one another's work. More and more we spoke about the work we were doing: how it made us feel as people, what we thought about it, where we wanted to go with it. We talked on and on even more than before about our relationships with, and predilections for, certain of the children with whom we worked. Gradually we really did begin to see each other as people, but through the work.

The 75 Team walks a thin line between work and friendship. Phillip, Sue, Teri and I are friendly. Sometimes we see each other outside school. We know the crucial facts of each other's lives; we have visited each other at home; we have eaten lunches and dinners together. But, in the truest sense of the word, we are co-workers more than we are friends. We share one of the most important aspects of our lives, our work. It is work we all believe in—helping children to create art out of their own needs and feelings. Our different backgrounds and various talents add to the quality and diversity of our Team. For all our differences in energies, psychologies and modes of creative expression, we share the same work ethic.

We still leave meetings feeling like geniuses. When I hear Phillip speak about conversations he has had with children, or Sue describe her linguistics course, or listen to Teri sort out her feelings about a group of girls she is working with on a video documentary, or when I get to talking about the importance and nature of *voice,* and everyone is listening, then I am impressed with our ability to take our own work and one another's work seriously. It is the bond of co-workers which has been the key to the strength and success of our work.

Luis, A True Story
by Meredith Sue Willis

The girls had trouble choosing a boy to be the prince in the Cinderella videoplay. The boys in the class seemed either too small and delicate or else so big and mean they would destroy the magic. In the end they chose Luis, a boy who could have been the lead girl's twin. He was just the same height as Yvonne with the same expressive forehead and rich dark hair. Luis hadn't had a part in the boys' play earlier in the year, and he wasn't sure he liked being the only boy in the girls' play. They bullied him pretty badly too, shoving him and whispering things in Spanish that I couldn't catch. One day when my back was turned the evil stepmother kicked him in the crotch. I saw Luis pucker up struggling with tears and announce he was quitting the play. Yvonne the Cinderella was mad at everyone, including me for not stopping the incident. She certainly had no sympathy for Luis, who was as much a prop to her as the special ball gown or the slipper he fits on her foot.

Luis waited for me in the hall outside, and I only had to beg a few minutes before he reconsidered. After that I watched the tough girls more closely, making them leave the room for the more tender scenes. I was impressed with Luis and Yvonne; they almost never cracked up in giggles and spoiled takes. In the final videotape they appeared to be very sweet children in a dream.

In the fall I ran into Luis in the hall and he immediately put on a pout. "Susi, when we gonna make a movie?" I said, "You were in a movie last year!" He frowned darkly and of course I understood that Cinderella had been someone else's fantasy. I already had a lot of projects started that year, and even though Luis had been easy to work with, a good trouper, he didn't strike me as aggressive enough to be the central force of a movie the way Yvonne had been the year before. There is almost always one determined kid who gets the others excited and convinces me of his or her seriousness. In that class that year I was pretty sure the kid was going to be Sammy.

Sammy had been the Indian chief in the boys' movie. We hung him in the final scene by taking alternate shots of his drooping head in the noose and his dangling feet. He was small and energetic, and he knew exactly what he wanted, and everytime I came in their room, or even in their hall, there would be Sammy reaching out to me with a sincere handshake saying, "We ready when you are, Susi, no problem, Susi, whenever you want. But we like to practice a little soon, you know." Sammy was big on handshakes. I began to notice standing just behind Sammy was Luis, establishing by his presence his right to be included in the "we." We had script conferences, and I found Sammy's ideas very clear and cinematic. He was an aficionado of Bruce Lee films, and his plot had a simple epic quality that I liked. There was to be a brutal crime against the family of the hero, and then a lot of chases and fights against the ones who committed the crime. The hero was to be Sammy, of course, and Luis would be his brother. The whole class knew about the movie, to be done in silent super-8 color film, and the cast was growing day by day. All of the biggest boys were going to be in the gang of bad guys. Yvonne invented a part for herself. Everyone was excited; the teacher was glad to cooper-

ate; the main thing worrying me was the actual karate fighting. Or was it kung fu? I have never had a good grasp of the martial arts.

I took Sammy and Luis into the writing room and told them to show me how the fights were going to look. They took off their shirts, chose opposite corners of the big yellow rug and came at one another as if they had been working on this for weeks—I suppose they had, in gym, in the playground. Sammy, when he wasn't using his gift of salesmanship, turned out to be a talented tumbler. He leaped at Luis, bounced lightly off his chest, and did a backward flip that ended in a somersault. I was amazed. Did he really do that? Luis didn't tumble, but he never took his eyes off Sammy, helping him with his flips, never lowering his hands from a certain defensive position. He leaped well, sideways, with a great deal of grace. What they were doing had little to do with fighting, although a couple of the kicks seemed dangerously close to a jaw. They were really engaged in a celebration of their own bodies. One of the other writers who uses the room wandered in, and I was embarrassed, caught red faced here watching the sweat collect on the boys' bare shoulders. I broke it up, and they came toward me trailing their shirts behind them. Luis asked me to hold his while he combed his hair. I knew all about kids who write dirty words to see what you'll do about it; I know kids who kiss each other in the closets and bathrooms, but this was something new. I felt without a protection I have always depended on in my relations with children. A few days earlier when I wore some new pants to school, Luis had said, "Susi! You got fat!" "I did not," I said. "You just never saw me in pants before." I didn't like being called fat, but that bothered me less than the idea of Luis looking at my thighs. There was a lack of barriers. I began to notice that some of the boys in this movie opened doors for me, or even when I came into their room took my arm and escorted me over to the regular teacher's desk. They were mostly Dominicans, some Puerto Rican, a few from South America.

I thought about one summer when I worked at a camp for senior citizens. There was a dishwasher there who used to talk to me a lot, a seventeen year old retired jockey who didn't seem like a kid at all. He told me about his wife ("Not a married wife, you understand...") who was thirty. He said it is good for a young guy like himself to live with an older woman. She understands things, settles you down. He insisted I take his phone number in case I ever got lonely and needed a man. Very polite and practical. And no barriers at all. That was what I sensed about my boys in the karate movie; they didn't see any particular reason why they shouldn't look at me as a girl, as a woman.

I decided I was in love with everyone involved in the movie—boys, girls, teachers. How could I not be? Twenty beautiful children waiting for me to tell them where to stand, when to speak. And they really were children after all. Down in Riverside Park we would be ready for a big fight scene when someone would start to cry because he had taken his tumble in doggie caca and everyone had laughed and insulted his manhood. Luis was different from the others only because he was a little more tractable, a little more willing to stop playing ball once we finally got the cameras set up.

When the first rushes came back I was impressed by a lovely shot of him through a chain link fence. The good brothers are sneaking up on the bad gang and Luis raises his arm and points. He seems taller than in person, with more prominent cheek bones, his gestures a touch more emphatic than the

other boys'. I found myself paying more attention to him as an actor, especially the day Sammy missed his big scene.

It was the birthday sequence, a flashback memory of family togetherness. We had an apartment so we could film on location, everybody had their coats, cameras, props—and I couldn't find Sammy. Sammy had another iron in the fire. He was in a gymnastics group, and he had practice that morning. "I been waiting all year for this, Susi," he said when I finally found him trying to slip away from me into the boys' bathroom. I understood all right. I was furious. Luis is a better actor anyhow, I thought. He probably should be the star. He seemed to attract the camera, and such responsive features! "Smile, Luis," I say. "You're happy when they give you the birthday cake." And the magic is that he does smile, the instant I say it, as if he already knew what I wanted. He smiles over the candles toward me; he makes a little gasp and lifts his shoulders.

I began to depend on him to show the emotion that any given scene required. The others were responsive too, but Luis seemed to catch on first, and they would catch it from him. He always had an eye on me, scowled and smacked a fist in his palm if I said be mad. He was my good ballhandler, my playmaker. When the birthday footage came back I said softly to the other adults, "Luis is awfully good, isn't he?" And everyone had to agree, but no one knew that he was good just *for* me.

It was no secret to Luis, though, that he was my Star. He was quite convinced that he had the right to be with me anytime I did anything remotely connected with his movie. He followed me the day I took the cameramen upstairs to edit. I said there wouldn't be room for him in the closet too, but when we got out in the hall and started up the steps, I discover Luis trailing us. He had somehow made himself invisible to the teacher and slipped out of

Still from The Brothers Who Get Revenge: *The birthday party flashback.*

209

The Brothers Who Get Revenge: *Luis leads the charge at the chain link fence.*

class. He doesn't try to con me into thinking there was a misunderstanding. He comes with his chin stuck out demanding his rights. "How come *he* gets to come?" asks one of the editors. "Well," I say, "It's his movie—he should be in on some of the decisionmaking." Luis sneers at the other two: "*Sí, Susi dice que es mi película.*" I love to hear him speak Spanish. It is a taut accent with all the final sounds pronounced. I begin to realize that much of his childish softness, his charming dependence on smiles and pouts, comes from the limits of the English he speaks. His ear is good, so his pronunciation fools you into thinking he is fluent. In Spanish, the other boys let him do the talking. He gives a running commentary on the uncut reels of film we are looking at. It is a street scene. Luis says, "*Mira, estas dos putas—perdona la palabra....*" Look at those two whores, pardon the word. I wonder what his family is like. I know nothing except that his Spanish is clear. He orders me around a little now, this Luis who speaks such nice Spanish. "Hey Susi, you let me do some editing? Let me do the machine now."

I need a session for sound effects and music when the editing is finished, and I take Luis and Sammy upstairs with me. They do some drum rolls that I tape, and then we go out of the school and across Broadway to a record shop. It's a grim clammy New York day, and I always feel a little out of place on the street with the older boys, as if this were really their turf, or at least a place where I am of no use to them. Sammy immediately whispers in Luis' ear, then says, "Hey Susi, can we keep the records? Hey Susi, you gonna buy us a hot dog?" Sammy walks backward, stoops to pick up something off the street, drops it. I have a vision of a future Sammy, wheeling and dealing in a glory of physical energy, a page on the floor of the New York stock exchange. A hustler. Luis meanwhile stays with me, walking with dignity. Sammy finds a ball in the gutter.

In the record shop Sammy says, "You decide what record, Susi, you buying, you decide." "No, the idea is you two pick out what records go best with your movie." Sammy smiles; this is adult territory, where money talks and Sammy doesn't have any. He whistles under his breath and tosses his ball in the air, just high enough to show he isn't interested in records, but not high enough to get in trouble with the owners. They, a man and a woman, keep an eye on him anyhow. It turns out they don't speak much English, and Luis takes over the responsibility of explaining me to them. This is a role he is comfortable in, translating for adults. Smoothly he explains that we're from the school, that we're making a movie. Not wanting to lose too much authority, I say, *"Sí, una película, a la escuela."* The owners are amused and attentive. They ask me in English if I'm the teacher, and I say, *"Sí, soy la maestra."* Luis cocks his head and concentrates on the music and nods: "For the fights." He seems confident, and I am impressed with his seriousness. He chooses another record, a sentimental Freddie Fender song, country and western, with some verses in Spanish. I had not been sure until now of his sense of the wholeness of the movie.

Back on the street again Sammy is still holding separate from us. He asks to borrow fifty cents, just till tomorrow. I am hurt that he is still hustling me, so I give him the money. Brazenly he goes to the Italian ice man and spends it all on a double dip. It's a sort of bribe too, because he now walks at a distance, as if he were trying to stay out of our way. Luis gently begins a conversation. "You go to college, Susi?" he asks; "my teacher she still going to college." "I guess she's working on a master's." "How many years you went to college, Susi?" "Let's see, four years, and two more of graduate school makes six."

"Hey Luis!" calls Sammy, already halfway down the hill. "Hey Luis catch the ball!" But Luis ignores him. "You like to go to school, Susi?" I tell him it's one of my favorite things to do, and he smiles, a very contented mysterious smile. Does he have a fantasy, maybe a fantasy of catching up with me so we can always be equal, asking one another questions? My fantasy today is of being his mother and depending on him to help me with the shopping, with the institutions, because I don't know the language. I say, "Do you think you'll go to college someday, Luis?" "Ye-es," he says with the peculiar two-syllable pronunciation that makes it sound like " *O sí!*" No doubt in his mind, not right now. He is like an older boy, himself in a couple of years. But he changes back and forth. When we get to the school door he breaks into a run and chases Sammy, and they burst into their classroom together.

We have finished shooting the movie. The film festival and graduation are almost upon us. I catch myself going around the school watching for my friend Luis, taking detours in order to pass his class. I stop by the auditorium when they are having graduation rehearsal. I don't see him at first, then suddenly here he is, coming up the aisle with his chin first, ignoring whoever is trying to keep him in his seat. "Where have you been, Susi?" He stops just short of me, just beyond where it would be comfortable for me to put a hand on him. I touch other children all the time, move them out of the way, give a hug, pluck fuzz out of their hair. But I don't touch Luis, and he doesn't take my arm any more. "The film is finished, Luis. There's nothing else to do." "Take me," he says, threatening. I mock him: "Take me, take me." His indignation fades, he lights up with the smile and I light up with my smile and

we smile at each other a little while, until we have reestablished the specialness of what we are to one another, and then I have a class to teach, and he has to practice marching. I am very tired, though, and when I leave him I feel that the smile isn't enough. That there should be progress, advancement, conquest. If we aren't going somewhere, then we must be slipping back. I feel the imminence of loss. There seems to be nothing to do but lose Luis. What else? Invite him out to a karate film and buy him popcorn? I fantasize; I try out scenarios in my mind. All I can find that lasts is our smiling back and forth.

Luis's film is a big success. Little children whisper when they see him in the hall: "There goes one of the Brothers." Everyone is perilously practicing karate in the hall, and coming to me with ideas for movies, kung fu, gangsters, Flash Gordon. Adults notice Luis's special face in the movie, and when I point him out in the flesh, they say, "*That* one? He seems so little!"

We have a showing just for his class and their families, and I meet his parents. The mother is young and plump and speaks only Spanish. I dread fumbling around saying what a good boy Luis is. She hardly looks at me, doesn't seem to realize I had anything to do with the movie. She acts as if the whole movie were for her, as if Luis were for her. He is soft and babyish today; I see that he *is* for her. I have to leave; I tell the teacher I'm going, and head for the door, almost bump into a man just arriving. "Oh," says the teacher, "This is Luis's father. You have to meet Luis's father." He is in his early forties, not short, good-looking in an oppressed, weary, working-stiff way. He wears laborer's loose jeans and he holds a cap in front of him. In desperation I enunciate carefully in Spanish that Luis is a very good boy. Luis comes running over to us, but stops at a little distance and stares at the floor. His features are sleepy and coarse, his hair seems unruly. Is he afraid of the father? Is the man brutal? What does he have planned for Luis? I didn't think anyone still clutched caps respectfully. Both of their faces seem thick and far away from me. I see Luis in those unfitted jeans with the cloudy expression. I see Luis hurrying out into heavy, snarled working life.

There is really not much more to this story. I didn't see Luis again until graduation day and that day I gave all my kids kisses and Luis too. I remember the way his skull felt under his shiny deeply coiled hair. He was grinning and wearing a tie. All the sixth graders were feeling pretty high. I said, "Will you come and visit me next year?" He frowned at me for even asking. "You know it, Susi!"

But I don't see Luis in the fall, and I don't see him in the winter, then I do see him one time the next spring, a year later. I am in the auditorium at the school where I am helping out with a talent show, and I hear a commotion and notice some big boys have come in, a signal for trouble. I recognize Nelson first, the heavy from our karate movie, the bad guy, and then I see two little blonde fourth grade girls jumping up and down and squealing over something. They are chasing another junior high boy, and he comes running down the aisle laughing, staying just a little bit ahead of the girls, and I see it is Luis, stretched out, taller than I am, as tall as Nelson, and so skinny! He doesn't see me at first, he is laughing over these two little girls, who shriek, "It's him! It's him!" And one of them turns to me and says, "Isn't he cute? Isn't he the cutest thing you ever saw?" I nod: "He's cute all right." And Luis finally sees

me and just for a piece of a second his face lights up and he launches himself over the little girls and lands in the empty seat beside me. I ask him if that is his fan club, and he shrugs and grins. He sits for a second on the edge of the seat, and then leaps up, yelling for his friend. "Nelson! Nelson! Come and see Susi!" Nelson comes over and grins too, and Luis stands beside him, showing off how big he is, that he is proud to be Nelson's friend. They grin at me for several seconds, and of course none of us has anything to say to each other. Then Luis gives his lean body a twist, a fish-leap sideways, a wrench away from me, and he slithers up the aisle without saying good-bye. Nelson waves, and then they're gone.

So Far Away
by Theresa Mack

We rode up in the elevator to the 16th floor, the girls chattering about graduation parties and summer camp plans. Next week they would graduate from sixth grade, leaving P.S. 75, each other, and perhaps videomaking behind.

As I opened my apartment door, they all scattered to familiar spots. Caroline and Radha flopped onto the water bed. Amy ran into the kitchen to unwrap a surprise package, and called us in to see the cheese cake she'd brought for us to share. Kendra pranced from room to room, while Eliza started gathering chairs around the TV set and cautioned Radha not to be so rough on my bed.

Of course we ate the cheese cake immediately. No one wanted to wait till lunch. The girls were already showering me with thank-you's for the year-long project. We had finished editing their videotape just in time, and now we would look at it.

Last September they had run through the halls till they found me, to show me a script they'd written and wanted to make into a videotape. Their story was about a young girl who lives with her divorced lawyer mother. The girl, Ellen, is secure and popular at her school in New York City, but her mother decides to move to the suburbs for a better job. Ellen has no choice but to leave her friends and enter a new school, where she becomes a social outcast. Ellen resents her mother's involvement in her career, because it leaves her mother so little time for her. Ellen's mother is frustrated and guilty; she cannot seem to live her own life and fill Ellen's needs as well. In the end, mother and daughter decide it just isn't working out, and that Ellen should go back to New York City to live with her father. The girls wanted an ending that was realistic, they told me, and not one that neatly resolved all problems.

I was very impressed with their script, and I liked the girls, so I agreed to help them with the production. They were bright, strong-willed and energetic. Caroline, Amy and Radha formed the core group, and became the main directors, actresses and videotapers. Pretty, dark-haired Caroline talked so fast she seemed empty-headed at first. I learned she was smart, a good collaborator, and an excellent actress in her sensitive portrayal of the mother. Amy, the smallest in the group, played the part of Ellen and was the driving force behind the project. Amy was precocious in many ways; very perceptive, very intense, very much wanting this videotape to be the best ever made at P.S. 75. Radha played a minor role of Ellen's best friend, which gave her many chances to work the camera. Awkward at first behind the camera, she quickly developed skill and sensitivity and showed real talent in setting up scenes for the camera.

Eliza was a marginal character, one of the original group but never really a part of it. More serious than the other three, she found it hard to join in their gossip and giggling. She was dependable and always ready to do unglamorous production tasks. Unfortunately, she allowed herself to be put down or excluded; it was no coincidence that she played the role of Barbara, the outcast at Ellen's first school. Kendra became a regular a few months into

the project and she was a delightful addition. A slender fine-featured little girl, she was usually in high spirits and her zany sense of humor helped offset the tension between Eliza and the other three girls.

Starting in September, I met with the girls one day a week, a luxury that their open-corridor classroom teacher made possible. The girls came to the project with a strong desire to direct it themselves and I played as back-seat a role as I could. I always become very involved with any project I do with children, not only teaching and advising on technical matters, but offering ideas for characterization and plot development. But I also work hard to establish a relationship with the kids which gives *them* control of their production and encourages them to feel that I'm a resource person rather than an authority. This group of girls developed their own characters and the dialogue for each scene through improvisation, which they directed for each other and then showed me for reactions and suggestions. They also handled all the sound, lighting and camera work.

Production went slowly at first because they were learning along the way. They started by recording whole scenes in one long take from one point of view. But after playing back the scenes, and reshooting with a few suggestions from me, they grasped the technique and power of breaking a scene into shots, shooting from different angles, and considering the composition of each shot as well as the action. Then they really began to make a videodrama, and not just videotape a play.

What I did more than anything else throughout the year was continually channel and direct their energy back to the production; inspire them when they became tired or discouraged; and help them resolve personal conflicts when those conflicts threatened to undermine their production. Today, I felt, my work was over. We had come together for a celebration, to view the finished product, to bask together in the glory of completion. The girls had spent the last few weeks screening the several takes of every scene and writing an editing script based on their preferences. Since we were running out of time we agreed that I should do the actual editing according to their script. What was important now was completing the piece in time for shows and cast parties before everyone disappeared in June.

So, although the girls were familiar with every detail of every scene, today was their first view of their work pulled together into a finished videodrama. It was called "So Far Away." The title and credits came onto the TV screen superimposed over the opening scene—a game of tag—which introduced Ellen, her best friend Laura, and the awkward new kid Barbara. I sat forward in my chair, a little tense, and watched the girls' faces as they watched their movie. Part one, which builds towards Ellen leaving for her new home, moved quickly; the acting was strong and the story line clear. The confrontation between Ellen and her mother in scene two sets a tone of tension and draws the audience into the story.

E: Are we going to move again? Level with me. Are we going to move?
M: Yes we are. I'm sorry. It's for both of our benefits.
E: Both of our benefits! I don't want to move, Ma. We're always going someplace. We never stay in one place. And besides, I'll be leaving all my friends.
M: Ellen, look, you'll adjust. You always have adjusted to the moves we've made and you'll adjust again. Change is a very important part of life. Don't *worry* about it.

E: But listen, Ma, I probably won't have any friends there. You don't even understand. (She's wringing her hands and her voice is high pitched.)

M: (cutting her off) Ellen, just because you're upset don't take your troubles out on me. Now listen. This is the way it is. It's too bad you're not happy about it, but I can't do anything about that. This is the way it has to be and that's it—final.

The scene ends with Ellen running from the room, and going over to her friend Laura's house for comfort. To cheer her up, Laura suggests they practice the hustle; she puts on a 45, "Don't Go Breaking My Heart," and the two girls dance together in Laura's bedroom. All the girls howled with laughter over this scene, and Amy and Radha, the actresses, blushed with embarrassment. For me, it was a "goose bump" scene, one of the most poignant and intimate moments in the movie, the overhead shot adding to the sense of witnessing a usually private pre-teenage ritual.

Part one ended with a teary goodby between Ellen and Laura, shot on location at Grand Central Station, and fading out to Carole King's "So Far Away." There were a few seconds of silence, a few sniffles, then wild applause from all six of us. The movie is so good! we all agreed, so interesting, emotional, well-acted. Everyone complimented each other on dialogue, gestures, camera work. "Let's see part two," Caroline said, and I quickly threaded it up, as eager as they were to see the final twenty minutes of their drama.

Part two opened with a very low key scene, Ellen and her mother arriving at her new home, then Ellen's mom lying to avoid taking Ellen to a party with her. Immediately there was a different tone to the story; part two was more about depression than conflict. As we watched, the drama seemed to limp along and the mood in the room began to change. The kids started squirming, unsticking their bare legs from the wooden chair seats, and muttering occasional criticisms of what they were watching. Somehow the emotional impact of part one was not being sustained in part two, and technical problems seemed more frequent. Or was that because the story was dragging on too long for what it had to say? The girls' attention began to drift and the room seemed to get hotter.

As the videodrama ended, there was an uncomfortable moment of silence, then quiet mutters of disappointment. And I mean serious disappointment. They had completely forgotten their thrill over part one. "It's awful," moaned Amy. "We worked so hard on this all year—for what? It's terrible!" Her voice got higher as it always does when she's about to cry. She seemed to speak for everyone.

For a moment I felt slight panic, not knowing what to do next. They were right, part two had serious problems. I felt my own fear of failure. It's all right to work long and hard, even to flounder along the way, as long as there is success in the end. But what if after all these months of working and learning, the kids were left feeling that they had failed. I couldn't bear the thought, and I knew I couldn't explain their feelings away by saying, "It's the process that counts, not the product," or "Your expectations are too high, don't be so demanding of yourselves." Over the past months we had become work peers, and they were reacting much as I would react to my own work.

During these few moments, as I tread water and wondered what to do next, the girls began jumping around, bickering over chairs, lunches, views of the TV. Suddenly it dawned on me that, of course, we were nowhere near

finished. I was forgetting how important editing is, how much it can change and shape a film or tape after it has been totally shot. This was only a first "rough" edit. There was still a lot we could do with part two, but I knew I had to act quickly.

"Look at me and listen carefully," I said, riveting my eyes and energy on them. They were so clearly disappointed I knew I had to think fast and talk honestly. I told them I agreed with their overall reaction to part two. But it also had many strong elements such as Ellen's phone conversation with Laura, Kendra's crazy lady in the psychiatrist office, and especially the closing scene between Ellen and her mother. I explained that editing was now the crucial factor, and that no movie was ever finished after its first edit. There was still much they could do with part two by cutting out scenes, tightening scenes, even reordering scenes.

They understood immediately. They stopped their self-criticism and started making suggestions for changes. It was too early to feel remorse for an experience wasted—we still had work ahead of us. We decided to eat lunch in front of the TV as we reviewed part two, because time was becoming precious. The rescreening was difficult. It was painful to view scenes that they weren't entirely pleased with. It was also tedious and boring to stop after each scene to discuss it, consider changes, and make notes on how it should be re-edited.

This time the girls viewed their tape with more distance, looking for ways they could reshape and improve it. "Remember," I said, "the audience doesn't know your script or what you shot. If you feel a scene is technically very poor, or contributes little to characterization or story line, you can cut it out completely. No one but you will ever miss it." They all agreed to cut out a bathroom scene and a hallway scene in the new school. "And you can also re-order scenes," I reminded them. They decided one scene between the mother and her psychiatrist was enough and cut out a second long psychiatrist scene because the sound was poor and the dialogue repetitious. They made several other subtle changes which tightened the piece and intensified the feeling of part two.

Sometime during this editing session, the feelings of pride, excitement and accomplishment welled up again in the girls. This videodrama was a very personal expression of their feelings about friendships, about adults, about impermanence, about the realities of relationships and how they can fail us. They were so closely identified with the videodrama that it had seemed like an all-or-nothing risk, which at first viewing struck them as total failure. But as they re-edited they took control again and reshaped a piece of work that, no matter how personal, now had a life of its own.

They left my apartment in high spirits, very excited about the approaching shows and cast party. "So Far Away" wasn't perfect, it had its flaws, but they had worked hard and gone as far with it as they could. It was a strong drama and the girls felt successful. And having faced the black pit of failure, I think their feelings of accomplishment were all the sweeter.

P.S. 75 Movies and Videotapes (A Selected Filmography)

Videotapes

THOSE WERE THE DAYS: This videodrama interweaves the experiences of ten girls at a boarding school as they deal with each other and their feelings about being sent away from home.

WORK: This engaging video documentary shows people at work talking about their jobs: butcher, carpenter, artist, editor, and former magician.

FIRE: Based on a true incident about their teacher, Mr. Burns, whose child was trapped in a locked apartment, this tape dramatizes what might happen to a family hit by fire.

BLACK GIRL LOST: A stark tale of a girl growing up amid poverty and drunkenness. She falls in love with a drug dealer and eventually comes to a tragic end.

THE PENPAL TAPES: Highlights from tapes about city life (Sal's Pizzeria, the subway, Broadway), made for kids in South Carolina, who reciprocated with tapes of their own.

THE KID VAMPIRE: A vampire is on the loose, attacking Mrs. Karasik's class and breaking out of caskets. In the dramatic climax, the townspeople storm the vampire's castle in Central Park.

13 IS MY LUCKY NUMBER: A child controls her family with witchcraft until she is finally brought to justice. One of the deepest and best videodramas made by children anywhere.

SHADOWS OF LIFE: The Gilfrey family faces a crisis when the wife starts playing around with the mailman in this tongue-in-cheek Child's Version of a Soap Opera.

AN AFTERNOON WITH ANNA: Anna Heininey, who lives in the senior citizens residence across from P.S. 75, talks with children about her own childhood and old age.

SIDEWALKS OF THE CITY: Looking in new ways at the familiar sights around them: Some City Sounds, Geometric Shapes, The Heart of the Subway (power station), Signs, Graffiti, Construction.

HOW TO LIVE WITHOUT A FATHER: An ordinary day in the life of a family of 5 women. The arrival of a letter from the absent father agreeing to a divorce leads to emotional clashes.

THE COWARDLY COP: Inept pair of cops chase criminals and keep letting them get away. Good acting and visual values.

MURDER AT GRANDPA'S HOUSE: A group of friends vacationing on an isolated island find there is a mysterious murderer about. Is it one of them?

LOS TRES PRISONEROS: Cowboy drama in Spanish and English. Three bandits escape jail, and face gun battles.

SO FAR AWAY: A young teenager's happy life becomes miserable when she has to move to a new city because of her mother's new job.

Super-8 Films

THE BRAIN: A comic fantasy about a child who throws away his brain, made by 1st and 2nd graders.

THE END OF THE WORLD: A haunting documentary of nature and the streets, beautifully photographed, with a reflective sound track by the three 1st and 2nd grade girls who made it.

HALVES OF A DREAM: A charming black-and-white film in which two little girls fall asleep and have a dream full of adventures and monsters. 3rd and 4th grade students.

HEAVEN AND HELL: This zany animation uses ingenious cutout techniques as some 3rd and 4th graders look in on heaven and hell.

AMERICAN HISTORY CARTOONS: History comes to life in these delightful versions of The Winter at Valley Forge, Boston Tea Party, Declaration of Independence, and Cornwallis at Yorktown, made by fourth and fifth grade students.

DOLE MAN: P.S. 75's answer to The Cabinet of Dr. Caligari. Mental patient falls in love with banana. 5-6 grade.

LOVE AND HATE OF MRS. JONES: A woman and her lover plot to kill her husband, but her children find out about it. Visually arresting silent film. 5-6 grade.

ESTO ES MI CALLE: Elsa shows us the activity on her block, West 96 Street, in this tranquil documentary of New York City street life.

THE BROTHERS WHO GET REVENGE: Three brothers relentlessly pursue the gang that attacked their family: karate, killings, and bittersweet memories. Made by 5-6 graders in a bi-lingual class.

TROPICANA NIGHT CLUB: P.S. 75's first synch-sound, singing, dancing musical. Love and jealousy stir up trouble for two couples at a nightclub. 5-6 grade.

THE BROKEN VASE: A complex psychological drama, beautifully filmed and acted, about a family of women haunted by a tragic memory. Made by 5-6 grade students.

POVERTY WITH A TOUCH OF WONDER: Cine-poème of the loneliness of an urban neighborhood; shot in color and black & white by 5-6 grade students.

BROADWAY THROUGH MANY EYES: This lively cine-poème with fast-paced editing and original sound track, reflects the variety of life on New York City's Broadway. Made by 5-6 grade students.

THE UPS & DOWNS OF THE WESTSIDE RUNAWAYS: Three children leave home to escape their mean mother and have a series of adventures on the streets of New York. Made by 3-4 grade students.

Two stills from The Tropicana Night Club.

The Monster attacks in Halves of A Dream.

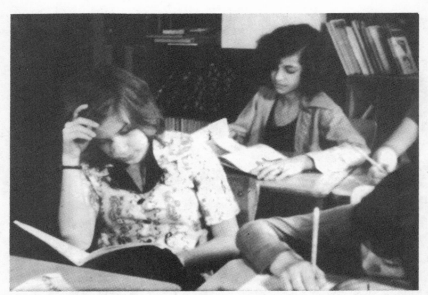

Two stills from The Broken Vase. *(Above) The mother in her secret room of memories. (Below) The daughter finds it hard to concentrate on schoolwork.*

Teachers & Writers and Me

by Hannah Brown

One morning five years ago, when I was in the fourth grade, a teacher named Miss Noyes from Teachers & Writers Collaborative came into my class. She talked with us for a while and then we wrote stories on a topic she gave us: The Secret Life of a Strawberry. I had no idea on that fateful day that in a few years I would be working for Teachers & Writers. After that day we had creative writing every week. After a couple of months we got a new writing teacher, Karen Hubert, who worked with us for the rest of the year. I often wrote stories on my own, but I was glad to be able to spend regular school time writing.

In fifth grade, unfortunately, I didn't get to work with Teachers & Writers. I made up for that lost year in the sixth grade, though. I spent more time in the Writing Room than I did in my classroom.

First, there was *The Harry Sneedless Stories*. This was a bunch of stories I had written the year before. Teachers & Writers had them printed up into a book that was given out in the school. I was really proud. I felt like a literary figure at age eleven.

I was also taking the film course that Phillip Lopate was giving. I expected to be bored by it, but I wasn't. After a few months, I started hanging around after class, asking Phil questions about the films. By January Maja Anderson, Jared Crawford (two kids in my class), and I were showing the movies for the film course. I remember when Phil taught us how to use the projector. We watched him carefully thread the projector. It seemed awfully complicated to me; I didn't think I could ever learn how. Just as I was thinking this, Phil turned to me and said, "Now you try it."

"I can't," I said, but he insisted that I try. So I did. I threaded it easily. After that, I soon learned how to use the film editor and splicer. Phillip suggested a project for us to do. He gave us several large tins filled with dozens of 16mm films no one was using. We were supposed to splice pieces of these films together and make a compilation film. We agreed to do the project, having no idea of what we were really getting into.

At first, we only used to work one afternoon a week, going through the dozens of unmarked films and labeling them one by one. Then we worked in our classroom, spending most of our days on it. But that situation was difficult because the kids in our class wouldn't stay away from us while we were working. So we had to move into The Closet.

The Closet. I hesitate in writing about it because I'm not sure I can make anyone understand what it was like and why it was important to us. It was, literally, a closet; a walk-in closet, where no more than two or three people could fit comfortably. Teachers & Writers was using it as a storage room for books, films, and video equipment. It smelled horrible, since it was right next to the bathroom. Bookshelves filled with books and equipment lined the walls. There were a couple of small desks (we used them for editing tables) and a varying number of chairs. Add three people to all this and you are left with no more than six inches to move around and breath in. There was also a pipe that went across the ceiling that we (especially Jared) used to climb up the bookcases and hang from.

I'll admit that not every second of the hundreds of hours we were there was spent working (that's a whole other story) but we did make a film. A masterpiece. It was called *The End.* It was about 700 feet long when it was finished. And our team had a name; we were Anderson, Brown, and Crawford. Most of the films we used in *The End* were boring educational movies, the kind that kids are shown at lunchtime on rainy days. Movies like *Mittens the Kitten* about a cute little girl and her cute little cat. Or *No Dishes Tonight,* a film earnestly narrated by Bill Wheeler of the American Restaurant Foundation, about the joys of eating out and the proper way to order tea. Another of our favorites was *Man From A.U.N.T.I.E.,* a cartoon about a little green Martian who comes to earth and learns all about insurance. Guess what foundation it was sponsored by? Another film we desecrated was the famous documentary, *The River.* The other movies were mostly unfinished student films.

Here is a description of a few minutes from *The End:* A girl sets down a bowl of milk. Her kittens come and drink from it (from *Mittens the Kitten*). Then the narrator's voice comes on and says "Let's say it together—'drink'." Then the word drink is spelled out on the screen, over the image of the kittens drinking. Then we cut to a shot of a drunk lying in the street with a bottle next to him. Then we spliced in a title that read "Brought to you by the Helena Rubinstein Foundation." We let that title run for about three minutes so the audience got bored. Then we cut to a shot we'd found of a boy walking into a bathroom and sitting on a toilet. Then he flushes the toilet, and we cut to the flood scene from *The River.* "Down the Monongahela, down through New Orleans, Baton Rouge...down.... to the Mississippi!" the narrator shouted, to the accompaniment of pounding dramatic music.

Finally, we decided it was finished. Phil showed it in the film course. We were so nervous the morning it was shown. As we anxiously made our last-minute changes, we appealed to a Higher Power to please, please let them *like* it, let them not walk out, and to please, *please* let the splices go through the projector all right. Since the film had hundreds of splices and since a lot of the films we used were old and brittle, *The End* went out of slack about every two minutes, causing the film to tear and the image to blur. We prayed that the splices would hold in the best parts. And we were lucky. Though *The End* suffered its usual technical problems, the showing went very well. They didn't hate it! They didn't walk out! I was shocked and happy as I heard them laugh in the funny parts. They liked it! It was a hit; we were triumphant!

But we were no where near finished with *The End.* We wanted it absolutely perfect, so we continued to work on it for the rest of the year. We also made a Super 8 film, *Dole Man.* I still consider *The End* our best work. I really thought it was terrific (if I do say so myself). Unfortunately, it's lost. We've looked all over for it, but we can't find it. It really bothers me. I don't even like to think about it. One of the great lost films.

I graduated from P.S. 75 at the end of that year. The next year, I was too busy hating my new school to bother with anything else. But last year I began working at P.S. 75 once a week as a Teachers & Writers volunteer. I worked with Phillip last year and this year I'm working with Teri Mack making films with little kids. At first, it was very weird. I kept thinking, "What am I doing here? I'm not a teacher! I don't know what to say to these kids. I'm not old enough to be telling them what to do." At first I didn't say very much. The

kids, who were in the first and second grades, seemed to like me anyway and I gradually overcame my shyness. They also didn't seem to notice that I was a kid, too. (I was thirteen.) They were always trying to figure out what my relationship with Phil was. "Are you his wife?" they'd ask. "His daughter?" I told them I was his friend and they stopped bothering me. I helped them with the camera and lighting and edited their films with them, or discussed ideas for new films. When I talked to the kids about their ideas, I discovered there were two things that most of them wanted to make movies of: a car going off a cliff and exploding into flames and a film about Spiderman. One kid actually believed he *was* Spiderman.

We made four films, of which *The Brain* is my favorite. *The Brain* is the story of a kid who gets tired of thinking and takes his brain out of his head. The boy goes crazy and becomes very dumb, while the brain has a few adventures, including playing the piano and going to the bathroom. Then another kid picks up the brain, puts it in his head, and becomes twice as smart. Then comes the big classroom scene: the smart kid does all the math problems in a few seconds but the dumb kid doesn't know anything. The teacher yells at the dumb kid and while she is yelling, he takes a gun out of his pocket and shoots himself. Adults aren't usually too crazy about this film (the suicide disturbs them more than it does children) but kids love it. We had a good time working on it, especially while we were filming the brain's adventures in the school. The first day of shooting, we wanted to show the brain moving by attaching a string to it and pulling it. But we'd forgotten to make a hole in it to tie the string to. We tried to make a hole with our fingers, but the shellacked papier-mâché wouldn't puncture. For lack of a better idea, we went to the candy store and bought some bubble gum. We all chewed it, then stuck the pink gum to the underside of the brain and stuck the string to it. This held for a little while. The scene we were doing that day called for the brain to be dragged over a pile of garbage. The brain became very sticky and dirty and generally unsanitary. I made one of the kids carry it back to school.

This year I've been working with older kids, third and fourth graders. We're making a film about three children who run away from home and their cruel mother. Well, that's the history of my association with Teachers & Writers so far. One more thing: I'd like to thank all the writers and teachers who've helped me and taught me—Karen Hubert, Phillip Lopate, Teri Mack, Sue Willis, and Miss Noyes. Thanks.

Combining Art and Dance
by Sylvia Sandoval

At P.S. 152 in the Bronx, Bob Sievert was teaching art workshops. I was teaching dance. We decided that we would like to try a project that combined art and dance, and it seemed to us that one of Bob's fifth grade classes might be a good group to work with.

Before I met the class Bob and I had a brief planning session. Bob said he thought his side of the project might be the construction of some sort of props; the dancers could carry them around. I was leaning towards the idea that I could introduce the class to dance if I asked the children to explore the movement possibilities of various parts of their bodies. That is, "Experiment with all of the ways your arm can move. Now, let your arm make the impulse that leads your whole body into movement." This way of working can continue through all body parts, head, shoulder, leg, foot, torso, hips etc. The idea didn't originate with me. It's basic to dance.

Bob said, "I've been listening to Scott Joplin and feel really turned on to moving to that music right now."

I was happy he'd suggested Joplin's music because I like it, too. The next day Bob brought his Joplin tape to school, and a group of children from the art class, those interested in dancing, went with me to try movement of body parts to rag tunes. It went well. Then I tried to think of how we could combine props and body parts. Well, of course! We could have larger than life-size, cutout drawings of the dismembered parts. We could have a head dance, an arm dance, a torso dance, a leg dance. Then, somehow the parts could combine to make complete figures. I was excited by the idea. I envisioned a dance with a comic, cartoon-like, sort of goofy quality. The notion of a mix and match game appealed to me and I felt the children would enjoy it.

Bob thought the idea would work, and though I didn't tell him my feeling about the style, he must have also considered the concept a zany one because exaggerated, crazy, cardboard figures began to appear in the art room. They seemed to me to be perfect for the dance. There were purple, blue and orange faces, arms with huge watches and blue fingernails. One pair of legs had orange and black striped stockings.

In the meantime the dancing group began to lose some enthusiasm. First of all, it was never the same group. One day someone wanted to be "arms." The next day he would become "heads." The day after he wanted to go back to painting. That was fine since Bob and I both liked the children to have the freedom to experiment with all materials available, but we weren't building cohesive dances and we had a problem with music. The children had decided that Scott Joplin was too old-fashioned. At first I hoped to retain their interest with a little music history, and I brought in a newspaper picture of Joplin. I should have known it wouldn't work. Their minds were made up.

One girl said, "Is he dead? Don't show me anyone dead. There have been too many deaths in my family."

I brought in a tape of some very fast banjo music. The children liked it. The banjo piece was composed as long, or longer ago, than Joplin's time, but I've learned that when children say "old-fashioned music," they simply mean

Bob brought the "audience" half of the class into the dance room.

During rehearsal I tried to demonstrate for the children that since they were somewhat encumbered and covered by the props their movements needed to be exaggerated.

The "Heads" began low to the floor. Then they looked high; they looked low. They outlined circles in space. Each danced in his or her own way and finally they all came to a resting position.

The "Heads" began low to the floor. Then they looked high; they looked low. They outlined circles in space. Each danced in his or her own way and finally they all came to a resting position.

The "Arms" used an idea that is almost always appealing to children—a fake fight.

The "Torsos" played an imitate-your-partner game. One did a few dance steps; the other repeated the pattern. Then roles were reversed. The "Legs" must not have impressed the photographer. We have no pictures of the leg dance. The idea was to let leg movements, leaps or extensions, lead the dancers to three sequential points in space.

The parts became jumbled. They wove in and out and stopped at intervals; each at a different level.

slow. An adult would probably never think that most Scott Joplin compositions had slow tempos, but they are cool and sophisticated and children, with their fast inner pulses, often crave something more peppery.

The dance progressed after the change of music, but I had to set simple structural outlines for each section, so that no matter who took over the various roles the dance would still have a basic form. At last, when the props were completed, and we were able to use them, inspiration returned for the children and for me. One day we had a performance. The children who wanted to dance that day performed for the children who had been artists during the first half of class time.

Before the audience arrived the dancers posed in various positions around the room.

The parts become complete figures. (Photographs by Roberto Sandoval)

Drawing
by Robert Sievert

When I first began to teach art, more specifically drawing, years ago, I always relied upon techniques that were for the most part inspirational, reaching for ideas and topics that would bring forth an emotional response from those I was working with. I did a lot of work with the face, having children draw contrasting faces, surprised / depressed, or maybe happy / surprised, or even mean / nervous. I made a lot of faces with kids, literally: we all moved our faces into extreme gestures of pleasure, pain etc. and then tried to draw the response our features made. Narrow eyes, broad grimaces were the subjects of our drawings. I would hold up the drawings individuals did and the class would go wild with pleasure or disapproval. Or I would show them Van Goghs and have them draw nightmarish landscapes or ask them to draw pictures of their experiences in the city or traveling with their parents.

This was rewarding for me and for the drawers, but I must admit that after five years or so it became exhausting for me mentally to pay attention to children making expressive breakthroughs in the visual arts in the classroom. I would start to daydream in class, whatever the medium, paint, chalk...I was extremely competent at setting up materials and allowing art to proceed. At the same time a mechanical dullness began to be inside my head as I functioned inside the classroom. I could sure cope but I had to search out alternative situations to renew my sense of aliveness to teaching.

I was hired by a program to do art in the streets of the South Bronx. It was the wild west all over, people jumping out of windows, stabbings and shootings all the time. It was a much more stimulating setting and it took a lot of energy to produce art in the middle of a great deal of action. There were crowds of people making art, dancing and watching. There were many children who could only watch us from fire escapes because their parents wouldn't allow them down on the street.

The whole street had an energy that throbbed—cross it and it snarled at you but if you were able to relax and go along with it, it was capable of producing enormous projects. I remember one mural I painted with a group of children on Seabury Place in the Bronx. It was dusk and we were setting up paints on the street in this fairly well-lit area. This group of junkies came stumbling down the street. As they passed I invited them to join us. One did, and as he started to work on this powerful symbolic painting that included eyes and prisms and cosmic whatever, he explained to me his whole vision of the universe, which included God and many spiritual beings, earthly forces and heroin. (The mural was painted on one of those large garage doors with many squares; on each square each participant painted his idea of the city. See photograph.) I gloried in the painting of murals on the sides of burnt out buildings with junkies and winos, I thought their struggle cosmic and their expression profound. Needless to say after doing this for several years I was as burnt out as anyone who deals with the streets for long and had to move on out of sheer self-preservation. The unyielding clutch of poverty had begun to get to me and I was ready for and appreciative of the comforts of the classroom.

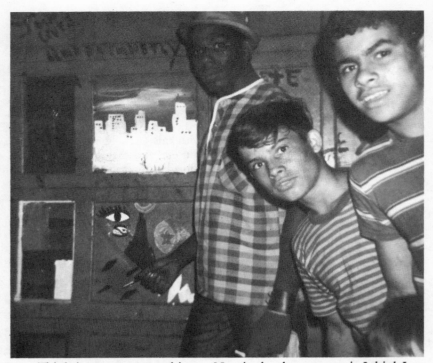

This brings us to current history. Now in the classroom again I think I am past my earlier problem of mechanical functioning, and my awareness and contact have been sharpening. I now realize that drawing is not just the expressive tool that I always imagined it to be. It can also be a way by which children can come into contact with certain physical and material realities. Drawing can teach how things work.

I first began to see this when I did work with plant and insect anatomy. I began to realize that children love to learn to become familiar with form. Given basic instruction in drawing forms such as the body of an insect, they would do it over and over again: sometimes taking it into realms of imagination such as drawing insect families of mamas and papas and babies doing very human things like going to the store; or sometimes just drawing the form over and over again for the pleasure of knowing all the parts and how to put them together. I once watched two boys repeatedly draw a pair of lungs with all the alveoli and connecting tubes on the blackboard, getting it down to the finest detail, and then erase it piece by piece and then redraw it again. Afterwards I asked them what they had been doing and they told me they were recording someone breathing in and breathing out. The drawing was the breathing in and the erasing was the breathing out.

Other forms, such as the growth pattern of a tree, can get a completely involved response. Very often when I am meeting a new group of children I use this project as a way of getting to know them. I draw a tree trunk on the board and then begin to show how the roots and branches grow out of the tree in an orderly pattern. First I show the primary divisions and then the endless

236

subdivisions. It has always seemed to me that as each student masters the problem of representing growth, a sense of growth within themselves is stimulated. I feel that they are then freer to draw life and life processes without the clutching knowledge that we all feel at times that we can't draw. Slicing an orange crosswise and observing the section patterns can also stimulate drawing. Cutting fruits and vegetables apart provides many different seed patterns and many suggestions for interesting designs.

Asking students to draw maps and diagrams of how to get from one place to another is a sneaky introduction to the task of observing life. I once spent weeks with one class drawing overhead views of the section of the city they lived in and then filling it all in with traffic patterns. We drew cars, trucks, buses, and people zooming in all different directions.

About two years ago a boy came up to me in the halls of P.S. 84 and asked if I could teach him "carabathy." After much inquiry I realized that he

was asking about calligraphy, writing with pen and ink.

In art school I had been forced to take about two years of calligraphy. At that time I groaned over the task of mastering the pen and ink. I was much more at home with my three inch brushes making dramatic gestures at a canvas. I was horrible at it for the first year and could not complete a page without leaving behind blobs and smears.

But bravely I said yes to this boy and got the right pens and papers and started my first calligraphy group at P.S. 84. The following months amazed me in that calligraphy proved to be so popular with children. Children and teachers all want me to start new groups in their rooms. I must admit that over the years I have often gone back to my pens and ink with a sense of love. Still it amazes me.

I was explaining my amazement to Teddi Polito, an open classroom advisor at P.S. 84. Teddi has great insights. She said to me, "Well you know people just love to draw, and what could be safer than letters—everyone knows them so well."

What shocked me about her statement was the fact that she considered calligraphy drawing. Of course it is, but I have never thought of it that way. The basic urge to draw and make marks is deep within us all. Drawing is a form of meditation and also a strong communicative tool. When one is drawing one is exploring form and feeling, plus communicating a sense of one's self. Ask any handwriting interpreter. One can read about cavemen and Indians and their lives, but nothing is as powerful and instructive about them as their drawings and carvings. When one confronts art, even from the distant past, the questions of who created it, and for what purpose, become secondary to the direct experience of witnessing what another's hand has wrought.

Gymnastics

This is The Balance Beam Still The Beam

This is Floor Exersise Still Floor Exersise

Russian split

Back handspring

The End

By Rachel

240

Lizards by Angel

Teaching Art:
Examining the Creative Process
by Barbara Siegel

For the past four years I have been teaching art to young public school children in Fort Greene, Brooklyn. Before that I taught painting to groups of adults who, for the most part, were enthusiastic hobbyists or painted for relaxation. In both cases, the experience of teaching provided me with a welcome alternative to the sometimes excruciatingly lonely aspect of being an artist. After a long day in my studio spent critically appraising my own work and asking myself countless unanswerable questions, it was with considerable relief that I would go to a class where I had the easier task of answering other people's questions. In the process of answering their questions, or in presenting basic artistic concepts that were new to my students, I often had to rethink and redefine for myself ideas which I had perfunctorily tucked away into the back of my mind as simplistic or aesthetic givens.

My interest in the science of visual perception, which has had a great influence on the direction and form of my own work, was certainly stimulated by having a ready-made laboratory—the classroom—in which to see these principles at work. I was initially surprised to find that my adult students' sensitivity to the visual world was often hardly more acute than that of the children I taught. I encountered few adults in the first weeks of any given semester who had consciously observed that a tree trunk was a composite of multiple colors and textures. When it came to rendering the contours of the human face, it did not seem that for all the extra years spent gazing into the mirror, the adults were any better equipped to analyze what they had seen there than were the children.

What the children may have lacked in visual experience, they made up for in conceptual agility. One day I was working with a group of children and suggested they all make paper collage faces. The class was busily cutting out reasonable facsimiles of eyes, noses, and mouths, when suddenly a boy jumped up and dashed over to the large supply closet at the back of the room. After searching in it for a few minutes, he triumphantly returned to his seat bearing a large red wooden bead. This bead, which he had probably spotted months ago in a dark recess of the closet, was immediately transformed into the shining red nose of the face he had been making. His ability to see the potential generic connection between a nose and a red wooden bead was a talent which I admired. If one of my adult students had creatively used an oversized bead as the nose in a face collage his classmates might have smugly labelled it "childish."

In my own work I am now exploring how a group of seemingly dissimilar images acquires formal and conceptual connections with one another through physical proximity within a given system. I have spent considerable time and effort developing an ability to see these connections, while my young students do so quite effortlessly. It strikes me that children as a group are naturally more adept at sensing such relationships than adults. Perhaps this is because they can't comprehend the notion of "finiteness" as thoroughly as an adult

can. Without a true sense of the finite, one's definition of any given thing is less fixed and more organic.

My grammar school students are very funny people. Their unusually fine senses of humor have developed, perhaps, as the most rational response to the endless absurdities in their complicated lives. Fortunately this humor often finds its way naturally and easily into their art work. As children, they have not yet developed the adult self-consciousness that makes it so risky to reveal the funny or absurd side of oneself in one's work. Their right to be irreverent and ironic is one which these children would not easily surrender. It must be some compensation for so rarely being taken seriously by the adults in their lives.

While children's natural playfulness is one of the most appealing aspects of their creative process, it is at times an obstacle to creativity. I often ask students to draw portraits of one another as they sit facing each other around the classroom tables. The purpose of this exercise is rather dry and serious—to teach the children to observe facial structures more closely and specifically than they ordinarily would. Usually this project leads to much hilarity and the drawings quickly degenerate from close observation to wildly and intentionally distorted caricature. I don't encourage the children to be playful in this case because here irony and absurdity aren't really creative, but a manifestation of embarrassment over unusually intimate visual contact with a classmate's face. The children's anxiety is increased because while in many art projects the implicit authority of given standards is minimal, here it is inescapable: The children's own eyes tell them when their drawings are inadequate, but so also, (and with great gusto) do their subjects.

In the years I spent teaching art to adults, I found that humor or levity was almost exclusively reserved for general conversation or ironic self-commentary on a student's inability to get the desired results in a painting. Frustration with the work of painting might be translated into playful verbal commentary, but this playfulness or irony was not intentionally expressed in the painting or drawing itself as it would be with children. Only very rarely did an adult student choose a humorous situation to be the subject for a painting. The correct approach to one's work was highly serious; the proper subject a stately landscape perhaps, or a seated figure gazing thoughtfully out of a handsomely decorated interior.

When I first began to think of myself as a "serious" artist, I, too, approached each painting with much gravity. I would now describe those paintings as ranging from serenely lyrical to down-right ponderous. Although now humor is a fundamental ingredient in my work, at the beginning I convinced myself that it would have in some way diminished or trivialized the significance of what I was doing. In fact, the revelation of a sense of humor in one's art work involves a degree of self-exposure with which many adults are not initially comfortable. We can afford to be absurd or careless in speech because speech is so ephemeral. There will be no physical evidence of our absurdity lingering on to indict us. Even the printed word is less substantially threatening than painting or sculpture. Much of the anxiety would probably disappear were I to ask my elementary school students to render a portrait in words instead of color and contour. A drawing or a painting or a sculpture is awesomely concrete and fixed in time and space. A written description may be

inaccurate or incomplete, but an imaginative reader automatically supplies missing details and corrects inaccuracies in his mind's eye. While the incorrectness of a child's misshapenly drawn nose is blatantly obvious to all, the less than perfect written description of that nose might go unnoticed.

It is interesting for me to realize that as the humor and idiosyncracy of my own work has increased, its physical presence has become less concrete. Whereas I once applied paint to very large bulky canvases, I now work with small fragmented or serial images each individually attached to the wall, thus creating spatial ambiguity. Many of these images are "ephemeral" in that they are photographs of drawings or constructions which I draw or construct, photograph, and then dismantle. The photograph's function as a record of a transitory image tends to counteract its own physical visual presence. Words are incorporated into these pieces partially for their associative potential. These words, by referring to a time and place beyond the physical limits of the image as it exists on the wall, serve to further obscure the spatial confines of the plastic medium. An artist like Sol Lewitt, on the contrary, uses words to define or reiterate a visual element. In his wall drawing "Six Geometric Figures," 1975, the words, "a rectangle whose left and right sides are the same length as the distance from the upper left corner..." describing the loci of a specific rectangle and, in fact, literally covering the area of that rectangle on the wall, are both the rationale and the medium for that image's concreteness or "fix" in time and space.

I have devised a number of projects for my elementary school students which like my own work circumvent some of the rigid physical limitations of conventional artwork. These projects have been unusually successful. While I'm sure that in part this success naturally results from my own special enthusiasm for any project involving concepts derived from my own work, it is also likely that the degree to which such projects offer greater flexibility and are less permanent or fixed reduces the anxiety that even children feel when committing themselves through the medium of paint, or plaster, or whatever.

One such project for third graders involved making large almost life-sized doll figures cut out of oaktag and then painted or otherwise decorated. Instead of presenting this project in a more traditional way, I decided to ask each child to be responsible for making only one third of a complete figure. Each one had the choice of designing either a head, a torso, or legs. I had previously outlined the basic figure parts according to one template and then cut each figure into three separate parts so that the finished thirds could be "mixed and matched" in any combination. The three parts were attached with removable pins so that at any time the dolls could be dismantled and rearranged.

The only difficulty I encountered was the overwhelming popularity of heads as opposed to bodies and legs. Otherwise, the children loved making these dolls. The awesomeness of representing the human figure was relieved because initially a child had only to deal with a disembodied pair of legs or torso. The "disjointedness" built into this project meant that objective criteria were less applicable. There was less than the usual concern about perfection or "completeness" because the parts were by definition incomplete. Achieving completeness meant surrendering some control over one's work. While this was troublesome for some children, it reduced their final

accountability and enabled them to be more daring. There was an element of uncertainty in all of this which made the work that much more interesting and exciting.

I recently did a project with a large fifth grade class that, though different in format, had many features similar to the one described above. The children and I spent considerable time studying still life. I had shown them slides of still lifes by major artists and then each member of the class worked for several weeks on an individual complex colored drawing. While they began as simple still lifes, most of these drawings evolved into highly detailed room interiors which included, among other things, a still-life. At the completion of this project, I was so impressed with the work, that I decided to have the class design a huge collaborative collage of a room interior with still-life on the back cork wall of their classroom.

The class was divided into two groups each responsible for a different category of objects: things on the wall, the table, the floor, etc., with detailed lists of possible items in each category. This collage, like the dolls, was to be the aggregate sum of many parts. Although the scale and scope of the whole collage was vast, groups of children were only responsible for a fraction of the whole. Individual students were responsible for single objects, or, in the case of collaborations between pairs of students, parts of objects, and so no one had a herculean task. Having worked individually on smaller but more comprehensive drawings, the children now had the luxury of a narrow focus. The intensity and energy applied to manufacturing a single teacup or a lattice-backed chair or an exotic fishtank was equal to that expended previously on an entire drawing. The combined energy of the whole collage when finished was cumulative, and thus, much greater. As parts were completed they were immediately stapled onto the wall in appropriate positions. As new items were added, earlier groupings of objects had to be rethought. These were removed and rearranged to incorporate the new work. The collage had its own internal evolutionary logic: simple objects gradually became more detailed; once more basic components had been completed (a table, or a cabinet), the trimmings were added (a decorative figurine or food garnish); a "general" loaf of white bread on a plate was, several weeks later, "specifically" sliced. This continuous rethinking and reworking was built into the nature of the project: it was both spatially and temporally fluid.

A careful analysis of my own work has revealed basic premises useful to me in devising projects for my students. Although the artistic interests and needs of a child are different from those of an adult or a professional artist, the creative process is problematic and filled with anxiety for all of us. An awareness that some of these problems are specifically linked to the nature of a given art form may suggest ways to diffuse them in any classroom and may also lead to a clearer understanding of one's own work.

Part Four:
Behind the Scenes

Administering the Program
by Phillip Lopate
The Job of Director

The political structure of the Collaborative has always been that of a monarchy, with the director setting policy, hiring and firing personnel, and being responsible for the financial survival of the organization and every working facet within it. In general, this setup has earned the gratitude and the relief of artists, who have not wanted to be burdened with administrating the program—although there have been times when they desired more input. The group is not a democracy. Nor, to my knowledge, has anyone ever seriously proposed that it be one. T&W directors have always acted on the assumption that "the buck stops here." Theoretically, they have to answer to an advisory board; but the board is relatively weak.

The director is thus in the enviable position of possessing substantial autonomy over operations. But the requirements for the job make it not an easy one to fill. The director has to be someone who is artistically sensitive, and able to understand writers—perhaps even a writer him-or herself; who has a good eye for what educational integrity or shallowness looks like; who is visionary enough to stimulate the group forward, but enough of a solid bureaucrat to see that the books are balanced. Leader, writer, educator, bookkeeper, fund-raiser, office drudge. Many creative individuals do not like administration work, being in an office from 9 to 5; but even those who enjoy paperwork tend to get impatient with administrative routine after awhile, and want to meet new challenges or find a more pressing urgency for their idealism. If you add to all this the fact that the pay is poor, there is little chance of it ever getting better, and each year the organization's survival is in question, you begin to get some idea of why there were six directors of Teachers & Writers Collaborative in the first six years.

One way of explaining the turnover is that the job attracted people who were too big for it. Important as its work was, the Collaborative—or at least the administrative, office end of it—was not a large enough arena for their personalities.

Herbert Kohl, Teachers & Writers' first director, has cheerfully admitted to me that he is "not the world's greatest administrator"; but his priceless contribution was in stimulating everyone around him, and throwing off a quantity of ideas that would end up charting the course of the Collaborative for several years. After being an administrator and grant-proposal writer for a year, however, Kohl began to feel he was losing himself, and the thought of a whole new round of hustling for grants was unbearable. He handed the job over to Zelda Wirtshafter, who took it more or less as a stopgap, temporarily, never envisioning herself as the permanent director. "I don't get my pleasure from being an administrator," she told me also, seeing herself more as a teacher and a friend of the arts. But she carried out her administrative duties conscientiously and effectively. If Kohl may be spoken of as the innovator, then Zelda Wirtshafter was a quintessential consolidator. It was under Wirtshafter's regime that visiting writers began to be stabilized in particular schools, and to achieve with hard work some of the early promise of the group's theoretical statements. After a year of desperate measures to keep the

Collaborative afloat, she too was burned out. But her involvement with the Collaborative did not stop there: she remained on the advisory board, interviewing candidates with Robert Silvers whenever there was need for a new executive, and contributing leads and suggestions in crises. Silvers, in fact, credits Zelda Wirtshafter's continuing participation in the organization as one of the major reasons it has been able to survive ten years.

The next director to be chosen was Joel Oppenheimer, the poet. Oppenheimer was the most unlikely person one could imagine for a bureaucratic post. With his iron-grey Old Russian beard, his live-and-let-live manner, his love of storytelling and baseball and writers' bars and alcohol (this was before he went on the wagon), he would seem to have been, at least at this historical remove, an odd choice for the director. Yet the board had its reasons. Everyone liked Joel Oppenheimer, he needed a job, and he had a name in the literary world—something which might come in handy for funding. Most important of all, Oppenheimer had character, he had "soul," if you will. Robert Silvers, publisher of the *New York Review of Books* and also chairman of T&W's board of directors, explained the thinking in retrospect this way:

> In my experience, education administrator-types can be a very dreary lot. We didn't want someone like that who would kill the spirit of the thing. Oppenheimer was lively, he knew many poets. It was good to restore the thing to a poet. Other poets would not think that this Teachers & Writers Collaborative was a hidebound bureaucratic affair as long as he was in there. He was a free spirit. Eccentric, independent. And we felt that maybe this would be revivifying.

That an organization could take the chance of appointing as its leader someone who had little administrative experience, in the hope that he might "revivify" its atmosphere in some unpredictable, intentionally left-open way, says much about the view that the board had of the director's function, as well as the chronically ambivalent attitude within Teachers & Writers itself between its goals of stability and poetic surprise.

Joel Oppenheimer rarely came into the office, but on the other hand he was happy to donate his presence to any necessary public function. In a sense, he functioned as a willing figurehead. Silvers and Wirtshafter, knowing that Oppenheimer might not prove the most attentive administrator, had taken the precaution of hiring Sheila Murphy as assistant director, and Johanna Roosevelt as secretary. Sheila Murphy acted as a troubleshooter between the school administrations and the writers, and Johanna Roosevelt typed, kept the books and did everything else.

Oppenheimer was usually "available for consultations" at the Lions Head Pub in Greenwich Village, a writers' hangout. Any organizational matters that needed the director's immediate attention tended to be taken up at the Lion's Head. Our conference table was a round mahogany job in the back room; and I remember one afternoon going down there to meet Carolyn Kizer, who was then head of the literature panel for the National Endowment for the Arts, to discuss possible future funding for the project: Oppenheimer and Kizer matched drink for drink and story for story, while the rest of us tried to keep up, laughing our heads off one moment and begging for money the next.

The actual office of the Collaborative, where they had just moved from Columbia University in Fall 1968, was at the Arsenal in Central Park. This

251

landmark, next to the zoo, a few feet away from the Delacorte clock whose Mother Goose figures revolve at the striking of the hour, has the look of a large toy castle. Once an actual military fort, the Arsenal now housed the offices of the Department of Parks and Cultural Affairs. In a large, hectic bullpen not unlike a newspaper's city room, Teachers & Writers Collaborative was given a desk of its own. One desk. It was at this point that I went to work for the Collaborative, and I remember my puzzlement the first time I came by to pick up my check, and thinking to myself: This is it? This is *all*? I was told cheerfully to pull up a chair (there was barely room for one) by the rather elegant-looking Johanna Roosevelt, who was trying to type her way through a mound of children's poems.

With comic largesse, the Collaborative, back to the wall, had squeezed between its desk and the neighboring one a carton of education and poetry books with a sign saying, "Free! Take some!"

As one looked around the bullpen, there was a visible excitement and *esprit de corps* among the Department of Cultural Affairs' bright young cadre. Those were the Parks Department's salad days, when Mayor Lindsay's appointees, Thomas Hoving (on his way up to the Metropolitan Museum) and August Hecksher had brought in an ambience of fashion and bustle, and every worker and volunteer was running around with heady, optimistic plans to "liberate" cultural spaces and bring Art to the People. The combination of high and low, moneyed names and ghetto programs, blue-chip cultural institutions suddenly wanting to "decentralize"—whether it was films projected against a tenement wall on a hot summer night, or opera in the park, or environmental happenings under the Brooklyn Bridge—made Cultural Affairs the place to be for young, ambitious graduates.

The Collaborative, which shared some of these ideals of spreading art around, fit into this wheeling-and-dealing art and government milieu, where for the time being it was allowed to nestle rent-free*, while it figured out what its next step would be.

The organization was limping along at the time without much sense of direction or purpose. It met only once that year, and that was an end-of-year cocktail party in which the writers were introduced to each other for the first time. The 1968-69 writing staff included Clarence Major, Lennox Raphael, Art Berger, Tom Weatherly, Jean Smith, Ron Padgett, Dick Gallup, Joel Oppenheimer and myself. If it was a fairly leaderless time, it was also one of great opportunity. The original set of writers had drifted away, and the project was taking chances hiring young, as-yet unestablished authors. Within a period of a few months, Ron Padgett, Dick Gallup and I were all taken on the payroll (each got a day's work, at $50 apiece) on the basis of little more than a good word from Kenneth Koch. I wondered why they had even hired me, as I had had almost nothing in print and no experience with children. It was a classic sink-or-swim situation, with no training or instructions on how to proceed, or what constituted a well-done job. Not a few people in those frontier days sank.

The only directions I was given were to keep a diary. I knew my old Columbia classmate Ron Padgett had an excellent analytical mind; and I would

*The niche had been secured through the helpful offices of Trudy Kramer, a long-time friend of the Collaborative and at the time a staff-member with the Department of Cultural Affairs.

sneak into the Arsenal and read his single-spaced diaries (I later learned he was doing the same with mine!), and this study of Padgett's techniques and insights and self-doubts, together with Kenneth Koch's suggestions to me about writing assignments, formed the bulk of the outside training I received that year.

The Writing Lesson

In the Teachers and Writers Newsletter, a mimeographed magazine which published excerpts from the writers' diaries that might be useful to other teachers and interested readers, there was beginning to be a slight move away from the muckraking-exposé pieces about the schools, and a new absorption, at least among some of the writers, in the praxis of teaching writing as an art.

Kenneth Koch's brief tenure with Teachers & Writers Collaborative had left a strong influence on certain writers who came after him. Koch's books on the subject of teaching poetry-writing have altered the thinking of many educators, and have, in a very real sense, paved the way for thousands of other poets and artists to enter the schools. The enormous public relations value of Koch's work should not obscure his theoretical contributions to the field. Koch's most essential insight was "the poetry idea," a way of encouraging children to write contemporary poetry by breaking the activity down into easily followed steps or game structures. The poetry lesson thus became structured around the presentation of the game-task, the assignment for the day. Koch rightly recognized that children would not sit still long for talks about appreciating the art of poetry, but would rather jump in almost immediately and try it on their own.

One good effect of emphasizing writing by the children so quickly was that the writer was able to demonstrate results, to the school, to the children, to the sponsoring arts agency, and to himself.

The writers joining the T&W program were curious about finding ways of translating their supposedly esoteric contemporary poetics into exercises readily accessible to young students. Koch's collection of assignments were understood to be only one of the many possible constellations of assignments for teaching writing. Concrete poetry, found poetry, sound poetry were all introduced—it was a period of great fertility and experimentation. Every week each writer would go in and try a new poetry idea, often concocting one from scratch. Some of the assignments proved to be frivolous in the extreme, or flopped with the children; others endured and became "standards." Everything was shared rather wonderfully among the writers: there were virtually no attempts to protect an idea, or claim it as one's own invention. Instead, the writers involved in teaching felt pleased with the new cleverness of the field as a whole, and proud to be part of something in its burgeoning stages. One Saturday, a dozen or so writers met to bombard each other with writing-lesson ideas, which went into a mimeographed *Book of Methods,* edited by Ron Padgett and Larry Fagin, and was given out free to classroom teachers and other writers.

Some of this sharing had to do with friendship circles and literary schools or "families." The emphasis on linguistic experimentation, for instance—the joy in using words as foreign objects, and in creating interesting textural sur-

faces—was a hallmark of what has been called the•New York School of Poetry, which included Koch, Padgett, Gallup, Fagin and David Shapiro. Their entry into the Collaborative brought about a shift, away from social and political concerns and more toward aesthetic and pedagogic ones. Not that the Collaborative became apolitical overnight: on the contrary, many discussions still centered on racism and the oppressiveness of schools and the dangers of cultural imperialism, and so on. But around 1970, Teachers and Writers did witness somewhat of a split between the politically committed writers (who tended to be Black and Hispanic), and the more apolitical white New York School poets. I would not like to make too much of this schism, especially as the activist writers were often involved in formal literary questions, while many of the experimental poets had distinct political opinions and demonstrated their convictions with public acts. But the difference was more a matter of taste, of tone: of what one wanted to talk about most.

Marvin Hoffman

The Collaborative's need for a strong director could no longer be put off. When Joel Oppenheimer announced that he was leaving, a search began for someone who would take the organization in hand and give it direction. Sheila Murphy, who would stay on as assistant director, suggested Marvin Hoffman, a friend of hers and of her husband Dick Murphy, and the appointment was approved.

Marvin Hoffman had been trained as a clinical psychologist at Harvard and Berkeley, but he gave up practicing therapy because it seemed less immediate than working directly for social justice. He went South during the civil rights struggle and spent several years helping to organize around the Child Development Group of Mississippi (CDGM), one of the most active, effective and controversial units in Project Head Start. Coming from the CDGM experience, he brought a moral seriousness and, one might even say, solemnity to his work at the Collaborative. He questioned; he visited classrooms to watch the writers whom he had inherited from the previous staff, and was not always happy with what he saw; he wrote letters to them expressing his thoughts on their strengths and mistakes, which they were not always happy to get; and he worried, worried constantly, about whether the work of the Collaborative had any meaning and impact on the vast school system, or was only window dressing. Hoffman was also concerned that there seemed to be no procedure to upgrade or train writers once they had been hired; no consistent educational philosophy for the program; and no mechanism for honest expression of criticism, or self-criticism, that would revitalize instead of intimidate or terrify the working staff.

It was Hoffman who instituted a series of evening meetings with the entire Collaborative staff which were more than simply cocktail hours: political issues and educational methods and goals were put on the table for debate. Hoffman's background in the crucible of Mississippi civil-rights battles had prepared him to be able to acknowledge a certain amount of mistrust between races, and even to allow such tensions to come out in the open without having to smooth over angers immediately. Marv Hoffman took seriously the need for Teachers & Writers to hire ethnic minority staff, in serving a school system with such a large black and Spanish-speaking population. He hired Felipe Lu-

ciano, Sonia Sanchez, Pedro Pietri, Carole Clemmons, Doughtry Long, Verta Mae Grosvenor, Rosa Guy, and Miguel Ortiz. While some of these appointments worked out brilliantly, it was his personal frustration that several minority writers—perhaps because they were "rising stars," suddenly in great demand—were rather indifferent and undependable as teachers in the schools. Some of them had a way of treating any criticism about their performance as a racial slur. The sensitivity which black and Hispanic writers brought to the Collaborative in the area of racial affronts had the effect of keeping the administrative staff on the defensive. And, at times, that seemed to be the main intent of raising the charge: to serve notice to the Collaborative to be on the defensive (as, no doubt, the minority writers felt themselves constantly, in an organization which always seemed to have white bosses). One new black writer refused to turn in any diaries, on the grounds that he didn't want a white establishment organization "picking his brains." It was an interesting position, weakened only by the fact that he was doing so little effective work in the classroom that no one could figure out what secrets he thought he was protecting. The patient tug-of-war to get diaries out of him had less to do, finally, with any interest in his teaching discoveries, than with the fear that if one broke the diary rule, all would follow. In the end he was allowed to continue working without filing diaries, and he drifted away a half-year later.

In the October, 1970 issue of T&W Newsletter there appeared a fascinating exchange of letters between John Holt and Marv Hoffman, which reveals the precise growing pains and questions that the Collaborative was facing at that point. Holt, a tough critic, had been present at some of the conferences leading to the birth of Teachers & Writers Collaborative, and was on the Collaborative's advisory board, so that, in a sense, he is speaking in this letter as an interested shareholder wanting to know if the original Huntting stock has kept its promised value or has been diluted. The "we" in the first paragraph shows Holt's continuing identification with the enterprise, at least at this moment in time:

There are two ways of looking at what we are doing. One is that we are coming into the schools to provide a slight alternative and change from the dull and dreadful fare that children get most of the time. The other is that we are going in to plant seeds which we hope will grow after we leave—in short, we are trying to give some ideas to teachers which they may be able to carry on without us. I had the feeling that we thought we were doing the second, but I also have the feeling that it isn't much working out that way. In other words, there isn't a great deal of carryover from the work of the visiting writers to the work of the regular teachers in the school. To what extent is this true? Has there been, as time goes by, on the whole more or less cooperation from the schools? Are more, or less, teachers getting interested in the kinds of things we are doing? Are more teachers beginning to take over some of these ideas themselves?
 Some of the stuff in the diaries troubles me, too. I get an impression that these visiting writers are trying to work out a set of tricks that will "get children to write." This seems to me in many ways a wrong idea in itself, and in any case a contradiction of the idea we had when we started. The original idea was that working writers would not so much think up tricks to make children write as let them into the processes by which they do their own writing—more of what Dennison calls the continuum of experience. Merely having the visiting writer do the same trick he asks the children to do does not seem to me to meet this need. The problem is to let them into the act of his writing. How do these thoughts fit in with the work of T & W? Have I assumed too much from reading the latest issue—I haven't read many of the others.
 Where do we go from "horrible menus," for example? What next?...

255

Holt also took exception to the Collaborative working so much in public schools, instead of outside, in alternative situations. Marv Hoffman's lengthy reply, excerpted below, shows his own complex and ambivalent position toward the value of the Collaborative's approach:

...The questions you raise about what we are trying to do and what's coming of it are penetrating. We ask ourselves the same questions all the time. The answers depend very much on how depressed or excited we are on any given day. Here are today's answers:

(1) We are most certainly not just trying to provide some relief from the tedium of the regular school day. We *are* trying to plant seeds of change that teachers can cultivate on their own. Our success in that regard depends very much on how each mixture of writer, teacher, students, and school happens to jell. In the worst cases, the teachers have used the writer's presence as an opportunity to go for a smoke or mark papers. In the best cases, the teachers have continued very exciting writing work when the writers were no longer there. On balance there are more of the latter cases than the former, largely because we try to choose open, questioning teachers to work with in the first place. (What do you make of an anomaly like this: in one class I visited this year the teacher, a very talented young girl, was getting extraordinary writing from her kids before the writer ever showed up. The writer, a very busy young black poet, buzzed into and out of the class at top speed every week, never bothering to confer with the teacher and never bothering to read what the kids were writing on their own. She was eliciting stuff from them which was far more primitive than what they had already proven themselves capable of!) On the whole, the schools have grown more cooperative and *more* interested as time passes. They're excited by what we're doing and want more of it.

I had thought at first that our greatest impact would be in classrooms where there was direct contact between writers and teachers. Now I wonder. Judging from our correspondence and the kinds of subscribers we're picking up for the Newsletter, I think now that more teachers are being helped (changed?) by our printed material. In effect teachers seem to relate at least as well to the writers' diaries as to writers—which shouldn't altogether surprise us since a writer's special skill is communicating by remote control, as it were....

(2) Whether the writing "assignments" described in some of the diaries amounts to *tricks* or not is a worrisome problem that we've obsessed over a lot. First you must realize that some of the writers who use these "tricks" write their own poetry in very much the same way. They *are* drawing the students into their own "continuum of experience." You may or may not like the poetry they write but they are not merely concocting gimmicks for kids which bear no relation to their own writing styles and approaches. The truth is that I really don't know how a writer is supposed to draw anyone into his continuum of experience, except by sharing openly with them his passions, his doubts, his anger, etc. This I expect of any person who wants to work with kids, and I think the writers with very few exceptions are very successful with sharing themselves with their students. But the core of the writer's experience is his writing, which is private and essentially unsharable; the end product yes, the process no.

Much as I dislike gimmicks and tricks I think they have a certain place in the early stages of opening kids up to writing. There is so much damage done to students and their writing before the writer enters the picture that you need some dynamite to blast away the hatred of putting words on paper and the inclination to write only what is most banal and conventional because this is what is expected. There's something to be said for almost forcibly demonstrating to kids that they have wild imaginations which can be translated onto paper and appreciated. The problem comes in deciding when to put the tricks aside and allow students to write in a self-generating way, without an endless dependence on outside assignments and ideas. Some of the writers have begun to worry that they are falling into a rut in which the students expect a titillating new gimmick each week. I'm worried too. So far we've learned a lot more about how to get started than about how to sustain and refine....

During the Hoffman administration, emphasis began to be put on developing self-generating, sustained writing by students, and long-range curriculum units, as opposed to one-shot assignments. Collaborative writers were experiencing some of the drawbacks of the "writing idea" approach, which began to feel like a straitjacket locking the writer into one lesson = one writing

idea, with no real carryover from class to class. A few writers were uncomfortable with the authoritarian, top-down delivery of the poetry task, which conflicted in style with the more equal-footing relations between students and teachers that open classrooms were trying to establish. Others thought that the "writing idea" approach had a too ready-made feel to it, reducing them to mere mechanics—like the Collaborative writer who said in her diary, "I told the kids what the idea for this week was and they started writing immediately. Is this all???" The very fact that teachers were so willing to gobble up manuals, like *Wishes, Lies and Dreams*, was enough reason to make some writers mistrust the whole approach.

Marv Hoffman sympathized with the new writers who found the writing-idea pedagogy frustrating, or who wanted to strike out on their own with other ways to relate to children and teach the craft of writing. But he also saw the value of the writing ideas being generated in Teachers & Writers' workshops. The Collaborative was able to present itself in grant proposals as a "laboratory," which deserved to be funded in spite of its small number of students served, because it developed methods that could be used nationwide. It was Hoffman who initiated the publication project to assemble these formulae into a catalog. The largest-selling publication ever put out by the Collaborative (currently in its eighth printing), has been the *Whole Word Catalog*, which is nothing if not a recipe-book of writing ideas gathered from the experiences of Teachers & Writers workshops. The organization could not afford to turn its nose down on the need among school teachers for such quickie ideas to pillage the night before, if only because income from the Catalog I and II's sales was often what paid the light bills.

Meanwhile, Marv Hoffman supported long-term projects, such as the work of Roger Landrum, whose account of inspiring student-dictated readers was published as a separate T&W book, *A Daydream I Had At Night*. Dick Murphy, who had become publications director of the Collaborative, began going into a public school with a combined writing-and-social studies project on utopias, which brought about sustained independent writing by students who invented their own religions, martial arts, schools and more. The utopia project led to a very helpful guidebook on the experience, *Imaginary Worlds,* also published by the Collaborative. Though Herb Kohl had been the first director to encourage the publication of writing curriculum units, with his Fables Project, Hoffman and Dick Murphy were really responsible for starting the ambitious book-publishing arm of Teachers & Writers, as something in addition to the regular magazine.

It was a peculiar feature of the Hoffman regime that the office was run essentially by two married couples, Dick and Sheila Murphy, and Marv Hoffman and his wife, the novelist Rosellen Brown (who tried to stay out of it but got sucked into editing the *Whole Word Catalog*, among other things). The two couples were close personal friends, and shared a liking for country things and a commitment to humanistic education, as well as a common "peak experience" in the Mississippi Freedom Project—which they sometimes compared to New York City and the Collaborative, to the inevitable disparagement of the latter. The fact is that, being activists and teachers by temperament, they were discontented spending so much time in an office, answering

forms and filling out administrative reports. They were also confronted with the difficulty of overseeing in any meaningful way so decentralized an operation. They had the choice of running themselves ragged from school to school, borough to borough, trying to learn first-hand what the program was accomplishing, or staying in the office to write grant proposals and raise more money for a program on whose value they could only speculate.

Teachers & Writers, as indeed any organization with workers spread out over many sites, has the classic problem of separation between the front office and the field. From an administrative point of view, this has led to a nagging anxiety about substandard performance, because there is no way of "policing the field," as it were, short of extremely unpleasant surveillance or punch-card systems which are antithetical to the spirit of the organization. The Collaborative's solution has been to hire workers it felt it could trust, and assume that they would have the ingenuity and resilience to keep creating good work for themselves. But this is not always the case; moreover, if there is no dependable way of knowing how good a job a person is doing, there is also no possibility of aiding those who are faltering.

The administrator's worries over unseen worker performance can also, of course, be a distorted reflection of his or her own impatience with office life, and impotent distance from the actual field of operations.

In the case of Marv Hoffman and the Murphys, they had to lean heavily on diary reports. Understandably, they appreciated frankness in these journals, and tended to disbelieve those who had only positive experiences to relate. Accounts of failures as well as successes began appearing regularly in the T&W magazine. In fact, word went around among the writers that the quickest way to get accepted as a valuable staff-member was to confess to failure! This was certainly a simplification, but it is true that the Hoffman administration preferred a certain amount of humility and honesty about mistakes to the cant of self-publicity so often found in these accounts. It is to the credit of Marv Hoffman and the Murphys that their skepticism never lapsed into cynicism, and that, in spite of the fact they were never fully certain of the value of the Collaborative's mission, they set higher standards for quality and hard work and self-examination, starting with themselves.

Part of the administration's sense of isolation from the classroom program came about because of the office's move to Brooklyn. Pratt Institute Center for Community Improvement had donated to the Collaborative a legitimate office: it was no longer possible to run the whole project from the Arsenal desk, and here, at Pratt, there was ample space and sunlight. However, the location of T&W headquarters in this more remote, Fort Greene section of Brooklyn made it less inviting for casual drop-in visits from writers and other guests. Marv Hoffman and the Murphys finally hit upon the solution of getting involved themselves as teachers on a part-time basis, both to discover what the writers had to go through, and to get out of the exile of their too-quiet Brooklyn office. At first they offered their services in a community storefront-type loft, with the poet Dick Lourie. But so few people from the community came by that they had to abandon the effort. Then Marv Hoffman began going into a public school to teach writing once a week, and Sheila Mur-

258

phy worked at a teacher-training center to set up a language arts materials corner, and Dick Murphy did his utopia project.

But by that time it was already too late: they had decided that New York City was not for them, and the two couples packed up lock, stock and barrel and moved to New Hampshire, to work in a country school. Their evacuation left a frighteningly total void in the leadership of the organization. Before they quit the Collaborative, however, they made sure that there was funding for the next year's program, the new books were safely at the printer's, and the office files in better shape than they had ever been. And they also left behind their efficient secretary, Pam Seney, to explain procedures to the new director.

A New Director

The new director of the Collaborative was Martin Kushner, formerly with the Connecticut Commission of the Arts, where I had known him briefly, in fact, as an enthusiastic, able administrator. Kushner was a "theatre person," who had a degree from the Yale Drama School and had trained with Grotowski in Europe. He had left the theatre temporarily because of the scarcity of work, and decided to give himself over for the time being to arts administration. In his interview for the directorship he had impressed Silvers as being "full of beans, a lively, intense guy." Marty Kushner certainly was not dull: young, volatile, funny, short and dynamically quick, with the restless energy of a Mexican jumping bean, he had plans to bring theatre people into the Collaborative and to open it up to other arts.

Steve Schrader was named assistant director, and Steve's cautious, commonsense style made a good counterweight to Marty's brainstorming flights.

Their first task was to move the office back to Manhattan: the Brooklyn space had been reclaimed by Pratt, and so a new protector had to be found. This time P.S.3, an open corridor school in Greenwich Village, offered the Collaborative a rent-free home. P.S.3 had been taken over by a band of parents and community people who wanted to start an experimental, open classroom public school. Zelda Wirtshafter was one of the main organizers in getting the P.S.3 project off the ground, and she was able to convince the principal (or as he was called, head teacher), John Melzer, to let Teachers & Writers occupy an office in the building. In return for which, Teachers & Writers would ostensibly lend its educational prestige to the new enterprise, and maybe work with some of the children.

Settling into their new home was a bit chaotic: the only one who understood T&W's organizational procedures was Pam Seney, the secretary who had been left over from the previous administration. Pam had worshipped her old boss, Marv Hoffman, who seemed to her the very model of maturity and thoughtfulness, and she made no secret of the fact that she had less than the same respect for her two new male supervisors. They were floundering around trying to establish an office routine, when she knew that these procedures had already been developed by Hoffman and the Murphys and herself. Whether it was where to find a certain record in the files or how to handle the printer or which writers were doing a good job, Pam Seney knew a great deal more about Teachers & Writers than her bosses, and she resented having to train those above her. Given her obvious grasp of the organization, it was proposed that

259

she be promoted to an Associate Director. But she didn't want the extra responsibility and the headaches that went with it. She wanted to be a secretary, who took orders from people who knew what they wanted.

The indecision usually attendant on the first months in office of a new director, who has to learn the company and lead it at the same time, was prolonged by Marty Kushner's personality, with its erratic swings between activism and a sort of surprising existential uncertainty. Each day he hatched new schemes for expanding the program into prisons and old age homes, and hiring new people; then he would be entangled with doubt and delay the follow-through. Kushner's real excellence as an administrator was in giving quick support, financial and emotional, to something that was starting to take off well. He was attracted to the arts team concept, or indeed to anything which crystallized a lot of energy in one spot. He rapidly understood the potential of the P.S.75 Team as an exemplary model for the T&W organization and arts education in general, and he gave us a free hand to go ahead and expand as we saw fit. In the path-clearing days of that enterprise, when speed and a vote of confidence were so essential, I was able to achieve with a phone call to him what might have taken me months, or years, to obtain from a boss with a more conservative temperament.

In addition, he had his own lively ideas about teaching, and I could bounce anything off him as a sounding-board: call him the night before teaching a class and ask him to think of the missing piece of a lesson plan. And likely as not, he would. He and I enjoyed each other's clownish energy, driving each other to higher, more preposterous feats of work. We became quite close. Marty was finding it difficult to adjust to New York: he had just moved from a country house in Connecticut, and, as a theatre person, with half-a-mind to try joining a drama troupe in the evenings, he had that excitement and dread of coming up against the Big Apple. He felt the strong need for a protecting community around him, and thought the Collaborative might provide that fellowship. Why did there need to be such an arbitrary separation between life and work? he asked. Here were good, intelligent people with the same career interests, the same ideals: the group could become a kind of decentralized city commune.

To me, Teachers & Writers would never be a commune. At best, most members at the time had a tepid fondness for each other; but when they left the school, they went home to their wives, or husbands or their lovers or their cat, and so much for that. Still, I sympathized with his urgent sense that the group should try to become more supportive for each other, try to pull closer.

Marty was also for getting more policy input from the group. Since he was new and feeling his way, he announced that he would be open to anyone's ideas about the Collaborative's future programs and direction. His first rude awakening came at the opening all-staff meeting of Teachers & Writers. This historic melee, at Christy Noyes' house, is recalled in Ron Padgett's interview:

> The group was at its most ripping and slashing. The first meeting he ever presided over was unbelievable! He got up to say something and about six people said "Sit down, shorty."....It was the kind of thing where a person would say what he might have been doing in his school and as soon as he had finished or even in the middle somebody

would say, "That's a lot of bullshit," and then the person would say, "What do you mean, bullshit?" and the other person would say, "It's bullshit, that's all!"

The Collaborative writer-and-artist staff had swelled at that point to include Bill Zavatsky, Clarence Major, Art Berger, Ron Padgett, Dick Gallup, Verta Mae Grosvenor, Rosa Guy, George Cain, Bill Mackey, Bob Sievert, Marc Kaminsky, Maria Irene Fornes, Sue Willis, Charles Self, Miguel Ortiz, Christy Noyes, Tom McGonigle, and myself. The collected individuals were far from being a working group: many of the faces were new, some were just passing through, and the sense of commitment to this thing called Teachers & Writers Collaborative was very watery. One Black writer said, perhaps for effect, that he considered "the gig something like Welfare," which deeply offended a white artist who said that if anyone were just using the job as an excuse to collect a monthly check for doing nothing, then he might as well resign. There was much yelling and interrupting, and no one knew quite what the argument was about, but nearly everyone managed to make a righteous speech, and to rally a few people to agree, and also to feel that the others had missed the real subtlety of his or her point. It was theatre.

Afterwards, however, Marty was more leery about calling meetings to ascertain the will of the group. He elected to meet with the writers one-to-one, to visit their schools and watch them teach and go out for coffee and befriend them. I think that in a very real way he succeeded in bringing about a more human quality to the Collaborative, and in lessening the distance between the administration and the writers.

In his visits to the schools, however, he was beginning to be troubled by the familiar syndrome which Marv Hoffman had experienced: to begin with, Kushner was observing too much teaching that was mediocre, under-committed and poorly-received, and with that knowledge came the realization that some people would have to be let go; at the same time, he was beginning to get an itch to teach himself and to escape from office confinement five days a week. If he could do some teaching, he could get a keener sense of the standards to expect from everyone else. Marty was torn between wanting to throw himself into teaching, and needing first to achieve a better grasp of the administrative job. In the literature on educational leadership, this split is often discussed vis-à-vis the principal's role, with one solution proposed being a "dual leadership" of head teacher and chief administrator. Very rare are those individuals who can combine both skills and temperaments in satisfactory balance. And yet, the role of director in an organization such as Teachers & Writers seems to inspire subordinates with such expectations of parental omniscience, that the person at the top often comes to feel that he *must* be able to do both.

With the offices at P.S. 3, it would seem that there was a golden opportunity both to administer and work with kids. But here a word must be said about the physical circumstances of the host institution. P.S. 3 is a very old New York public school, vertically built, with peeling walls and separate up and down staircases bounded by metal gates. As soon as you come into P.S. 3 you are confronted with a large gymnasium. The gym takes up most of the first floor, but there are offices on the side, and one of these offices was given to Teachers & Writers. It was a generous, high-ceiling space broken into two rooms, with more than enough area for everything to be stored, and it might

have been perfect, were it not for the steady booming echo from the gymnasium right outside the door. Once, a foundation vice-president whom Marty was talking to on the telephone asked if we had offices next to a swimming pool. When visiting the office, there was something about having to confront children in their most free-wheeling, wild mood that gave one a desire to lunge for the Teachers & Writers office and bolt the door as quickly as possible.

Marty had started a school newspaper with some of the P.S. 3 children, but he found that it was a time-draining activity, and had to cancel meetings of the newspaper staff. By this time, however, the children had discovered the Teachers & Writers office as a hideout, and would come in on one pretext or another just to get away from their classrooms. Marty and Steve and Pam found it difficult to conduct business, answer phones, write memos, with a pack of demanding children around. So the dream of integrating teaching and officework in one site turned into a bit of a nightmare.

When frustrations of organizational detail built up, Marty would sometimes let out a roar or start banging a chair against the ground. I always took it as a kind of acting-out jest, a leftover from his Grotowski training to physicalize inner stress—but others were not always so quick to dismiss it. Now, in looking back on those days, I realize that they were right and that I had allowed too wide a latitude for theatricality. One morning in October, starting his second year as director, Marty came into work and had a nervous breakdown.

Marty was taken to a hospital in Connecticut. By the time he had recovered, it was clear that he would step down as director. For the sixth time in six years, the Collaborative received a new executive officer, Steve Schrader. The job was beginning to look as if it had a curse on it.

Two-and-a-Half Years
by Marv Hoffman

A while back I received an invitation to the tenth anniversary celebration of the Child Development Group of Mississippi, a statewide Headstart program that was one of the original Great Society poverty programs. I worked for CDGM for several years, not too long before I became director of Teachers & Writers Collaborative, which is now also ten years old. These two birthdays are especially gratifying to me. In spite of all the talk in the sixties of creating "new institutions," so little from that period survived: just a lot of proposals, applications, rhetoric, publicity—and then nothing. I find it satisfying to reflect on the fact that the two "new institutions" that absorbed a good portion of my adult working life have not withered away. I'm not certain what it means, but I'd like to think that with some luck, a modicum of sensitivity, and a small number of good people, something which is relatively stable can be created. (One other ingredient which is not as trivial as it may sound: It's got to be fun. James Herndon says somewhere that social change is a long hard struggle, and if you're going to last it out, there's got to be a lot of joy along the way.)

I have found myself saying some pretty pessimistic things in the last five or six years, laughing sarcastically at the innocence of the sixties. Then I look at genuine, worthy survivors like T&W, and it makes me wonder.

Sheila leads me from the Sheridan Square subway station into a less familiar underground—The Lion's Head Bar. Halfway down the long counter sits Joel Oppenheimer, graying hair reaching down into his imposing beard. It is mid-day but it is clear that Joel has already consumed more than one drink. He discourses loudly on the current state of baseball in general and the Mets in particular. I have been informed that the Lion's Head *is* Joel's office and has been during his year-long tenure as T&W director. When there are interviews to be conducted, meetings to be held, they are scheduled for right here in the semi-darkness. Organizations that operate in oddball ways are a particular weakness of mine. I am, at once, intrigued and appalled by them. At CDGM, our headquarters shifted periodically from a sterile expensive office building to an unswept loft, heated by open gas space heaters. The loft was above a shop that dispensed ten-cent pig ear sandwiches and featured a blaring jukebox, the bass section of which set our floorboards to vibrating.

Joel is a warm, vibrant, passionate man who should be holding forth in a St. Petersburg cafe. He loves poetry, lives it, recites it in between accounts of his early years as a printer. He loves T&W with a similar passion, but I can't imagine anyone less suited to organizational fetters and Joel, to his credit, knows it. He is getting out and Sheila, an old Mississippi compatriot and now Joel's assistant, has recommended me as his replacement. I've just come through a rather unsuccessful year-and-a-half of trying to write about Mississippi, social change, the poverty program and other unmanageable topics. I tell Joel about Mississippi, about my recent involvement as an advocate of community control in the wretched school decentralization battle, about my weariness with educational politics, my desire to be more directly involved

263

with children and the *substance* of their education.

By this time it is late afternoon and we are now at a back table. Joel is re-assured that I am not a grey *apparatchik* who will computerize the soul out of T&W. Although not a writer myself, I am married to one—a writer-in-law. So the succession is sealed, although none of us is clear who's responsible for hiring a new director. That's the kind of place T&W is.

I am at a center table in the Russian Tea Room with Sheila and Dick Murphy to meet with some of the members of the Board of Directors of T&W. They have heard of the planned staff changes, of our plans to work as a team of three. The chairman of the Board is Robert Silvers, editor of the *New York Review of Books*. It is from its pages that I first heard of Herb Kohl and of the organization which he founded—T&W. *The New York Review* is probably one of the leading intellectual publications of the period, which makes Silvers, by intention or otherwise, an intimidating figure. Silvers and the two other board members question us coolly and distantly about what we've done and who we know. Every cue in their voices and bodies is broadcasting: I'm not impressed. They've never heard of us, we're not writers, we don't know very many important or famous people.

In the succeeding two-and-a-half years I will rarely get beyond this sense of distance on their side and defensiveness on mine. I am not forgiven for being someone other than Herb Kohl. I hope I am telling you about this to do more than air an old hurt (which is certainly there). I want to bring to mind again a certain element of T&W which existed alongside the bohemian, free-spirited side, namely a certain high-culture and high-class snobbishness, a determination to succor the natives (teachers and children) which has blessedly departed from the program.

By the time our lunch is over, it is clear that we will be allowed to go ahead without too much protest. Truth is there's not much money in the coffers and in spite of the romance and reputation of this program, there wouldn't be that many eager takers.

The Headquarters. What kind of image does that word evoke? It is a large upstairs room in a building modestly called the Pratt Center for Community Development. The building is on a grim industrial block in the Clinton Hill section of Brooklyn, only a block away from some of the grandest mansions in the city, residue of the Pratt family riches. Beyond a long-dormant fireplace there is nothing grand about our office. In fact when I first step through the doorway I find myself magically transported back to Mississippi, minus the smell of frying pig ears and the bass drone of "Wait Till the Midnight Hour." As an added attraction here we have gates and bars on all the windows, but I will learn soon enough that they are scant obstacle to the enterprising local junkies. Several times the building's typewriters and movie projectors find their way into the hands of the local fences, from whom we are only once successful in retrieving them.

Through the months of that first summer I sit in the semi-abandoned office, among its debris of cast-off furniture and piles of early newsletters, reading through the old files, the diaries of Anne Sexton, Louise Glück, David Henderson, of some young writer who has since slipped into the Weather Un-

derground. I tell myself I am becoming "oriented" to the job, but it is in fact an act of unchecked voyeurism, a purely sensual delight at first, finally giving way to the hollow headachy feeling that tells me I'm itching to begin myself.

From time to time a writer drops by or calls to find out if last year's job will continue, or if there are any new positions open for next year. I sometimes wonder whether our major criterion for selection is the dedication or desperation necessary to make the long subway trek into the wilds of central Brooklyn. We are not at the crossroads of the world, for which our reward is unbroken stretches of work-time on the one hand, and an uneasy sense that it's all happening elsewhere, on the other.

The most important "elsewhere" is of course the fifteen or so schools in which our writers are working regularly.

Anyone who has not been inside a big-city elementary school since childhood is in for a rude surprise. There is a garrison-like feeling to it that I don't remember from my six years at P.S. 189 in Brooklyn. I remember running frantically from one locked door to another in an East Bronx school, my anxiety mounting with each unresponsive handle. And I was trying to get *in*!

At the moment I am entering a school on the Lower East Side which I will later come to learn is a bit less claustrophobic, though the cutting reception of the school secretary would make it hard to convince me of that at the moment. I am to meet the principal and arrange this year's assignment for Dick Gallup, who has already worked here the previous year. The job is easy, since the principal already knows that though Dick may look weird he's harmless, the kids and teachers like him, and he doesn't cost the school anything.

I'm anxious to get out of the office and around to the classrooms where Dick will be working today. Everywhere in the halls children are clutching the toothbrushes they got at a free dental demonstration. We're not the only show in town.

The pattern is one that will become familiar to me later, but which comes as a surprise the first time around. Door opens, Dick and I enter, a cheer goes up (for Dick, not me), teacher either smiles or frowns, either makes ready to participate with the kids or to cut out for a break. Dick passes out some of the kids' writing from last year which has been typed in our office. Some of it gets read, some filed away and some crumpled up. Then Dick explains this week's writing idea, the class plays with the idea on the blackboard and then sets about trying it on their own. There are some new kids who haven't written with Dick before and they are fidgety during the ten or fifteen minutes that the others are concentrating intently. For them there is no backlog of pleasing successful experiences with writing. Then the papers are collected. Dick reads a number of them aloud, amid much laughter and a good deal of praise from Dick. Groans and goodbyes and on to the next room: the show wagon moves on.

I'm not completely thrilled with the writing idea or the results but I haven't seen enough yet to be able to formulate my reservations, which seem minor against the backdrop of productiveness and good feeling. These are the precious stolen hours and half-hours I'll be grinding away for, and I've got to believe they're worth the effort.

That's what things looked and felt like in 1969 when I first arrived at

T&W and for the most part it's also the way they looked when I left in 1971. In the ego-tickling letter with which Phillip Lopate enticed me out of my Christmas vacation cocoon, he says "I know that when you came to T&W it was very messed up and when you left it had direction and organization. What were the changes you instituted?"

I'm not sure what happened over those couple of years, but whatever it was seemed astonishingly slow, undramatic and mundane in the doing. Dick and Sheila Murphy and I, along with one of the several capable secretaries we wore out, spent much of our time straightening out the books, trying to make sure that the writers got their money on time, seeing to it that writers were showing up where they were supposed to be most of the time, collecting journals and children's writing and arranging to have them typed; thumbing through the writing to cull material for future newsletters, editing, typing, laying out newsletters which were then carried to the printer; hauling the printed copies back to the office, addressing them, hauling them to the post office, getting the mailing list transferred onto accurate permanent addressograph plates. Then we were visiting writers in their classrooms, contacting school administrators about placing writers in their schools; calling city, state and federal agencies about funds, writing proposals for them. And on and on.

I defy anyone to produce a less dramatic job description than that. Yet these are all the elements which, cumulatively, make an organization stable, reliable, a bit freer from the buffetings of daily crises. (This way they're only weekly.) I've come to realize that there are people who are flamboyant initiators. They give birth to new institutions but are often unfit parents, unmindful of details, unpredictable, magnets for controversy. And there are people who are less likely to start anything of their own, but more suited to seeing things through a (hopefully) long life. The Murphys and I were of this latter species and T&W remained rather free from turmoil while we were around.

There are a few themes that seem to stand out from those two years. First, there was a strong emphasis on T&W publications. This was partly a matter of making an ideology out of one's inadequacies. At that point Sheila was the only one among us who had experience with children, and editing was one of the things we did best. But, more important, I became increasingly aware of how little impact 10 or 20 writers could have on a one-day-a-week basis, if their work didn't go beyond the classrooms they were working in. Through the newsletter and the books we began to publish our work had a visibility and impact far out of proportion to our actual size. Remember the old war movie in which the good guys have five trucks and in order to make a show of strength they drive around in circles, turning their headlights off at the end of the road and back on again at the start? That's sort of the way the publications at T&W worked.

Although this may seem contradictory, there was a simultaneous effort to focus, narrow, concentrate our efforts, to stop trying to do a little bit of something for everyone at all age levels, everywhere in New York City. We began to limit ourselves to stays of at least one year by at least one writer working below the high school level. Later on we began to see the wisdom of concentrating a whole team of writers in one school district or even in one school. The first steps were taken toward setting up the P.S. 75 project which has produced so much good work.

It took a long time for someone who had come out of a social activist background to stop thinking in grandiose terms about how to have a rapid impact on the 580 school system in New York City and to realize that it was more sensible to move deeply in one small corner and find ways to make the ripples of that outstanding work felt outside afterwards, if it seemed appropriate. I had come to T&W in search of a small, human-size institution to devote myself to and nothing I've seen or done since has led me to doubt the virtues of smallness, of concentrating your energies so that their effects, good and bad, are at least visible.

Finally, my civil rights years impressed on me the need to have the program serve the black and Puerto Rican communities. We hired more black and Spanish-speaking writers than our predecessors, and we aimed our efforts at several "minority"-dominated school districts. It didn't always work out so well. For one thing we were less familiar with black and Spanish writers and as a result missed out on some fine opportunities; the writers we hired were sometimes the people who chanced to come by in our moment of need. On the other hand, there were fine teachers like Clarence Major and Felipe Luciano whose students produced some outstanding work.

Nevertheless, the classroom work of the black and Spanish writers was not the real problem. It was when we tried to bring together all our writers for our extremely rare "staff" meetings that the frictions surfaced. The priorities of the white and non-white writers were so much at odds that conflict was inevitable. I remember watching the look of disgust pass over the face of a militant black writer as he listened to a long-haired white colleague describe a goofy, big-winged bird that one of his kids had written about. "Shit, man, how's that gonna help my black kids survive in the ghetto?" That was a chasm.

Our attempts at social consciousness were not a notable success in other areas either. In an old newsletter I wrote about our "Loft" project where we tried to set up a community center-type program in a working class white neighborhood, staffed by writers. For interminable hours Dick Lourie and I sat in that near-empty loft waiting for the kids, who had forsaken us to pop pills in a hallway around the corner. Suffice it to say that our strength was in the classroom, not in the street, and I'm pleased that the program seems, since then, to have stayed where it belongs.

T&W's mark on me is greater than mine on it (although it hasn't done much for my writing). Two-and-a-half years of being a middle-man between writers and kids left me with an insatiable desire to try my own hand at it. As soon as that hunger overcame me, I was as unsuited to running the program as any writer anxious to set to work on a new novel. In my last few months I began working one day a week in a classroom in East Harlem. It was the highlight of my week and I knew I wanted a deeper immersion.

So, after a frantic summer of compiling the *Whole Word Catalog*, we were off to a small rural school in Vermont where Dick and I first set up a writing center and later took over a fifth and sixth grade classroom. Now, after two-and-a-half years of training teachers at Antioch Graduate School I am back in the classroom, working as a teaching principal in a small New Hampshire mill town. In my work over the last five years I have seen writing of extra-

267

ordinary quality from rural kids who offer no surface cues of interest or ability in writing. More important, I have found myself deeply involved in some of their lives and the lives of their communities, for me an unexpectedly rich amalgam of the satisfactions of working in Mississippi and at T&W. The challenges deepen endlessly: individual, political, literary. I can neither believe that it is more than seven years since I sat down in the Lion's Head Bar, nor that the experience has left such a mark on me. I find, almost to my embarrassment, that T&W helped lead me to the realization that I had what religious folk refer to as a "calling." Who could ask for more?

Interview with Kenneth Koch

(This interview took place in Kenneth Koch's apartment on January 5, 1977.)

KOCH: So what would you like us to talk about?

LOPATE: I would like to know how you got started teaching children, and how it was connected to your own poetry.

KOCH: Let's see. At the beginning I wasn't sure it had any connection with my own poetry, except the fact that I was interested in doing it because I was a poet. It all started when I began teaching adult poetry workshops at the New School, and that was in 1957 maybe, when I was around 32. I was very interested in doing that, because I felt that not only was I writing a kind of poetry that people didn't know anything about and didn't know how to talk about, didn't know the value of, but that I was in the middle of a whole movement of people who were writing that way. Mainly Frank O'Hara, John Ashbery, and Jimmy Schuyler, (what's come to be known as the New York School of Poetry) and some painters as well, though that connection's been overstressed. It was connected to a whole different kind of taste in, or 'take' on, modern literature. We were all reading Jarry, Mayakovsky, Ronald Firbank, David Schubert, John Wheelwright, Eluard, Michaux, just to mention a few people who were not being talked about in schools at all, in 1957, that I know of. And I was very excited about this new aesthetic that I thought our work had.

LOPATE: Would you like to define what you saw as your aesthetic?

KOCH: Well I have to go backwards in time a little bit to define what it was I thought then. ("Go backwards in time"—there's no other way to go backwards!) One has a different sense of who one is and what's important, when one has just left home—I had just left college recently, five or six years before—than one does when one is middle-aged. But it's easy to begin with some things I didn't like. One thing that I didn't like was *allusiveness*, along the lines of Pound and Eliot. I liked Pound and Eliot a lot—but that kind of way of alluding to other works and to unknown things, when used by lesser poets, was very annoying. It's just like earlier poets who would bring in the sea at the end of a poem, or bring in God at the end of a poem: it's sort of a bogus way to give distinction to a poem and to make it seem important.

And also something I disliked a great deal was the mood of despair and depression, a sort of meaningless, negative attitude toward life; whereas all of the people who wrote these poems, like all other people, were living their lives for pleasure. I really say it all in my poem *Fresh Air:* all this sort of Yeats-inspired 'symbolic' baloney. It seemed like people weren't admitting they enjoyed their lives. They were insensitive, I thought, to the surface: they were insensitive to language. Here was William Carlos Williams, *shining,* and early Wallace Stevens shining; and none of these other dunderheads seemed able to see that language had to be fresh or it didn't exist. The academic poets being published in the *Partisan Review* and the *Sewanee Review* at that time, it seemed to me, were writing poems based on ideas and attitudes, and their language wasn't exciting. I could read one line by Walt Whitman, or Paul Eluard, or Rilke, and it was convincing in a different way from these poets' lines.

LOPATE: I remember once Ron Padgett saying he objected to the idea of a poem as an essay. Is this what you mean? A poem-as-thesis?

KOCH: What do you mean?

LOPATE: It gets very tricky because, didacticism is something that a poet has to work with. You, Ashbery, O'Hara, all do occasionally work with telling people what you think and what *to* think. So I'm obliged to think that what you're really talking about is a weight, or a valence, that you didn't like.

KOCH: Yes, it's true. Obviously my book *The Art of Love* is mainly instructional poems; some meant very seriously, some more lightly. But I think in order for me to write, say, something like *The Art of Poetry,* I had to spend a lot of time and energy breaking up all the established ways of talking about these things in this 'heavy' way. What these academic poets were doing was talking about poetry as an established, known thing. As I said in *Fresh Air,* they're all thinking about "the myth and the Missus and the midterm." They all had nice jobs in universities. Of course I don't think there's anything wrong with having a job in a university, or I wouldn't have one. (Laughter) But with the poetry then, it was good if you mentioned Cuchulain, or Helen of Troy—it didn't seem honest, it didn't seem right to me. I was excited by other sounds. I had a very excited feeling at that time that I really knew a secret about poetry. And I think that secret is what my poem *When The Sun Tries To Go On* is all about.

LOPATE: What exactly was the discovery you made in *When The Sun Tries To Go On?*

KOCH: I felt almost that I'd found out some way that words are connected, that is not completely rational. Of course everybody knows that, just as everybody knows that there's gravity. But I guess if you really *feel* gravity, it's very exciting. Like everybody knows that there's some sort of principle in the universe, but if you have a religious experience, you're very excited. And I was. It's almost as though I felt I'd learned the language of the birds. I was very excited about putting words together and having something happen, that I didn't understand but that I knew was right. It seemed to me that just a little bit of that freshness in language was worth all the essay-poems in the world.

Another thing that inspired it, is my just having spent a year in France. And my being able to be very excited about French poetry when I didn't entirely understand it. I would read something like, just to make up a line: *"Le mur est contre le blanc de ma court,"* and I would see a courtyard, a court with kings in it; and I wouldn't know if it was a white emptiness or a void, and so it was very rich. I tried to make a kind of texture—awful word!—I tried to put words together to give that feeling of richness. *When The Sun Tries To Go On* begins:

And, with a shout, collecting coat-hangers
Dour rebus, conch, hip,
Ham, the autumn day, oh how genuine!
Literary frog, catch-all boxer, O
Real! The magistrate, say "group," bower, undies
Disc, poop, "Timon of Athens." When
The bugle shimmies, how glove towns!

270

Maybe I was a little influenced by John Cage's music then too, and by other modern music I was hearing. But I see, as I read this over now, that I was bringing in real memories, really strong associations, without ever wanting to make anything out of them. I wanted to keep them in their pure state. In other words, I wanted to bring in all these details from my life and things I'd sensed and thought and felt, without making a case for any of them, without saying what any of them meant.

Now, "And, with a shout, collecting coat-hangers" is based on when I was in the Cub Scouts, in Cincinnati, Ohio, when I was ten or eleven years old. The Cub Scouts and Boy Scouts used to go around at a certain time of year collecting old coat-hangers, and then we would bring them in and the scout troop would sell them, and they would make money to buy food for bonfires or something, I don't know what. Or maybe the scout troop gave them to charity. So this beginning line is all connected with a memory of a kind of nothing experience, which really is one of the most powerful things there is. Because it's about time, the past; and at summer evenings, spring and summer evenings, just that delicious time after supper, I remember it was, when it's still light enough to go out after supper, and you were ten years old, and you don't know what the hell is going on in your life or in the world; going around to people's houses is an adventure, going around to people's houses you're a public person and it's very exciting and you're doing good and you have these cold coat-hangers in your hand! And it's the Past. I think after that line, right away, I wanted to undercut the sentimentality. Thus the rather abstract line that follows, then the slightly joking "Oh how genuine!" But that's not all I meant. This poem is very extreme. I think in *The Circus*, the one that's in *The Art of Love*, I handle more straightforwardly a poem about the past. But I couldn't do all that at *all* at the time I wrote this poem because I would have fallen into all sorts of sentimental blather and symbolism and everything.

LOPATE: Well that's very curious: I just wanted to say that in *Wishes, Lies and Dreams* you seem to be encouraging people so much to get away from a purely personal recorded poem, and to have more of an escape. And then your own poetry took a turn backward toward the personal. So I wonder if that's a contradiction or if it's just an inevitable working out of something.

KOCH: Uh...You and I don't have the same ideas about "escape."

LOPATE: I'm using that word because you used it in the book: you say "escape" fantasy, imagination.

KOCH: I didn't use the word "escape," I don't believe, in that sense. Because I don't think that to talk about one's secret associations to things is an escape. And I don't think that anything one encourages people to do, no matter how artificial it may seem, that helps them to find their real feelings, is an escape. I presume that's what this interview is about, is what you and I don't agree about. I think sometimes that in urging people to write about their block, or how they really feel about their parents, one is imprisoning them and preventing them from ever finding their feelings and their strength and writing about what they really care about. So I've never encouraged anyone to write anything that was an escape. But if I see someone who's standing in front of a locked door, I'll say, "Go out the window."

271

When I had kids write directly—I mean directly in the sense of, when they write about what they think about the news or what they think about the President or what they think about their block, they always wrote dull... It's true I didn't pursue it a long time, I obviously wanted very quickly to make people do something else when they seem to me to be stuck in other people's language, other people's ideas. Also, I wasn't the way you were. I was working at the beginning with younger kids, and I wasn't as involved in their lives as you were; I wasn't going every day. I was trying to find a *method:* it's a different thing.

LOPATE: I really do think we work differently, and I don't think it's necessary, at least this particular moment, for either of us to say, there was only one way.

KOCH: No, I don't think that at all.

LOPATE: My feeling about the work—to bring all this out into the open—is that you performed an act of literary analysis which was incredible and invaluable. It put a powerful tool in people's hands. And it had a lot to do with poetry: it had a lot to do with looking at poems, and looking at what the substructure of poems were. And I did something else entirely: got involved with the life of the school and the children, and other arts.

KOCH: I agree with you, what we did was very different. How could you possibly do the same? You're a creative person, one doesn't want to have an eighty-year-old baby!

LOPATE: But what interests me in what you did was that, I do feel a very strong connection between your poetry and your teaching approach. I keep thinking of the word "analytical" when I think of your approach. Although everybody always labels it as spontaneous and free, in fact there's an intellectual act behind it. You've taken both your own poems and other people's poems, you've looked at them, and you've tried to find the kernel of them that could be transmitted. So that the list poems you wrote, like *Poem of the 48 States, Lunch* or *Thank You,* seem to be paving the way for *Wishes, Lies and Dreams.*

KOCH: Can we go back to that connection we started off with about my teaching at The New School, and how that got me into teaching poetry to children?

LOPATE: Sure. Go ahead.

KOCH: Anyway, when I started teaching at the New School I felt I was onto this new way of writing that I could tell people about, and help them to write, give them feelings of power, confidence, excitement. And I started using *assignments.* The usual poetry writing workshop for adults, the standard Iowa-type Grade A workshop, is where everybody writes poems; and then one week one person mimeographs a lot of his work and then everybody reads it and criticizes it. And any workshop is good for awhile, just as probably any kind of therapy is good for awhile: you get to talk to someone in therapy, and think you're important, and get to see that your feelings are important. And in a workshop, it's always good to be with other writers and it's good to have some opinions and to feel that what you're writing means something; but it seems to me that kind of workshop is obviously limited. What you find out is

272

how you rank in the class; and how good people think what you're already do-
ing is. Whereas I found, right away, that most people who come into a
workshop are doing one thing fairly well. Like at the time I started teaching at
The New School, some people were writing delicate little quatrains, and some
people were writing cluttered sonnets; and obviously what these people need-
ed was not to be told how well they were doing, or how they ranked, but to be
told, "For God's sake, do something different! Read Lorca, and write like
him. Or read Whitman, and write a list of forty things. Or write about your
dreams, or write a poem with just one word in every line." What they needed
was new experiences, because they were too narrow. Also, since I had a new
aesthetic that I was bringing into this, I thought I *had* to give them
assignments to show them what I thought, because I knew that my idea of
what poetry was was going against what they thought poetry was. For exam-
ple, one thing I did at The New School very early on was I had people write
poems about their dreams. I said: "Dream, and write a poem about it. And
also bring me a prose account of the dream." I didn't know what was going to
happen. But in almost every case the prose account was better poetry than the
poetry account, and this was like a wonderful way to show them that it was
better to be particular, to mention names.

I got a lot of confidence from that teaching at The New School. There
were a lot of talented people who came to my class: Joe Ceravolo, and John
Perrault, Ruth Krauss, and Tony Towle, and Peter Schjeldahl. It was very in-
teresting. Well, then I taught writing at Columbia in the same way, always
giving assignments: the kids at Columbia I could force to do the work every
week, whereas at The New School it had to be kind of voluntary. Then I
started to be interested in teaching poetry to younger age groups. *One* thing
that got me interested in doing this was that there was now a certain interest
on the part of the government, and among intellectuals in New York, in
primary education. Jason Epstein [senior editor at Random House] had started
to put out a newspaper called *New York, New York*. Did you ever see any
copies of that?

LOPATE: No.

KOCH: It was terrific. It was to come out once a month, and it was to be like
The Weekly Reader was in school, or the Scholastic Magazine, but very, very
good. And my friend Emily Dennis was doing an art column for this, telling
kids what Abstract Expressionism was and showing them how to do it
themselves, and what Pop painting was. I proposed to Jason that I do a poetry
column. He said, "Well, you need some experience in the schools." So Emily
proposed that I go teach at Muse in Brooklyn, which she was director of.

At the same time, I was very annoyed because there started to be these
'conferences' at Tufts, and Sarah Lawrence, on teaching children. God, they
made me mad. There were all these poets I considered "academic" and
unlikely to be able to teach children to write. I thought at the time that I
could teach poetry to adults as well as anybody could, and I thought that the
way I taught might just work with kids. And I was annoyed that this whole
thing seemed to be going on without its principal character—me!

LOPATE: This motive of competition doesn't seem to me wrong. A lot of
good things get started because you feel that the wrong people were doing it.

KOCH: Oh I know! I asked Betty Kray of the Academy of American Poets to let me read poems in the high schools. There was this grant from the government to the Academy of American Poets, where they'd give poets $75.00 to read their own poems and read other people's poems and talk to the kids about it. David Shapiro had told me it was fun, and I sort of poo-poohed it; I was very skeptical, but then as time went on I got interested. I did it four or five times, and I noticed two things: one was that the kids really loved poetry; and two, that it was a waste of time to go there once and talk to them about it, because they went right back to the old dispensation. Then I asked the Academy of American Poets to get me into a school with a workshop. One important thing I owe to them is that they decided to try me in an elementary school. That was wonderful. I'd thought the ability to write poetry came with puberty. I didn't think it'd be possible. So I said, "Well, I'll work with the sixth grade, but I want specially selected kids who already like poetry." Fortunately that didn't happen: I'd have gotten six girls who wrote about butterflies. A lot of the best writers in that school already hated poetry, they never would have volunteered for a workshop. Another person I'm grateful to is Jack Silverman, the Principal of P.S. 61, he said I had to have a whole class.

LOPATE: Yes, that's a very good way to break in... And then how did you get connected to Teachers & Writers?

KOCH: After the first stint, I wanted to go back the next year, and there were no more funds from Academy of American Poets. Trudy Kramer had gotten very interested in what I was doing, and I think she got me the contact with Teachers & Writers Collaborative.

LOPATE: Did you know when you went in for the second stint that you were going to write a book about it?

KOCH: Yeah. Oh, for sure.

LOPATE: So Teachers & Writers gave you the money for the second stint?

KOCH: Yes.

LOPATE: Who was in charge then? Did you have any dealings with them?

KOCH: I didn't see them much. What they mainly did for me was to give me money for my work in the school. One thing I liked, that was wonderful about Teachers & Writers, was I had to keep a journal. Without that, I don't think there would have been a book. A terrific thing about Teachers & Writers was that I could turn in the poems and they'd duplicate them for all the kids. That was wonderful. I went to maybe one or two meetings and I-I felt... you see, all I ever really wanted to do, was find a way to teach poetry to children. I'm probably more scared than I should be of getting involved in administration. I just remember there being a desire on the part of Teachers & Writers Collaborative for me to get more involved. Maybe to help them draft things, or to meet somebody and talk about different ideas, to really "rap" with a street poet who was teaching somewhere else. Somehow, I was teaching at Columbia and writing poetry, and I didn't want to get involved with the organization. There's something that's always made me afraid of that, which is why I was so glad to find a way to do good to people without being in an organization. I remember just these suggestions of meetings and get-togethers, which I never had any ideas about. Another thing I never had any really strong ideas about,

because it wasn't the main thing I was interested in, was that area that Herb Kohl and Jonathon Kozol are so involved in, which was how to revise the school system, how to change the schools. Naturally, I've gotten somewhat more interested in that, but I never devoted a lot of time to it. As you can tell from the fact that the next thing I did was to teach people in a nursing home to write poetry, what I'm really interested in as far as education is concerned, is how to teach people to write poetry.

LOPATE: How did you actually do the writing on *Wishes, Lies and Dreams?*

KOCH: I worked on the Introduction of *Wishes, Lies and Dreams* hard for six months. I must have written it ten times at least. And I did the same thing with *Rose, Where Did You Get That Red?* Each book took me about two years to do and there's not that much of my writing in them.

What I tried to do in those books is to make what happened as available as I possibly can to anyone else who wants to do it. If you saw some of the first versions of those books, or even the new book I wrote about teaching old people, it's all like: I went in, I didn't know what to do, I thought this, I tried that, I felt scared. And then I'd get too involved writing about the people. I got very interested in the children, and I got interested in child psychology, and what else was going on in the school, but that would have been a different book. I think that my interest as a writer in the subject is method-analytical. Not my interest as a teacher.

LOPATE: That's interesting. I guess the main problem I have with the two books is, I sometimes hunger for individuals. You know: instead of reading about 'the kids' I would have liked more of *this* kid, or *that* kid. And obviously you came to a conscious decision very early on, that, if not in your teaching, at least in your writing, you would refer generically to responses.

KOCH: Yes. I thought that would make it easier for other people to use it. See, there were two other directions that I could have gone in, in writing the *Wishes, Lies and Dreams:* one was to talk about the individual children—which, say, Ned O'Gorman does a lot. To get very involved even in the family life, and what the other teachers are like, and so on—more like what you do. It's like you're some sort of surprising member of an already existing society who's trying to work it all out. That was one thing I could have done. It's a good thing I didn't, because it's not what I'm best at. The other thing that I was very tempted to do, which I'm not bad at, is to write an essay on aesthetics: that is, to talk about why the children's poetry was good, what its qualities were. That was much harder to resist. A lot of the early versions are about that, and that would have been, I think, fairly useless. My friend Emily Dennis was very helpful there. She was the one who sort of inspired me to do this. She taught painting classes at the Metropolitan Museum; and she did very radical things, like having them read Wallace Stevens and then paint something, she had them do collage very early on. She kept telling me, "No, no, no, it can't be about the aesthetic qualities of children's poetry: think of all these children in the world who have been badly taught, who would be happy if they wrote poetry. Very few people are going to care about the aesthetic part and understand the aesthetic part; that's not going to help teachers."

So I decided to be *clear.* But I figured that then there was another temp-

tation, which was to write it as an instructional manual: do this and do that. But that's an unpleasant tone. So what I did was, I selected from my experience. I wrote it first person, but in such a way that anyone who read it could see the process clearly. And that tone was hard to get; that's one reason it took me so long to do it.

LOPATE: In effect, did you have to work at creating a persona, a character for the narrator?

KOCH: Oh no, it was really I. I didn't mean to say there was any trickery in it. You know there's this thing that we writers think about all the time. First there's what happens, or what seems to happen in the world: and then you go to *write* about it. Like the conversation that we're having, there are many ways that we could write about it. How would you write about it so that it would show people that it was a good way to talk, or an intelligent way to talk? You could say, "These are five rules for conversation." That was one temptation I had. Or else one has to give a sense of Phillip Lopate alive, Kenneth Koch alive, and the room and the weather, but not too much, otherwise people get lost in the detail. Writing is hard: I found expository prose the hardest thing I ever wrote.

LOPATE: Did you see it as an experience as much in your writing expository prose, as in writing something about education?

KOCH: No. But I'll tell you: it occurred to me, when I was writing some of the poems in *The Art of Love*, namely, *Some General Instructions*, *The Art of Poetry*, and *On Beauty*, that if I'd not been very much influenced by the children's poems, what I really had been influenced by was writing those two books, and above all, lecturing on the subject.

LOPATE: By your own internalized teaching voice.

KOCH: Yes, first by working at being clear, which is a strange experience for me, and more, by being on the lecture platform and answering questions and telling people what to do. But no, I didn't consider it an experience in writing prose. I was just very excited by what the children wrote. I don't know, I think I was excited the way people say they are when they make scientific discoveries. I thought I'd been fooling around in the laboratory and all of a sudden there was this cloud of pink smoke, which was really great. I thought everyone ought to know about it.

LOPATE: After you made this discovery, you were then used as a kind of exemplary model by the National Endowment on the Arts to get state poetry programs started: either you made personal appearances or the film that was made of you and distributed by the NEA was sent out. I know you once went out to North Carolina and had a big impact on everyone there. They still talk about you and base a lot of their stuff on you.

KOCH: Oh, yes? Good.

LOPATE: How did you feel about being used as a "spearhead," I can't think of any other word, for the poetry-in-the-schools project?

KOCH: Oh, I didn't really feel like a "spearhead." I was very glad for any attention that the work got. The first place to write an article about it was the *Wall Street Journal*. That was long before the book came out. Then there was an article in *Newsweek*. It was a positive article, but it referred to them as

276

"slum children." Those kids were so terrific—did I ever tell you that story about the slum children thing? I read the article in *Newsweek,* and I went to school. When I got there the Principal, Jack Silverman, says: "Ken, the kids are pretty upset. The parents are upset." And I said, "Jack, national magazines are vulgarity itself. What can I *do*? I didn't—I never referred to anyone here as 'slumdwellers,' you know." He said, "I know but what are we going to do, Ken? You got to do something. Maybe you talk to the kids." So I went upstairs to the main class I taught, fifth graders, and said, "Listen, I know you've read this article in *Newsweek* and you must be upset about it..." And the teacher kept saying, "Hey, Kenneth—" "What is it?" I said. "They already did something about it. They decided to write letters to *Newsweek.*" And they'd *all* written letters. Some of them had written poems and letters saying really good things. Eliza Bailey wrote this terrific thing which was very funny, it was a poem beginning: "I used to be a slumchild, but now I am a poet."

LOPATE: How did you take becoming such a symbolic figure? The publicity, and all that.

KOCH: Oh I liked it. (Pause) I've always thought it was just ideal to get famous or get a lot of attention, for doing something good. When I was a kid I thought, "Oh I'll write some awful thing and get famous," but I realized when I grew up that of course I didn't want to do that! It's like being famous for how ugly you are. And I thought this teaching method was a really good cause. At various times in my life I've tried to get involved in politics. And I have no talent for it. I'm lousy at going to doors, I feel stupid in parades, though I've been in a lot of them. Even when I'm in a parade, I can't say, "Hey hey LBJ, how many kids did you kill today?" You know, I've tried to write political poetry, *The Pleasures of Peace* took me two years to write. I kept trying to put in things about *suffering,* and all that stuff that I really didn't like about the Vietnam War. And, just like when you transfer somebody's heart to somebody else's body, it kept jumping out. Finally I ended up with a poem about the pleasures of peace. And *here,* in the middle of my life—I'm at the age of forty, forty-five—I discovered a way really to help a lot of people. Like children and teachers. It's not giving them food to eat, but what can one person do? And so that made me very happy. I just loved going to North Carolina, to California, and to Oklahoma and to Texas, and telling everybody how to do this thing. I didn't convert a lot of teachers. But I did some. Then I was getting so much mail I had to get a secretary for awhile, for teachers and kids who wrote in, "Dear Mr. Koch, Here are our poems..." The poems were always kind of good, you know, because of the simple way they are, even when they're not terribly original.

LOPATE: Didn't you ever feel, like, "What have I wrought?" when you read your ten thousandth "wish" poem?

KOCH: I thought it was all right that ten thousand children were writing wish poems, because it had been a great experience for children in every school I taught in. And for each one it was an individual thing. It's like, it can make you depressed to think about fifty thousand people in New York City making love at the same time, but each of them sort of likes it. (Laughs)

LOPATE: I never had that take on it. I mean, when I went into schools and

they had their bulletin boards with the wish poems next to the lie poems which were next to the dream poems, I didn't think of it as fifty thousand people making love at the same time. I gritted my teeth a little bit, because it began to seem like in ancient China, where they had the same civil service examination all through the land: everyone had to write a poem on the same subject? It felt like civil service examinations.

KOCH: Yeah, well. What are you asking me: if I felt like the way Einstein felt when they made the atom bomb? (Laughter)

LOPATE: I'm just going fishing, I suppose. By the way, I don't think this is exclusive to you. I remember when I made up some assignments, and then I'd see them popping up *ad infinitum*, when I felt they should have been buried long ago.

KOCH: Well, I said in my book: Here are twenty ideas. There are lots more I didn't use. A teacher who gets accustomed to this kind of teaching will find things of his or her own. I never wanted them to be used as formulas.

LOPATE: I think that's true. By your providing the analysis, anybody who is clever could then see, for instance, that the number of subjects for a list poem was infinite: it's as infinite as the number of things in the world. And that happens most of all in *Rose, Where Did You Get That Red*, where there's such a fertility of ideas, it's really exciting. I think *there*, more than in the first book, you made a convincing case that these aren't the only legitimate ideas, because you really do have a lot of throwaways.

KOCH: I wish you'd read that book when you wrote yours, I felt what you said about my work wasn't quite fair. And *Rose, Where Did You Get That Red?* had been published before you wrote your book; but you mentioned on-ly *Wishes, Lies and Dreams*, and said—you said something like, uh, I don't connect the children to the poetry that's inspired me. Whereas that's all that *Rose* is about.

LOPATE: No, that isn't what I said. I can sympathize with the fact that you didn't like what I said about it—though God knows I rewrote that passage fifty times!

KOCH: There were a couple of other things I didn't like that you said, because you... you picked a very uncharacteristic poem to illustrate. That poem by Charles Conroy does sound like a New York school poem, but *nothing* else in *Wishes, Lies and Dreams* sounds as much like the New York school of poetry as Charles Conroy.

LOPATE: Well, I also had some problem with lines like, "the raspberry com-ing out of the trees," with that kind of imagery.

KOCH: I don't remember any raspberry coming out of trees.

LOPATE: It's in one of the poems. And there's, "I wish I was in Candyland with all the..."

KOCH: Oh, that thing inspired by Shakespeare's songs.

LOPATE: And I sort of feel, in both books, there was an uncomfortable amount, for me, of "purple monkeys" and "root beer ice cream sodas" kind of thing. To me, I wasn't sure that this *was* children's imagination, or whether it was an adult's version. Did you read the chapter in my book called "The Land of Polka Dots," where I talk about that?

KOCH: I believe I read the whole book.

LOPATE: Yeah, well, anyway. These things—these things—I start to stammer because I really, I really feel like... you know, my debt to you is immense. And not only impersonally, but personally: you actually got me started on this, if you remember. You helped get me my first job in teaching.

KOCH: I gave you your start, kid.

LOPATE: You were quite unstinting in your help. And so, gratitude always carries with it a little whiff of resentment.

KOCH: I know, I know it well.

LOPATE: On the other hand, I had to struggle very hard to distinguish in my own mind between what I took from you, what I actually did disagree with, and what seemed to me to be simply, "Well I want them to pay more attention to me and not to him."

KOCH: Yes, I know. Anyway, it was those two things that bothered me: that I didn't think Charles Conroy's poem was characteristic, and you used that to make a point which was convenient for you. The second thing was that you did complain that I didn't connect children with poetry directly, and I had written a whole book about it.

LOPATE: No, I may have said that I felt you didn't connect them directly enough with their *lives,* not with poetry.

KOCH: Not connecting them directly with their lives is a legitimate disagreement that we have. I don't *agree* about that; I mean, I think I do connect them with their lives. I think of that little black girl in Newark, New Jersey when I was teaching a fourth grade class and the first time I saw them I said, "Everybody write down a wish. Just a wish—write the *craziest* thing you can. Anything you want to, something really very simple that's crazy." This skinny little girl in the first row wrote down something, and she ran up and showed it to a substitute teacher who was there, a big white lady whom the kids liked. And this lady patted the girl on the chin: "No, no, Veronica. You don't really wish that. Now you go write what you really wish." I'd been teaching for a long time so I knew this wouldn't do. I said, "Let's see it, Veronica." And Veronica had written: "I wish I was dead." And I said—I don't think this is your teaching technique—I said, "I think everybody who's alive wants to be dead sometimes, it's natural, it shows you have strong feelings. Now go sit down, and write *why* you want to be dead, okay?" So Veronica went and did it. She ran up with a big smile on her face, and showed me this piece of paper, which said: "I wish I was dead so I could turn blue and scare people." (Laughter)

LOPATE: Terrific. Okay.

KOCH: And particularly in that school, in Newark, the teachers told me that the children who had *never* talked about their feelings had really talked about really strong feelings, because of doing very artificial things like *I Used To Be But Now,* or *I Wish.* My whole point is to get to feelings, not to—

LOPATE: Let me just clarify what I was trying to do in that chapter. The one where I discussed your book. It was to allow the reader to situate himself above *all* methods, including my own. My point was basically the Nietzsche idea: that all philosophies are disguised psychopathologies. And when you look at

them you can see something underneath them, their character structure. And so all I was saying was that all these poetry-teaching methods can be looked at anthropologically: instead of saying, this is the way children write, or, there is such a thing as the way children feel—to realize instead that the systematizer or anthologist is being subjective and bringing his own aesthetic likes and dislikes to the teaching of children's poetry. And by the same token, the writing that I get from my kids is at least as skewed as the writing that you get from your kids.

KOCH: I appreciated that part; I just told you these two things that I didn't think were fair.

LOPATE: I know. I thought the Conroy poem was a cheap shot myself.

KOCH: Good! Okay.

LOPATE: I did.

KOCH: Because I don't think any sensitive reader of the poems of Marian Mackles, and Ilona Baburka and Jose Lopez, and my other students at P.S. 61, would see much similarity with the work of the poets of the New York School. I mean, I really don't.

LOPATE: Well, for instance, the emphasis on pleasure and on color, and on linguistic surface where two words chemically bounce off each other, I felt was very similar. There was a lot of extroverted surface. And there was very little, let's say, for want of a better word, of "uncertainty." Basically it was poetry of empowerment, which I thought was an interesting thing—and by the way, a pretty good way of approaching kids—but it overstressed empowerment and hedonism.

KOCH: I do stress that.

LOPATE: And understressed certain kinds of experiences. And I tell you, the second book, *Rose*, I don't feel that way about as much. You know when you talk about the Rilke poem, your assignment there is, Let's go into this tentative quiet stuff where you're feeling something uncanny...

KOCH: Yeah, yeah.

LOPATE: I suppose I myself write sometimes out of *cul-de-sac* experiences which aren't necessarily empowerments.

KOCH: I think now we're talking about something interesting. Now if you had said *that*...(thinks a moment)...That's—that's fine. I think I do stress power. That's very well said. I mean, that's true about my whole approach, even to teaching old people. As when I told old people to imagine that they were the ocean. I feel that people find their feelings, and find their subtlety, in power.

It's certainly true that I feel that inspiration is in a feeling of power. I remember Allen Ginsberg told me about one poetry workshop he taught; he taught some married women somewhere and he said, "They weren't writing. Finally I got them to do something." The assignment that finally worked for Allen was, he told them all to think of something they felt that had been done to them which was completely unjust; and they should write about that and really vent their feelings. You know, that worked for Allen, and that would never have worked for me.

LOPATE: That's interesting. Nor for me, probably.

KOCH: I suppose it's true that one could get tired of the expression of power and excitement...

LOPATE: Or enthusiasm. To try to define this more, I think that part of the reason why I do have some of these difficulties is that in a lot of ways our values overlap. That is, I like enthusiasm too, and I like power, too. But I do feel there's an overpowering *vocabulary* of enthusiasm in your books; I prefer to confess more failure, simply because then it seems more exciting when there's a breakthrough. But if I'm just told that there's excitement, excitement, enthusiasm, pleasure, then I start not to believe it. It's like a tonal problem, or a code. Sometimes I felt in *Wishes, Lies and Dreams* that there was a special vocabulary that was focusing the reader's attention again and again on the positive: like the words "pleasant..."

KOCH: "Inspiring, exciting..."

LOPATE: "Enthusiastic." "They were all excited," you would say. "This they'll love." It's like taking a horse's head and sort of pulling him by the bridle and saying, "Look at this! It's *nice!*"

KOCH: Uh-huh. Yeah, I guess...

LOPATE: And there *is* a lot of poetry that can come from entirely different feelings.

KOCH: Sure. I know it well. Including negative details is hard for me. (Reflects) But I think one of my strengths as a teacher is making people feel very confident.

—End—

Nine Years under the Masthead of Teachers & Writers Collaborative

by Ron Padgett

I have been mulling over this article for months, ever since Phillip Lopate invited me to write one for a special Teachers & Writers volume. I readily accepted Phil's invitation. After all, I was the active member of Teachers & Writers with the most seniority (though I do go "on leave" occasionally). I thought that I, with my astounding grasp of education and my widespread experience, ought to contribute something of outstanding and lasting value to this publication.

Still, I regretted being given a deadline. I have always disliked writing under the gun, about to be shot, in effect. It's like being assigned a topic for your term paper, with every day late counting off on the final grade. Add to this a distaste for the very word "deadline"—you pick up the receiver, the line is dead... Operator! Operator!—and you have me driving about the state of South Carolina, where I am working as "writer in the community" with the South Carolina Arts Commission, wondering how to write this piece.

Should I be serious and instructive? Formal and essayistic? Ramblingly anecdotal? Searingly honest? Painfully stupid? Talk down? Up? Sideways? Should I pretend to have the gall to say what it's "really like"? Sift through my old teaching diaries, bridge relevant passages to form a reconstructed picture of my Teachers & Writers work at P.S. 61, P.S. 84 and P.S. 19? After all, there are Teachers & Writers traditions as to how to present your work.

Look back through the newsletters, from the first crudely designed issues with their fire and spunk, on into the confessional era, when mistakes tended to be doted upon in the name of sincerity, on into the team approach. Through it all there have been some wonderful discoveries, too, which have served as models for teaching the arts in the schools. It has not been said loudly or clearly or often enough how much of an influence Teachers & Writers has been on the teaching of the arts in public schools, especially in creative writing, dramatics and film.

I'm not talking just about Kenneth Koch's work. I'm talking also about the very idea of a group such as Teachers & Writers, a group which has miraculously managed to function through 11 rather strange years (1967-1978). I'm talking about the fact that our artists know that they can go into the schools and try out virtually any new idea, and still be around long enough to see the long-range effects. You can't do this with short-term programs such as Poets-in-the-Schools, which are also fine, but limited, creatively speaking, insofar as the poet is not encouraged to experiment when the school is paying for it. If a school hires a poet for a week, and that's their artistic budget for the year, by golly he's expected to produce, not to fool around with some weird new idea. And when the week's over he disappears. There is a lot of traveling salesmanship involved in the Poets-in-the-Schools programs.

They can be good programs, too, but you will find few experienced artists eager to work in them over a long period of time. They are more suitable for younger artists who have had just enough teaching experience to qualify—they have the energy, and are not yet numbed by the repetitiveness of the work, or the feeling that comes over you when you wake up not knowing which town you're in and think, "Oh my God."

Many of the techniques, strategies and ideas of Poets and Artists in the Schools programs grew out of Teachers & Writers, via the magazine and books. Herb Kohl's books, Kenneth Koch's, Dan Cheifetz's, Phil Lopate's, among others, have had a tremendous effect on the way artists work in the schools. Teachers & Writers has served as a model project from which you can take what you like and leave the rest. Many have borrowed from us.

The first thing the people at the South Carolina Arts Commission asked me was, "Tell us everything about Teachers & Writers Collaborative." They were especially interested in the effects of camaraderie among the different artists. It seemed desirable to them to have all your artists know each other and feel free enough to exchange ideas and sympathies.

I glance at my old Teachers & Writers diaries. I can't believe it: the first is dated exactly eight years ago! February 20, 1969, my first day solo at P.S. 61. I had been over there a week or so before with Kenneth Koch, who had called me to see if I'd like to stand in for him at P.S. 61 teaching poetry writing to kids once or twice a week. Kenneth had been my mentor at Columbia, cajoling me into staying in school and graduating. His advice had always been good.

But I didn't want to teach poetry to anyone. I just wanted to be a poet. I had been back in New York for two years, getting by, with a wife and baby boy, and I thought I could continue this way, by hook and crook, so why should I get a "job"? Kenneth assured me it wasn't a "job" in that sense of the word. I'd be able to make my own schedule, teach only one day a week, write a diary account and mail it to Teachers & Writers Collaborative, the group sponsoring him. Finally he asked me to visit his classes and see what it was like. The clincher was that the school was only a few blocks from my apartment. So on the appointed day I strolled briskly through the ruins of the Lower East Side, deeper and deeper into those particular social and economic ravages, to Avenue B and 12th Street. I felt silly carrying a book instead of a gun. It seemed incredible that Poetry was going to be taught here, instead of Self Defense.

Inside the school I was hit immediately by the smell of "school." It had been a long time since I had been inside an elementary school, about 15 years. The smells of the cafeteria, gum wrappers, floor wax, chalk dust and children were virtually the same in New York as they had been in Tulsa, where I grew up.

Kenneth hurled a tremendous amount of energy into his teaching, he was a human whirlwind, funny, excited, and persuasive. He seemed to be laughing all the time, even when he wasn't. It was on waves of excitement that he conveyed his messages. The kids loved him—a great cheer arose when

he entered the classrooms. I thought to myself, "This is great, but... ulp, can I follow it?" In the last class Kenneth asked me to read some of my poetry to the kids. I picked a few short things, read them and drew some illustrations on the board. One poem was about an electric eel that, when it swam itself into the shape of the word "eel" in script, lit up. The kids liked my poems, but I didn't have any idea of where to go from there, and so Kenneth rescued me.

(Soon after, when I took over his job, he gave me copies of all his teaching diaries. I read with special interest the one describing that visit—he said I had a "nice and easy manner with the kids" or something to that effect. I was surprised and flattered—I had felt like a wooden idiot.)

I returned to the school on February 20, alone this time. The nearer I came to the school, the more fear I felt. What if they didn't like me? On the front steps I stopped and looked at the school facade—it was terrifying. I distinctly remember saying to myself, "Who needs this? I'll just go home!" Followed closely by, "What's the matter? Chicken?" And with that I bolted through the door and up the stairs to my first class.

At first I aped Kenneth shamelessly. Afraid that the kids wouldn't accept me as his replacement, I even borrowed his tone of voice and sense of irony. It worked! They liked me! They wrote poems! They were good poems! I went home! I wrote a diary account! I showed it to my wife! I told her every minute thing that happened! We had dinner! A check would arrive! I was exhausted!

As time went on my role shifted from being Kenneth's understudy to being more myself. The kids accepted the transition. I finished out the school year, working with four classes per day, once a week. For this I was paid fifty dollars a week, which covered preparation, classroom time, setting up schedules, writing and submitting diaries. My diary accounts tended to be lengthy, detailed and personal—I usually spent an hour or two on each one, writing it as soon as I got home. I also kept the kids' poems and sent them to a woman named Joanna Roosevelt at the old Teachers & Writers office in the Armory in Central Park. She mimeographed all the poems and returned them to me for distribution at the school.

Some months went by before I even met her, and even then I did not understand her role with the group. She was pleasant, pretty and intelligent, but it never occurred to me to ask her what her role was, or in fact what Teachers & Writers was, or even if it were okay that I now worked for Teachers & Writers. I just steamed ahead, assuming all was well. Finally I was invited to a Teachers & Writers Collaborative group meeting, at a loft down on Chrystie Street, I think. There I met others involved with the group. Basically everyone sort of milled around with a drink and some cheese and crackers and went home. I had very little sense of the people as a group. Not that I minded—in fact at that time I had no interest in being part of any group other than that of my immediate friends.

When Kenneth returned from his sabbatical, he began work on his book *Wishes, Lies and Dreams*. I helped him with details and advice, and supplied some poems and ideas. He seemed so busy with it, and with teaching at Columbia, that he never asked for his old job back. I don't think I ever offered it back, either, though of course I would have quit at the slightest suggestion from him. Somewhere along the line I had started to feel that it was

partly my job, and I liked it. It was interesting and strange to go into a public school in New York and teach poetry. I enjoyed thinking up new poetry ideas and trying them out. It was funny to walk down the street in my neighborhood and have little kids run up and say, "Hey, Mr. Poetry Man," or "Mr. Padgett!" or even "Mr. Koch!" (Apparently my Koch imitation had been effective.) I felt good about working with the kids. I didn't have any grandiose ideas about education and "saving the kids"—I have since acquired a few such notions, alas—I simply enjoyed writing poetry with the kids. At that time I was made welcome at the school by the principal, Mr. Silverman, whose trust I appreciated, and by several teachers, Miss Pitts, a sensational teacher who helped me more than anyone else, Mrs. Wyck and Miss Magnani, among others.

About the same time, I started teaching a poetry workshop for adults at the St. Mark's Poetry Project one night a week, and Saturday morning writing workshops for kids at MUSE in Brooklyn (another Koch appointment!). The St. Mark's workshops involved about 20 adult poets, serious writers, more of a seminar-workshop than a class; the MUSE workshops, taught in collaboration with other poets, had more freewheeling groups. They met at 11 and 12 o'clock on Saturdays and were voluntary—imagine kids from "ghetto" neighborhoods attending poetry classes on Saturday! Others commuted from Manhattan and Queens. At MUSE you could conduct the sessions just about any way you wanted—you didn't have to be so careful about watching your language or offending anyone. In some ways it was more like group therapy, and with the groups smaller, I could work with kids individually, instead of with a "class." Some incredible writing came out of MUSE, produced by kids, now in college, who are still writing. The two-poet approach taught me a lot about different ways to work: Dick Gallup, Phil Lopate, Larry Fagin, David Shapiro and Bill Zavatsky were my co-workers at various times, and we all learned from each other, in the workshop room and on the long subway ride back to Manhattan.

While at MUSE I was learning how to work with individuals, and at St. Mark's how to discuss poetry writing in a professional way, at P.S. 61 I was learning how to conduct an entire class, where I could bring professional seriousness and individual attention to bear when necessary. These three positions affected each other to a degree I didn't realize until later. I was also learning the feel of a class period, and how to shape it.

Gradually I began to call myself a poet. From the age of 16 I knew I was a poet, but I had never answered the question, "What do you do?" with "I am a poet." Teaching drew me out of my private role as poet. When a kid yells in the supermarket, "Mama, that's the poet!" you are embarrassed at first; later you yell back, "Yep, that's me!" I learned that when you attend PTA meetings, for instance, people are interested to learn that you are a poet. They think it amazing, even, that a person should be a poet, and make some kind of living that way. I had always been afraid that people would think I was a creep, because only a creep would write the stuff they put in the high school textbooks we had when we were growing up.

In the late sixties and early seventies, it was not uncommon to meet educators who doubted the usefulness of art in education. They readily ad-

mitted that art was "valuable" somehow—after all, look at all the people involved in art, and look at the prices of original paintings! Such blatant philistinism has diminished over the past four or five years, under a bombardment of arts information on television, in the newspapers and magazines, in educational journals and through the good offices of the National Endowment for the Arts and the state and local arts commissions and councils, through which most artists-in-the-schools work. Public attitudes seem to have changed, too. No longer is it fashionable, except in the deepest pockets of ignorance, to tout "the 3 R's" as the only way to go. Even these educators are beginning to take a more reasonable and humane attitude toward education: that to teach a child to sing, to make creative decisions, to get along with his peers, to understand one's self, to work and be happy—this is not such a bad way to live. If all educators do not yet understand this, most feel the pressure to go along with it. If that pressure is concerted and constant and sincere, open and benevolent, we will soon have made a definite move toward a more civilized society. I really think Teachers & Writers Collaborative has had a hand in this movement. I suppose it has political implications, insofar as everything can be seen as having them, though it has no strictly political intentions. It is not necessarily a radical or a conservative movement. It amounts to an attempt to change the heart of the country.

I warned you that I had acquired some rather elevated notions. When I realized that my work was usable, it changed my thinking about where I fitted or didn't fit into the scheme of things. As a hand-to-mouth poet I had felt very spiritual, almost invisible, and virtually useless, except to myself, my family and my friends. But I lacked the solidness of, say, a hammer, or a cold chisel. My poetry stopped at the printed page. There was nothing you could do with it. Which is fine, if that is what you want. To be able to go on, convert that product into a technique others could use, was like discovering a ten dollar bill folded up inside your wallet, a bonus! Working in the schools was for me a bonus.

The energy flowed both ways. The kids taught me so much, how to pay attention to them, how to behave with them, how to like them and appreciate them, how to give ground. Their directness and honesty changed my teaching methods. If I came in with an idea they found boring, the snores were audible. Gone was conventional adult *politesse*! It was replaced with "Are you kidding?" Often I'd defend my ideas; other times I'd realize how lame they were, conceived in a small New York apartment in the middle of the night—they had seemed great then! In the face of reality, they wilted. On the other hand I learned that kids aren't always right, either, in what they like and dislike in art: too often their attitudes are learned from dubious sources. If I felt strongly about a kind of poem, I learned to defend it, right on the spot, with conversation that really meant something to the listeners, most of whom were 11 year-old Puerto Rican Americans. I came to realize that if you want to convince the kids, you have to make good sense and be persuasive, not on a soap box or pedestal, but down here on earth.

My own poetry took on a more down-to-earth tone, too—at least it seems so to me. Much of it still seems quite nutty, I realize, but even its nuttiness is more available than the rather ethereal gibberish I used to write (O divine gibberish! I still love you!). How down-to-earth my work has become is open to

question, I suppose, and this is not the place to discuss it. Suffice it to say that I felt a change. Shall I ascribe it to being a teacher? I shall. Aging has added its soft touch, too, no doubt: it seems a long way between being 27 and 34, from having a child of 2 and a child of 10.

Teachers & Writers has changed, too. Elsewhere in this book, I'm sure, that change is described in further detail. In general it has developed a surprising degree of organizational maturity. There have been some weird moments, to be sure, predictable for a group of artists on a program with its future in constant jeopardy. No fringe benefits! No insurance! No unemployment compensation! No job guarantees! It can make you edgy.

I remember one Teachers & Writers meeting, long ago, that grew so tense I expected to see chairs flying through the air. Gradually the group, with some changes, mellowed, and we had a group of friends who were as convivial as they were mutually instructive.

A higher level of administrative sophistication was attained. A publications division was formed, and our books were redesigned to make them more attractive. Educational book clubs picked up some of our titles. Following the lead of Random House publishing Kenneth Koch, other major publishing companies saw commercial possibilities in our books on education: Horizon published Marc Kaminsky, Doubleday Phillip Lopate, Little Brown Dan Cheifetz, McGraw-Hill Bill Zavatsky and myself. Teachers & Writers earned the reputation of a group willing to take radical steps in education, but also able to consolidate those gains.

Now that Teachers & Writers is a demonstrable success, we must face the genuinely interesting question: Where do we go from here? How long should we rest on our laurels? Should we change directions, redefine the group? In what ways?

Some questions can sometimes be answered by referring to what has become an increasingly popular phrase: the "bottom line," in this case, finances. Teachers & Writers has always been organized on an annual funding basis, partly because its most consistent funding sources have been governmental (also on an annual basis). It is easy to see why Teachers & Writers has never adopted a five-year plan. Perhaps it is time to do so, despite annual funding. Teachers & Writers could make a major breakthrough in public funding if it were able to develop long-term funding for long-term projects, the same way it has made such breakthroughs in public education.

You have finished your article. You will revise it, retype it, mail it to Teachers & Writers Collaborative and see it appear in their 10th anniversary book. You are glad to be relieved of the obligation. And it turned out to be fun to write. You are even weeks ahead of the deadline!

You put a paper clip on the pages, numbered in pencil, and start to straighten up the manuscript of your old P.S. 61 diaries. You had meant to consult them during the writing of this piece, but you never did. You just knocked the pile over. Straightening it up, your eye falls on the words "November 21, 1972. Today was wonderful, wonderful, wonderful." You flip through a few pages, then peek at the final page, a poem written by kids in Miss Perelman's kindergarten class, 16 May 1973. Suddenly you remember

Joyce Perelman, what a terrific woman she was, and how you didn't think of her as a "teacher," just a woman who was there with the kids doing whatever was necessary. You remember her Puerto Rican assistant, a really nice looking and pleasant young woman whose name you have forgotten. You remember the times you took 6th graders down to the kindergarten and had them teach the classes. You remember the pleasure you felt on seeing this work well. And your eyes go back to the page,

MOCO ["Snot" in Spanish]

Moco is a little cow
That comes out of the nose
He stands under your nose
And on top of your head
And on your ear
And on the floor
And he says,
"Rah! Rah! Rah!
Loco loco loco diablo!"

Latin Nostalgia
by Miguel A. Ortiz

When I was a child I loved to go to school. There were things about it that I didn't like, but on the whole I would rather have been in school than not. It was downhill from there. I hated junior high school. High school was a mixed bag, and college a complete waste of time. When I finally received my degree I was determined never to set foot in a school again. I could not imagine a more hateful profession than being a teacher in a school. So how did I get to be a teacher of poetry for Teachers & Writers Collaborative?

By the time I graduated from college I realized that I was totally unfit for business. Since infancy I had had a propensity for graphic arts, but had become disenchanted with painting. Upon graduation I was confronted with the practical problem of keeping body and soul together. I had a succession of jobs. For four months I was a caseworker for the Welfare Department. Ten months I spent with the Employment Service, as an interviewer. Those two were full time jobs. The others were all twenty hours a week maximum. I couldn't see spending more time than that earning a living. Besides I needed time to write. After the Employment Service I swore no more full time jobs. When I quit, I had nowhere to go and I hadn't saved a penny. I had no regard for security in those days. Funny thing about writing, when I had all the time I needed I didn't get any work done. When I didn't have any time I had a tremendous craving to sit down and write. Anyway, there I was with no job and no income. My friend Emmett Jarrett, a poet who had participated in a poetry program in the schools sponsored by the Academy of American Poets, had just received an invitation to be in the program again. He didn't have the time, so he said to me, "Miguel, why don't you go instead of me. Just call Betty Kray, and say you're a poet friend of mine." So that's what I did. I didn't have any other prospects. I didn't expect to get the job. I didn't expect that anybody would seriously believe I was a poet. I had about ten poems that I was willing to show anybody, and I had doubts that they were any good. (My doubts about those poems have now been confirmed and I'm glad nobody asked me, then, to prove my vocation by producing my poems.) To my astonishment there wasn't any procedure for hiring the poets who would participate in the program. (At least not one that was obvious to me.) When I called the Academy, someone said, "Yes, we're having a meeting. You're welcome to come." There were poets and teachers at the meeting, very few of us as I recall, perhaps ten or twelve people all together. We sat around discussing the teaching of poetry. I remember Paul Blackburn was there. I knew who he was because he had taught at City College, and a friend of mine had taken a class with him. I don't remember any of the other poets. At the end of the meeting Betty Kray suggested that the poets and the teachers pair up. That was it. I had a job. All I had to do was show up at the school once a week, spend the day teaching poetry, and I would get seventy five dollars. "Incredible," I said to myself, "Seventy five dollars for a day of teaching poetry." One day out of seven and I could make a living. I couldn't believe it. And I wasn't even asked to prove I was a poet. (I suspect now that some influential friend put in a word for me.) Of course I had never been in front of a junior high school class in the

capacity of teacher. I had no idea what I would do. Well, that's not exactly right. I had an idea. I would do what my teachers had done. As I recall I didn't have to teach these students how to write poetry. I had only to educate them about poetry—contemporary poetry, a subject about which school teachers are presumably completely ignorant. For seventy-five dollars I wasn't going to argue.

The teacher I was working with was Fred Herschkowitz from Joan of Arc. He made me a success. What his interest in keeping me afloat was I don't know. Maybe he was so totally into teaching that he decided to teach me how to teach. Maybe it was second nature to him. I'm sure that to another teacher I would have been just another burden. Maybe I relieved him of the responsibility of planning for that one day a week: all he had to do was salvage my poetry class, which was perhaps easier than generating one of his own. Or maybe it was a combination of reasons.

Fred was a marvelously energetic teacher. I caught the teaching bug. I found myself spending more and more time preparing for my poetry day. I was learning how to get through to the students. At the beginning the language I used to talk about poetry was usually over their heads. Fred would tactfully rephrase everything I said. Eventually I got the hang of it. But somehow poetry still eluded them. Why don't they perceive the power of these images? I asked myself. They don't translate words into pictures. How can I show them that it can be done? I decided to make a movie. I would take a poem and transform it into a moving set of images. That should do it. That would show them what they had to do (besides I wanted to make a movie).

I took Dylan Thomas' "A Hunchback in the Park" and adapted it to Central Park. I played the hunchback. My friend Barbara Grinell operated the camera. It took a whole week, working day and night to shoot and edit the film. It cost me twenty-five dollars to make the 8mm fifteen minute film. (Later on the Academy paid me seventy-five dollars to show it at a library so I made fifty dollars on it.) The film was a tremendous success in the classroom. That is, it was popular, though I doubt that it achieved the objective I had intended. I discovered one thing. Children love films. In school a film rarely fails. I decided to follow up the hunchback with "Pwacari, the Monkey." This is a South American Indian myth, which I translated from Spanish and adapted for the film. In this film I combined graphic art with live action. Barbara drew large illustrations of the story which we then shot and interspersed with live action played by members of the class. The illustrations were wonderful, and the kids loved seeing themselves on film. The story was good too, though again I couldn't tell whether they were into it specifically or just digging the fact that they were watching a film. "Pwacari" wasn't as good technically as "The Hunchback" but the kids liked them both. For me as well as for the students the films were the high point of my first term of teaching. On the whole I felt I had a good teaching experience. Fred and I got along very well and we managed to work as a team in the classroom. I was later to find out how rare and lucky for me that was.

The term came to an end. It was time for an evaluation of the program. That was to happen at a meeting with the poets and the teachers they had worked with. Only this time there were many more people there than at the meeting where I had been hired. The meeting took place in a library. Every-

one gave a verbal report on what his or her term had been like. A pervasive conflict between the poets and the teachers quickly surfaced. Fred and I were the only ones who reported a harmonious partnership. I was surprised at the time. Looking back I can only thank my lucky stars to have met up with Fred. We were each crazy enough to accommodate each other. For that short space of time our development coincided enough to allow us to cooperate with and complement each other. *

Marv Hoffman, the director of Teachers & Writers at the time, was at this evaluation meeting. He came up to me at the end of it and asked me whether I would participate in the Collaborative's summer program. I was overjoyed. I had been a little worried about what I was going to do for money once my stint with the Academy came to an end. I was once again surprised by the informality of the hiring procedure. I never spoke to Marv about what led him to hire me on such short acquaintance, and without any initiative on my part. I can only speculate that he was impressed with the fact that I got along with a teacher. I'm sure also that he was seeking minority people. Back in the sixties that was a significant factor in getting hired by a socially conscious liberal organization.

I worked the summer with a group in East Harlem, all the while wondering what was going to happen in September and not daring to bring up the subject with any of the Collaborative people. I was afraid to seem pushy. For some reason I got the impression that that wasn't the thing to be at the Collaborative. Or perhaps that one shouldn't be pushy in an overt way. Back then the Teachers & Writers office was in Brooklyn in a space donated by the Pratt Center for Community Development. The room was fairly spacious and one of the windows opened on a large back yard that was completely overgrown with vegetation. It was wonderfully green and refreshing to look at on hot summer days. September rolled around. I was in the office one day and Sheila Murphy casually said as I was about to leave, "I almost forgot to ask you: do you want to continue working with us?" I breathed a sigh of relief.

I had the sort of job I had been angling for, part-time but making enough money to live on, fifty dollars a week. Now I was going to sit down and write the great American novel. I sat down pencil in hand, a ream of paper at my side, but this masterpiece that had been for some time just on the verge of pouring out of me suddenly decided to go into hibernation. I prodded my psyche as hard as I could but all that came forth were a few piddly stories.

In the meantime I had become infected with the missionary zeal that was at the time part and parcel of Teachers & Writers. The Collaborative was a child of the sixties—a liberal organization that was dedicated to bringing

*Fred left teaching shortly after that, and we lost touch with each other. He became involved in more radical activities. I have always been more of an armchair radical. He always had to be in action. I have subsequently met up with people who have dealt with him, and they all agree that he is a difficult person to get along with, (I'm translating their comments mildly). I'm always amazed to hear that. I knew, when I worked with him, that he was not well liked by the other teachers. He was always pointing out the kinks in the system. He would not keep his mouth shut, and that frightened many people. I was fascinated by him, because I found it so difficult to be outspoken myself.

about momentous changes. It was the spirit of the times, the New Frontier and the Great Society. All the wrongs of the world were rightable, all that was needed was love and a concerted effort by all of us right thinking people who had suddenly discovered each other. Teachers & Writers was certainly part of that mood. It seemed to me that everyone working for the Collaborative firmly believed that the presence of one writer in a school was a powerful enough catalyst to precipitate the millennium in the public schools. This truly Romantic belief in the power of art and artists was an article of faith without which Teachers & Writers would not have gotten off the ground. I began to read educational materials, and my zeal was fired by Dennison's *Lives of Children* and Kohl's *36 Children*. Yes, we sensitive, aware people would, by setting an example, lead those backward, cowed educators into the glow of educational enlightenment. In a few years we will have brought about a revolution in the schools, and the schools in turn would revolutionize our society. Racism and economic inequality would forever disappear from the national scene taking along with them crime, war and mental illness.

My first encounter with public schools under the auspices of Teachers & Writers came that fall. I was given the names of a couple of teachers at P.S. 54 in the Bronx. I was to call and make all the arrangements myself. Of course these were teachers who had been involved with Teachers & Writers the year before, so they knew what I was talking about when I called them. They knew more than I did.

Thinking back to those early days when I was first with Teachers & Writers I am amazed that I managed to survive them. In a way it was like being a non-swimmer suddenly in deep water. Before I was given the name of the teachers at P.S. 54 I had explored other possibilities. Part of what the organization wanted to do was to be constantly on the lookout for odd places for the writers to work in. "Odd" meaning countercultural, community based, as opposed to mere "schools" which are, I suppose, bureaucracy based. I don't know what that distinction really means other than the eternal difference between the good guys and the bad guys. In any case, I remember searching for an art center run by the Whitney Museum. When I found it, under the Manhattan bridge, no one there could help me. No one was in charge. In any case, it didn't look too promising for a writing workshop. The center was a large space, in what seemed a condemned warehouse, divided into semi-private cubicles with easels and storage spaces for painters. The place seemed rather cheerless and empty. The people who used it came and went at different hours. As long as I was in the Lower East Side I decided to walk over to the Henry Street Settlement and look into their film program. The people there had a hard time grasping what Teachers & Writers was, but if they could get someone to work there for free, they were all for it, except that they wanted someone more than once a week. Once a week was all the work Teachers & Writers was willing to give me (and it was as much work as I really wanted).

Checking out these leads was somewhat disheartening. There was such a sense of disorganization wherever I went. I was all too familiar with community based anti-poverty programs run by whimsical wheeler-dealers dubbed "community leaders," as a group, the most unreliable and double-talking bunch of people I have ever met. But it was the sixties and everything was community this and community that. There was subtle pressure emanating

from the office which in my mind took on the guise of a party line to which it was wise to pay lip service. This party line had something to do with the innate wisdom and superior moral judgement of "the people." "The people" has always been a difficult term to define, because semantically it would seem to include everyone; politically it is used to distinguish, again, between the good guys and the bad ones. The bad guys are always the ones that are not "the people" or vice-versa. In our case "the people" was not anyone connected to the Board of Education nor school administrators nor even most teachers. The people are never middle class. I noticed also that "the people" were rarely white. I was glad to find that I was a "person," but I was always apprehensive that the definition would change. I was always self-conscious about the fact that I was not a rabid revolutionary. My desire for change is always coupled to a need to see the world function in a rational manner, whereas the rhetoric of most revolutionary sentiment seems to be anchored in anger. I could never write political poems, rail against landlords and capitalists. I was too absorbed in being in love, or lonely, or exhilarated. Not that I had no fantasies of throwing molotov cocktails at limousines full of industrialists. I had plenty of those. I grew up in the South Bronx hating landlords, policemen and doctors equally. But somehow roaches and rats never scurried across my poems. Probably because poverty was not the overwhelming experience of my life. I had religion, history, art, literature and a family life: all the things poor people are not supposed to have. My mother and father provided me with this almost by accident, but they provided it nevertheless.

Political and social stereotyping was but a minor strain at Teachers & Writers. I mention it only to point out that the organization suffered, however minimally, from the common effects of the sixties. Two of which were a propensity for asinine rhetoric and misplaced fervor. I was as guilty as anyone else of indulging in rhetorical double talk, and unrealistic expectations. But all things considered we did manage to do some good work. At P.S. 54 the children, some very dedicated teachers and I managed to produce several stunning films.

At the end of the year of working at P.S. 54 I felt I had had enough of the public schools. I had done some good work. I enjoyed the children but the atmosphere was stifling. The regimentation was more than I could take. The injustices that arose in the normal course of a school day were often horrendous—not because teachers were especially mean, but merely because the set-up of traditional schools is a brutal one. I don't remember feeling that way as a child. I only remember specific instances of injustice and brutality on the part of particular teachers. But I didn't perceive the system. Children are at a disadvantage in that respect. They tend to be aware only of immediate experience. Of course this is also their great strength, and something which schools, in their zeal to teach them to abstract, always try to destroy. The result is often an adult who will not see the trees for the forest.

P.S. 54 and schools in general depressed me. Sometimes I blame it on the architecture and sometimes on the administrative structure. But ultimately one reflects the other. There is nothing hospitable or comfortable about school buildings. There are no beautiful spaces, no comforting textures. Straight lines, heavy doors, wire enclosures dominate the decor. When children are allowed any degree of freedom of movement in a school building it always re-

sembles chaos, because the movement is seen in contrast to the architecture of constriction. The minute one walks into a school one is forced to deal with a rigid and unnatural order suggested by the building. One is immediately in conflict, and this is even before confronting the people who are committed to, and whose livelihood depends on, enforcing the system represented by the architecture.

I first attended a Catholic school in Puerto Rico. It was one long rectangular building with four rooms—a kindergarten, first grade, second grade and third grade. I don't know what happened when you finished third grade. Maybe one transferred to the public school. I remember they had just built a public school in my town. It was not well thought of. It was built of wood. The Catholic school was made of concrete. The school and the church were next to each other and they were both surrounded by an impressive iron fence. What is school anyway? When I was a child I thought it a place where one learned reading, writing, and arithmetic. But now I think: what was the iron fence for? and the concrete building? In fact many children don't learn to read and write and yet schools are not abolished. They are considered important and huge sums of money are spent on them. They must be doing something right.

I didn't see any future for me at P.S. 54 or in any school that was run that way. I had heard wonderful tales about experimental schools that were attempting to right the wrongs (I have a weakness for righting wrongs. And I guess I'm lucky there aren't any windmills about) of the public schools. I let it be known down at the office that I was interested in finding a more congenial place to work, namely an alternative school.

Just about this time the administrative staff of the Collaborative changed almost completely. Only the secretary Pam Seney remained. This was the first change of directorship since I had begun to work for the Collaborative. The assistant director and school co-ordinator also left at the same time, so with a new set of top personnel none of whom I knew, I was a little apprehensive as to how secure my job was. Common sense told me that new administrators like to put their own people in. It occurred to me that the best thing to do at a time like that is to stay put, maybe I should stay at P.S. 54 until I figured out which way the wind was blowing. My fears were put to rest when I received a call from Steve Schrader, the new assistant director, informing me that the Joan of Arc Mini-School had requested a writer, and it seemed to him just the sort of set-up I was looking for. We arranged to meet up at the school to get me started. This was already a new procedure. In the past I would have been given the name and number of someone at the school, and I would have had to make my own arrangements. I had not yet met Steve nor Marty Kushner, the new director. So this trip to the school had a dual function.

I met Steve at a storefront on Columbus Avenue between 96th and 97th streets. It had been an office of Teachers Inc., but was now serving as the headquarters of the Joan of Arc Mini-School. There were students lounging about the brightly painted room, papers were scattered all about, old textbooks were stacked here and there, people were coming and going. We spoke to Loretta Pitt, an English teacher who was in charge of trying to round up as many outside resources as possible for the English part of the program. I gave her my course description, and we decided that my class would meet on Tues-

day and Thursday afternoons. After that was settled Steve invited me over to his house for coffee. He lived nearby.

My teaching experience at the mini-school turned out to be the most intense one I had had up to that time. The circumstances were unusual from a personal side as well as an educational one. I was just emerging from a relationship that had slowly disintegrated, and which had received its coup de grace over a long and painful summer. My life seemed shattered. The school provided me with a focus, something to do, to draw me out of myself. My psychological disorientation had the side effect of producing a great deal of nervous energy.

My class became an immediate hit in the school. About twelve students were officially enrolled, but I generally had twenty to twenty-five students in the room. (There was an attempt, that first year, to run the school loosely enough to allow students to attend classes they were not officially enrolled in. This practice was not wholeheartedly accepted by all members of the staff, but it was, for a while, the official policy. As long as a student was in a classroom, it didn't matter what classroom he was in.) I was as astounded by the popularity of the class as was everyone else in the school. I had envisioned a low-keyed class with a few odd students who along the course of their school career had by chance become interested in writing. Writing seemed to me to demand too much discipline to be appealing to most junior high school students. I should have known better. I should have remembered my own adolescence, and how overwhelming had been the discovery that I could deal with my emotions by expressing them, even if it was only in the most guarded symbolism.

I had no preplanned writing course to offer. I didn't know from day to day exactly how the class would go. What I had was a goal I wanted the class to achieve. I wanted everyone in the class to feel comfortable enough to share with everyone else some intimate truth about him or herself. That, I felt, was the only way that a writing class could work successfully. Only if the students felt trusting enough of each other would they be able to write anything worthwhile. The possibility of communicating in comfort would spur the desire to write. I knew the feeling I wanted to create among the members of the class, but I didn't quite know how to achieve it. I thought back to the only successful writing class I had ever attended. It was conducted by Denise Levertov. She started off the class with a simple, effective activity, which immediately set the tone, and did a great deal to make the class as dynamic as it was. She had everyone in the room, beginning with herself, deliver an oral autobiographical sketch. "Just include anything about yourself you think important." The process picked up momentum as we went around the room. By the end of the two hour session there was a tremendous sense of cohesion and camaraderie in the group. I decided to begin my writing workshop at the mini-school in the same manner. It worked.

I managed to foster in the class a respect for self-expression. Every work was performed. The students picked right up on that, and they gave each class its own format. I always carried my tape recorder with me, and so they fell right into doing a radio show. An emcee would introduce each reader and do a little routine, the way disc jockeys do. From there it was a short step to doing dramatic improvisations. I tried to find situations of conflict that would allow them to express real feelings.

I stayed away from writing assignments. Almost all the enrolled students wrote poems and stories without being given any specific assignments. I tried to limit my role to giving suggestions as to how particular works might be improved. For instance: I would urge a student to use more details, or I would point out where words were redundant, where repetition instead of emphasizing merely weakened. Everyone wrote. Even students who had never written poems or stories before wrote at least one that I considered a sincere expression of a deep feeling in a fairly accomplished way. We put out a little magazine in which everyone in the class was represented. I made a linoleum block for the cover, a black man playing a guitar, and we printed it on a proof press Teachers & Writers used to have. It was more work than I had anticipated (I had planned to do all the covers myself), so I brought a group of students down to the office, and I initiated them into the fine art of printing. I don't always do things in the most efficient way. It would have cost only about five dollars to have a commercial printer run off one hundred copies of my linoleum block. I didn't know that. I thought the cost would be considerably more, and I was into saving the organization money. As it was I didn't even put in a bill for the expenses I did have. No one had made it clear to me that Teachers & Writers was willing to shoulder the extra expense of producing more elaborate publications than the usual mimeograph sheets stapled together that we had gotten used to.

I remember the work of each of the students in that magazine. It was unique among work I had received from students, because it dealt sincerely with issues and feelings that were on their mind. I didn't have the sense that they were writing for me, or because they were in a class. They were writers who met together twice a week to share experiences. Their work reflected the trust we had in one another. Susan Carr wrote a poem lamenting the excesses of hip culture, attributing the turn to drugs to the natural frustration resulting from the discrepancy between the ideals of the hippies and the reality of everyday life. For her that was a significantly different poem. She usually wrote very sappy cliche-ridden love poems. Mildred Diaz wrote two poems, her whole production for the term, but they were gems. She claimed that she had never written anything creative before. One of the poems was entitled "Have to Let You Go." It had the rhythm and expression of a popular song. I'm sure it was effortless; it came to her as leaves come to a tree. The second poem is a perfect expression of her character. The first line is, "I remember when he asked me out—" Then she goes on to talk about how her friends reacted, how they offered advice which she spurned, because she is her own woman and will do what she pleases. Diana Perez was a very sensitive quiet girl who knew her own mind and commanded respect through her dignity. She wrote poems about her struggle to find love and to communicate with God. But she had a sense of humor too and could write a parody as well as anyone. Then there was Yvonne Washington, our resident revolutionary. Her poems were full of rhetoric and vengeance. Her energy made her often the center of attraction. She was often disruptive, but once her energy was focused she became the sweetest child. Benjamin Bell was our major wit. He wrote a story entitled the "Female Conquerors" in which he satirized, but with due respect, the women's liberation stance prevalent among the white girls in the school. Last but not least was Maxine Kaufman. She kept a journal in which she managed to record

with inimitable humor the nuances of her relationships with family, friends and teachers.

The mini-school was an insane place. The energy level there was so high it would have registered on a geiger counter. It was a whirlpool on the edge of which I thought I could operate. Before I knew what was happening I had been sucked into the center, but I surprised myself one day when I realized that I wasn't trying to scramble out.

When I began working at the mini-school, I was possessed by a demon that I could exorcise only by constant activity. Work, I had to work from morning till night without stop. I had to tire myself out so that I might sleep in reasonable tranquility. If I wasn't completely exhausted I would not be able to sleep, and I'd pace up and down my two room apartment until the early hours of the morning. Or else I would walk aimlessly through the Village looking into the distraught faces of the quickly wilting counterculture. The school provided me with an opportunity to focus all of that nervous energy. The place was crazy enough to accommodate everybody's neurotic drive. That was simultaneously its strength and its weakness. The school was the brain child of two people: Alice Duke and Oliver Tweed. (The names have been changed to protect the innocent.) Alice was a whirlwind of energy. She raised the money, wrote the proposals, pulled the strings, blackmailed the bureaucracy. Whatever dirty work had to be done, that involved power, she did it. She was a Robespierre without a vision, a Lenin without a Marx. Oliver was the Romantic who wanted a school where children would have as much power as the adults. Oliver however dropped out of the program before it really got underway. That left Alice with a school dedicated to an ideal that was in conflict with her basic character. She had no respect for the rights and integrity of other adults, much less for children. Why she was so involved in setting up an alternate school I can only guess. I know for sure that she loved power and the games that could be played with it, the intrigue, the setting of one person against another. She was past master of creating a tempest in a teapot. The setting up of a situation where she could give scope to the need to exercise power and create havoc, while at the same time doing an inordinate amount of work might have been reason enough. She needed to work, she was obsessed with it. It was a sickness. I worked to exhaust myself enough to be able to sleep. She feared to sleep.

I of course was not aware for a long while of the destructive aspects of her character. At first all I saw was a heroic woman who worked hard trying to set up an ideal school. She battled all the old enemies, the bureaucracy, the apathy of parents, hostility of her colleagues. She looked always sad and exhausted. I rushed to offer my help. She accepted with charming gratitude. She knew how to manipulate.

The first few days I was at the school everything seemed chaotic. Everyone was constantly assuring themselves it was natural for an experiment to be somewhat disorganized at the beginning. Everything would quiet down in a few weeks. But it was obvious at a glance that organization was sorely needed. What nobody seemed to hit upon was the fact that organization doesn't just happen. Somebody had to make decisions, give orders and directives that would result in an orderly flow of events. Everyone had faith that that would begin to happen automatically at some point. What no one noticed, at least

not until late in the year, was that Alice had a stake in keeping everything disorganized, and that in fact the chaos was largely the result of her deliberate method of doing things. To her chaos was power. As long as the situation seemed overwhelming to everyone else she was indispensible.

Commitment was the byword of the school. I decided to be committed. I started by attending staff meetings. They took place at Columbia Teachers College every Tuesday night. I was treated to a display of explosive egos. Of course I was tremendously amused, and challenged by the situation. Rose, the reading teacher, was a regular spit-fire at those meetings. Everywhere else she was colder than an ice flow. At the school she did not leave her room to socialize with the other teachers. At three o'clock she left right away, and preferred walking to the subway with the students rather than with any of the staff. Sometimes she ate her lunch outside on the steps in front of the building. On several occasions when I came to school early and sat on the steps trying to start a conversation with her I had less success than if I had been trying to start a fire with wet twigs. But at staff meetings she was the only one who presented a coherent and rational approach to teaching.

The staff of the mini-school was a motley collection. No two could agree on methods or philosophy of education, much less on personal life style. The main part of the staff consisted, of course, of full-time Board of Education employees. There were six of them. The rest were student teachers from Teachers College and myself. Cliques began to form. The main one, that is, the one with the most power, consisted of Alice, Marvin and Loretta.

Marvin was the math teacher. He had a genuine interest and concern for the children, but he was not very inspired. Once he grasped an idea he could put it into practice after a fashion, but he could never imbue it with real life. He was an imitator, and he loved systems. He could set up a system and see that it functioned at the mechanical level. The failure of the system to provide for emotional and psychological variables was incomprehensible to him. For instance, he systematized his math curriculum into programmed lessons which the students might do in sequence on their own. Each lesson was on a mimeograph sheet. Whenever a student successfully completed one sheet he was ready to go on to the next. Success was measured by the number of right answers the student was able to provide for the problems on the sheet. Of course the students arrived at right answers in a variety of ways, a great many of which had nothing to do with understanding the mathematical concept the sheet was supposed to elucidate. At one point I sat down to tutor a student who was well advanced in the number of sheets she had completed but was ignorant of the fact that two sides of an equation are always equal. She could have muddled through the rest of the course, getting enough right answers, but never grasping this basic premise of algebra.

Marvin was of course proud of his system. He thought of it as innovative. Each student had a folder in which he or she kept the completed sheets which were color coded. Marvin was constantly dreaming up new and improved sheets. The folders were kept in milk crates which Marvin had scrounged and had had the students decorate. He was attempting to run an open classroom, and for that he deserves credit. It entailed a great deal of work which he never shirked. Perhaps in time he would have realized that the system lacked an essential component, his understanding of the learning process, and he would

have moved to remedy that deficiency.

Marvin, the school functionary, was less admirable than Marvin the teacher. In the running of the school he subordinated himself to Alice in a fawning way. He was content to be her lackey, to follow her lead as a puppy dog follows his owner. At times it was embarrassing to watch him. At meetings he would not venture to make statements until he had ascertained what Alice's point of view was on the subject under discussion. He would never take the chance of being opposed to her. On rare occasions, by some mishap, his misunderstanding of what she had said, for instance, he found himself in the predicament of having uttered a statement which contradicted hers. As soon as he realized what he had done he would be in such a muddle that the power of speech would fail him, and he would hem and haw through the rest of what he had intended·to say. He practically worshipped her. He would have dumped bodies into the river at her bidding.

Marvin and I connected in one way. We were both handy, and when the school moved from the Boys' Club on the East Side to the storefronts and loft on the West Side he and I did a great deal of the carpentry, plastering and re-wiring of fixtures. At that we worked well together. Out of that developed a course which we taught together, in the style of on the job training, "Mini-School Maintenance and Repair." Marvin could be fun. He was athletic, albeit in an ungraceful way, and his uptightness crept into everything he did. He had a three hundred dollar bicycle and he wouldn't let any of the kids touch it. When it rained he didn't ride. He didn't want to get his bicycle wet. That kind of attitude put a damper on the class, but on the whole he was fun and the kids admired his ability and his strength.

The third member of the ruling clique was Loretta Pitt. She was the one who had contacted Teachers & Writers. She was a conservative in her teaching approach. She considered her role in the school to be one of disciplinarian. Acting tough was her bag, and she played it to the hilt. She carried on a cat and mouse game with students, as well as with adults, being alternately charming and emotionally brutal. Students in her classes were in constant fear of being put down in front of their peers, but many of them loved her, and thought of her as a strict teacher, who really taught. Students who have assimilated the values of the system judge a teacher not by how much the student is able to learn, but by how much the teacher makes them believe they ought to have learned. This is one of the ironies of the system—that the slave begins to see himself through the eyes of the master. To Alice, Loretta was a foil to use against Marvin as Marvin was one to use against Loretta. The three made a perfect grouping for conspiracy and intrigue. Two of the other teachers Betty Bushman and Linda Jefferson never got too involved in the school. That is to say, they did not devote their whole existence to it, the way others did. They avoided entering into alliances.

The second major clique consisted of the radicals: Rose and a loose conglomeration of student teachers and volunteers. Loose because they shifted positions more easily than the power clique, so that it was often difficult for the radicals to present a united front. I allied myself to this group. At some point I found myself being its main spokesman along with Rose. My interest in Rose had stopped being purely educational, but that's another story, which I will tell some other time. Suffice it to say that my personal interest having

become entangled with the politics of the school I found myself spending seven days a week there, while still getting only fifty dollars from Teachers & Writers. Of course I did not fail to constantly point out to Marty and Steve how much time I was spending at the school. I'm sure they were duly impressed. Sometime during the second term I began to get paid for two days instead of one.

The first year at the school was exciting and tempestuous. Tallying up the results of constant work, constant politicking, a constant stream of crises any one of which, we thought, might spell the end of the school, many of us found that we had burned ourselves out. There were too many hard feelings for some of us to continue working together effectively. Many people left the school. The second year was but a shadow of the first. A third year was unthinkable for most of us. A complete turnover of staff had occurred by the beginning of the third and last year of the school.

What killed the school? The major ailment was lack of leadership. Alice, who had written the proposals and pulled all the strings, and who bore the title of project director, was not a leader. She was a manipulator incapable of inspiring or helping people to produce their best effort. Her method was to trick and manipulate people to get as much as she could from them. As they grew hostile to her methods, she discarded them. Any enterprise initiated in this manner bears the fruit of its own destruction. The second major flaw of the school stemmed from the first. There was no unity of purpose. The staff could not come up with a coherent philosophical line on which to base educational decisions. Contradiction was the general rule, so that the students were always getting conflicting signals. For instance, attendance policy was never clear. At first the standard rule prevailed. If you signed up for a class you were required to be in that class at the appointed time. Of course there was a great deal of cutting. The rule changed. You didn't have to attend the class you were enrolled in as long as you attended some class. But every teacher was not equally happy with this new rule, and some required strict attendance. Grading was another problem. Since the school was still part of the public school system numerical grades were required for the permanent record card. The school had decided to use non-numerical evaluation for the student's use, and individual teachers differed in their approach, some staying close to the numerical standard and others abandoning all semblance of it.

The different degrees of commitment among staff members was a source of friction. Those of us who were at the school constantly resented those who left at three o'clock. I must confess that I was guilty of this along with my political opponents. The one thing we had in common was a neurotic need to overwork. It was an insane notion that took hold during the sixties among radical educational groups, like Teachers Inc., the extremist form of which was that a teacher should be devoted to his job day and night without respite, that he or she should live within walking distance of the school, and spend large portions of time visiting the students at home and getting acquainted with their parents. This view was a natural consequence of the importance placed on school as a primary battleground in the struggle for social change. On the face of it, ten years ago, this belief sounded logical, though definitely unpleasant. Who can devote that much time and energy to such a selfless task and remain rational? At the Mini-School we suffered from this over-zealousness, and

we certainly were not able to keep our heads. Looking back, what we expected out of the struggle in the schools seems foolish. The real problem lay elsewhere. No amount of school reform would move us any closer to the solution. I don't mean to say that we should not strive to create more humane schools. By all means that task must continue, but let us not confuse it with social revolution.

POSTSCRIPT:

My desire to teach was at a low ebb after two years at the Mini-School. It was frustrating and discouraging to have a project with so much promise come to a bad end. Just about that time at one of the Teachers & Writers meetings the subject of how our publications looked came up. There was a general feeling that we were letting a good thing go to waste. The problem was that the publication part of Teachers & Writers was handled in a haphazard way. The Newsletter was like a stepchild. It got put together whenever there was a spare moment. It was not anybody's primary concern. Steve, who had succeeded Marty as director, asked, "Well, is there anybody who wants to do the publications as a full time responsibility." I had a vision of what the publications could be. It would take very little, I thought, to improve them immeasurably. I didn't immediately step forward. The job might take up more time than I wanted to give it. I allowed sufficient time for anyone else who was interested to speak, but no one did. "If nobody wants to, I'll do it," I said with a question mark in my voice. "You got it," said Steve.

Don't Just Sit There, Create!

by Wesley Brown

I'd always had this fantasy about having a job that would require me to impart my experiences writing prose and poetry to others. However, it didn't bother me that my dream gig went unrealized since I was comfortable brooding over the fact that my enormous gifts were not being subsidized. But change has a way of putting in an appearance just when you've gotten used to its absence.

I was sort of nonchalant about it when a few years ago a friend working with Teachers & Writers Collaborative got me an interview with the executive director, Steve Schrader. Since an interview is never a guarantee of anything, I figured at least it would be an exercise for my persona of, "I don't mind and it don't matter."

The interview was not the usual kind where 'the job' is this awesome responsibility that I must convince its caretaker behind a desk that I am capable of filling. But instead of talking about whether I could fill the job, our discussion centered around whether the job was adequate to fill me. I left the interview secure in my belief that my raw creative stockpile would continue untainted by contact with anything outside myself and remain a diamond in the rough.

But as is usually the case when you don't try very hard to be liked, you're more likely to make a good impression. Apparently Steve liked me, because he hired me. I resented the prospect of having an employer who demanded that I not only, during a prescribed number of hours, help children to somersault through one dimension of the creative process, but that I also get results. Like faith, creativity is often the substance of things hoped for and the evidence of things not seen. It couldn't always be summoned at a precise moment and be expected to show. But wasn't this the situation I'd always wanted to be in? So what was I to do? Dribble, shoot or pass?

Basically, I was apprehensive about eliciting from children the same impulses I try to wrench from myself. Over the last two years my experiences with children in this regard have been varied. For example, this year I've been having the kids I work with explore surrealism by writing stories that invest the commonplace with elements of the weird, the strange and the out to lunch. One morning I bumped some ideas around in my head that had some surrealistic possibilities: an adventure story about an around the world foot race called a World-a-thon, a mystery story about a disco where once people start doing the Hustle and the Bus-Stop, they are unable to stop, and an ill-timed meeting between Santa Claus and King Kong atop the Empire State Building.

At nine-thirty in the morning Maria, Loyda, Alisa, Alison, Roberto, Carlos and Allan charge into the writing room.

"How come you didn't pick us up Wesley? We been waitin for you," Roberto says, and immediately begins banging on the piano. Allan, who I believe is a member of Roberto's shadow cabinet, follows suit. One of the girls attempts to pound a taste on the keys but is spirited away with some punches by Roberto. The four girls break up into two groups. Maria and Loyda, who are both hispanic, push a table and chairs together for themselves. The two

other girls, Alison and Alisa, who are black, do likewise. Roberto and Allan, who are also hispanic, continue to crucify the piano with dissonance. Carlos doesn't join them but goes over to the windows and leans against a radiator. His features and his name suggest that he is black and hispanic. Isolation from everyone may be the price he is already paying for his divided experience. Less than a minute in the room and allegiances are already clearly defined.

"All right, Roberto and Allan, stop playing the piano a minute so I can tell you what I'd like you to write today."

"I don't wanna write," Roberto whines.

"You don't have to if you don't want to, but you have to stop playing the piano...Okay, today I'd like you to write a story about a race where people run around the world. And the race is called a World-a-thon."

"That's a stupid story," Allan says. "How's somebody gonna run around the world with all them oceans in the way?"

"That's why I want you to make it up. Use your imagination. It doesn't have to be true."

"Me, Allan and Carlos are gonna write the story together," Roberto says.

"You can do that if you want to."

"I know we can. I just told you."

"You need any help Alison?"

"Nope."

"What about you Alisa?"

"I dunno what to write."

"Just try to imagine—Allan leave Carlos alone!"

"He think he smart. I'm a hurt him."

"Wesley, come and read my part of the story."

"In a minute Roberto... All right Allan, I'm not playing with you. You're supposed to be writing not fighting."

"Ohhhh, Wesley think he cool cause he made a rhyme."

"Wesley, are you gonna read my story?"

"Yeah, I'm coming... Alisa don't run around, people are trying to concentrate... Roberto, I thought you wanted me to read your story."

"It's on the table."

"Don't you want to go over it with me?"

"I don't need to go over it, I wrote it!"

"Roberto, leave Maria and Loyda alone. They're trying to write."

"They ain't writin. They copyin off each other."

"Could you keep it down Roberto? It's getting a little bit too noisy in here."

"It's not too noisy for me."

It's easy to mystify the process of doing anything. But the similarities between my attempts at getting children to discover themselves through writing and my own are too striking to ignore. Both involve a lot of WORK. That's probably the reason I wouldn't have squawked had I not gotten the job helping kids explore something I have a lot of fun doing. But before writing becomes fun for me I have to make tremendous demands on myself. In other words I've got to kick my ass! What pisses me off about working with Teachers & Writers Collaborative is that for the fun of being part of the process of children bringing their world alive through language, I have to go through an-

303

other variation of an ass whipping. Often, what is thrilling me, is also killing me.

The question is: Do I need all of this? I'm afraid so. The chaos and distraction that are part of my work with children represent the same impossible situations I have to contend with in other areas of my life. The point is that certain facts of existence do not prevent our lives from giving off (to use Emily Dickinson's word) a phosphorescence that endures long after the facts are in. I am always impressed by how resourceful children are in shoring up enclaves of their own in the midst of everything to the contrary.

To dwell in the possibility of continually experiencing oneself in shapes that thrive outside the physical space of one's body is to do things the hard way. It is much easier to be lulled into a sense of non-participation in the world and not oppose representations of ourselves that could be easily reproduced on any Xerox machine. So much in our environment speaks to our need to be briefed by the official sources of perception and not rely on an intuitive grasp of our own lives.

My relationship to my own creative impulse is always a tortuous struggle of keeping sensation alive in myself at the same time that I'm trying to re-create it. And I need the opposition I get from children, as I stand over them, conveying in my manner, if not with my words: "Don't just sit there, create!" They probably suspect I know better. But in case I've forgotten, they create enough disruption to go along with their storywriting to remind me of the ambience that attends such demands.

A Love Letter To My Church
by Dan Cheifetz

However this turns out as communication, thinking about it has been worthwhile for me. I decided to do what I so often ask my students to do—to write out of the secret self. I tell the kids: don't be content with first thoughts; dig deeper, into thoughts and feelings that are important to you, but that you may be reluctant to express in public. These are what produce moving and worthwhile writing, because they are the most authentic, and maybe the most valuable things we possess; and the willingness to share them with others, although difficult, is the first commitment a good writer must make.

So I have gone as deeply as I can into my thoughts and feelings about Teachers & Writers and have come up with—not the objective critical piece I had originally planned but a (slightly abashed) love letter. For the truth is, I'm really crazy about T&W.

I often think, when I pass a New York City church, how almost miraculous it is that in the midst of the city's commercial crush, the absorption with getting and spending, there should be places set aside for spiritual expression. I reflect on the vast amounts of spiritual energy that must hover in churches (as the Reichians used to say about cosmic energy being concentrated in a well used orgone box) where so many people have communed with the Other in themselves, or Out There.

Something of this sense of a special place, unexpectedly set apart from commerce and competition and compromise, and devoted to another, higher plane of life, is in my feelings about Teachers & Writers. To explain the power of that image with me, let me talk a little about my background.

A child of the Great Depression, and the son of a failed but ever optimistic promoter-type father, I took in early his idea that the only real world is the world of commerce. "The business of America is business," said President Coolidge, who was in the White House when I was born. (It occurs to me that the administration one is born under may be an even more important life-influence than one's astrological birth sign!) The world of teaching and literature have never seemed, in my unconscious economy, practical places to make one's way in life. So I drifted into a succession of jobs, first in Hollywood and then on Madison Avenue, and today earn much of my living by free-lance writing of sales training programs and film scripts for corporations.

Yet that part of myself which is creative, experimental, playful, gifted at teaching and socially contributory (the part of myself I like the most), also found ways to express itself. I have written a children's book, plays, a book on creative dramatics and have conducted workshops on creative expression for children and adults for many years.

But though I found independent ways to express this side of myself, I lacked a support system for it. Spiritual leaders have told us how much those who seek to grow in the life of the spirit need the sustaining reinforcement of similarly dedicated people—"monks on the path" to share our journey with. On my path as sometime teacher and workshop leader, I needed, but rarely found, others who wanted—not to be authority figures or conveyors of mere information or of the establishment wisdom—but who genuinely wanted to

305

reach children; adults not afraid to expose and teach from the deeper reaches of themselves, nor afraid to experiment and take some risks, in the hope that they could make children less afraid to open themselves up, and thus help them develop into more whole, more open and self-expressive human beings.

I have found that kind of support with Teachers & Writers. T&W has provided me with a kind of personal "church" in which I have been nourished by the gathered creative and, yes, spiritual energy generated by the people of T&W during ten years of commitment and work. The part of myself which I like the most has found good soil to grow with at T&W.

One part of that part is my playful self. I like to play in my work, and my work for T&W gives me a chance to play: including the fun of bringing into the classroom the subversive idea that you can enjoy yourself, even in a classroom. Somewhere in his study of American schools, Christopher Jencks wonders why, since we spend about a sixth of our lives in school, we aren't allowed to simply enjoy ourselves more while there. One obvious reason is, the still powerful puritanism that insists kids are in school to work—that playtime is over after age five or six, except during brief "recesses." Another possible explanation is that so many elementary school educators seem to be in their careers primarily to feel themselves as powerful. Letting children play—that is, letting them be themselves and do what *they* want to do sometimes—threatens the adult's need to be all-powerful and always in control.

But aside from the factor of enjoyment, it is my conviction that play is not one of life's extras. We, adults as well as children, have a most serious need for play. That's not a new idea, of course. J. D. Huizinga (in *Homo Ludens*—Man the Player) speaks of play as almost an instinct, a fundamental expression of the human spirit that is suppressed at the individual's, and at society's, peril. He says the playful impulse lies at the base of "the great archetypal activities of human society," including language, the law, science, ritual, art and philosophy, as well as the drama and sports. And, of course, the seminal work of Dewey and Piaget, and others, has shown how vital play is to us in the learning process.

In the elementary schools I've taught in, such insights are rarely put into practice at all. And, from what I've read of American education in general, that is the common experience. Feeling about play the way I do, this lack is the aspect of early education I personally lament most. But, because I work for Teachers & Writers, it is an aspect I can personally do something about, in however limited a way. I can help the children I teach to value their own playfulness. I can also help children break out of and go beyond their play *rituals*. Playing the same game, in the same way, over and over, is fun, and reassuring, but growth and creativity are missing. So I try to find ways to help children focus their playfulness, and combine it with their intelligence and imagination; to help them learn how much fun it is to play with words, ideas, images, numbers, dreams, roles. That way, they can learn to synthesize known elements into fresh combinations, and ultimately have the satisfaction of creating something new out of themselves.

In sum, I love T&W because it gives me the chance to play, and to play usefully. But the most important reason for my good feelings about T&W these days is that it has helped me evolve as a person, as it has evolved as an organization, and in my evolution to find out what I want most to teach.

Since T&W exists outside the educational establishment, it has been relatively free to set its own teaching criteria. Or rather, to *re-set* its criteria, since as an organization it has moved far beyond its original purposes. The many areas we're into today—film, videotape, drama, fine arts—attest to that movement. And since T&W is continually changing and growing, we as members are tacitly encouraged to change and grow.

More important, I like to think that T&W, tacitly or not, encourages each one of us to teach out of our most authentic selves, and out of the significant experiences of our lives, as well as using our special talents in the arts. To me, this is the most valuable kind of teaching for children. Kids often are cut off from the feeling lives of adults, since we're so self-protective, so embarrassed by our humanness in front of others, especially children. Kids also rarely get the benefit of what adults have actually learned in their lives—learned not from books but from our own experiments, mistakes, triumphs. If kids sense a teacher is willing to expose his fallibility and vulnerability to them, and to share some of the hard won insights of his own life, they will respond to that teacher. The teacher becomes a reachable, human model for them, something they need much more than a distant authority figure.

Whether the above describes the teaching model that T&W sets up, or it is largely my own, doesn't really matter. The point is that T&W's special atmosphere has permitted me to take this model for my own, and it is a model that has led me to new ground.

I began with T&W in a Harlem elementary school as a workshop leader in creative dramatics. As I went along, I realized that—along with helping kids have a chance to play in school, and helping them express their intuitive, creating selves—I was very interested in helping them develop some skills that might let them manage their lives better.

The cry today is "back to basics" but I know no more essential learning than how to live one's life with fulfillment and purpose. The skills to do so are rarely taught in the home, and almost never in school. I mean such skills as learning how to assert one's rights and one's needs with dignity and without self-defeating aggressiveness; how to get in touch with one's personal powers and how to use them to get what you want; how to take responsibility for one's actions; how to relate better with other people and how to communicate clearly and effectively with them; how to set goals and meet them; how to organize work; how to be a leader; how to work productively in a group.

It has taken me a lifetime to learn some of these skills. For example, over the years I have learned (the hard way) how to deal effectively with people in power so I can get some of the things I want from them. I have discovered what behavior works in a certain power situation, and what doesn't work. The skills I have developed out of such learning, combined with my study of the methods of others, have helped me create the beginnings of a curriculum on this subject. It is my belief that such skills for living can be taught (as a friend of mine put it) as dance steps can be taught.

My teaching method is to first bring the issue to the kids' consciousness. Taking the power and self-assurance issue as an example: I have the kids role-play, in pairs, powerful people and less powerful people—e.g. principal-teacher, teacher-student, master-pet, etc., then switching parts so as to feel what it's like to be, in turn, overdog and underdog. Other activities—such as

writing a personal bill of rights or getting a chance to lead the group for a while—teach them more about power and its responsibilities in their own lives. Then they might act out how they characteristically ask a parent or other adult for something they want, and in the process become more aware of how they now deal with the problem of power and self-assertion. By working with them, I can help them learn how a change in their approach (switching, say, from throwing a tantrum to trying gentle persuasion) might help them get what they want more often.

The creative modalities—writing, drawing, play-acting, etc.—can all come into play with such teaching, with the ultimate goal for the child the supreme creative objective—the creation of oneself. As for the continuing creating of *myself*, such teaching has helped me integrate my pragmatic, worldly self with my creative, experimental self—mainstream meets inner stream.

Getting all these goodies for myself, is it any wonder I love my "church"? However, a church must be fed and supported. Love is a two-way street. Recently I gave a workshop for other members of T&W about what I do with kids, and their enthusiasm indicated I was making a good contribution to their own teaching insights. It was satisfying to feel I could give something back for all that I had received.

Pausing, and Looking Back
by Alan Ziegler

PART ONE Spring 1977

In the past few years I have conducted creative writing workshops with students ranging from six to eighty years old, in such places as public schools (including my former elementary and high schools), community libraries, colleges, P.T.A. meetings, and senior citizens centers. I've had one-shot sessions with groups as large as sixty students, and at the other extreme I've met once a week with a single student for a school year. I've gotten quite familiar with the subways, buses, commuter railroads, and cabs in the New York area. Most of my workshops have been sponsored by Teachers & Writers Collaborative, N.Y. Poets in the Schools, and Poets & Writers, but I've also done sessions for groups with names like Young Visitors and Sub Sub.

Until I began teaching I never owned an appointment book. I was able to remember everything I was supposed to do—occasionally resorting to a note on an index card in order not to forget a distant engagement—and I never missed appointments. But it didn't take me long to realize the necessity of a well-coordinated schedule mapped out in a tidy calendar book. If it's Tuesday it must be Yonkers because Wednesday is Lynbrook and Thursday is Spring Valley.

I must be careful with the amount of work I take. I get jobs teaching writing workshops because I'm a writer. The fundamental principle underlying these programs is to let writers preach what they practice. I must allow room in my schedule for writing, thereby limiting the amount of money I make, in order to do something that brings in precious little money. The irony stares us all in the face: we cannot make a living writing poems and fiction, but we can make a living helping others write poems and fiction. Presumably, some of our students will also wind up not making a living writing but teaching others to write, who will then...

The result will be an exponential growth in creative writers until the government starts funding deprogramming projects.

This, of course, is facetious, the kind of talk writer/teachers share over a beer when they are overscheduled and underwritten. We're fortunate to have this work. For me, teaching is not at conflict with art but is itself an art form. The same creative energy that fuels my writing also contributes to my teaching. I must constantly find ways to "make it new." I deal with writers block on a mass level; instead of struggling with the finish of one poem (my own), I often have to help many kids simultaneously weave through their creative fabrics until they each have something they would be proud to own. I experience the same kinds of ups and downs in my teaching as I do in my writing. Sometimes I'm "on" and everything is clicking and the room almost glows with energy. Other times I'm "off" and have to draw on my professionalism to complete the task.

Usually the teaching feeds into and out of my writing. If I am excited or troubled about a piece I am writing, perhaps I'll talk to my students about it, thus clarifying my own thinking. There are times when I'll discover something

new about literature in the course of working with a class. Of course, there are also those moments when I am exhausted with language, indifferent to imagery, and / or more concerned with my needs than with those of my students. Teachers are somewhat like psychologists. You must be sympathetic to students you may not personally like, and you must respond freshly at times to work that, although special and important for the student, is something you've seen countless times.

I feel good about my chosen work: writing, and teaching writing. Language and people are the two intertwining components of my work, and both writing and teaching instigate and accommodate the whole range of emotions. Both can be precious, volatile, fluctuating, surprising, and disappointing. In both writing and teaching, you can alternate between having control, relinquishing control, and sharing equally; it is the wise writer or teacher who knows when it is appropriate to "be in charge" or to "let things happen."

It is always instructive and / or comforting to be able to talk with others who engage in the same tasks as you do. "Shop talk" appeals to almost everyone; we all want to learn from others and share what we've learned, and we all need simply to get some things off our chests. We share teaching ideas, but it is also important to share jokes and frustrations. For most among the new breed of touring writers and artists there isn't ample opportunity to meet with colleagues. My association with Teachers & Writers Collaborative has been a treasured one because it provides me with a home base and what at the best times seems like an extended family. Also, Teachers & Writers Collaborative works in extended teaching situations—you become, in effect, an adjunct faculty member at your schools—a needed balance to my "free-lance" work.

In the abstract, Teachers & Writers Collaborative can be an intimidating group. Each member has achieved a degree of distinction in his / her art form, as well as in teaching. Because I had only been writing poetry for a couple of years, and had just a dozen days' teaching experience when I was hired, I was particularly nervous about my new colleagues.

Virtually every article I had read by a Collaborative member was articulate and inventive. But they also often displayed qualities of vulnerability and questioning; teaching creativity was presented as an unfolding situation, with its highs and lows and no set of absolutes. Life in the classroom is no textbook fantasy, as I was quickly learning. This image of honesty projected through T&W's publications eased my intimidation somewhat, but it even seemed to me that T&W people were better at being honest than most of the rest of us. So, it was accompanied by an entourage of butterflies in my stomach that I went to my first T&W meeting, at the apartment of then-associate director Glenda Adams, in September 1974.

I had just begun working for the Collaborative at P.S. 11 in Brooklyn, along with artist Barbara Siegel and novelist Richard Perry. Barbara was also new to T&W, and the two of us sat together on the couch and talked about P.S. 11 while we sneaked glances at the socializing going on around us before the meeting was to begin.

Many had not seen each other over the summer, so there were the hugs and smiles of a reunion. It was heartening to see such a close group, but I wondered how long it would take me to feel a part of it. I wanted it to happen right away but knew it had to come slowly and naturally, otherwise it

wouldn't be a genuine closeness. I wondered if anyone would notice the "new kids on the block."

It didn't take long. Karen Hubert—whose articles I had particularly liked for their human quality—came over to Barbara and me and said, "I don't know you two...but I'd like to." The process had begun.

At my second meeting, Karen said something else which made a big impression on me. She stood up and announced that she'd have to leave the meeting early, but that she wanted to say that she had a lot of warm feelings toward the group. Then she left, not explaining any further. It seemed to me an extraordinary thing to say to a group of people, and yet this is a group that deals in a large part with the expression of feelings, so it was quite appropriate.

In January of my first year with T&W, Steve Schrader called to ask me if I would do a lengthy piece on the Collaborative for *American Poetry Review*. I accepted, partly because it would give me a chance to talk with all the members about their work and their relationship with the Collaborative. Also, here was my chance to speed up my assimilation process. One by one, each person confirmed to me his/her feeling of connection to and freedom within T&W. Each person felt an implicit demand for hard and good work but was secure that it was up to each individual to decide how to define and pursue his/her objectives. (The only form of discontent I heard was a nostalgia for the conflicts of the late sixties and early seventies, and the thought that perhaps our stability and hominess were at the price of not dealing properly with social issues. I had an ambivalent reaction to this. I had been active in the student movements of the Sixties, and missed talk of lofty goals. But it was also a relief to be involved with a group that didn't fight a lot within itself, and didn't have a distorted notion of its capabilities for social change. Perhaps T&W's work is its ideology.)

It took me a while to feel totally comfortable in the Collaborative. I was given the room to grow and develop, but I still had to grow and develop. It was not until I proved myself (to myself) in the classroom, that I felt I really belonged.

I didn't plan to be a teacher of creative writing any more than I planned to be a creative writer. I arrived at each from a chance opportunity that acted as a catalyst for desire, determination, and talent.

I wasn't the kind of child who had a treasure chest of special books; I didn't sneak into a corner after dinner and write poetry or my autobiography. Until after college, most of my writing was journalism. My first fling with journalism came in fifth grade because I couldn't sing—or so the music teacher determined. He selected all but five of the kids in my class to be in the chorus. My teacher, perhaps in order to soften the blow, made us the newspaper staff. I carried on newspaper writing throughout high school and college. My attempts at creative writing were mostly confined to song lyrics. During the spring of my senior year (1970) I began writing fragmentary poems (influenced by Richard Brautigan) during brief respites from the campus protests I was involved with. Two days after graduation I embarked on a career as a newspaper reporter.

My newspaper career lasted only a few months. (In a scene reminiscent of a grade "B" newspaper movie, a senior editor advised me to "be a writer" while I was young and could deal with insecurities and frustrations.) I moved

back to New York City, thinking I would write in-depth, novelistic, investigatory, sensitive journalism. A friend told me of an ad in the Village Voice for a poetry workshop conducted by David Ignatow at the 92nd St. "Y". You had to send in six poems; 12 people would be selected. I had harbored secret "poet" fantasies, and I thought that the workshop could also help my prose writing, so I sent in six of the little poems I had written. I was accepted into the workshop, and my life changed. Journalism stepped into the back seat, and poetry got behind the wheel.

This is over-simplified, but I tell it because it is crucial to the attitude I bring into my workshops. I consider myself living proof that poets are not a separate breed of people recognizable at an early age. For many of us, an encouraging and sympathetic teacher can be of enormous help in our poetic growth. For me, it was David Ignatow in 1971. But who knows? If my fifth grade teacher had decided that those not selected to be in the chorus could be the poets instead, and there was a group like Teachers & Writers Collaborative in those days to send someone to work with us, I might have begun my poetry career a lot earlier. So, when I go into a classroom, it is with the belief that *any* kid, despite previous signals, might connect with poetry, and that *every* kid is capable of creative expression.

My beginning as a teacher was also partly a matter of circumstance. I had heard of people who taught poetry writing to children, but I had never worked with kids in any capacity and thought that I would need special training to attempt it. One afternoon during the fall of 1973, Stuart Milstein called and asked me if I could, on short notice, do a few poetry workshops in a Brooklyn elementary school, filling in for someone who had just dropped out of the program Stuart had organized. I was scared, but I said I'd try it. Stuart told me that Teachers & Writers Collaborative had some publications that might be of help.

There wasn't time for me to send away for the books, so I went to the T&W office, which was then a donated room in P.S. 3 in Greenwich Village. Entering the building, I realized I hadn't been in an elementary school for 16 years. The sounds and smells seemed eerily similar to my old school so many years and miles away, and immediately I felt younger and smaller. I knew T&W's office was on the fifth floor, but I didn't know which room. I poked my head into several classrooms before I found someone who pointed me in the right direction. Going up stairways and through halls gave me the *deja vu* feeling of somehow doing something wrong—a vague sensation that rose from my sense-memories: going up the down stairs, being in the hallway when you weren't supposed to, etc. By the time I found the right room, I was exhausted and having second thoughts about making a reappearance in an elementary school disguised as a teacher. The kids wouldn't believe it for a second.

The Collaborative office was a classroom with stacks of books, envelopes, and papers. I walked in and shyly introduced myself to a man who was composing a letter. It was Steve Schrader. I told him about the program I was going to be working in and asked him exactly what was Teachers & Writers Collaborative. He set aside his work, gave me coffee, and talked to me about their work in the schools.

I left the office with a pile of free books and an embryonic feeling of my

312

future within me. My sessions in Brooklyn were difficult but incredible, leaving me hungry for more. I participated in a T&W-supported training program led by Bill Zavatsky for Poets-in-the-Schools, and hooked up with my former elementary school for a series of workshops. I learned as I went along, the best place there is to learn: in front of a class. I submitted an article to the Teachers & Writers Newsletter. It was rejected, but Steve asked me if I would be interested in working in a school in Brooklyn the following fall.

So, when I meet someone who wants to do this kind of teaching but feels like an extensive background is needed, I respond the same way I do when someone says, "I'm not a poet," which is: "See what other people are doing; try it yourself."

Things happened quickly for me. When I started with T&W, I had just begun doing workshops for Poets-in-the-Schools, and I also began teaching writing in the City University. I had been making a living as an editor of an ecology magazine. Now I was a full-time teacher.

When I made my first appearances into classrooms, I always knew what I was going to do with the class. My own creative pride, bordering on stubbornness, was such that I rarely went in with an "exercise" lifted directly from a book or from another poet, at least not without a twist or variation of my own. Whenever possible, I tried to do things I had conceived myself. I might later find out that something I thought I had invented had already been done before, much to my annoyance.

Gradually, my presentations became more complicated, with more possibilities for writing. Forced to address large groups in other teaching environments, I worked mostly with seminar-size groups for Teachers & Writers, where I was able to deal more with individuals. I had an obsession to type immediately every good poem written by one of my students, so they wouldn't vanish into the air like unrecorded jazz improvisations, and so I could share them with other students.

As soon as I had developed a full bag of "teaching tricks," I realized that I often didn't use it, that teaching creativity means teaching creatively. It has less to do with formulas and more to do with human beings and familiarity with such processes as discovery, recall, adaptation, influence, connection, manipulation: the use of language to create, re-create, and, not to be forgotten, recreate.

My T&W sessions were like laboratories for me, where I was able to explore and experiment. I was also able to work in different forms. For example, I had a group that was doing acceptable writing, but their writing didn't compare to the excitement I heard in their voices in the hallways and out on the streets. One week I brought in a tape recorder and started doing dramatic improvisations with them. The kids opened up tremendously, and the results were reflected in their subsequent writing, long after the tape recorder was put away.

As I said at the beginning of this article, I've been to a lot of places, with a lot of students. In Part Two I will take a closer look at some of them.

PART TWO

What follows isn't about teaching writing per se, but about some of the

313

Alan Ziegler with student.

people I have known. Most of these sketches were adapted from my journal of my first two years teaching, and I have emphasized difficult situations. A lot has been said about the "magic" of teaching poetry; as any magician will tell you, magic is not easy.

* * *

There are moments in teaching one cannot prepare for, or even antici-

314

pate. At a workshop with a group of senior citizens, a woman was writing along at a good pace. She stopped suddenly, an annoyed look on her face. She looked up, as I'd seen so many other students do, as if the next line might be written on the ceiling. I walked over to her, confident that I could help her out of her literary *cul de sac*. So many times before I had been able to say the right thing to help students find a way of continuing a piece of writing; after reading what they have so far, I would ask them the question(s) I might ask myself if I were the author.

But in this case there was another factor. I read her incomplete poem and started talking to her about what might follow. It didn't change her look of annoyance.

"I can't write anymore."

"Do you follow what I'm saying?"

"Oh, yes, I have plenty of my own ideas, but I can't write anymore."

"I don't understand."

"I just can't write. It's this thumb, it goes dead on me."

I offered to take dictation, but she wasn't able to verbalize her ideas.

"I want to *write*."

There was nothing either of us could do but wait till her thumb stopped playing dead.

* * *

Before my third session with a 4th-grade class, I ask the teacher to point out any kids having trouble writing, who I might otherwise not notice. During the writing segment of the class, she points me toward a girl with a shine to her hair, Shelly. You notice her hair because she is covering her face with it, as she leans over her paper. I walk over and see that the paper is blank. I talk to her but she is silent. When she finally speaks, the words come out slurred— perhaps a speech impediment, perhaps carelessness. I ignore other demands on my attention and spend most of the class with her. A challenge. Shelly says she has nothing to write about. I ask her if there's anything or anyone that she feels strongly about, either love or hate or disgust or attraction. Finally, she confides that she does like her mother and her cat. After a few more minutes of conversation she writes a simple little poem about her mother and her cat. Shelly and I have both met the challenge. The teacher is impressed; Shelly has written a poem.

During succeeding visits, Shelly becomes more than a challenge. I am getting to like her, and she is getting attached to me. We have long talks, and since Shelly usually doesn't talk much, the teacher is anxious to know what we talk about; does she talk about her family situation—rumor has it that her mother has a new boyfriend. Actually, Shelly and I don't talk about very important things; it is just important that we talk. When I see Shelly in the halls, she runs up to me, smiling. When she smiles, she looks attractive, and I have begun to think of Shelly as an appealing student, one whom I like to spend time with.

One morning I see her at the other end of the hall. She doesn't see me. A boy accidentally bumps into her and then shouts out to his friend, "Someone get me the Cooty Gun! Shelly touched me! Hurry, the cooties are all over

me." Shelly hears this and continues on into the classroom, without changing the expression on her face.

I am horrified, partly at the cruelty of the situation but also at Shelly's nonreaction, as if this were a common experience, nothing to get upset about. Perhaps it tears at her insides, but she is unable to let it come to the surface without making herself even more vulnerable. I feel like twisting the boy's arm behind his back, pushing it upward until he apologizes to Shelly. But I realize that even nonviolent coercion on my part would reduce any apology to hollow words. And if I talk to the boy, it might just give him another reason to resent Shelly.

I resolve to speak highly of Shelly in hearing of other students—to use my position of prestige to heighten her class standing. I want very badly for Shelly to write terrific poems so I can read them to the class. But Shelly does not write terrific poems. She tries hard, but perhaps she is simply not capable of it. A learning disability, the teacher calls it—a phrase that has always struck me as a self-fulfilling prophecy. But Shelly does her best and improves, and I have to distinguish what is progress for her from what my ego wants, which is to turn her life around.

One day, I criticize Shelly's poem, thinking that she has become complacent due to my support. When I come back into the classroom a few minutes later to tell the teacher something, I notice that Shelly is crying. I go over to her and ask her if I said something that hurt her.

"I hate you," she whispers and returns her head to her desk, where it occasionally trembles with soft sobs.

I walk away, myself near tears, remembering the "Cooty Gun," worrying that I have become one more tormentor for her. But I convince myself that she says she hates me because she's probably afraid she likes me too much. I still feel badly.

The teacher comes over to me and says, "Shelly cries a lot. Always tears. The best thing is to ignore them. She'll be okay in a few minutes. Oh, I heard that Shelly's mother is getting married again and they're moving away from here soon."

Later, I see Shelly in the remedial reading room, a place where she thrives with the small group and sympathetic teacher. I ask her if it is true that she is moving. She begins to cry again.

* * *

When I walked into the classroom to pick up my group, I noticed that there was a substitute there. I also noticed there was more than the usual amount of screaming going on. Then I noticed the fight. There were fights when I was in elementary school, but I can't remember them happening in the classroom. Perhaps brief flare-ups, but retribution would be severe. One of the fighters—the one obviously in control—was Kenny, from my group. I helped break them up, and held Kenny back for awhile. When I let him go, he went after the other kid again, and I had to grab him. The room was in chaos, but I was able to get my group together and get them down to the writing room, although they carried with them the tension and excitement from the classroom. I told them that I didn't know what had happened upstairs, and if anyone wanted to say anything about it, they could; otherwise I wanted

316

them to forget it and get down to work. Kenny was pacing around, furious. I told him I'd speak to him in a few minutes. Then I noticed that Theresa was crying.

"What's the matter?"

"I bit my tongue."

A few kids started to laugh, but a couple of others defended Theresa by affirming how painful that is. Theresa said she wanted to see a doctor. Kenny was still stalking, and the rest of the group was talking. I took Theresa out of the classroom and ran into the assistant principal. I asked him where the nurse was, remembering there was always a nurse in the building when I was in elementary school. "Nurse? She comes in one day a week, what's the problem?"

He told Theresa to go wash her mouth, that she'd be all right. She came back in the room, teary-eyed but "feeling better." Theresa, a large girl, tends to lean against other children as she writes. She sucks her thumb. Was her bleeding tongue the real reason for her tears? Why did she bite her tongue? I just don't know these kids well enough, yet. Can I ever, forty-five minutes a week?

Meanwhile, there was Kenny to deal with. I got the group writing, and said to Kenny, "You look awfully mad. Do you want to tell me about it?"

He said no.

I asked if he wanted to write what the others were writing.

He said no.

I smoothly adapted to the situation and asked if he wanted to write about anger, or revenge.

He said no.

"What do you want to do?" I asked, all out of suggestions.

"Go back up to the classroom," he replied.

I was surprised, since I had told them that "going back up to the classroom" was the only form of punishment I would use with them.

"How come?"

"So I can kill that kid."

"Oh, well, I don't think I'll let you back up now. I don't want any murders during my time. I'd have to go to court as a witness and it would take too much time."

Kenny almost smiled, then spent the next ten minutes trying to convince me to let him back up. He told Thomas that he was going to "kill that kid" and asked someone else to dig a grave at lunchtime.

Finally, Kenny looked at me and said, "I'm not going to convince you to let me up there, am I?"

I said no.

There's more to this teaching writing than meets the muse.

* * *

I was teaching a remedial writing course in a branch of the City University. Some of the students bordered on illiteracy; all were uncomfortable with the written code. It was a Saturday morning class, comprised mostly of adults back for a try at college after years of working and / or having families.

I had the class do a lot of creative writing, on the premise that if they could get excited about writing—perceive writing as an opportunity for clarifi-

cation and release of feelings and experiences, and as an opportunity to *make* something with words—they would be better motivated to go through the rigors of learning the technical aspects of the language.

Midway through the semester, as we approached the standardized test for admittance into the regular English courses, I started emphasizing grammar. I wondered if the time we had spent on creative writing would have my anticipated effect. Most of the students did well—though not as well as I'd dreamed—and at the end of the semester we had a party. I was talking to one of the younger students, who was telling me he was going to do reserve duty in the army but would return to school the following semester. Then he looked at me with a distracted glint in his eyes and said, "Do you ever get the feeling that you just gotta drop everything you're doing and write a poem?"

"Yes," I replied. "It's one of the most exciting moments in writing, that sense of urgency."

"Well, that's what I'm feeling right now," he said and stood there, as if awaiting permission from me.

"Go do it," I said.

He went into a corner of the room and wrote into an abandoned exam book. He returned with this poem, which he gave me as he said goodbye:

TEACHERS

Teachers where did they
come from, like the winds
of this world, blowing north,
south, east, west, being kind,
cruel, happy, heartbreaking.
Always moving, going one way, then
another. Where do they come
from these winds of learning?
Touching our lives but for
a few hours a day but
changing us, shaping, like
the wind blowing sand
always changing it. Where
do they come from these
winds of learning? Are they
human? Where do these
winds of learning come from?

By Laverne Williams

* * *

Until today, I never yelled at a class. Instead, I used reason, psychology, or obliviousness to deal with disorder. But today the group really got me angry. I felt it building up in me during the first half hour, and finally heard myself saying, "Damn it!" There was a moment of stunned silence, then the responses:

"Hey, you said a curse." "We're going to tell." "That's a bad thing to say." They began giggling, perhaps thinking that they now had something "on" me.

318

Their disregard for my anger got me furious.

"You think it's funny, would it be funny if I said it again? Damn!"

Again there was giggling and taunts, although this time a bit more subdued.

"Still funny? Okay, damn damn!"

Now it was silent except for nervous shuffling. I continued: "Damn, damn, damn, damn, damn, damn."

The silence was now complete. Finally, someone said, "Hey, Alan's really mad."

I went on to explain that I was mad because my feelings were hurt at their disregard. We had a good talk. In a few minutes things were back to normal, and I realized that this is the way they are used to settling things: someone gets mad, an argument or fight starts, and soon it is settled and forgotten. I realize that I am not a child and cannot always deal with things this way, but I have to admit it felt pretty good.

* * *

It's the last day of a six-day residency. I have already said goodbye to two of my three classes. Something was missing in the goodbyes—a sense of separation. I've long since stopped looking for a sense of completion after a short-term residency. In fact, it's the feeling of incompletion that indicates something has been accomplished: the feeling of things forming without the opportunity to grow to maturity, but of something wonderful having begun.

This is a part of the short-term residency experience. One does not have the time to explore in depth the possibilities of language, or of human relationships. I meet a lot of people, and we separate while our relationships are still brewing. I have had goodbyes that are both sad experiences and affirmations that the children have discovered something they value during my time with them. I always hope we can see each other again. If not, I hope there is something that endures in memory.

But this day I have not felt anything strong from the first two classes. They seemed preoccupied. Perhaps they were being defensive, not dealing with the fact that they probably will never see me again. Or perhaps I just haven't been all that important to them, and there is little for them to miss.

I have felt sluggish all day. The kids have an inability to spell coupled with an obsession with correct spelling, a combination that resulted in me spending too much of my time buzzing around the room, a high-paid spelling bee, instead of discussing matters of the soul with them. I tried to explain that I didn't care so much about spelling. Maybe they misunderstood and thought that I didn't care about them. I wonder how much I have meant to these kids.

As I approach the last class, I will myself to make this a strong one. I prefer parting that is sweet sorrow rather than parting that is limp yawning. (I'd rather be wrenched from a goodbye embrace by an impatient bus driver than be pecked on the cheek by someone who turns away with a forced smile several minutes before the bus warms up.)

I shut out the lights in the classroom and ask the kids to visualize the poem as I read it to them. With the lights out, the children slide into a calm-

319

ness rare for a fourth grade class. I talk to them about the poem, about poetry in general, and then about me. The inertia of the day is shifting. I tell them how much I've liked being with them.

At the end of a successful writing session, I ask if there are any questions. "This is the last day. You're not coming back," a girl says.

"That's not a question."

"Why aren't you coming back?"

"Because if I did, I'd be disappointing the kids at the school where I'm supposed to go next."

"What school? We'll transfer," someone else says.

"You can't, it's too far away."

"Then we'll go and beat them up and take you back here."

"You can't beat them up, it's a high school."

"We'll get our parents to beat them up."

Every call for questions about their poetry is answered with a variation on why do I have to leave and when will I come back.

"Maybe next year," is the only truthful answer I can give.

As they are putting their coats on, shortly before 3 o'clock, they start writing things like, "I love you, Alan," on the board. A girl whose name I never learned grabs my briefcase and runs around the room, yelling, "He can't leave without this."

I sit down on a desk with my feet on a chair and say, "I'll stay."

They cheer.

"But it's time for you to go, children, the buses are almost ready," the teacher says, injecting a dose of reality.

The girl with my briefcase says she'll make me a trade. "I'll give up the briefcase and keep you."

"How about if I take you with me?" I suggest.

She gets excited. They decide that the whole class will come with me.

We have now played out this goodbye for as long as possible. The buses really do have to leave. But we all feel better. We all go outside and the kids board the buses. Before my cab comes for me, the buses pull away, one by one. I am left alone at the school.

* * *

Almost all the students at this school are black. Before I started teaching there, thinking of "all-black school" as an abstraction, I anticipated problems with the kids' accepting me. (I also thought there would be some cultural adaptations I'd have to make, having gone to all-white schools until college.) I expected that sooner or later there would be some kind of racial confrontation, but after several months it still hadn't happened, and I began to forget about it. Until one afternoon, when I heard Thomas yell, "You stupid honky." I felt a combination of relief and apprehension; relief that the tension was broken, but apprehension that this was now going to be a problem. But at least my preparedness wasn't going to go to waste—I was about to have a racial confrontation and it would be interesting.

I asked Thomas to accompany me into the hall. He was scowling.

"Thomas, how long have we known each other?"

"About six months, I guess."

"Well, now did you just discover that we are different colors?"

"What are you talking about, man?"

"Didn't you just call me a honky?"

Thomas looked at me quizzically, then replied, "I didn't call *you* a honky, I was talking to Shawn." Shawn is lighter skinned than the rest. "I wouldn't call you a honky."

I felt silly, embarrassed.

"Oh," was all I could reply.

A couple of weeks later, I heard someone else call Shawn a honky, the way kids might call someone fatso or foureyes. I yelled out, "Hey, there's only one honky in this class, and I'm it." They laughed, very tolerantly.

* * *

As a writer I must fight distractions. It is sometimes a losing fight. But nobody tells me when to write; if it doesn't happen early in the morning, it might happen late at night. Writing under deadline is a different situation, of course, but there are rarely deadlines for poems or stories. You set your own pace, and sometimes even make poems out of your distractions.

As a teacher, I ask kids to write at a pre-appointed time. And they must do it in a room with as many as thirty other kids. And so many distractions.

How can I compete with the first snowflakes of the year, as they delicately salvage an otherwise gloomy, rainy late-November afternoon? First one kid spots them and is at the window, followed infectiously by half a dozen more. I've never seen this class so genuinely excited. Should I compete?

"Sit down, this is time for poetry," the teacher yells, meaning well. She is trying to help, saying, "Come on, children, you've all seen snow before."

But we haven't seen snow for eight months, and there was hardly any snow the winter before. This is the only "first snow" we'll have this year, and it will probably last only a few minutes before it turns back into rain. My heart is with the kids who are scrambling for position at the window. I want to go outside with them.

The best we can do is talk about the snow and write about "first times" and "reunions".

Yes, discipline is an important factor in writing, or any other art. But so is spontaneity, so is joy. The kids were truly curious and in a state of wonder looking at that snow. This had nothing to do with "misbehaving". If it were my class, we would have gone outside. But shortly after we got out there, the bell would have rung.

* * *

I noticed a kid hovering around the doorway to the Teachers & Writers room while Barbara and I talked about a project we were working on. The kid inched his way into the room. I had never seen him before. I said hello and asked his name, which he slurred several times before I could make out that he was saying "Willis."

I asked Willis if he liked to write, and he shrugged and numbled that he did. I asked him if he'd like to come down to the room sometime, that per-

haps I could arrange it with his teacher. "I never go anywhere, I just stay in the classroom," he replied.

I asked him to write down his name, teacher, and classroom number, that I'd made arrangements for him to join a group. It took him a painful few minutes to get the information down. He was in class 4-3 (next to bottom on the tracking ladder), on the "2 fool" (meaning floor). Instead of making "arrangements," I decided to work with him right there. "Sure," he said into his chest when I asked if he'd like to write something.

He picked up a pencil, and I suggested that he write down some things he felt were important to him—family, food, sports, whatever.

He wrote diligently but slowly for several minutes while I talked to Barbara. When I looked at his paper, I was disappointed. On the blackboard was the sentence, "I am learning to type," and Willis had written:

I am learning how to type.
Am how to type.
Learning am how to type.
How am I to type learning?
Me to is I type me.

His "poem" was something a "conceptual" poet might have written. I sometimes feel that a lot of conceptual art comes out of a desperation to do something new, but Willis was probably writing out of a desperation to write anything at all. The difference of the performance abilities fo 4-3 as compared to my students from 4-1 became graphically apparent to me. The reasons for this discrepancy seemed too elusive. Here was one kid. I tried to find out about him.

"How come you're not outside with the others?" (It was lunchtime.)

"Because I always get into trouble."

"You get into trouble whenever you go out?"

"Yeah, I wind up fighting."

"Don't you have anyone to be friends with?"

"Just my brother."

"What class is he in?"

"4-4."

It was difficult to get these answers from him. His face was bruised; he looked smaller, but not younger, than a grown man. I showed him an art book Barbara had brought in and suggested he look at the pictures and write about what he sees. The book was *Fasanella's City*, with childlike out-of-proportion paintings of city scenes. I found two baseball paintings, one of the Polo Grounds and one of a sandlot game. We talked about the differences between the paintings, and he wrote:

I saw men play baseball in yard and in stadium.
Men hit ball in ran around bases
They smile.

The period was almost over. Willis went back into the hall, where he was playfully grabbed by the assistant principal. They seemed to have an extensive relationship, as if Willis were a kid in perpetual trouble. Perhaps he had "escaped" from the office before wandering into our room. Either way, he at least had the initiative to stand in the doorway. How many other kids "never

322

leave the classroom"? How do we find them? What do we do with them?

* * *

THOMAS

When I first started working with the fourth graders, Lynn, their teacher, warned me about Thomas. She said he was anti-white, smart, and reluctant as hell when he wanted to be. Today, Thomas didn't want to write. I started to use all the "tricks" I have come up with to get a kid to write. He stared down at the desk, but I could tell he was listening. Finally, he looked me in the eye and said matter-of-factly, "You're not getting anywhere."

I had to smile. So much for "technique." I asked him if he wanted to be let out of the group and not have to come down with us anymore. He started sparring with me, and every time it got down to him leaving the group, he decided not to. Then it would go in the other direction, but when it got to the point of him agreeing to write, he would decide maybe he should leave the group. Finally, I told him I couldn't spend anymore time with him, and if this happened next week, it wouldn't be fair not to take someone else in his place.

After I walked away, Thomas started to write. It was one of the best things of the day.

Today Thomas was his usual "I don't want to do this" self. I calmly met his demands, like "I want to start over," "I want to go to the bathroom," "I want to get another pen," and didn't put any pressure on him to produce. I know he has the talent, and I know he's difficult. I talked to Lynn about him, and she said he's so smart he can figure out what your expectations, hopes, and fears are, then use them to get his way. I like Thomas, although I feel sometimes that he succeeds in taking me away from the others, and that's not fair. But I'm stubborn and don't want to give up on him. I suggested today that he write about what goes on in his house, and he said he could never do that, implying that it's not a very happy house. But am I reading into that statement, letting him fulfill my image of the bright-but-tortured problem child with enormous potential?

Thomas asked me if he could go into another room where there's a water fountain. I told him he could, but to come right back. After five minutes, I went to get him. Coming back to our room, he dawdled in the hall, then started putting on a dance act. I told him to hurry up, that it was time to go to lunch. He said okay, but then started messing around again. I didn't say anything, but must have looked as disappointed in him as I felt, because all of a sudden he said a barely inaudible, "I'm sorry" and went into the room with the others, where he quickly finished his poem.

Thomas is gradually becoming an important person in my life. He has to have attention for everything he does. He can't even withdraw quietly; today he covered himself up with coats on the couch in the room and played dead. A visually-loud death. The other kids complained at having their coats used for Thomas's "coffin" and soon the whole room was in an uproar because Thomas decided to "rest" awhile.

Thomas is closest to Kenny and is the only one Kenny defers to physical-

ly. Kenny is probably tougher than Thomas but lets Thomas get away with things. Thomas is an expert at manipulation and brinkmanship. He yells across the room; no one challenges him. Today, I decided to have another "talk" with him and asked him to step out into the hall with me. He refused. I announced that Thomas was going to be suspended from the group, and he went running out into the hall with the expression of a respectful adversary, as if to say, "Well, you got me there, because I don't want to be suspended." In the hall, I put it as straight as I could to him: "Thomas, I really like you. You're smart, a good writer, tough, and you interest me. But I also want to work with the others, and I'm not going to let one kid take so much time away from everyone else. I don't want to have to kick you out, but if you make it a question of you against them, I'm going to do it."

Thomas squirmed. He didn't like what he was hearing. I think he understood. He asked if he could get a drink of water, as if that way his trip into the hall wouldn't be a total defeat ("If you let me get a drink of water, I'll return the privilege by not giving you trouble today"). He knew I would let him get a drink anyway, but this way it was a favor for a favor. He kept his word for the rest of the period. The poem he wrote was particularly violent, even for him. Sublimation?

We began writing a play today, with an inauspicious start that led into a small breakthrough with Thomas. Thomas declared that writing a whole play was too much for him, so he wasn't going to work today. I responded, "Good, actually the fewer of us here the easier, you can go back." If Thomas wants to play brinkmanship, then why not bring it to the brink right away? I told him I know he doesn't want to leave, and he knows I want him in the group, so I'm not going to go through that routine anymore. This is it, no more crap.

He started slowly back to the table and sat down, strangely calm. Lionel said, "Good, we need you, Thomas." And Thomas opened up a smile and replied, "Yeah, you need me."

Then I told Thomas and the group they actually wouldn't have to do any writing; we would improvise scenes into the tape recorder. Thomas took control and actually helped keep order while the tape was rolling, after I explained that it would be impossible to transcribe the tape if more than one person talked at a time. It was a terrific session, and as I played back the tape for the group, at one point my voice came on. "Who's *that*?" Thomas said mockingly. "That's Alan," someone answered, and Thomas replied, "I know, I was just kidding."

I may be in for more tough times with Thomas, but I have a feeling that several installments of my dues with him have been paid.

I did "letter" poems with the 4th grade group, giving them a choice of either writing a letter to an inanimate object or to a friend or relative who had died. As I read a sample letter, one of the kids said, "That's corny." I looked up, thinking it was Thomas—that was a "Thomas" thing to say. But Thomas was quiet, concentrating, even though I had stopped reading. I continued, reading a letter-poem written to a friend who had been killed by a car, and one to a dead grandfather. All of a sudden I saw Thomas's vulnerability pierce

through. Previously, his vulnerability was at most a suggestion, more an abstraction that I knew had to be behind his tough-guy facade. But I had never actually seen it this clearly. His concentrated silence was strong enough to quiet down a couple of kids who thought it was funny to write to dead people. Then Thomas wrote a touching poem to his great grandmother.

The previous several journal entries are from my first year with Thomas. [He is now in sixth grade (1977) and in a couple of months will be moving on to junior high school.]

Over the subsequent months—and years—Thomas did a lot of strong writing, often exercising leadership in the group. He also caused problems from time to time. He seems hooked to an approach/avoidance cycle. Recently, after coming late to class ("I had to talk to the principal about some business"—and he probably did) and then not contributing anything, I found this note on my desk next to his notebook.

Dear Alan,

This is Thomas. Don't be mad. I promise to write next week and I already wrote something—look in the book.

Yours truly,

Thomas

Looking back, I realize that I am now a lot "tougher" with kids like Thomas. I can still be tolerant and understanding, but not as much at the expense of the rest of the kids. I have more "street smarts" and know when I'm being challenged, and how to speed up the process. Thankfully, though, I am still stubborn and reluctant to give up on a kid.

* * *

Sharon, a fourth-grader, handed me a little composition titled, "How I Feel About Poetry." It reads: "I like it when Alan comes because he tells us to write what is on your mind, and I have secrets that I keep to myself. When I let them out on the paper, he reads it. It makes me feel much better that someone knows what is on my mind. He also teaches us poetry."

On the bottom of the page, Sharon drew three boxes; in each of them, she wrote one of her secrets:

"I don't like the way my brother and sister treat me."
"I don't like school a lot."
"I don't exactly love to write with Alan."

* * *

Lisa is a constant. For almost two years now, no matter what is going on with the writing group, through distraction and conflicts, Lisa shines through. She takes care of her business. Even when it takes a struggle, she enjoys writing; it's not just something she does to excel in. She is perfectly capable of fooling around, but she always settles down to get it done. Her writing is sometimes serious, sometimes playful. She is respected by teachers *and* classmates.

In addition to being in a writing group, sometimes Lisa comes to our room alone, to write—without any outside direction—in her notebook. Today she seemed to be particularly happy with what she wrote:

My mother made
a great promise.
My father made one,
too.
They both promised
me to stop quarreling.
At least for a little
while.
My cousin made
a promise,
my uncle and aunt,
too.
But they all broke
their promises one
by one.
I don't want a perfect
family who would always
dress up fancy and neat.
Just a family that keeps
a promise,
altogether,
one.

Sometimes kids can "write well" but the writing has no life to it—the bones are assembled in the correct formation, the features are properly positioned, but the poor creature has a blank expression, can't laugh or cry, sing or dance. As writing teachers, what are we looking for? A good experience with writing, the feeling that there was some reason to take pen to paper (other than someone told you to do it), should be right up there on any list of goals. Sometimes this good experience comes from a nutty, surrealistic romp through language; sometimes it's a skilled manipulation of words, which has the effect of depicting an observation or experience for the reader. Sometimes, as in the case of this poem by Lisa, it's a direct rendering of a state of feeling—getting something off your chest and onto paper, via your mind. Is Lisa's a good poem? I don't want to think about that right now. Was it a good writing experience? She thought it was. (She pointed out that she had exaggerated, and that had somehow made her feel better.) I read the poem to another class. They listened, quietly, caught up in the words.

Conclusion: Overview— and a Look Ahead

by Phillip Lopate

Teachers & Writers Collaborative continues to scrape along with a patch-work of year-to-year funding. By choosing to develop a few strong, deep programs in a limited number of sites, with long-term residencies, it has taken a direction rather dissimilar from the whole Artists-in-the-Schools thrust. In effect, it has carved out a small niche for itself as an experimental "laboratory." I use that word in the sense that Professor Elliot Eisner does, in calling for more small, local arts-education laboratories. He says:

> Laboratories, like art studios, should be places where people can feel free to "fail." Laboratories should be places that work at the forefront of developmental activity. They should not only contribute those materials and ideas that have been demonstrated to be successful, but also share with the field insights into the variety of its other efforts that did not work.

The strengths of the Collaborative over the years have been the freedom it accords artists to define their tasks as they see fit; its support of deep, long-term work; the fostering of a pedagogy built on close personal ties between children and adults; and the generous sharing of its experiences, both good and bad. One is well aware that there will probably never be dozens of small laboratories built on the Teachers & Writers model, since they cost more on a *per capita* basis of populations served, and are therefore harder to justify to potential sponsors. Teachers & Writers itself would have to find other justifications than that it is easily replicable; because it certainly is not. Let us hope that this world will continue to honor other reasons for institutional existence than rapid replication.

The irony of Teachers & Writers Collaborative is that it started as a lone, counter-Establishment operation—one of the first agencies anywhere to send writers and other artists into schools on a regular basis to change them into more humane places—and in a matter of several years found itself marching in a crowd, part of a nationwide (if modest) federally-mandated invasion. This national Artists in the Schools program now includes dancers, writers, film-makers, musicians, painters, craftspeople, environmental artists, etc. in all fifty states. The decision of the Federal Government to fund artists-in-the-schools nationwide, through monies which originated at the National Endowment for the Arts level and then were dispersed to each state arts council, took some of the bite out of Teachers & Writers' renegade posture, while the 70's took care of the rest. Teachers & Writers has remained an independent non-profit agency, in contrast to many similar programs which operate straight out of their state legislatures; but the differences resulting from that fact are sub-tle, and there is much overlap in personnel and interests.

Teachers & Writers can thus be seen both as a microcosm of, and an exception to, the larger thrust. Even when it acts as the exception, the group is inevitably affected by the powerful currents of national policy and funding fads, which it either has to swim twice as hard against, or adjust to diplomati-

cally without compromising its identity. The economic reliance which Teachers & Writers has come to place on two governmental agencies, The New York State Council on the Arts (NYSCA) and the National Endowment for the Arts (NEA), for its most consistent patronage, ties the organization very directly to the fortunes and winds of national arts politics.

Thus it makes sense now to examine the larger picture: the whole Artists-in-the-School program.

Pedagogical Concerns

The Artists-in-the-Schools program is now over ten years old, and it has spent much of that time spreading the program, developing new sites, generating a positive public image, and lobbying in legislative bodies for increased government arts spending, as well as trying to attract corporate funding. It has been long on public relations and short on critical analysis—but that is a defensible history for a newcomer, and besides, there is nothing we can do about it now. It would be indefensible if Artists-in-the-Schools continued for another ten years without wrestling more seriously with some tough basic questions: What is the purpose of the program? Who is it intended for? What are its educational goals? What role should its practitioners, the artists, have in determining policy? What have been its results so far? What will be its lasting effects?

On some profound level, the Artists-in-the-Schools program has never made up its mind whether it is 1) a truly serious educational effort, or 2) a committed manpower training program for unemployed artists. It would be nice to think that both can be accomplished at once; but then, both would have to be spelled out with serious forethought, whereas, in my experience, one is always left to take care of the other, and the attention falls between two stools. For example, there have been hardly any solid materials emanating from the National Endowment for the Arts office defining the educational theory, guidelines, collected insights and techniques which it wishes to see realized for its money. Ordinarily, that would be a blessing: the fewer guidelines from Washington, the better. But what it amounts to here, I'm afraid, is the absence of any articulated *educational vision*. (By educational vision I mean things like: what is the connection between artists-in-the-schools and the rest of the curriculum? What relationship does poetry-teaching have to language acquisition at an early age? What constitutes good practice? And so on.) True, the NEA did produce films documenting two of its practitioners, Kenneth Koch and Michael Moos, but these were more in the nature of recruiting films to show to P.T.A.s to get the program in the door. Beyond the platitudes about creativity and the enriching role art plays in our cultural life, very little has been said about what the program actually hopes to accomplish educationally.

Elliot Eisner of Stanford University, an aesthetician who was called in to do a study of the National Endowment for the Arts, puts the case quite clearly in his report:

> The National Endowment for the Arts policy regarding arts education has been in a state of confusion. The messages that it has given to the field have been mixed and at times contradictory. On the one hand it has made its case for funds with the Congress by extolling its potential contributions to the 47,000,000 children that attend the public schools

of the United States. The Endowment has argued that the benefits of its programs are broad and that arts education is one of its major functions. On the other hand, it has conveyed to arts educators the message that arts education is not one of its major functions and that programs such as Artist-in-the-Schools are a means of providing employment for artists. This ambivalence has caused a great deal of stress in the field of arts education. If the Endowment is interested in arts education, then it seems reasonable to provide support to groups who are capable of contributing to the realization of the Endowment's goals.

What Eisner means in that last sentence is "professional arts educators whose major focus of attention is public elementary and secondary education." Eisner is by no means a disinterested party; as president of the National Art Education Association, he would clearly like to see that a bigger piece of the program go to his constituents, who have heretofore been frozen out by arts administrators dealing only with artists. The Artists-in-the-Schools Program is, after all, the largest federally-funded arts education program in the nation. He goes on to say:

> This program is a showcase for a school or school district. It is a program that appeals to the press. It is a program that lends itself well to public relations. And it is a program that has grown from an initial funding level of $145,000 in 1969 to $3,880,000 per year in 1977. Yet, it is a program that may be superficial in its effects while giving some communities and school boards the illusion that arts education is adequately cared for when a school has an artist in residence.

It is necessary to read between the lines here. Part of the difficult politics lurking behind the arts education appropriations story is a competition for jobs between classroom art teachers and artists-in-the-schools. In some cases, it has been charged, licensed art teachers were let go during the recent budget crunch, and then artists were brought in for short-term residencies which cost much less than a year-round art teacher's salary, but which garnered wider public relations exposure, thus helping to lull communities into a false sense of security about its diminished art education programs. To the degree this is so, the artist might be open to being called, in blunt labor terms, a scab. There is no way of knowing what the situation is, because as Eisner points out, no national surveys exist in sufficient detail to read those local patterns, arts education being one of the most statistically ignored areas. But to me it seems pathetic for arts education professors, artists-in-the-schools and classroom art teachers to be fighting over such a small pie: $3,880,000 isn't much on a national basis for arts education, especially considering the large sums that are spent on other parts of the curriculum.

I don't think Eisner's too-broad attack shows sufficient awareness of the places where the program has been successful, and the importance of those breakthroughs. But it is impossible to dismiss his perceptions about the program's lack of educational direction, its lack of professional seriousness in regard to the discipline of arts education, and its resistance to "careful and competent analysis and evaluation." He concludes, harshly but not, I think, without some justification, that Artists-in-the-Schools is the kind of program which "represents a tendency to seek image over reality, public relations over significant improvement, approbation over critical appraisal."

From this perspective, the Artists-in-the-Schools program does seem guilty of an almost willful ignorance of the field into which it has blundered—education, and more specifically, arts education. It needs to become much more

familiar than it has with the research literature, the developmental studies, the evaluation tools (both qualitative and quantitative) and the accumulated wisdom of other practitioners in the field of arts education. Perhaps once it does, it can convince the educational community of its own unique discoveries and the valid role it has to play.

What do artists in the schools legitimately have to offer?

A great deal, I think. They can have a very positive effect on the educational climate, as long as their main strengths are called upon and their functions properly understood, and they do not have to live up to false promises made in their name.

For instance, they are already having an effect in widening the permissible boundaries of artistic expression in the classroom. There is such a thing as "school art." There is no need to ridicule it too much; we all know what it is, and happily there are some classroom teachers who manage to resist it—not enough, however: basically it is teaching art by the calendar: on Halloween we make pumpkins and on Thanksgiving we make turkeys. Or, in literature, it is the "two birds with one stone" approach of teaching syllabification through the haiku and the cinquain, or else those creative writing topics that never seem to die, and that, by their very cute, arch nature are cut off from everything rich and vital in children's experience: "My Life as a Pencil" or "What is the Color of Love?" Then there is the "creativity steps" approach: limbering-up exercises with task cards and games which never get to the real thing. These formulae, encrusted on the heart of American classrooms through tradition or packaged creativity kits, innocent as most of them are, have very little to do with the way an artist actually goes about making art. Artists are said to be involved with pushing at the boundaries of acceptable art: they can encourage children to take larger aesthetic risks, or not to be afraid of expressing controversial emotional and social points of view.

The artist has an experience with forms—and especially with modern forms. He or she knows how to recognize when something begins to look like a contemporary artistic idea. For instance, if a sculptor sees a kid playing with junk, he or she knows that there are sculptures made of compacted junk, whereas a teacher who does not have this frame of reference may see it as just an anti-social act. A kid's chance remark may suggest to a poet the beginning of a poem. Artists are scavengers. They're very good at seeing forms in everyday life, and using what is close at hand as the starting-point for an art experience.

But there are several dangers in this professional quickness. One is that the artist may project an intentionality onto the child's "creation" which the child himself does not feel. This is a serious problem which must be self-monitored at every step. Another danger is that the artist, in following out an enthusiasm, may step on the toes of the classroom teacher and fracture the children's confidence in him or her. Tact and an understanding of school realities are requirements, no, obligations for this work. And if what is being offered is merely a counter-aesthetic to the "school art" approach, this is not enough either. An "opening to wonder" can become as much a cliché as paper Thanksgiving turkeys, and I shudder at the at-times mindless mining of the spectral, crepuscular, magical, haunted, grimy, daily, colloquially surrealistic, in

artists-in-the-schools programs. It cannot be adequate merely to exchange one aesthetic for another, slightly trendier model.

What artists have to give that is much more valuable is the release of their productive energies in the classroom itself. The energy that the artist brings to his or her work, and that the artist brings to the act of teaching, and that the children bring to their own creating; must be seen as coming from the same place. This is especially so since many classroom teachers do not make that personal connection back to their own passions, their own secret sources of creativity when asking children to make art. As poet Alan Ziegler says in his article:

> The same creative energy that fuels my writing also contributes to my teaching. I must constantly find new ways to "make it new." I deal with writers block on a mass level; instead of struggling with the finish of one poem (my own) I often have to help many kids simultaneously weave through their creative fabrics until they each have something they would be proud to own.

But it goes further than helping the students with their own artwork. In some cases the artist is actually making art in the classroom to set an example. Bob Sievert, the painter, will sometimes draw anything a child asks for, a rabbit or a mouse, say, and then turn the drawing over for the child to finish it. In working with mentally retarded children, he reports about one boy who loved to work in collaboration and who would draw a face if Bob drew in the mustache. While working with a group of adolescents on a large mural, he will join in the painting just for the fun of it. Most writers or filmmakers will admit, in a candid moment, that on large film or theatre productions, they functioned not merely as the "enablers" for the children's vision to find expression, but as the real director. The artists are putting on their own show. The result is a hybrid product: part children's imagination, part artist's—which may dismay the purists, who can't bear to see the adult's little rabbit peeping out of the child's forest. But, given the nature of school supervision and large-scale media projects, it would be hard for it to be otherwise. Besides, the children, I think, learn more from watching a professional in action, not only instructing them but letting his or her creativity flow collaboratively with theirs.

There is an assumption underneath much of this work—usually taken for granted, though perhaps it shouldn't be—that some creativity already exists in each person, and is latently waiting to be worked with, encouraged and liberated. The assumption extends matter-of-factly, unconsciously, from democracy as our official ideology. However, when we start to move from the proposition that all people shall be treated with equal justice under the law, to the proposition that all men and women, boys and girls, are innately artistic, we encounter certain difficulties. The first question to arise is, Is this proposition in fact true; is there any way of determining whether it could be true, or has any meaning; or is it merely a convenient operating principle for programs like Artists-in-the-Schools, and the NEA? Myra Cohn Livingston, in a speech for the National Council of Teachers of English, raised this question in terms of poetry:

> Why is it that we insist that every child is a "poet"? Every child is not a good reader or apt in mathematics or a crackerjack baseball player; every child is not a dancer or talented in drawing. But somehow we have jumped on the bandwagon that, if continued,

I fear, will produce one of the most frustrated and despondent generations of all times; they will have been led to believe that they are Titans, that hard work, disappointment, failure, no longer matter in the world, in society.

Mrs. Livingston is right: not every child is a poet. It is a nauseating sort of professional flattery to pretend that all children are poets until the spirit is crushed out of them. No matter what you do to keep the spark of imagination and language play alive, there will always be a very, very few people who choose to write poetry as a lifelong devotion, and who are any good at it. If teaching poetry in the schools is to make any sense, we must find other goals, other defenses for it than that of vocational training. But before we begin waffling on about the importance of metaphorical thinking and sensory sensitivity and affective expression and so on, perhaps it is precisely to Mrs. Livingston's last point, the importance of teaching endurance and recognition of failure in creative tasks, that the whole Artists-in-the-Schools program *should* be addressing itself. The poet or other artist is in a unique position to take the students through the unwinding lengthy processes of art, and to teach habits of work-completion, stamina, the overcoming of disappointment and false leads —because they have gone through it so often themselves. Artists have the experience of beginnings-to-ends. They know (or should know) how wavering the creative process can be, how messy it can be; and they know about the terrifying middles, when everyone loses heart. This is my quarrel with methods that stress creative "starters." We have enough gimmicks in art education to get students started: what is so often lacking is the follow-through. This is what Dewey said was the "esthetic part" of an experience: the rounding out, the fulfilling of a started motion. It is the artist's single most valuable insight. That this has not been taken advantage of sufficiently is a waste of the artist's true teaching role in the classroom. It seems to me that it is not enough for an artist who goes into a school to be a salesman giving students a glib taste of the positive in poetry or dance or whatever the medium is. The experiencing must go deeper. But this deeper level depends on the attitude of both the artist and the school towards each other, and the sponsoring agent, and the amount of time he or she is given to accomplish the task.

We have no way of knowing yet what the real effects of these programs are. There have been so few studies done, and these have mostly been of extremely small samples, or else, like the Western State Arts Foundation study of 1976, so shallowly euphoric that they tell us very little; they seem more like promotional brochures than serious science. At the same time, it would probably take a longitudinal study following one population for several years to determine what lasting effects exposure to the program had on the individual's learning and attitudes toward life; and such a study would probably be so expensive (more than the cost of the Artists-in-the-Schools budget itself!) that I am not at all sure it would be worth it.

Yet the public, and the interested educator, have the right to ask, What are these programs actually accomplishing? What are their long-range results? What if they were discontinued—what would be left in the schools? Can we expect that in a few years the artists will be able to be phased out, and the teachers to carry on in the same manner?

Lacking general data, I can only speak from my own experience. At P.S. 75 in Manhattan, where a team of writers and artists has been working for over eight years in what must be one of the most ambitious and mature public school artist-in-residency programs, we can sense that we have had a deep impact. Children who have graduated come back years later and tell us how important the experiences they had with Teachers & Writers were; some of them return to work with small children as junior artist-apprentices. The ones who made films with us want to borrow equipment to make films on their own during the weekends. These are of course the most outgoing or artistic or needy children; we lose track of many hundreds of others. The school seems to relish and delight in artistic productions now. Parents have gotten more involved as volunteers; teachers are more adventurous in teaching creative writing. Even so, I have the feeling that many things which the artists intuitively do as art instructors have not been transferable to the classroom teachers and assimilated into their regular pedagogic behavior. Oh, we have influenced the teachers and they us in hundreds of small, satisfying ways; but in the narrow terms of teacher replication, which funding agents use, we have not really brought the institution to a point where we artists could "phase ourselves out" and have our skills picked up by the permanent staff. Perhaps we have not made a sincere effort. I know I felt all along (as most artists in the schools feel) that what I do and know cannot be that readily duplicated by a classroom teacher. I am after all a trained writer; the teacher is a trained classroom teacher; and we cannot simply step into each other's shoes. It would take a gigantic effort, and what would be the point? We have our roles, they are different and complementary. The analogy might be to a hospital team, where neurologists and neurosurgeons and anesthesiologists and social workers are all expected to know something of each other's discipline, in order to work together most effectively for the good of the patient. But at the same time they recognize that they have legitimately separate tasks. None thinks of eliminating his or her role.

Is anyone out there willing to concede that artists-in-the-schools may have more than a pilot-project role to play in American education, that they may even have a permanent place—as dedicated career professionals, with a training analogous to but different from classroom teachers?

Bread-and-Butter Questions

Let us look at the other half of the claim about the Artists-in-the-Schools program: that it is mainly just a means of providing employment for artists. Personally, I am sympathetic to such an expedient outcome. Would that it were more the case.

Government arts agencies do acknowledge their manpower function. Leonard Randolph, former director of Literature for the N.E.A., said in an interview: "The poetry-in-the-schools program actually has the employment of writers as its primary function, so far as the Endowment is concerned." Yet the funds trickle down in so dispersed a way into so many hands, and for such short-term residencies, that very few writers are able to earn a yearly livelihood through this program. Writers-in-the-schools face the frustrating paradox of

being able to earn handsome sums of from $75 to $125 a day, but rarely receiving more than 40 days' work a year. They are like high-paid migrant workers who get laid off for most of the year, with an average annual income of $4000 or less. The self-righteous position which many organizations hiring artists have always taken is that the job must be part-time, to give artists enough leisure to produce their own art. This unfortunately does not answer the question of where food and rent is to come from (other part-time jobs, naturally). Even so, these few part-time positions are intensely coveted. One state arts council holds a yearly literary contest and awards them as plums, making sure never to repeat the same person, which practically ensures that the writers going into the schools will always be frightened, confused and amateurish as teachers. I know of other state arts agencies which are run as stables, with the administrators promoting certain "favorites" one year, who then find themselves frozen out of further employment without explanation the succeeding year. There are usually no guarantees of minimum employment, no "court of appeals" to take one's case to, nothing beyond the administrator's uniform statement that "the budget is tight this year."

In general, the artist-in-the-schools enterprise is fed by a large reserve army of unemployed artists, which gets continually turned over like a crop every few years, with the result that experience does not have a chance to accumulate nor the whole movement to mature—pedagogically or, for that matter, politically. One is stopped sometimes from opening one's mouth to complain by the knowledge that, "If you don't like it, there are ten others ready to take your place." Pedagogically, the program seems to be permanently arrested at Step One: that first exposure of the new artist introducing his or her medium to a new population. Meet the Poet. Since there is nothing approaching job security, and no veteran status, it is hard to see how a sense of professional commitment can be engendered for this kind of work. Yet, teaching in the schools is hard, and harder perhaps for someone without any commitment to it. The job cries out for involvement. The sponsoring arts agencies seem routinely to expect of their artist-employees an idealistic, dedicated attitude toward their work, and at the same time an attitude of fatalistic acceptance toward the ephemeral, uncommitted nature of the contract.

Economics is only one factor preventing the growth of professionalism and commitment. Another is the whole ethos of the operation, which seems to insist on innocence and freshness of viewpoint. The artist is flattered into thinking that his or her special advantage is not only the knowledge of craft, but a mind unencumbered by educational methods or regulations. Artists in the schools affect what might be called an "educational virginity;" they brag about never having taken an Ed course, and about being instinctively good teachers. The arts agency line, which supports this pride of ignorance, is a variation on the old Divine Idiot syndrome. It goes something like: the visiting artist knows nothing about education but will just come in and be so "finely tuned" that he or she will communicate immediately with the students. The fact is that, for every writer or artist who is an instinctively good teacher, there may be two who aren't: they may be far worse than classroom teachers, who at least have given some thought to things like classroom management, child development, curriculum, and so on. So the Holy Fool theory sometimes produces emphasis on the holy, and sometimes on the fool.

The paucity of any serious training for new artists going into the schools, and the continuation, even after ten years, of the sink-or-swim method, are partly to blame for the dizzying up-and-down quality of the program. I think that maybe it wouldn't be such a terrible idea if artists entering schools knew a little bit about education, read some Piaget or Dewey, maybe took a course with an experienced hand, were supervised more closely and helpfully, had a chance to do preliminary observations to learn something about the social and political life of the school they were going to have to function in, for however short a time.

Of course, getting to know the social organism of the school is rather futile when one is only in for a short-term stint—say, one to four days. These "scatter-shot" residencies are still the norm nationwide, and will probably continue to be so because of the pressure, exerted downward from Congress and state legislatures to the arts agencies, to demonstrate the greatest possible exposure per capita per dollar for artists- in-the-schools programs. As long as tax payers' money is being used, head-counting (and poem-counting) become a major standard of performance; but the private foundations are also interested in numbers, geographical spread, "rippling effects" and "more bang for the buck." The pressure to reach statistically large populations is more than anything what condemns the Artists-in-the-Schools program to being arrested at Step One, the introductory lesson, the medicine show, shallow exposure rather than depth or relationship. As long as "quickies" and one-shot demonstrations dominate the Artists-in-the-Schools program, there is no point really in discussing how to improve the curriculum or define the movement's educational philosophy. All that will be left behind is a blur.

The geographical pressure to reach more counties and towns and hamlets means that the artist-teacher who wants to make a living will have to go on the road. People react differently to road trips: some love it, are exhilarated, others find it wearying. But almost all report that it burns them out after awhile. Ron Padgett, a consummate professional, described the life in an interview:

> I don't like going on the road to teach too much because it is unimaginative and it's boring and it's basically P.R. work. The idea is that you sort of try to sell this idea to an entire community. I find it tiresome. Originally I didn't. It was exciting and weird. You take an airplane to some town and you stay in some hotel, but it gets very dismal. I should think it would be like travelling in the N.B.A. You're going out as a poetry salesman, in essence, to some town and teaching for a week, say, or three days, or whatever those short-term residencies are. The thing about going on the road is that you make quicker money. But it's, to me, much more boring work because the people all want a "good" result from those programs. They are laying out this money quick and they want some intense Berlitz course in poetry. And so I have always felt more or less constrained to use ideas which have been tried and tested in the Teachers & Writers situation, where you get to work very much on your own terms, so that we will have a successful program there.

The Teachers & Writers Collaborative can certainly be seen as offering an alternative model, with its support of long-range open-ended residencies, where artists are encouraged to work in any media in school for as long as the experience is rewarding. It would be nice to see this model take root in other places. Nevertheless, Teachers & Writers is no paradise; it too has come under increasing pressure to bring in money with short-term workshops, so that if it

does not watch itself it could turn into just another "Office Temps" type operation for artists.

Unquestionably, short-term residencies can achieve good, and they can have wonderful moments and triumphs. But what leaves pain, even in the good ones, is that one is constantly being ripped away from people one had started to like, and whose names one had just learned: from a child who had just supplied the first personal fact, so that one could begin to teach individually. How can any sort of commitment be engendered when one is always required to leave so suddenly, and to phase oneself out? Just as in love affairs, it's very hard to feel commitment under those circumstances; the cast of characters keeps changing.

Should artists be attached to institutions? I think they should if they are, like some of us, temperamentally in need of roots and a stable work situation —just as 18th century composers benefited from having a steady court patron instead of having to move each year. But not all artists feel as I do. Denise Levertov, in her book *The Poet In The World,* stated the other case cogently:

> The artist who is a part-time teacher, especially if like myself he has taught each year at a different school, can more easily, confronted not only with new faces but with a different style of student in each place, forget what he did last time, or if he remembers it, find it inappropriate to this new group and new surroundings, and so start out with a genuine sense of adventure

Now I am all for a sense of adventure; but I find when I am moved around from new place to new place and not allowed to deepen my work in one location with the same group of co-workers and students, that is precisely when I tend to repeat myself. Obviously it is different for each artist. Besides, Levertov speaks of the desirability of changing schools every year, not every ten days. However, she goes on to enunciate the ethos of freshness, in terms that are consistent with standard Artists- in-the-Schools philosophy (with which I *cannot* agree):

> What the non-professional teacher—the artist who is invited to teach *his thing*—has to offer must surely be precisely a fresh response to the individual group of students and his passionate interest in the art he is teaching, free from habits picked up from his own former teachers or in courses on pedagogy.

Perhaps this is true when one first begins; but after awhile self-consciousness sets in, and desirably so. Moreover, no one is free from the habits of former teachers. Art comes from art, as Ad Reinhardt was fond of saying; in just that way, teaching comes from teaching, and it would be impossible to expect to escape influence in either area. Teaching is, after all, an art. The key word in the above passage is "non-professional": so long as one sees the artist who teaches as a non-professional, the ethos of freshness is valid. It is an ethos which happens to dovetail nicely with the economics of the Artists-in-the-Schools program, with its fresh supplies of interchangeable labor and its fresh recruits. However, we artists who have been teaching five years or more in the program find it hard to regard ourselves any longer as "non-professionals." We know we are teachers—as well as artists. It is a dual career. Perhaps we were not supposed to have stuck around this long. Every year I see gifted, highly experienced veterans drift away from the Artists-in-the-Schools program because there is nowhere to go in it: no chance for a living yearly wage to support themselves or their families, and no chance for professional growth. As

one poet wrote me, when he threw in the sponge: "From this angle all my work with kids looks like a dead end. When everybody was out there getting their Ph.D.s and slogging away as assistant profs, I was knocking myself out in a job that offered no advancement or security. How come nobody ever told me that? Why couldn't I see it?...I mean, I *know* the work with the kids was very important, wouldn't have traded it for anything. But suddenly the ground shifts, a section of earth rips away, and you see all the plumbing of your missed opportunities staring out at you."

And there is also the frustration of not being able to have greater administrative input, which Elizabeth Ayres of Poets-in-the-Schools (PITS) describes:

> Because the poets feel so strongly about their work and their vision of how PITS can grow, the sense that their experience doesn't matter, has no effect, no impact, has led to a general feeling of tremendous frustration and hopelessness. One identifies a problem, sees that it is damaging the program, sees how it can be alleviated. One tries to convince the PITS administration to solve the problem. Yet, one year, two years, three years later, the problem still remains and has, in fact, worsened, as all unsolved problems do. One realizes that this problem will never be solved and that coupled with other problems, it is interfering with one's ability to continue working in a professional fashion. So one either gives up one's standards, or gives up on the program.

The timidity of the artists in asserting their demands and ideas is an interesting phenomenon, with many explanations. The fact that artists have shied away from demanding higher or more consistent salaries has to do partly with their awareness of the limited budget: they are told that if their salaries were to be increased, it would mean hiring fewer artists, and their solidarity with more needy artists tends to inhibit that demand. But another reason has to do with the conflicts the artists feel themselves toward this second career. If they were to be promoted they might have to give more time to it, which would mean more time taken away from making art. Artists have a tendency to lead contingent lives, unrealistically looking upon their current money-earning job as transitory while hoping to strike it rich any moment via artistic success. The odds, unfortunately, are very slim against that sort of success. By refusing to come to terms with their prolonged need for a steady non-art income—instead, nickel and dime-ing themselves with part-time jobs—the artists, in effect, have contributed to their own financial insecurity.

The artists have also been reluctant to get involved with administrative tasks, seeing it as somehow petty or dirty—with the logical result that they have often been betrayed. Again, it is partly the artists' fault: as long as they allow someone else to run the organization and make all the decisions, as long as they don't care to see themselves as administrators, or to get their hands dirty with "petty details," just so long will they be pushed around.

Curiously, one of the factors inhibiting any political organizing among artists in the schools is that they never meet by themselves, but almost always with their bosses, arts administrators. The gung-ho sense that "we're all in this together," true as it may be, obscures the reality of a labor-management situation in which one group has power over the other. If a national conference on artists-in-the-schools were to be called six months from now, the request to exclude arts administrators or foundation officials from it would probably be dismissed as paranoid. Yet, such gatherings of artists-in-the-schools personnel always tend to be dominated by the arts administrators with

the most power and money, who are then petitioned and sounded out as to what will or will not be possible next year, given "the realities of the way the money is going." The practitioners never have a chance (or give themselves a chance) to decide by themselves what *they* want, irrespective of the powers-that-be's announced limits.

Similarly, though there exist numerous periodicals which document the work of the artists in the schools, from the NEA's *Cultural Post* to state arts councils' annual reports, these journals are put out by the sponsoring arts agencies and their administrations, and consequently tend to reflect more of a "goody-goody" public relations line which will be useful in fund-raising and selling the program to schools. There is no professional journal edited by the practitioners themselves for their own use, in which they might dispense with the hyperbole, and communicate with each other more subtly, honestly and complexly about the problems they have had in the field, and their perceptions of the state of the art.

The situation is changing, however. In scattered programs across the country, artists have been meeting in private groups, staging protests, submitting petitions. They are looking at problem areas such as job allocation, administrative accountability, administrative support for artists in situations where conflicts with schools occur, retraining (instead of summary firing), articulated standards of performance, with the possibility of peer observations and evaluations and longer residencies. Some of the fights have been over very local matters: one West Coast group is fighting a two-tiered salary system whereby the arts administrators make exorbitant salaries and the artists get crumbs. Another group is protesting an increased work-load, the demand for free teacher workshops, and the new rule to punch a time clock. The artists are in a double-bind of being defined technically as "consultants" but treated as employees—moreover, employees without rights or benefits. Many of the struggles are still around *per diem* issues: very little has been said about an *annual* wage, or minimum work guarantees. So far the focus has been on dollars-and-hours issues; I would eventually want to see this trade unionist approach (necessary as it may be), linked more consistently with questions of educational policy. This is beginning to happen: the artists themselves are feeling a need to find out what education is all about, and how they can fit into it. The mood of the experienced workers may be summarized in this statement by Elizabeth Ayres: "We see ourselves as not simply teachers of poetry, but as a new breed of artist: the artist/educator, the artist who believes that he or she can, through his or her work in the schools, effect radical and profound change in education and in society's relationship to the arts."

Some of these themes—training, supervision, the expectation of a steady income from one year to the next, journals, greater control over workplace and caseload size—will sound familiar enough: they are the standard call to arms of an emerging profession (such as social work). The "Artist-Educator" is more a hope than a profession; it is still in the process of invention as a possible career. No one seemed to expect or plan for it to come into being. Witness the inability of many arts organizations to comprehend the challenge of the veterans, who not only want more say in financial decisions, but who want the educational part of the program to be taken more seriously. The existence of these veterans represents the possibility of establishing a continuity in the

338

field, so that experiences, assignments and theoretical challenges can develop systematically, as in any orderly discipline, and hard-won insights can be passed down to the newer members.

Let me make it clear that I am not in any position to propose a training syllabus; or a blueprint which would provide reasonable economic security for artists in the schools; nor can I come up with a balanced formula which would protect the jobs of worthy senior artists while ensuring that new teaching blood had a chance to come into the field. Such detail would be premature: we are not at that stage of agreement yet. I am only trying to get some people to look past the so-called "unavoidable" "business-as-usual" system we are living with now, and to entertain at least the possibility of other arrangements.

I have been trying to eliminate some of the excess images and false functions which have come to be attached to the Artists-in-the-Schools program. The artists, as I see it, are not meant to be salesmen for culture. That is a vulgar misuse of their talents, and though they have willingly gone along with that agenda, taking to the road, it has often burnt them out. They are not trainers of the next vocational surge of poets and painters. (Those individuals who choose to make a life in art will, as they always have, learn what they have to one way or another.) And the artists-in-the-schools are not, probably, such excellent teacher-trainers that they can be expected to pass on their skills and disappear, so that the teachers will do precisely what they did.

This leaves us with very few rationalizations for the program. Wait—there is one more false promise to uncover. We are often told, we poets in the schools, that we are "building the future audience" for poetry. These children we are now yelling at or smiling at in the schoolrooms, these tow-headed tykes, will one day plunk down five dollars for our own book or a fellow-poet's volume in some out-of-the-way bookshop. The audience for poetry-lovers will double, triple; we will become a nation of poetry-lovers, all because of that friendly poet's visit to the classroom in the fifth grade. This, I am sorry to say, is nonsense. There are reasons, valid reasons, why best sellers are best sellers, why some books have more "pull" or sex appeal than others with the public, and why a volume of even our best poet's poems does not sell 20,000 copies. I cannot speak for other countries; but in this country, poetry, especially new poetry, at its highest level of expression, will always have a small public. This does not strike me as such a tragedy. Poetry's lack of universal appeal has directly to do with the limited audience to which it is addressed—which is not necessarily something to be taken up and reformed. As the great Italian essayist Nicola Chiaromonte has written:

> Surely, to say that art is universal makes sense only if we mean that true art is accessible to anybody who feels its attraction. It makes no sense if we maintain that it must be so fashioned as to be within everybody's reach, on the level of a public service. The truth is that we never create, act, or talk for everybody, but solely for those whom we love—or hate—enough to want to communicate with. There is no such thing as a language for everybody.

I fear that the spread of government and corporate spending for the arts in the 1970s, valuable as it has been, is at times based on the wrong assump-

tion that art *is* the language for everybody, and that it only needs better distribution to be happily consumed and spoken by every citizen. This causes the NEA and its state subdivisions to act sometimes like a utility company. It also leads artists wishing sponsorship to try to fashion their message so "as to be within everybody's reach, on the level of a public service." The quest for a demotic style with which poets in the schools could reach the masses of students and convince them of the clear "good guy" attractiveness of poetry, has led to a curiously shrunken version of the American poetic tradition, which jumps directly from American Indian songs to William Carlos Williams, Gregory Corso and Nikki Giovanni, with barely a second's glance backward at Walt Whitman (he uses too many big words). This aesthetic of the "pure American tongue," and with it the assumption that "common man's" speech is already three-quarters on the way to being fine poetry, has come to dominate the poets-in-the-schools movement with only a few peeps of protest. This is in spite of the fact that such an aesthetic of plain speech rests inevitably on a good deal of mannerism, condescension, linguistic over-simplification, and anti-intellectualism. The line one hears so often from the Poets-in-the-Schools hierarchy is that "teaching Shelley and Keats and all those dead poets is what turns kids off to poetry." (But what's the good of loving poetry without Keats?) Those who persist in teaching literary heritage are called "academic poets," a very derogatory term among PITS people, and they are simply not hired. Now I have no great love for academic poetry, but I wonder to what extent that term is being used as a screen-word to mask anti-intellectual attitudes and outright fear of literature. At this point I would welcome some more traditional poets in the program, if nothing else than for diversity, and a counter-balance to the homogenized type of "with-it" practitioner. The stereotyped idea that children will only go for young, hip artists just isn't true. Felix Stefanile, in his critical piece called "The New Consciousness, The NEA And Poetry Today," draws a composite picture of the Poets-In-The-Schools-approved practitioner:

> He or she is usually young, not even thirtyish....He travels a lot; the highway, or "wanderer" poem is a cliche of the New Consciousness imagination, inherited, and often copied, from pop music. He abhors rhyme as a poetic device, and his work—if he is good—reveals an immense alertness to immediate surroundings. New Consciousness people are film people, and the best work of the kind of poet I am attempting to describe is luminous with casually correct detail, the glow of a glass of water, the mist that fades away like smoke with the coming of the early morning sun. His ear, in contrast with his eye, and this has often been remarked by many critics, is often defective. The lilt of words does not attract him. In his often litigious sense of loyalty to the spontaneous and the natural the concept of word-play, of phrasing, holds no glamor, and as a matter of practice he wants his poem to be urgent, rather than lively or pleasant. Because of this his plain speech will, too frequently not to be noticed, falter into talk and gab. He is not a well read person, and the influences he shows, as I imply above, are more generational than personal: a rhythmic line out of a song, an in-joke, like Dylan's about drugs....At his best, and in the best sense of the word, he is an utterly *personal* poet, by which I do not mean confessional, but solidly placed in consciousness, and in his fear of abstractions and hypocrisy, stubbornly grounded in the narrow space of his confident ego.

This portrait may be too condescending, but Stefanile is right in feeling that there is an aesthetic sameness that comes out of these programs, a new WCW-clone orthodoxy. And here I would argue that aesthetics and econom-

340

ics and the above type dovetail nicely: because it is a type which uniquely suits the financial character of a program that is premised on hiring workers who will work for below an annual living wage, who will accept a transient "consultant" status indefinitely, and who will *drift away* after a few years when they are told there is nothing more for them.

It seems as if we have come a long way from the Tufts and Huntting Conference reformers of 1966—the Muriel Rukeysers and Benjamin DeMotts and Herbert Kohls who were angry at social injustices and concerned about the deadness of the English curriculum. And yet, in a very real sense, the situation which exists today is their heritage, a medley of their ideas (like the one about preserving "people's authentic language"), played through a kind of echo chamber, distorted and betrayed in some cases, fulfilled in others. What we have been witnessing for the last decade or so is the institutionalization of a cockeyed, progressive, moral speculation—that it would be a good thing for writers and other artists to go into the schools and help out somehow—institutionalized from the Federal bureaucratic level on down to the local schoolhouse, with all the unevenness and success and mediocrity and confusion and learning that goes on when you try to implement a nice idea all over at the same time without really understanding what's underneath it, or where you want to go with it. Now we know a bit more than we did at the start. Now we have to try to learn what it is we know.

I have given space to the critics of the Artists-in-the-School Program because I think their views are interesting and in many cases insightful, and because such criticism may stir up more useful reflection at the present time than the same old praise. At the same time, I must make it clear that I am a passionate partisan of these programs—even if I wish to criticize them regularly from the inside. In the present climate, criticisms of a federal program are often misused as an excuse to get rid of it. That would be disastrous. The program is just at the point where it can benefit from its rich and confused experiences. What needs to be done is to take a serious inventory of accomplishments and failures: find out what projects worked, and why, and sift through the insights of the practitioners to see what technical discoveries and what methods deserve wide dissemination, for the benefit of those that follow. Then we need to yoke, quite consciously, the representatives of the various arts education programs together in one mutually supportive effort: art teachers, artists in the schools, aestheticians, developmental psychologists, and researchers. Any ambitious, coherent effort at improving the instruction of arts education would certainly also require a much increased federal budget: the present amount is a joke, and it deserves the hot air it has reaped. Perhaps we also need to fund many more small arts laboratories across the country, on the scale of Teachers & Writers. We need to look into the whole question of year-to-year funding, and the toll that has taken on the program energies of quality independent agencies.

Finally, it will be necessary for the Artists-in-the-Schools program to become much more self-conscious about its educational purposes and its manpower policies. It cannot afford to ignore the growing professionalism in its midst. The artists need to have a greater voice in the policy of the organiza-

341

tions for which they work. It goes without saying that with this greater voice comes more responsibility, more of a fully-developed dual career situation, and perhaps more conflict about one's sole prime identity as an artist. But then, artists have always had to live in the world.

Contributors' Notes

JONATHAN BAUMBACH is a novelist, teacher and film critic, who has been associated with Teachers & Writers from the beginning. He is a founder and former director of the Fiction Collective. In 1979 he will bring out a book of stories, *The Return of Service*, and a novel, *Chez Charlotte and Emily*. He is currently on a Guggenheim fellowship living in the south of France.

ART BERGER has been a newspaper printer, writer, editor and poet. Since 1968 he has been involved in education. While making the rounds as a poet in the schools he went back to school to acquire a BA from Queens College and an MA from Rutgers. He has since worked with prisoners, the elderly, the handicapped and psychiatric patients. He is currently teaching and working on a doctorate at Boston University.

HANNAH BROWN is seventeen and attends high school in Manhattan. Her interests are books, movies, and ballet. She would like to be a writer. Last year, a short story of hers received second prize in the National Youth Writing Competition. She continues to be a volunteer for T&W and currently gives a writing workshop for third and fourth graders at P.S. 75.

WESLEY BROWN was born in New York City. He has published poetry and fiction in numerous anthologies and magazines, and has written a novel, *Tragic Magic*, published by Random House. He has taught at York College, Hunter College, Empire State College and Sarah Lawrence College. He is currently living in New York.

DAN CHEIFETZ is the author of *Theatre in My Head* (Little, Brown), about children's improvisational theatre. He has led Teachers & Writers workshops in creative dramatics and related arts in Harlem and Queens public schools and has trained teachers to use creative techniques in the classroom at CCNY, Lehman College and at several public and private schools.

DAVID HENDERSON is a poet and the author of *De Mayor of Harlem* (E.P. Dutton). His poems have appeared in *Black Fire* and numerous other anthologies.

MARVIN HOFFMAN was trained as a clinical psychologist and after finishing graduate school went to Mississippi to teach at a black college. In 1966 he was involved in the operation of the Child Development Group of Mississippi, the first large-scale Headstart Program in the U.S. A former director of Teachers & Writers Collaborative, he has more recently headed the Elementary School Teacher Training Program at Antioch. Currently he is an elementary school principal.

KAREN M. HUBERT worked with Teachers & Writers Collaborative for over six years during which she taught writing and video tape production to children and older adults. She received her M.F.A. from Columbia University. She has published fiction and poetry in several magazines including *Poetry Now, Sun,* and *The Paris Review.* Her book of poems *In Search of Fred and Ethel Mertz* is published by Release Press, N.Y.C. She is now the proprietor and chef of Hubert's a French restaurant located in a century-old tavern in Brooklyn.

LEONARD JENKIN is a writer for the theatre, film, and the printed page. He also tells his daughter quite a few stories. He lives and works in New York.

JUNE JORDAN is a poet. Her publications include *Some Changes* (Dutton), *Things I Do in the Dark* (Random House), *Who Look at Me* (Crowell).

KAREN KENNERLY was administrative assistant at Teachers & Writers under Herb Kohl. She had studied Noh theatre in Japan and has been a senior editor at Dial Press. Her publications include *The Slave Who Bought His Freedom* (Dutton), and *Hesitant Wolf and Scrupulous Fox* (Random House).

KENNETH KOCH'S books of poetry include *The Art of Love, The Pleasure of Peace, Thank You,* and *Ko, or A Season on Earth.* He is also the author of *Wishes, Lies and Dreams: Teaching Children to Write Poetry; Rose, Where Did You Get that Red? Teaching Great Poetry to Children, The Red Robins,* and *A Change of Hearts: Plays, Films, and Other Dramatic Works.* He lives in New York City and teaches at Columbia University.

HERBERT KOHL is one of the founders of Teachers & Writers and its first director. He is the author of *36 Children, Reading, How to, Half the House, Age of Complexity, Math, Writing and Games, The Open Classroom,* and *Growing With Your Children.* He taught and directed an open school, Other Ways, in Berkeley California. He is currently director of the Point Arena Learning Center.

PHILLIP LOPATE is the author of two collections of poetry, *The Daily Round* and *The Eyes Don't Always Want to Stay Open* (SUN Press). His prose has appeared in *The Paris Review, The American Review* and *The Best American Short Stories of 1974.* He works for Teachers & Writers Collaborative. A book about his teaching experiences, *Being With Children* (published by Doubleday), is now available from Teachers & Writers. His most recent book is *Confesions of Summer,* a novel (Doubleday).

THERESA MACK makes video documentaries, teaches video and filmmaking to children at P.S. 75, and video production at the Media Studies

Graduate Program, New School for Social Research.

MIGUEL A. ORTIZ is editor of Teachers & Writers Magazine. His stories, poems and articles have appeared in *Hanging Loose, Promethean, The Phoenix* and *The Lion and the Unicorn.*

RON PADGETT has published ten books, poetry, prose and translation, the most recent of which are *Toujours l'amour* (poetry, Sun Press, N.Y.) and *The Poems of A.O. Barnabooth* by Valery Larbaud (translated with Bill Zavatsky, Mushinsha Ltd., Tokyo). He has been associated with Teachers & Writers Collaborative since 1968. He is currently director of the Poetry Project at St. Mark's Church in New York.

MURIEL RUKEYSER's books of poetry include *Breaking Open* (Random House), *The Gates* (McGraw-Hill), *The Outer Banks* (Unicorn Press), *The Speed of Darkness* (Random House) and *Waterlily Poems* (McMillan). Other books include *The Life of Poetry* and *The Traces of Thomas Hariot.*

SYLVIA MOCROFT SANDOVAL has performed with the dance companies of Katherine Litz, Carolyn Bilderback and Nannette Domingos. She has taught dance to people of all ages, pre-schoolers to adults. Some of the schools where she has taught children are The Professional Children's School in New York City, Dwight School for Girls in New Jersey, and public schools in Englewood, N.J. She conducted dance activities on the streets for summer arts programs in New York City. She currently teaches at P.S. 152 in the Bronx, P.S. 46 in Manhattan and P.S. 48 in Queens.

ANNE SEXTON was born in 1928 in Newton, Massachusetts and grew up in Wellesley. From 1961 to 1963 she held the Robert Frost Fellowship at Breadloaf Writers Conference and was a Scholar at Radcliffe Institute. She was elected, in 1965, Fellow of the Royal Society of Literature, London. She was awarded The Pulitzer Prize in 1967, and her play, *Mercy Street* was produced in New York in 1969. She died October 4, 1974. Her books of Poetry include *To Bedlam and Part Way Back, All My Pretty Ones, Live or Die, Love Poems, The Death Notebook, The Book of Folly* and *The Awful Rowing Toward God.*

BARBARA SIEGEL is an artist whose work is in the permanent collection of the Newark Museum. She is represented by the Marilyn Pearl Gallery and teaches at P.S. 173 and P.S. 123 in Manhattan.

ROBERT SIEVERT has worked as a muralist for the Metropolitan Museum of Art. He has taught for Teachers & Writers for five years and he has had three one man shows of his paintings at the Green Mountain Gallery in New York. His writings on the visual arts have appeared in *Arts, Art/World, Teachers & Writers Magazine* and *Learning.*

MEREDITH SUE WILLIS was born and grew up in West Virginia and has lived in New York since 1967. Her short fiction has appeared in magazines like *Commentary, Mademoiselle, Story Quarterly* and *Epoch*, and she is a 1978 recipient of a National Endowment for the Arts Fellowship in Creative Writing. Her novel, *A Space Apart*, is available from Charles Scribner's Sons.

ZELDA WIRTSHAFTER was a classroom teacher and then worked with apprentice teachers in the NYC public schools. She was one of the founders of Teachers & Writers and has worked with many community and alternative school groups seeking to develop programs in which community people, artists, writers, musicians, etc. work directly with children and teachers.

ALAN ZIEGLER's books of poems are *So Much To Do* and *Planning Escape*. His poetry and prose have appeared in such publications as *The Ardis Anthology of New American Poetry, Paris Review, The Village Voice*, etc., and he is co-editor of *Some* magazine and Release Press. He compiled the text of *Almost Grown* (photographs by Joseph Szabo) from poems by teenagers in his workshops. Since 1974 he has worked. for Teachers & Writers, for whom he currently coordinates the Writers-in-Lynbrook (L.I.) program and teaches workshops in Lynbrook and New York City.

Teachers & Writers Staff Fall 1979

Director	Steven Schrader
Co-director	Nancy Larson
Publications Director	Miquel Ortiz
Assistant to the Director	Cheryl Trobiani Neil Baldwin
P.S. 75 Project Coordinator	Phillip Lopate
Administrative Assistants	Joe Cohen Cynthia Green Pat Padgett

WRITERS AND ARTISTS

Dan Cheifetz
Barbara Danish
Elaine Epstein
John Farris
Marc Kaminsky
Bill Kough
Phillip Lopate
Theresa Mack
Richard Perry

Pedro Rivera
Barbara Siegel
Sylvia Sandoval
Bob Sievert
Ali Wadud
Kate Wenner
Sue Willis
Anthony Wisdom
Alan Ziegler

ADVISORY BOARD

Jonathan Baumbach
Benjamin DeMott
Leonard Fleischer
Norm Fruchter
Colin Green
Nat Hentoff
Florence Howe
Herb Kohl
Paul Lauter

Philip Lopate
Ron Padgett
Alfred Prettyman
David Rogers
Muriel Rukeyser
Robert Silvers
Eliot Wigginton
Zelda Wirtschafter

CETA WRITERS-IN-RESIDENCE

Barbara Baracks
Janet Bloom
Roland Legiardi-Laura

Dale Worsley
Jeff Wright

Teachers & Writers Publications

THE WHOLE WORD CATALOGUE 1 (72 pages) is a practical collection of assignments for stimulating student writing, designed for both elementary and secondary students. Activities designed as catalysts for classroom exercises include: personal writing, collective novels, diagram stories, fables, spoof and parodies, and language games. It also contains an annotated bibliography.

THE WHOLE WORD CATALOGUE 2 edited by Bill Zavatsky and Ron Padgett (350 pages). A completely new collection of writing and art ideas for the elementary, secondary, and college classroom. Deepens and widens the educational ground broken by our underground best seller, the first *Whole Word Catalogue*. Order two copies and get a free subscription for a friend.

IMAGINARY WORLDS (110 pages) originated from Richard Murphy's desire to find themese of sufficient breadth and interest to allow sustained, independent writing by students. Children invented their own Utopias of time and place, invented their own religions, new ways of fighting wars, different schools. They produced a great deal of extraordinary writing, much of it reprinted in the book.

A DAY DREAM I HAD AT NIGHT (120 pages) is a collection of oral literature from children who were not learning to read well or write competently or feel any real sense of satisfaction in school. The author, Roger Landrum, working in collaboration with two elementary school teachers, made class readers out of the children's own work.

FIVE TALES OF ADVENTURE (119 pages) is a new collection of short novels written by children at a Manhattan elementary school. The stories cover a wide range of styles and interests—a family mystery, an urban satire, a himalayan adventure, a sci-fi spoof, and a tale of murder and retribution.

TEACHING AND WRITING POPULAR FICTION: HORROR, ADVENTURE, MYSTERY AND ROMANCE IN THE AMERICAN CLASSROOM by Karen Hubert (236 pages). A new step-by-step guide on using the different literary genres to help students to write, based on the author's intensive workshops conducted for Teachers & Writers in elementary and secondary schools. Ms. Hubert explores the psychological necessities of each genre and discusses the various ways of tailoring each one to individual students. Includes hundreds of "recipes" to be used as story starters, with an anthology of student work to show the exciting results possible.

JUST WRITING (104 pages) by Bill Bernhardt. A book of exercises designed to make the reader aware of all the necessary steps in the writing process. This book can be used as a do-it-yourself writing course. It is also an invaluable resource for writing teachers.

TO DEFEND A FORM (211 pages) by Ardis Kimzey. Tells the inside story of administering a poets-in-the-schools program. It is full of helpful procedures that will insure a smoothly running program. The book also contains many classroom-tested ideas to launch kids into poetry writing and an extensive bibliography of poetry anthologies and related material indispensable to anyone who teaches poetry.

BEING WITH CHILDREN, a book by Phillip Lopate, whose articles have appeared regularly in our magazine, is based on his work as project coordinator for Teachers & Writers Collaborative at P.S. 75 in Manhattan. Herb Kohl writes: "There is no other book that I know that combines the personal and the practical so well...." *Being With Children* is published by Doubleday at $7.95. It is available through Teachers & Writers Collaborative for $4.00. Paperback $1.95.

VERMONT DIARY (180 pages) by Marvin Hoffman. Describes the process of setting up a writing center within a rural elementary school. The book covers a two year period during which the author and several other teachers endeavor to build a unified curriculum based on the language arts.

THE POETRY CONNECTION by Nina Nyhart and Kinereth Gensler. This is a collection of adult and children's poetry with strategies to get students writing, an invaluable aid in the planning and execution of any poetry lesson.

JOURNAL OF A LIVING EXPERIMENT traces the first ten years of Teachers & Writers Collaborative from the turbulent Sixties into the Seventies. The development of the organization into a stable and effective education force is traced with humor and poignancy. Kenneth Koch, Wesley Brown, Meredith Sue Willis, Muriel Rukeyser, Ron Padgett, and Bob Sievert are only some of the people who talk about their dual identities as artists and teachers. It's all tied together by provocative and incisively written commentary by Phillip Lopate. This is a book about activists—people who wanted to do something and are still doing it.

TEACHERS & WRITERS Magazine, issued three times a year, draws together the experience and ideas of the writers and other artists who conduct T & W workshops in schools and community groups. A typical issue contains excerpts from the detailed work diaries and articles of the artists, along with the work of the students and outside contributions.

--

☐ The Whole Word Catalog 2 @ $6.95
☐ The Whole Word Catalogue 1 @ $4.00
☐ Teaching & Writing Popular Fiction @ $4.00
☐ Being With Children @ $4.00
☐ Five Tales of Adventure @ $3.00 (10 copies or more @ $2.00)
☐ Imaginary Worlds @ $3.00
☐ A Day Dream I Had at Night @ $3.00
☐ Just Writing @ $4.00
☐ To Defend a Form @ $4.00
☐ Vermont Diary @ $4.00
☐ The Poetry Connection @ $4.00
☐ Journal of a Living Experiment @ $6.00
☐ Subscription(s) to **T&W Magazine**, three issues $5.00, six issues $9.00 nine issues $12.00

NAME _____

ADDRESS_____

☐ Please make checks payable to Teachers & Writers Collaborative, and send to:
 Teachers & Writers TOTAL
 84 Fifth Avenue ENCLOSED
 New York City 10011 $_____